Museums
for a New Millennium

Museums

for a New Millennium
Concepts Projects Buildings

Edited by
Vittorio Magnago Lampugnani
and Angeli Sachs

With an introduction by
Vittorio Magnago Lampugnani,

an essay by
Stanislaus von Moos,

and contributions by
Friedrich Achleitner, Colin Amery, John M. Armleder, Rita Capezzuto,
Luis Fernández-Galiano, Kurt W. Forster, Kenneth Frampton,
Katharina Fritsch, Masao Furuyama, Paul Goldberger, Ruth Hanisch,
Herman Kerkdijk, Juan José Lahuerta, Benedikt Loderer, Jacques Lucan,
Gerhard Merz, Michael Mönninger, Luca Molinari, John V. Mutlow,
Joan Ockman, Kenneth Powell, Sebastian Redecke, Thomas F. Reese and
Carol McMichael Reese, Angeli Sachs, Franz Schulze,
Ulrich Maximilian Schumann, Wolfgang Sonne, and Deyan Sudjic

Prestel
Munich · London · New York

Curated and edited by
Vittorio Magnago Lampugnani and Angeli Sachs

Editorial Staff
Angeli Sachs with Edda Campen and Thomas Müller

Copyedited by
Rita Winter

Translations
From the Dutch: Arthur Payman, Bussum; from the French: David Radzino-
wicz Howell, London; from the German: Peter Green, Munich, Elizabeth
Schwaiger, Toronto, Robert H. Thomas, Zurich; from the Italian: Marguerite
Shore, New York; and from the Spanish: Silvija Danielson, Chicago

On the cover: Oswald Mathias Ungers, Gallery of Contemporary Art, Ham-
burg. View up to glazed roof over central hall (Photo: Stefan Müller)
Page 10: Jean Nouvel, Fondation Cartier pour l'Art Contemporain, Paris.
End of façade with external staircase (detail) (photo: Philippe Ruault)

Cover design: Fritz Lüdtke, Atelier 59, Munich

Photo credits: see page 224

Library of Congress Catalog Card Number: 99-65366

Die Deutsche Bibliothek – CIP-Einheitsaufnahme
Museums for a new millennium: concepts, projects, buildings ; [this volume
was first published on the occasion of the exhibition of the same name held
at numerous venues in Europe and America from February 2000 through
November 2003 ; exhibition dates Hessenhuis, Antwerp (Feb. 4 – April 30,
2000) ... Museum of Modern Art, Kamakura, Japan (Aug. 24 – Nov. 23, 2003)]
/ ed. by Vittorio Magnago Lampugnani and Angeli Sachs. With an introd.
by Vittorio Magnago Lampugnani, an essay by Stanislaus von Moos, and
contributions by Friedrich Achleitner ... [Transl. from the Dutch: Arthur
Payman. From the French: David Radzinowicz Howell. From the German:
Peter Green ... From the Italian: Marguerite Shore. And from the Spanish:
Silvija Danielson]. - Munich ; London ; New York : Prestel, 1999
 ISBN 3-7913-2219-2

Prestel Verlag, Munich · London · New York
Mandlstrasse 26, D-80802 Munich, Germany
Tel. +49 (89) 3817 09-0, Fax +49 (89) 38 17 09-35;
4 Bloomsbury Place, London WC1A 2QA
Tel. +44 (0171) 323-5005, Fax +44 (0171) 636-8004;
16 West 22nd Street, New York, N.Y. 10010, USA
Tel. (212) 627-8199, Fax (212) 627-9866

Prestel books are available worldwide. Please contact your nearest bookseller or
one of the above addresses for information concerning your local distributor

Design: zwischenschritt, Rainald Schwarz, Munich
Lithography: ReproLine, Munich
Printing and binding: Passavia Druckservice GmbH, Passau
Paper: Galerie Art Silk 150 g/qm by Schneidersöhne

Printed in Germany on acid-free paper

ISBN 3-7913-2219-2

This volume was first published on the occasion of the exhibition of the same
name:

Hessenhuis, Antwerp (Feb. 4 – April 30, 2000)
Deichtorhallen, Hamburg (June 1 – Sept. 10, 2000)
Kunsthaus, Bregenz (Oct. 6, 2000 – Jan. 3, 2001)
Centro Cultural de Belém, Lisbon (Feb. 1 – April 29, 2001)
Castello di Rivoli, Rivoli/Turin (May 25 – Aug. 26, 2001)
Galerie der Stadt, Stuttgart (Sept. 21 – Dec. 16, 2001)
Modern Art Museum of Fort Worth, Texas (Jan. 11 – April 14, 2002)
Milwaukee Art Museum, Wisconsin (May 10 – Aug. 4, 2002)
The Columbus Museum of Art, Ohio (Aug. 30 – Nov. 24, 2002)
Museu de Arte Moderna do Rio de Janeiro (Dec. 20, 2002 – March 23, 2003)
Museo de Arte Contemporáneo, Monterrey, Mexico (April 18 – July 20, 2003)
and
The Museum of Modern Art, Kamakura, Japan (Aug. 24 – Nov. 23, 2003)

Concept and organisation of the exhibition:
Suzanne Greub, Art Centre Basel, Switzerland

Coordination of international transportation for all exhibition objects:
Maertens International SA/NV, Brussels, Belgium

Table of Contents

Preface

Contemporary museums, especially art museums, are not only one of the most important and noteworthy building tasks in the public domain, they also present an extraordinarily pure materialization of the architectural positions that inform them. In these edifices one can read contemporary developments in architecture with particular clarity—developments whose currents and tendencies are quick in succession, at times parallel and often opposite in nature. Thus, art museums become seismographs of architectural culture. At the same time, these architectural milestones must be investigated with regard to their usability. Museums are buildings that must respond to highly representative and aesthetic demands, while also fulfilling specific requirements with regard to urban design and function. The latter two are all the more complex because they are dictated by the art on exhibit within the building.

This book and the exhibition that accompanies it present a cross-section of the most significant, expressive, and high-quality museum structures and projects that have been designed and built within the last 10 years, or that are presently under construction. Obviously every selection is fragmentary and, to a certain degree, incomplete. We have concentrated upon the finest of contemporary museum architecture, presenting therein not always the most handsome examples of this architectural type, but rather the most emblematic. Above all, they should be representative of architectural currents, urban or rural sites, dimensions, and cultural demands. The 26 selected examples should proffer an excerpt from the complex panorama of the history of museum architecture at the close of the twentieth century, while offering a glance beyond the turn of the millennium.

This exhibition was initiated and organized by the Art Centre Basel, under the direction of Suzanne Greub. We took over the conception and scholarly support of the project as well as the catalog. With the appearance of this book about contemporary museum architecture, a time of intensive work will have passed during which many varied persons and institutions contributed to the success of the exhibition and of the book. First and foremost, our thanks are extended to Suzanne Greub and her colleagues at the Art Centre Basel, who, with great commitment, mastered the extensive organization of the exhibition, the often-difficult collection of the necessary materials, and much more.

Neither the exhibition nor the catalog would have been possible without the trust, collaboration, and support of the participating architecture offices. Beyond having made the material available for the presentation and the catalog amidst their actual daily work, they often prepared material especially for this project. The traveling exhibition has been made possible by virtue of the readiness of numerous host museums to enter into a multi-year adventure with us. We were able to engage numerous prominent authors for the book, most of whom have had a long and intensive relationship with the object of their architectural analysis. They all accepted the challenge of handling the manifold aspects in an analysis of a project and the architectural position of its architect, as well as questions concerning the cultural and urban context, in a differentiated and condensed manner. The work of the various translators and lectors, certainly not always an easy task, is important to mention here, above all in the person of Ruth Klumpp for accompanying the German text. At Prestel Verlag, Sabine Thiel-Siling and Rainald Schwarz (responsible for production) in particular have supported the making of this book with their best, making the collaboration a sheer joy. And finally, very sincere thanks are extended to our own project team, with Edda Campen and Thomas Müller, at the Institute for the History and Theory of Architecture at the Federal Polytechnic Institute of Zurich, for their continuous and competent commitment to the project.

Vittorio Magnago Lampugnani
Angeli Sachs

Foreword

In the course of the exhibition work at the Art Centre Basel and my resulting collaboration with various museums, I came upon the fact that these institutions have erected new buildings, planned expansions, or extensively renovated their existing exhibition spaces. I asked myself how one could justify this trend toward more and more museums and museum activity, while simultaneously wondering how these new edifices would look. From this beginning, I developed the idea of putting together an exhibition survey covering the most important tendencies in museum architecture at the close of the century and at the threshold of the new millennium. This included the question of whether these developments could point to the museum of the future, in the sense of an open place of communication for art.

A project of this caliber would be impossible without corresponding professional support. Hence, at the beginning of 1998 I turned to Prof. Dr. Vittorio Magnago Lampugnani from the Department of Architecture, History of Urban Design, at the Federal Polytechnic Institute of Zurich. To my delight, he agreed, together with Ms. Angeli Sachs, scholarly colleague at the same institution, to take over the scholarly support of this project as curator and publisher of the catalog. Their professional ability and support, together with the other colleagues of their project team, Edda Campen and Thomas Müller, were of great value, especially with regard to the conception of the exhibition and the book and the selection of the projects, as well as the selection of the exhibition components and all of the contributions connected with the catalog.

Without the permission of the participating architects, who lent us valuable material, as well as the other lenders, this exhibition would not have been possible. In addition, the efficient collaboration with members of the individual architecture offices made a significant contribution to the success of this undertaking.

My colleagues at the Art Centre Basel, Margrith Herzig, Françoise Hänggi, and Susan Lüthi, gave their very best. They tirelessly handled the extensive and demanding work required of the exhibition and the acquisition of material for the book.

To all of those mentioned here or elsewhere in the book or in the exhibitions, I extend my great thanks for this collaboration.

Last but not least, I am grateful to the directors of the host museums for the interest they have shown in this international traveling exhibition and for their readiness to exhibit it in their museums. The trust shown to us herein is both an honor and a joy for me.

Suzanne Greub
Art Centre Basel, Switzerland

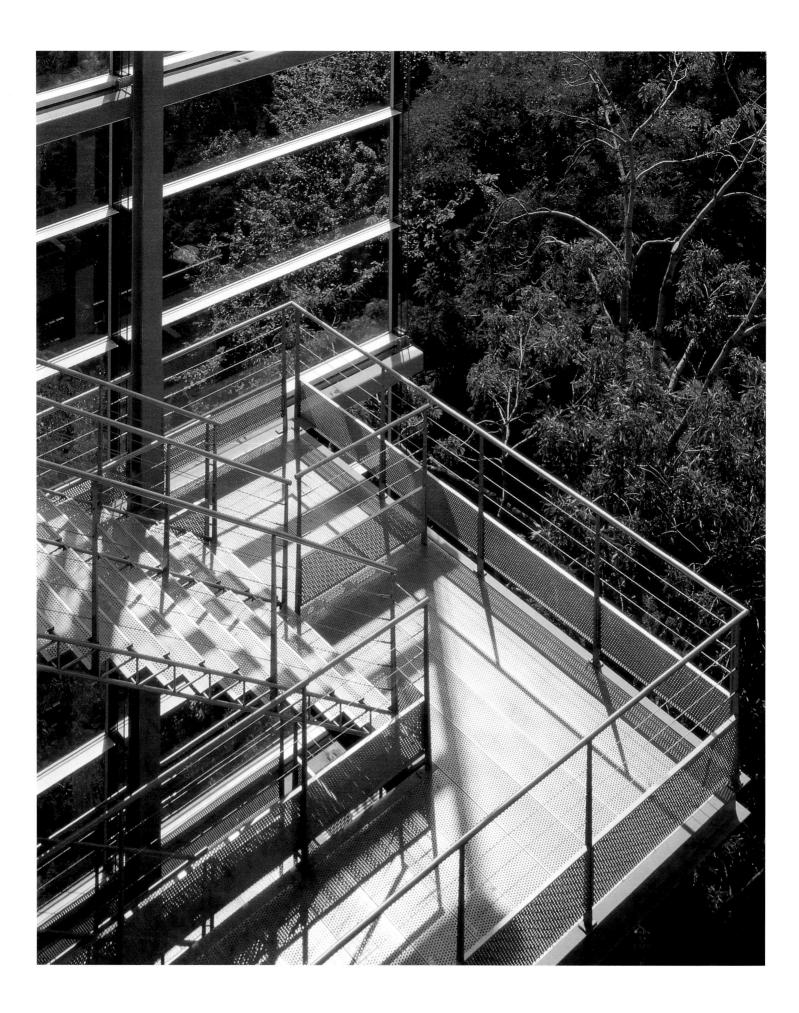

The Architecture of Art:

The Museums of the 1990s

Vittorio Magnago Lampugnani

At the beginning of this century, which is drawing to its close, Filippo Tommaso Marinetti declared in the first of many manifestoes he was to issue that museums were nothing but public dormitories. They had become superfluous, he claimed, in a world whose glory was enriched by the beauty of speed. A roaring racing car was more beautiful than the *Winged Victory of Samothrace*; there was no longer any need for a site to house and show this treasure. Marinetti wanted to free Italy of "the cancerous growth of academics, archaeologists, tourist guides and antiquarian booksellers ..." and also "of the countless museums ... which cover it like churchyards."

Predictions run the risk, however, of being proved wrong by subsequent events. And rarely has a prediction been so completely overturned. The futurists declared that the twentieth century would finally sweep out the old. Yet, with the exception of a brief burst of energy—embodied in the avant-garde, which was significant but really no more than an intermezzo—this century more than any other could justifiably be labeled *passatistic*, pet neologism and insult of the futurists. The shock of modernization and the terror wrought by two fully mechanized world wars were followed by a retreat into the values of the past. And art museums facilitated and symbolized this retreat.

Architects approached the task with growing enthusiasm. It echoed a need in society that could be endorsed or criticized, but certainly not denied. Thus the task of building new museums enjoyed an almost unprecedented level of political and financial support that directly benefited the architects. It also generated a latitude, or room for play (real or imagined, but more on that later)—in short, freedom to realize architectonic ambitions, no matter how audacious.

At first it seemed as if the twentieth century would rise to Marinetti's challenge and stop filling cities with obsolete "dormitories." Building new museums was simply not a priority in the public domain during the first half of the century. There were some exceptions: Rittmeyer and Furrer built the rational and elegant museum in Winterthur (1912–16) and John Russell Hope created the classi-

cist National Gallery in Washington, D.C. (after 1936). Heir to Marinetti's futurist ideas to some degree, the modern movement's main thrust was to build houses for people and not for art. Mies van der Rohe's exquisite project for an art gallery for a small town (1942) was the exception rather than the rule, as was Henry van de Velde's Rijksmuseum Kröller-Müller in Otterlo (1937–54).

Only after the Second World War did museum architecture regain prominence, and soon designs were translated into concrete projects and buildings. The Louisiana museum in Humlebaek, near Copenhagen, was a unique success in 1958–59. Jørgen Bo and Vilhelm Wohlert's complex spatial arrangement, introverted in character and with very precise wall openings, combined the quietude of art contemplation with the serenity of looking out at nature in a manner that was astonishingly matter of course. In this building, postwar modernist architecture is subservient in a most natural manner to the humility and restraint that had reached their peak in nineteenth-century museum architecture.

Although a contemporary of the Louisiana, the Solomon R. Guggenheim museum designed by Frank Lloyd Wright for the city of New York in 1943 could not have been more different. The powerful, sculptural shape stands in deliberate contrast to the uniform grid that is Manhattan. This building *likes* being center stage. Inside, visitors follow an ascending, curving ramp that apodictically dictates their route through the collection, leaving them no other option. The wall surfaces on the interior do not favor the paintings mounted there, and the large, round foyer at the center, with daylight penetrating from above through a Plexiglas cupola, is visually invasive and distracting. Here, architecture is the real attraction, the incontestable protagonist. This architecture does not serve the artworks it surrounds.

With the Guggenheim, the leitmotif for museum architecture in the twentieth century was established. Most subsequent buildings were variations on the same theme with varying degrees of virtuosity. Even Mies van der Rohe's new National Gallery in Berlin (1962–68), a realization of his early dream for a fully transparent museum,

was first and foremost a material or concrete translation of an architectural vision to which all practical requirements were ruthlessly subordinated. The large glass cube beneath a boldly projecting coffered steel roof is a difficult environment for exhibition purposes, while the actual gallery rooms in the basement appear more like a grudging afterthought aimed at meeting the requirements for which the project was conceived in the first place.

The Kimbell Art Museum in Fort Worth by Louis Kahn (1967–72) is a different case altogether. While Kahn's addition to the Yale Art Gallery in New Haven, Connecticut (1951–53), was still very much indebted aesthetically to Mies van der Rohe, the Kimbell calls to mind the enlightened solutions of museum architecture in the nineteenth century. The interior and the room layout are designed with careful neutrality, and daylight is filtered with perfect balance through skylights for optimal natural lighting: this is an ideal model of modern museum architecture.

Unfortunately, it is also a model that has fewer followers than one might wish. The next large-scale project, chronologically speaking, was the Centre National d'Art et de Culture Georges Pompidou, designed by Renzo Piano and Richard Rogers (1971–77). The plan and the site, the Plateau Beaubourg in Paris, turned mandate into manifesto, proclaiming a new attitude in building, neither organic like the Guggenheim nor structurally classicist like the new National Gallery, but high-tech. The unmitigated, radical expression of the exposed steel framework, combined with supports, trussed girders, cantilevered corbels, and diagonal wind bracing, is not only structural in function but above all eminently symbolic: the aesthetics of Archigram, the utopian group of English architects in the sixties, expressed in drawings that were as innovative as they were impractical, had arrived in the heart of Paris. That this aesthetic owed much to Antonio Sant'Elia, who had been "converted" to futurism by Marinetti and was acknowledged by the latter as the futurist architect *par excellence*, verges on history avenging itself: seventy years later, here was that novel and irreverent architectonic, developed to express the beauty of speed, applied to a "public dormitory."

Admittedly, it was done with an intention that would have pleased the founder of the futurist movement: to represent a new and dynamic form of culture, reflected in a complex and innovative concept. Just how ideological the project's goal and its architectural realization were, was quickly evident. The six atria for exhibitions, one stacked atop another, were soon remodeled because they had been conceived to pay homage to a myth of complete flexibility rather than to the art in them. The impressive structural framework, too, required a complete overhaul a mere twenty years after the sensational *machina ex cultura* (or culture machine) had been completed.

The Centre Pompidou with its claim to being no more than an envelope, a stimulus for the masses where they would contemplate and experience art as never before, is another case where the architecture is a greater attraction than the artworks. Countless "visitors" are carried upward on Plexiglas-encased escalators, yet few actually step into the exhibition rooms. By simply being there, they pay homage to this monument of modernism and continue onward to the rooftop, from which they enjoy a breathtaking panoramic view of historic Paris.

The high point of museum architecture as a playground for artist/architects occurred in the late seventies and eighties. Postmodernism brought with it a return to historicism and hence a renewed central role for the museum as a building task. Riding on a wave of public support never witnessed before, museums symbolized a new kind of communal building: it is no coincidence that the new museum buildings were called the cathedrals of our time. Soon every city, even smaller towns, clamored for a "social catalyst" of its own. Countless museums were built and visitors were more numerous than ever before.

At the same time, postmodernism introduced a typology and an iconography that corresponded to a new public appreciation for an old building task. The ritual of visiting a museum and looking at art was virtually choreographed; discriminating cultural requirements found expression in monumental embodiments of dignity. Architecture was *in*, and the appetite for it was insatiable.

The Stuttgart Staatsgalerie addition, the new Kammertheater designed by James Stirling (1977–81), became an architectural emblem of the new historical culture. Conceptually, the design was based on the competition entries for the Kunstsammlung Nordrhein-Westfalen in Düsseldorf and for the Wallraf-Richartz-Museum in Cologne (both 1975). In a complex intellectual game, the building concept juggles elemental volumes, surrealistic wall openings and unabashedly open historic references (which, no sooner expressed, are immediately taken back again). While an enfilade of large rooms occupies the gallery floor, the ground floor offers a space for changing exhibitions, as well as a lecture hall, archives, and the building services, all arranged around a circular sculpture courtyard; in front, the lobby and the museum café curve gently outward. Stirling has achieved an extraordinary

aesthetic, and the building immediately became a site of pilgrimage for architects and students of architecture from around the globe. Moreover, he has created an urban element that provides a confident and beautifully simple solution for a challenging urban situation.

The Stuttgart museum was the departure point for a new architectural genealogy that soon spread across Europe, the United States, and Japan. One of its main characteristics was "flexible uses." That is, the public areas such as restaurants and museum shops became increasingly important factors in setting the stage for urban ambitions. These new buildings were (urban) catalysts, ambitious aesthetic mechanisms that enabled their respective authors to showcase their expertise in architecture (and their erudition in history).

All too often the original goal seemed forgotten: to present works of art in an environment where space, light, and atmospheric conditions would be ideal. At the opening of his masterpiece in Stuttgart, Stirling is quoted as having quipped that the building would have been even better without the encumbrance of the paintings.

The *bon mot* should not be overrated. Looking at the museum architecture of the eighties, it becomes obvious that the requirement of creating space for exhibitions was often treated as the poor cousin next to the primary importance of architecture as an urban, typological, and form-giving experiment. Architects like Aldo Rossi, Giorgio Grassi, Oswald Mathias Ungers, and Josef Paul Kleihues excelled in urban planning and development; Robert Venturi and Denise Scott Brown, but also Norman Foster, Jean Nouvel, Renzo Piano, and Rem Koolhaas, discovered coherent and rigorous solutions for new uses; Hans Hollein, Ieoh Ming Pei, Richard Meier, José Rafael Moneo, and Juan Navarro Baldeweg drafted exquisite formal solutions by looking to the past for inspiration, with increasing liberty drawing first from historic styles in the distant past and then from the classic modernism of the more recent past. In cities like Frankfurt am Main, concepts and plans for new museum buildings were turned into urban renewal projects, setting in motion more than urban renovation and completion: they gave cities a new face and new life. Little innovation and progress, however, have occurred in the exhibition rooms, the very rooms for which the museum was built in the first place. They had become a pretext for other strategies and experiments, uppermost in the public's—and the critics'—mind.

It is as difficult to establish a common stylistic denominator for the museum architecture of the nineties as for that of the previous decades: increasingly, different attitudes coexisted and still coexist. Contemporary museum buildings tend to be astonishingly pure materializations of their authors' corresponding attitudes toward architecture: they are seismographs of the architectonic culture to which they belong. They illustrate the development in architecture and the accelerating change in trends which may run concurrently and parallel to one another, or, as is often the case, be diametrically opposed.

While the nineties have seen a continuation of this tendency, there has been one significant change. In addition to the new historicism and high-tech expressionism, next to postmodernism and deconstructivism, a new tension has entered into the international arena of architecture: minimalism. The diversity of twentieth-century pluralism has been augmented by yet another path.

It is a new path that seems particularly meaningful for museum architecture. For the restraint that is minimalism corresponds at first glance to the same reticence that has marked the highlights in the best tradition of museum architecture. The new generation of art museums seems predestined once again to *serve* art, which is an expression of the highest degree of reverence in architecture toward art.

First impressions are misleading. Upon closer inspection, even Álvaro Siza Vieira's masterpieces, the magnificent work of David Chipperfield, Jacques Herzog, and Pierre de Meuron, or the achievements of Annette Gigon and Mike Guyer, Eduardo Souto de Moura and Peter Zumthor emerge as rigorously restrained but nevertheless artistically ambitious mechanisms whose presentation is rarely as discreet as it may seem. Their self-imposed, unyielding aesthetic laws invariably lead to idiosyncratic, even invasive room arrangements that are at times in conflict with the requirements they are meant to fulfill. Minimalism does not necessarily deliver an "appropriate" or "natural" result.

One reason for the puzzling and overwhelming dominance that radiates from the museum architecture of the nineties is that it is less a product of nineteenth-century rational historicism than of twentieth-century abstract modernism. It is based on an intention where orthogonal spatial arrangements, unbroken walls, or structural details cannot be hidden. What truly matters in this architecture is not the art inside it, but the architecture itself. These museums are works of art that house other works of art. And the inevitable conflict is rarely mitigated by the design. Generally the artworks—guests within the walls of the architecture—come off second-best.

We are left with a paradox. Extreme reduction and extreme expression, and all that lies in between these poles, is ultimately driven by the same motivation: to establish the primacy of architecture over art. Museum architecture remains a playground for architects, as it has been since the middle of the twentieth century. It is but a platform for presenting a new, a different style, the same *amour de soi*, the same importunate manner, and above all the same indifference toward the true challenge that lies in this building task, merely couched in different terms.

But architects are responsible only to a certain degree. Their mandate is set by the client, the community, the patron, the curator. These, in turn, consult with the artists and their public, as indeed they should. The mandate, that is the "program," is therefore social in nature, provided it is fully developed. The weaknesses and the strengths of contemporary museum architecture are the direct product of the society to which it is accountable.

The strengths are indisputable. One such strength is that of all building categories, museum architecture personifies, more than any other, the art of building. It is the site where architectural ideas are realized in their purest form and where all major contemporary trends can converge in their most original, their most radical incarnation because they are after all the "leaders of the pack." In the process, urban, typological, and, last but not least, formal experiments are carried out that enrich and promote the discipline as a whole.

The greatest weakness has its source in just this strength: be its voice loud or soft, architecture overpowers the art it houses. This is also the product of a society where art is equated with entertainment, as opposed to art as a mechanism for learning. The contrast is stark and cannot be bridged. Compromises won't get us anywhere.

But alternate options will. Although contemporary society, and not a few artists, have adopted the idea of art as stimulating, sometimes touching, sometimes amusing, but always open to consumption, there still survives a small group which insists that art is for enlightenment and nothing else. There should be museum buildings for this group, too.

Perhaps the great challenge for museum buildings in the new millennium is this: to create architecture that is congenial to such a narrow interpretation of art. Perhaps the most powerful rejoinder to Marinetti's prophecy is this: to design and to build museums that are neither dormitories nor entertainment centers but laboratories for sensual perception and for critical thinking that is uncompromisingly rational.

A Museum Explosion:
Fragments of an Overview

Stanislaus von Moos

An explosion of typologies and formal themes, culminating in Frank O. Gehry's Guggenheim Museum in Bilbao (Fig. 3), has led many artists, museum professionals, and architects, to agree on what they deem "risky" in museum design, and conversely on what they see as valid and desirable for the long term. As early as 1984, long before the era of Gehry, the German artist-prince Markus Lüpertz remarked in an expression of discontent at the many "interesting" new buildings: "These new museums are beautiful, remarkable structures, but, like all art, they are hostile to 'other' forms of art. Simple, innocent paintings and simple, innocent sculptures cannot compete ... Architecture should have the generosity of spirit to play a more supportive role and not overpower the art with artistic aspirations of its own; nor should it—which is even worse—exploit art as 'decoration' for architecture."

Lüpertz was still envisioning the "classic museum" (let's ignore for the moment whether he truly judged his own work to be "simple" and "innocent"): "The classic museum is structured as follows: four walls, light from above, two doors, one for those who enter and the other for those who exit." [1]

Over the past years, a number of museums have delivered *de facto* proof that the classic model is indeed valid. Switzerland, of which I am best equipped to speak, has subscribed less to classicism than to the simple, neo- or late-modernist "box" in order to offer resistance to what seems to have become a standard "arbitrariness." The Goetz Collection, a small private museum in Munich (architects: Herzog & de Meuron), is to many emblematic of this attitude (Fig. 1).[2] Architecture of this kind is often experienced as "neutral" in form, historic associations, and relation to the objects displayed within. "Neutrality" seems best to satisfy what many museum professionals expect of a restrained exhibition space.

Minimalism and "Neutrality"
The Goetz Collection is, however, anything but "neutral." And as for the Kunsthaus Bregenz, a popular destination for all who seek out minimalist museum design, the extremity of *its* neutrality has been criticized for going so

far as to "destroy" some pieces in group exhibitions.[3] Shouldn't the aesthetic standard of the semantic "neutrality" in each of these cases alert us to a skeptical response? The problem is a familiar one. When Jean Cassou defended the white museum, the unadorned museum "container" of the fifties, as the model museum design that surpassed all ideologies, others countered, justifiably, that the "white" museum—seemingly devoid of representational pretensions—was more ideological in nature than any other museum design, if only because it was a concept that, having become sacrosanct in western Europe and the United States during the Cold War era, denounced all other museum ideas as reactionary and anti-democratic.[4] A further footnote in hindsight would be that "white" is rarely a true white in architecture and "minimal" does not necessarily deliver a "simple" overall impression.

Why then does "minimal" museum and exhibition design more than any other compensate for excluding historicizing connotations by creating an aura that can only be called sacred? Why does the sophisticated aesthetic Puritanism of such buildings often translate into autonomous artistic themes that impose themselves between viewer and object? And why, conversely, do "expressive" or "historicizing" designs—buildings that are anything but "simple"—offer breathing space for the art in them by virtue of their structure and complexity, yet still manage to push their own complexity to the foreground?

Answering such questions might lead one to relativize ideological prejudices toward museum design in favor of a more precise aesthetic perception and greater specificity in posing the problem. One might propose that an alternative exists to museum design whose architectonic envelope is merely "servile" or whose envelope is first and foremost a celebration of itself (as in the case of Richard Meier, who wanted to inaugurate the Museum für Kunsthandwerk in Frankfurt before the collection was put into place). The alternative then is not a question of idiom but of attitude. Another way of looking at it would be that "minimalist" and "deconstructivist" museum architecture is but an extreme variation of the current trend of creating museum design in close collaboration and dialog with the visual arts.

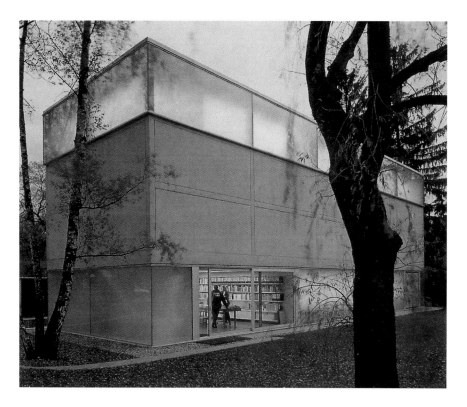

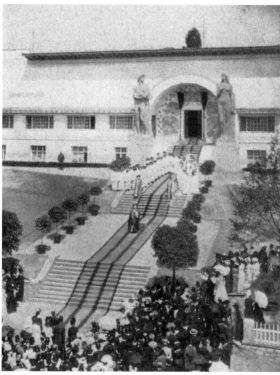

Museum Concepts around 1920

The idea of the museum as a site where the arts emerge from their isolation and converge into a Gesamtkunstwerk has its roots in the early twentieth century. It has less to do with formal design than with museum content. In a slim and now largely forgotten volume entitled *Umgestaltung der Museen im Sinne der neuen Zeit* (*Redesigning the Museum for Modern Times*), first published in 1919, Wilhelm R. Valentiner put forth the idea of founding a museum that would combine the fine arts, represented by master works of German painting and sculpture, with exponents from the decorative arts, juxtaposing the two "arts" for each era. The goal was to document the history of art with masterpieces from the permanent collections in German museums, presented in chronological order and extending over 23 rooms, beginning with so-called "primitive" art right up to contemporary art.[5]

Valentiner was curator of decorative arts at the Metropolitan Museum in New York from 1908 to 1914. Based on his American experience (as opposed to his German experience) he argued that museum tradition could be a didactic tool in teaching art history. In his mind's eye, Valentiner saw the building as the quintessential embodiment of German Art located in a provincial setting in Germany, close to Coburg, for example, or Marburg. Moreover, he thought of it as crowning a hill or a small mountain. By contrast, his ideas on the design were very general, stipulating simply that it should resemble neither a palace nor a warehouse. To Valentiner, placing the museum on a hilltop was of great importance: he felt that visitors would quite naturally make the transition from gazing into the distance to "an inward focus and a close-up perspective." One can easily picture the architectural images which may have inspired Valentiner (Fig. 2).

In his day, Valentiner's ideas were met with skepticism by art critics and curators alike. Some felt that they could detect the corruption of Bolshevik ideology (W. Pastor), while others decried Valentiner's proposal by arguing that he was merely interested in running a museum to entertain tourists, "a Bayreuth of the arts, an attraction for American tourists" (C. Glaser). Since Valentiner's book had appeared in Berlin in 1919 under the subtitle *A Memorial to the Workers' Arts Council*, it seems logical to connect his ideas with the revolutionary upheavals of the post-war era. Valentiner's concept has much in common with the idea for a "people's palace" developed by architects such as Bruno Taut, Hans Scharoun, Hermann Finsterlin, and others, sometimes even from within the Workers' Arts Council. Today, we can no longer determine to what degree Valentiner was aware of the connection between his ideas and the freely penned dreams of his architect friends yearning to create "sites for mutual exchange between the arts and the public," to paraphrase Bruno Taut (Fig. 4).

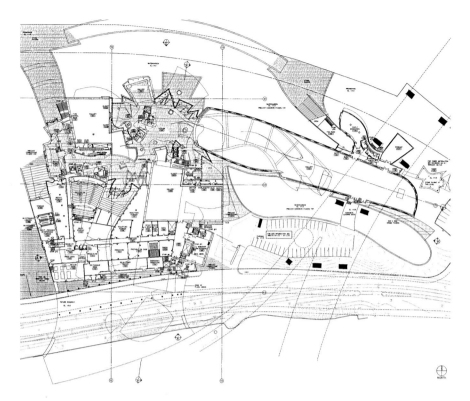

3 Frank O. Gehry: Guggenheim
Museum, Bilbao, 1993–97

4 Hermann Finsterlin: *The Houses
of Creative People*, 1919

The Avant-Garde becomes a Matter of State

They would have to wait until after 1945 before their
dream would became more attainable. They hoped to lib-
erate the genre museum from centuries-old architectural
traditions and translate the "free" form—hitherto delegat-
ed to the realm of fantasy—into concrete projects, no
matter how few and ahead of their time these were. In the
main, the renewal focused on the museum as a building
type, not as an institution. The process was driven by a
complex dynamic all of its own. The centuries-old tradi-
tion of the "classic" museum had experienced somewhat
of a revival in development projects for public museums
and galleries during the pre-World War II era. Nor had
this revival been limited to a National Socialist or Fascist
Europe (see below). The end of Nazi rule in Germany
prepared the ground for the state to make a clear break
with the rules of convention and to throw itself whole-
heartedly behind the artistic avant-garde.

At the same time, the voice of Pax Americana grew
ever more strident in the politics of culture and was grad-
ually absorbed into the language of the avant-garde. The
modern movement was ready to supply the official lan-
guage of art for the "free world." When we think of Frank
Lloyd Wright reinventing the museum out of a spirit of
the romantic "I," Taut, Finsterlin, and Scharoun, immedi-
ately spring to mind (Fig. 5). For example, Wright uses the
museum *parcours* as a means of bringing the wide expanse
of the universe once again into contact with the con-
sciousness and the reality of *here and now* (specifically:
Manhattan). In the light of Wright's late stroke of genius,
the socialist fantasies around 1918—those "deliberately
far-fetched ideas," as Taut called them—boldly foreshadow
less a socialist future than a mythology of unbridled cre-
ative individuality that is uniquely American. Before the
Fall of Public Man (or: *The Tyranny of Intimacy* as it was apt-
ly entitled in the German version) no one could have
contemplated implementing a program of this kind.
Harald Szeemann describes the consequences: "What
Kandinsky called the 'ethics of artistic impetus' [driven by]
'internal necessity' has become the standard to which
every museum architect subscribes, sometimes with disas-
trous results."[6]

In that light it is no political paradox that Frank O.
Gehry's museum in Bilbao—the brightest monument to
American cultural hegemony in Europe—should relate
more closely than any other recent project to those post-
war sketches for a revolutionary people's palace (Figs. 3, 4).

The Dregs of Tradition

One might assume that all this would have made the classical tradition in museum design obsolete. But Valentiner would have disagreed, as would some younger museum professionals and quite a few architects. Our perception of what a museum should be—in function and form—is still more readily informed by the Vatican, the Louvre, the Uffizi, and the Alte Pinakothek than by the fluctuations of current tastes in architecture (at least where museums that exhibit the Old Masters are concerned). The current invasion of modern architecture into the museum world aside, the Grand Louvre project under president Mitterrand—a continuous museological landscape linked by a mall—remains the singular most spectacular museum "operation" of the eighties. And one of its most interesting aspects is the treatment of the building's history, which has itself become an object for exhibition in the palace basement, where visitors are treated to an informative and well-documented "archeological" tour of the complex (see Fig. 8).

The varied display, which also includes some models, illustrates the development of the royal picture gallery from the seventeenth century onward, i.e. the development of the "classic" exhibition space. Initially, galleries had nothing to do with hanging paintings on a wall. Their simple *raison d'être* was to provide a link between distant sections in large palace complexes.[7] Nevertheless, utilizing such spaces for the display of art collections was a logical development. The Vatican is a case in point. The papal collections quickly spread across the multistory galleria complex, designed by Bramante after 1500, to link the Belvedere at the northern end with the center of the papal residence. (The first permanent sculpture collection, incidentally, was installed in 1508 commissioned by Pope Inocent VIII—in the courtyard of the Belvedere, a weekend residence, at some distance from the Vatican.)

Fontainebleau has a similar history. Works by Primaticcio, Rosso Fiorentino, and other famous artists "imported" by the king from Italy to France were displayed in its Galerie François Ier, originally built to connect the two palace wings. Soon after, Vincenzo Scamozzi built Vespasiano Gonzaga's Galleria in Sabbioneta near Mantua, whose interior was later decorated with statues. More time would elapse before the Uffizi in Florence served as both administrative offices and home to the ducal collection, which was housed in the deep enfilades—cornerstone of Vasari's brilliant intervention into Florence's town center—as late as the end of the eighteenth century (Fig. 7a). The development of the Uffizi into a picture gallery was similar to that in the Louvre, where the wing that con-

5 Frank Lloyd Wright: Salomon R. Guggenheim Museum, New York, 1943–59

6 Walter Dorwin Teague: Ford Motor Company Pavilion at the World Exposition in New York, 1939

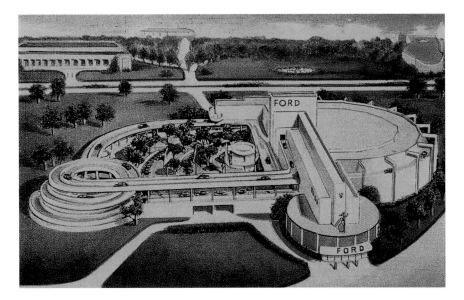

7 Traditional gallery types for sculpture and painting compared in size; all plans to same scale (1:1500)
a. Giorgio Vasari, Uffizi, Florence, begun 1560
b. Karl Friedrich Schinkel, Altes Museum, Berlin, 1822–28
c. Leo von Klenze, Alte Pinakothek, Munich, 1826–36
d. Heinz Hilmer and Christoph Sattler, Gemäldegalerie, Berlin, 1986–98

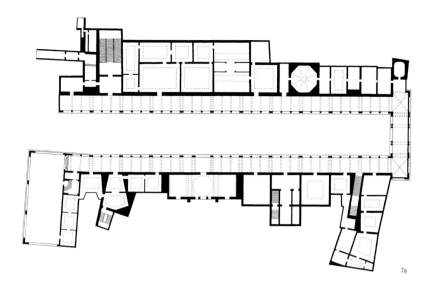

7a

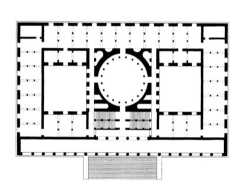

7b

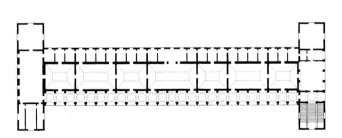

7c

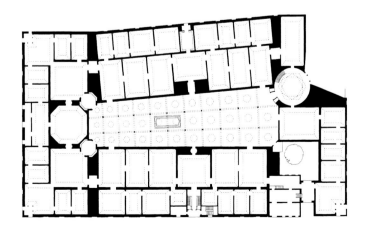

7d

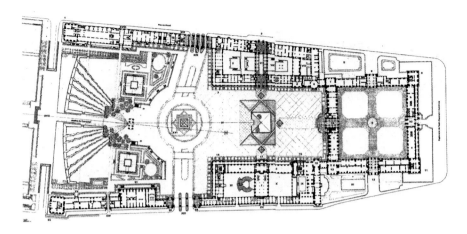

8 Louvre, Paris. Ground-floor plan

nected the palace core to the Tuileries had been built in the early seventeenth century but was used as a museum space only in the eighteenth century.[8]

The great American museums were all built during the first decades of the twentieth century: the Metropolitan Museum in New York (Wilhelm R. Valentiner's place of work prior to 1914); the Philadelphia Museum of Art; the National Gallery in Washington. These are buildings whose place as institutions representative of the official politics of culture is firmly based in the great museums of the Old World. And while each foundation is unique, they derive from the same compact model. Thus Smirke's British Museum in London and Schinkel's Altes Museum in Berlin are related. The floor plan for the Altes Museum (completed in 1828), with its combination of galleries and central access area (here a rotunda, Fig. 7b), has been widely imitated, as has Alois Hirt's approach to hanging paintings in the Altes Museum.[9] In this model, all is made subordinate to a clear didactic program: taking viewers by the hand and guiding them along a chronologically organized presentation of the development in art.

Klenze applied a reduced, linear version of the same concept to the Alte Pinakothek in Munich (Fig. 7c). The slightly larger dynastic museums of the late nineteenth century, above all Semper's Kunsthistorisches Museum in Vienna, have fixed the classic style as *the* design for museums as public institutions in the public's consciousness.

An Attempt at a Typology

These examples merely set the stage for the more specific topic under discussion here (the writings of Nikolaus Pevsner, Helen Searing, and others are recommended for further reading[10]). On the one hand, they cast a stark light on the chasm that separates modern museum design (including postmodernism) from the "great" tradition of the European museum. And on the other hand, they illustrate the thematic continuity that persists despite the morphological break of modernism.

What has shifted is the scale and the external face. Since the eighties not a few architects have nevertheless begun to revisit the tradition of the classic museum. For the Staatsgalerie in Stuttgart, James Stirling and Michael Wilford have grouped enfilades of galleries around a circulation rotunda, a direct allusion to Schinkel's Altes Museum (Fig. 7b, 14). Mario Botta found an analogous solution for the Museum of Contemporary Art in San Francisco, while Heinz Hilmer and Christoph Sattler shifted the entrance rotunda in Berlin's Neue Gemäldegalerie off-center, occupying the central position laconically with a large atrium (Fig. 7d).

Faced with these confusing scenarios, how can we define a "typology" for the contemporary museum? In what is probably the best overview of this topic, Victoria Newhouse has organized her work under the headings of public or private ownership, representational expectations, relationships with existing predecessors and core buildings (in the case of museum expansions), or even the visual arts.[11] By contrast, this author's approach of identifying four "typical" solutions—while somewhat lacking in order—may come closer to looking at the specifically architectural side of the issue:

1. The museum as a converted monument.
2. The "open" museum (the "loft" or *Kunsthalle*).
3. The museum with traditional enfilades.
4. The museum as "sculptural architecture."

1. The museum as a converted monument. In a world where the Vatican, the Louvre, and the Uffizi are still seen as quintessential models for what museums should be, one would do well to remember that conversion—all three examples started out as royal or ducal palaces—has been the rule rather than the exception in museum development. With the exception of sensational projects such as the Grand Louvre, conversions rarely take center stage in architecture. They simply don't make good "copy". Still, haven't some of the most important art museums and *Kunsthallen* found new homes in empty industrial monu-

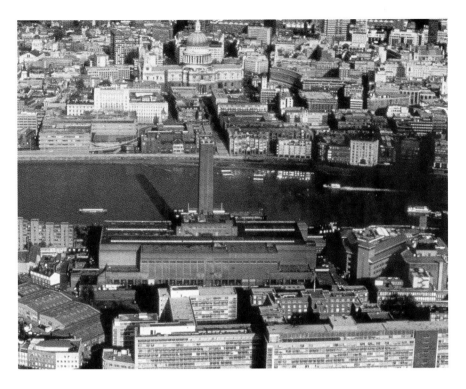

9 London. Aerial view of city center with South Bank Power Station, which is being converted into the Tate Gallery of Modern Art (architect of the power station: Giles Gilbert Scott, 1947–63; architects for conversion: Jacques Herzog and Pierre de Meuron, since 1994)

ments (the Musée d'Orsay in Paris; the Hamburg railway terminal building in Berlin; the Deichtorhallen in Hamburg; and the new outpost of the Tate Gallery in London, to name but a few. Fig. 9)? Has not factory conversion, into a museum or *Kunsthalle*, become one of the most widely practiced approaches worldwide (the Lingotto in Turin; the Dia center for the arts in New York; the Hallen für Moderne Kunst in Schaffhausen; the Musée d'Art Contemporain in Geneva)?

2. The "open" museum. As a space "without characteristics," the "open" museum of the sixties is in many ways the archetypal modern museum, hailed as "democratic" and user-friendly by its proponents, who claim that it diminishes the "threshold fear" that grips visitors as they enter other "hallowed" museum spaces. In favor of perfecting the technical installations, the "open museum" seemed to relinquish all pretension to architecture in the traditional sense. The Centre Pompidou (surely the most spectacular example of throwing monumentality in museum design overboard) has successfully bridged the gap between modern art and pop culture.

3. The museum with traditional enfilades. The twentieth century has never fully abandoned this principle, even though it contradicts the canon of New Building and its predilection for pavilion-inspired exhibition landscapes. In the eighties, when Lüpertz published his manifesto in support of the "classic" museum, the image of self-contained

enfilades seemed to catch up with the "open museum" concept. At the time, Dominique Bozo, curator of the Musée National d'Art Moderne in Paris, added internal insertions in a traditional style into the Pompidou's formless "lofts," a strangely historicizing wake at the grave of the "open museum" (architect: Gae Aulenti).

We have already mentioned the return of the classic enfilade in museum design (Staatsgalerie addition in Stuttgart by Stirling & Wilford). The Sainsbury Wing of the National Gallery in London (architects: Venturi & Scott Brown) was yet another variation on the classical theme, here combined with side or corner access areas (an obvious reference to Sir John Soane's Dulwich Gallery from 1810). Other revivalist examples were the new J. Paul Getty Museum in Los Angeles (architect: Richard Meier) and the Neue Gemäldegalerie in Berlin (architects: Hilmer & Sattler).

4. The museum as "sculptural architecture." This implies a redefinition of the sequence of museum spaces in the sense of a series of organic or expressive spatial forms that can no longer be defined in terms of traditional concepts.

Form versus Function

In the thirties, when the National Gallery was under construction in Washington (and the Haus der Kunst in Munich) Schinkel's Altes Museum still provided the answer to the question about the "archetypal" museum. The focus has since shifted to one of organization and order of precedence. But let's return to the problem of defining museum "typology." Typology concerns the museum as a whole, beyond appearance and structural configuration. Infrastructural issues are increasingly important, and design is only one factor among many. A French critic recently formulated the following definition of an archetypal modern museum. In particular, he distinguished three components:
1. Catchment areas (reception, lobby, coat check, restaurant, cafeteria, etc.)
2. Presentation areas (galleries, exhibition rooms)
3. Offices, workshops, administration, storage, conservation, etc.[12]

This seems simple enough. The museum, then, is a combination of these three functions, whereby the first and third elements (catchment areas and offices, workshops, etc.) occupy approximately two thirds of the usable volume; or, as Robert Venturi put it: "The ratio of 'space for art' to 'space for reception and access' was 9:1 in the nineteenth century. Today, this ratio is closer to 1:2,

i.e. only about one third of the available space is used for exhibition purposes."[13]

In other words, the museum has long ceased to be first and foremost a place where works of art are displayed and stored. It now contains restoration workshops, conservation departments, lecture halls, computer rooms, libraries, and offices; and still more: retail shops, a cafeteria, and kitchens. Consequently visitors who enter the museum often follow a long and complicated path past shops, cashier, information kiosk, and cafeteria, before they reach the art in the gallery. In the modern museum, "archetype" has therefore little to do with form. Instead, the archetypal is found, if at all, in patterns of arranging functional areas such as reception, exhibition, conservation, and storage.

There exists no catalog of architectural forms to satisfy all three functions (with the exception, perhaps, of the function of presentation itself, i.e. of exhibiting, for which the gallery form [read: enfilade] still offers a classic solution, as we have already established. But even this concept is anything but binding. Since Frank Lloyd Wright we have known that a gallery can also take the shape of a spiral).

Framework and Spiral

From the perspective of architecture, "hard" museum buildings are those where form, usage, and infrastructure are subordinate to an overriding morphological concept. An example of a morphological concept would be the framework or grid; another would be the spiral.

The Centre Pompidou is based on a fundamental concept—that of "neutral" space, i.e. a semantic vacuum— where anything is possible. The diverse components that make up the formal language of industry are themselves subject to specific premises. Historically speaking, the Centre Pompidou is first and foremost a daringly engineered scaffold construction, consisting of 45-meter-long steel girders that are anchored at the longitudinal sides of the rectangular building and span huge trussless loft spaces (Fig. 10). The lofts are available for reception, exhibition, or administration without any distinguishing features to set each function apart. The air-conditioning system is fully exposed on the east façade in all its multi-colored clumsiness, while tubular "public access ramps" meander up the west façade in snaking horizontals.

There are no definite precursors for any of these features in the history of museum design. In the search for forerunners one has to look further afield: to sluice-and-lock construction in the Weimar Republic, for example (e.g. the lock at Niederfinow, which raises boats in a water basin that is linked to the canal by more than 80 meters, Fig. 11). One could even regard some power stations in southern California as forerunners, although they could scarcely have been known to the architect at the time of drafting the design. The east façade may have been inspired by England's Archigram group (Furniture Manu-

10 Renzo Piano and Richard Rogers: Centre Pompidou, Paris, 1972–77. Photographed during construction around 1975

11 Sluice and lock, Niederfinow, 1931–33

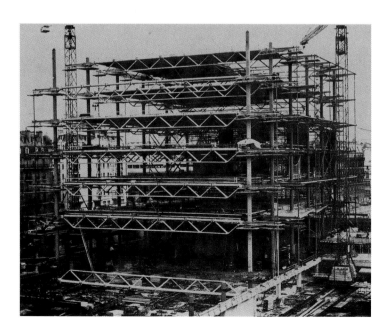

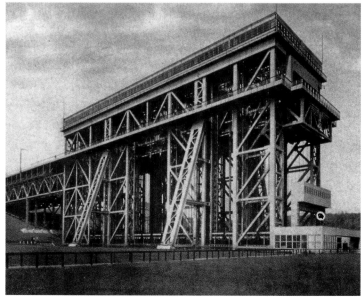

facturers project by Michael Webb, 1958) or by an early project by Gunther Nitschké (Palais de la Publicité, 1936), respectively. But none of the above are related to "museum" design.[14]

And now an example to the contrary: the Guggenheim Museum by Frank Lloyd Wright. Wright's solution is comparable to the Centre Pompidou in one aspect only: neither building derives the morphology of its solution from historic museum design. What matters in this example is the motif of the spiral, founded in the formal grammar of Wright's architecture. The theme was developed in connection with tasks that had little to do with the museum idea: the approach ramps to the Ford Pavilion for New York's World Fair in 1939 (architect: Walter Dorwin Teague, Fig. 6) may have inspired or even directly influenced the Guggenheim design. And some of Wright's own projects foreshadowed this work: a garage with gas station in Pittsburgh (unrealized, 1947). In the case of the Centre Pompidou, as in that of the Guggenheim Museum, there is a kind of grotesque coupling of science fiction with the art world. Forms from the visual inventory of technology are linked with the comparatively atavistic function of art exhibitions.

Diversification and the Influence of Art

From a purely economic perspective, the "explosion of typologies" that has occurred in museum design is best described as "diversification." The price of unlimited diversification in the marketplace of culture as an industry is first accelerated disintegration and then the total collapse of all rules of the game that make "culture" possible as a phenomenon that shares a common social goal. And the result? We pick up a phone and it slips from our hand like a plastic dummy; we stand at a sink and are faced with a mystifying array of flashing push buttons instead of faucet, soap, and towel; we buy rubber-encased tubes filled to bursting with toothpaste, but that uselessly dispense either nothing at all or else ejaculate uncontrollable amounts of paste. And, finally, we find ourselves inside a museum unfit for use as such or else only fit to exhibit itself.

For museum design, emancipating the building from its cultural, architectural, and typological heritage poses an obvious challenge: "freed" from the constraints of the past, architecture enters into a barter trade with art where concepts of form and space become the objects of trade. Why put a stop to it? Frank O. Gehry has said that he spends most of his life in museums looking at pictures.[15] When Gehry sits down at a table with Claes Oldenburg, Richard

Serra, and Frank Stella, traditional boundaries between art and architecture fall away—or nearly.[16] It would seem worthwhile to trace the first beginnings of this interdisciplinary promiscuity, submitting it to the "acid test" of the ground plan.

It is well documented that, long before the Guggenheim Museum, Wright had alread used the spiral motif for above-ground car parks and in the design for a planetarium that was to draw tourists to a hilltop in Maryland. He may well have been unaware of the shape's atavistic symbolism and may not have intended to reinterpret the ancient notion of the spiral as a symbol of growth and eternal rebirth. Still, this is precisely what he did do. Moreover, Wright could hardly have been unaware of the motif's role in modernist vocabulary ever since Borromini (let alone Tatlin's unrealized project for a monument to the Third International, 1920). In 1931 Le Corbusier had already developed the "four-sectioned" spiral as the central motif for his Musée à Croissance Illimitée (museum of unlimited growth, Fig. 12). The spiral was to grow proportionately with the expanding collection. One should remember that Le Corbusier was also an abstract or semi-abstract painter and hence was fascinated by the symbolic power of the shape and the laws that govern it. The spiral—a "global equation"? A key to laws of proportion that reach from watercress leaves to museums and beyond to the universe?

In their ground plans, postwar avant-garde architects may well have delivered astonishing proof of their identity as "artists in architecture." Thus Aldo van Eyck, whose ground plan for the Sonsbeek Pavilion, a sculpture park near Otterlo, was conceived in homage to Paul Klee (1948). Stirling and Wilford's addition to the Staatsgalerie in Stuttgart was inspired by the collages and *papiers collés* of Picasso and Braque, and in effect created an example of what Colin Rowe and Fred Koetter have called the "Collage City" (Fig. 13, 14). And finally Venturi and Rauch's project for the Museum für Kunsthandwerk in Frankfurt (1978) translated into a plan that stands as a metaphor for origin and natural growth, reminiscent of Brancusi.[17]

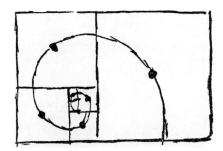

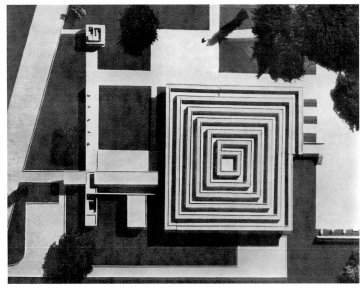

12 Le Corbusier: sketch of a regular spiral, generated by a progression based on the golden section, compared with the Musée à Croissance Illimitée, 1931

Giant Sculpture or Historical Pastiche?

Is modern art—by Klee, Picasso, Brancusi, but also by Serra, Stella, Judd—the formal and symbolic parameter for museum design? Given a building project to which an artist is favorably disposed from the very beginning, concepts of this kind would seem to be justified. Only in the completed work, though, do they prove to be compelling. The notion that architecture in the guise of art is "hostile" to the visual arts or actually "supplants" them (as Lüpertz claims) still has to be proved. Beuys' experience in the Guggenheim Museum in New York, and the experiences of Gerhard Merz and Claes Oldenburg in Hans Hollein's "difficult" Museum for Modern Art in Frankfurt am Main would seem to demonstrate the opposite. Ideally, one would like to measure the standard of quality that Wright, Gehry and Hollein—as well as Herzog and de Meuron— have established and fix it for all time; but that, of course, is illusory (Figs. 1, 3).

On the other hand, the museum of the future will of necessity become a site of memory. As such it could benefit from architecture whose framework lends support even more aggressively than the works of the above-mentioned architects do, especially since our architecture, as cultural heritage, counts among the "memories" that are worth preserving. When palaces and castles are converted into museums, architecture is often reduced, voluntarily or not, to archeological piety. This is a natural progression, even though it hasn't always been so. Looking back at the history in museum design since the fifties, projects such as the Palazzo Rosso and the Palazzo Bianco conversions in Genoa, both from the fifties, caused quite a stir with their provocative deconstruction of the traditional relationship between image, frame, and interior space, and their affected staging that removed works by Old Masters from their "familiar" surroundings and displaced them into the semantically "neutral" space of an aesthetic ideology.[18]

Nor should we forget to mention Carlo Scarpa and the Castelvecchio conversion in Verona (Fig. 15). Recognizing that the courtyard façade was by no means medieval in origin, but rather a twenties' *pastiche* consisting of original windows from Veronese palazzi set into a predominantly contemporary wall, Scarpa relieved the fabric with details whose number and invasiveness come as a surprise: the overall impression is one of embellishment by means of "transplanting" a historic skin.[19] Today's conservation authorities would hardly let intrusion on such a massive scale pass without objection. And indeed, the kinds of projects exemplified by Scarpa's work have largely ceased in the wake of a new generation's passionate stance towards conservation (an attitude which is by no means always catastrophic).

Robert Venturi and Denise Scott Brown tackled similar projects decades after the Castelvecchio conversion at sites that were less "burdened" by history: first with the Sainsbury Wing for the National Gallery in London and secondly with the addition to the Museum of Contemporary Art in San Diego, California. The façade imitates the elevation of an early stage in Irving Gill's original design and the pergola echoes the shape of the Women's Club across the street, also designed by Gill circa 1910. Like Scarpa (yet completely different as to formal means) they too laid bare the fictional character of the historicizing *pastiche*, as if they were simply demonstrating an architectural paradigm, i.e. how to walk the fine line between renovation and reconstruction. They went even further and turned paradigm into theme by way of architectural "sampling." Many in today's cultural establishment would regard this kind of approach as dangerously close to kitsch.

What then is the primary issue in the difficult dialog between the present and the past: the "image" or historic authenticity of the individual piece or artistic "facts"? The rider's monument to Cangrande Scala atop the pyramid-shaped tomb in Verona's historic town center is but a replica. The original stands in the courtyard of the

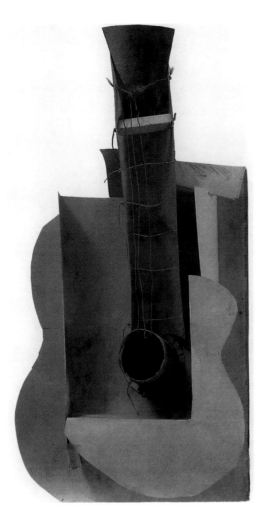

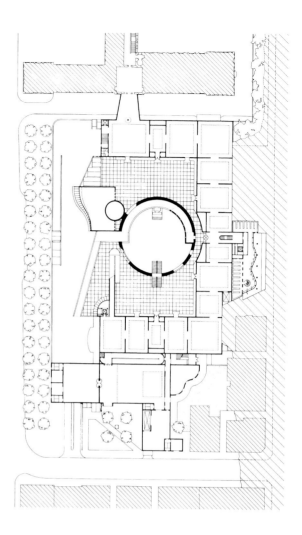

13 Pablo Picasso: *Guitar*, 1912. Metal and wire relief (Museum of Modern Art, New York)

14 James Stirling and Michael Wilford: extension to the State Gallery in Stuttgart, 1977–84. Plan

Castelvecchio: Carlo Scarpa has integrated it into the "scenic" museum tour as one of the main attractions (Figs. 15, 16). Mounted on a projecting base, it is the focal point in a spectacular installation and can be seen from a covered walkway from above or from a platform on the ground. As an institution, the modern museum transforms a tomb monument into an aesthetic object. The original site, where the monument was to perform its "actual" function as memorial, must make do with a replica.

In the aesthetic space of the museum, material and historic "authenticity" matter. For the cult site, i.e. the tomb, aesthetic artifice will do. Is the cult of authenticity therefore an obsession unique to the modern museum; and, conversely, is the tolerance for imitation the norm in a culture of remembrance that is defined primarily by anthropological rather than aesthetic concepts? [20] And if so: what are the implications for a culture driven by entertainment and leisure and called upon to be environmentally and socially "friendly," in an era where the "art of modernism" is merely one voice amid a whole chorus, and perhaps not even the dominant voice?

The Long-Term Perspective

At the very latest on the day the Centre Pompidou first recorded more visitors than the Eiffel Tower, the arts—and especially the system of financing them—succumbed to the logic of the consumer and leisure society. At the latest since that date, the availability of subsidies for cultural purposes has been strictly linked to the ability of the arts to attract the masses. This may seem regrettable, and it is certainly a tragedy in one respect: the competition to which the various interests in this field are exposed means the death of those museums and galleries whose curators have never taken any trouble to make their collections "interesting" to the public. This applies to all those "musty" collections of objects, specimens, and curiosities of natural and technical history—"musty" simply because the public has forgotten them; but it also involves the *raison d'être* of the "mildew" in museums that forms the actual substrate of an exhibition culture which is dressed up to make it attractive to the public.

As far as new buildings are concerned, there would seem to be a firmly held opinion, especially among architects, that a choice has to be made between "modern"

15 Carlo Scarpa: façade study for Museo di Castelvecchio, Verona, with the original equestrian statue of Cangrande Scala (colored crayon drawing, c. 1953).

16 Verona: S. Maria Antica with the tomb of the Scaliger princes and a copy of the equestrian statue of Cangrande Scala, based on the original in the Museo di Castelvecchio

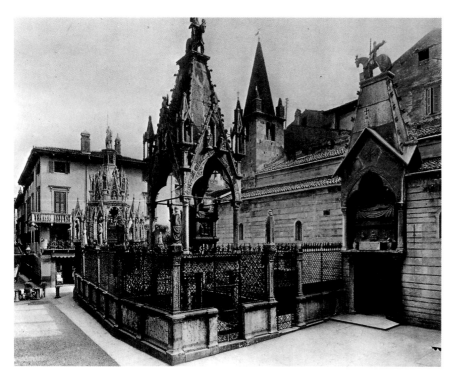

architectural solutions and solutions that either do not lay claim to the word or are not worthy of it. The indisputably modern appearance, or "legibility", of their own "contemporary" designs is regarded as the epitome of "open-mindedness." In contrast, any design strategy that shows "sympathy" for historical forms—although modern building legislation has made this a basic requirement as a sign of "respect" for the urban environment—is allotted a place among the garden gnomes. As a result of this, liaisons with pre-modernist architecture manifest themselves all the more exotically on the trivial plane of architecture for fun gastronomy and tourism in leisure parks, winter sport retreats, and highway service areas. Will the entry of the Bauhaus style into the international "low culture" of dining and tourist architecture, which is already taking place, clear the ground for the consolidation of a new, intelligent approach to history in the realm of architectural "high culture"?

In the context of museum construction, it seems paradoxical to have to canvass for the acceptance of something so eminently normal: for a design culture that also includes a sometimes more, sometimes less alienated historical quotation and a cautious treatment of surviving architectural monuments—as Scarpa and the Venturis have demonstrated, and as the German architects Hilmer and Sattler have shown in their distinguished new Gemäldegalerie complex in Berlin (Fig. 17) or the installation of the Berggruen Collection in a Neoclassical palace by Friedrich August Stüler opposite Charlottenburg Palace in the same city. Today, buildings of this kind would seem not to stand in the architectural limelight. But in view of the impulses they generate and the long-term effect these may have, that is perhaps not such a bad omen.

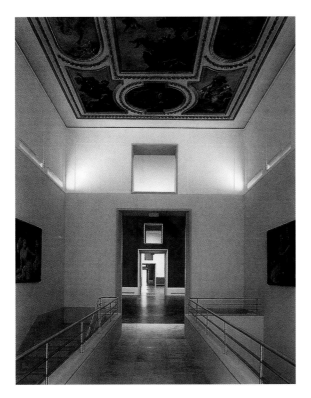

17 Heinz Hilmer and Christoph Sattler: Gemäldegalerie Berlin, 1996–98. View through the gallery spaces

1 Markus Lüpertz, "Kunst und Architektur," in *Neue Museumsbauten in der Bundesrepublik Deutschland* (Frankfurt/Main, 1985), pp. 30–33.

2 Architects have since distanced themselves from this position; see Gerhard Mack, *Kunstmuseen auf dem Weg ins 21. Jahrhundert* (Basel/Berlin/Boston, 1999), pp. 15 and 41. For an overview of "simple" museum architecture before 1996 see *minimal tradition. Max Bill e l'architettura 'semplice' 1942–1996/(Max Bill and 'Simple' Architecture, 1942–1996)* (Baden, 1996).

3 G. Mack, op.cit. (note 2), p. 14.

4 S. Jean Cassou, "Art Museums and Social Life", in *Museum*, II,3 (1949), pp. 155–58. For a critical statement on Cassou's position see C. Duncan and A. Wallach, "The Universal Survey Museum," in *Art History*, 3 (1980), pp. 448–69; especially note 34 and passim. Rarely has the myth of the supposed "neutrality" of the "white wall" been exposed with such insight and wit as in Brian O'Doherty's "In der weissen Zelle. Anmerkungen zum Galerie-Raum," in Wolfgang Kemp (ed.), *Der Betrachter ist im Bild. Kunstwissenschaft und Rezeptionsästhetik* (Cologne, 1985), pp. 281–93.

5 For a discussion on Valentiner see Monika Flacke-Knoch, "Wilhelm R. Valentiners Museumskonzeption von 1918 und die zeitgenössischen Bestrebungen zur Reform der Museen," in *Kritische Berichte*, 4/5 (1980), pp. 49–58.

6 Harald Szeemann, "Ecce Museum: Viel Spreu, wenig Weizen," in Gerhard Mack, op.cit. (note 2), p. 8; the expression "Tyranny of Intimacy" is taken from the German translation of Richard Sennett's title *The Fall of Public Man* (1974).

7 Wolfram Prinz, *Die Entstehung der Galerie in Frankreich und Italien* (Berlin, 1977).

8 S. André Blum, *Le Louvre. Du Palais au Musée* (Geneva/Paris/London, 1946), and Y. Cantarel-Besson, *La Naissance du musée du Louvre* (Paris, 1981).

9 Beat Wyss, "Klassizismus und Geschichtsphilosophie im Konflikt. Alois Hirt und Hegel," in Otto Pöggeler and Annemarie Gethmann-Siefert (eds.), *Kunsterfahrung und Kulturpolitik im Berlin Hegels. Hegel-Studien* (Bonn, 1983) (supplementary volume 22), p. 117 ff.

10 Nikolaus Pevsner, *A History of Building Types* (London, 1976), and Helen Searing, "The Development of a Museum Typology," in Suzanne Stephens (ed.), *Building the New Museum* (New York, 1986). Still informative, although difficult to track down: Henry-Russell Hitchcock, *Early Museum Architecture* (exhibition catalog) (Hartford, Conn., [Wesleyan University], 1934).

11 Victoria Newhouse, *Toward a New Museum* (New York, 1998).

12 Frédéric Edelman, "L'Architecture de la maison des muses," in *Le Monde*, January 14 issue, 1988.

13 Robert Venturi, "From Invention to Convention in Architecture (The Tenth Thomas Cubitt Lecture at the Royal Society of Art)," in *RSA Journal*, January (1988), pp. 89–103.

14 Current monographs on the Centre Pompidou touch only peripherally on such typological contexts. See "Centre Pompidou," special edition *A.D.* (=*Architectural Design*) *Profiles*, 2 (n.d.), with an essay by Alan Colquhoun. The fact that Nitschké's idea for a "billboard wall" was finally realized twenty years after the opening of the Centre Pompidou, albeit in a temporary fashion as a giant Swatch ad to cover up the renovation underway behind it, deserves mention only in a footnote. Aesthetically no more convincing than the majority of Swatch wristwatches, and therefore difficult to justify at a site that applies the most exacting criteria, the ad delivers an interesting, although partially involuntary, commentary on the integration of the avant-garde into our entertainment and leisure society, to which this museum has contributed in such large measure. However, this is a completely separate topic.

15 G. Mack, op.cit. (note 2), p. 26

16 Frank Stella subsequently discovered his own genius for architecture—a side effect one simply accepts in such circumstances; see Victoria Newhouse, op.cit. (note 11), pp. 119–29. On Gehry and his dialog with art see Kurt W. Forster, "The Architect Who Fell among the Artists," in Cristina Bechtler (ed.), *Frank O. Gehry/Kurt W. Forster* (Ostfildern-Ruit, 1999), pp. 9–15 as well as "Conversation between Frank O. Gehry and Kurt W. Forster, with Cristina Bechtler," ibid., pp. 17–95.

17 S. S. von Moos, "Secret Physiology," in *Venturi, Scott Brown & Associates. Buildings and Projects, 1986–98* (New York, 1999). The problem of the museum as an autonomous work of art has been the subject of numerous studies. See for example Jürgen Paul, "The Art Museum as a Palace of Aesthetics: The Neue Staatsgalerie in Stuttgart by James Stirling and Some Considerations Concerning the Cultural Function of an Art Museum," in *Tribute to Lotte Brand Philip* (1985), pp. 133–43.

18 The pros and cons of the discussion on museums in Italy at that time—in part inspired by the museum concept developed by Alex Dorner, who emigrated to the United States—have been unjustly forgotten. See, among others, Giulio Carlo Argan, "Il museo come scuola," in *Comunità*, 3 (1949), pp. 64–66 as well as "Problemi di museografia," in *Casabella-continuità*, by the same author, 207 (1955), pp. 65–67.

19 Richard Murphy, *Carlo Scarpa e il Castelvecchio* (Venice, 1991), C6–8

20 For a discussion on this topic in the context of contemporary conservation policies see Stephan Waetzoldt and Alfred A. Schmid, *Echtheitsfetischismus? Zur Wahrhaftigkeit des Originalen*. Carl Friedr. von Siemens Stiftung: Themen XXVIII (Munich-Nymphenburg, 1979).

John M. Armleder
I Just Want More

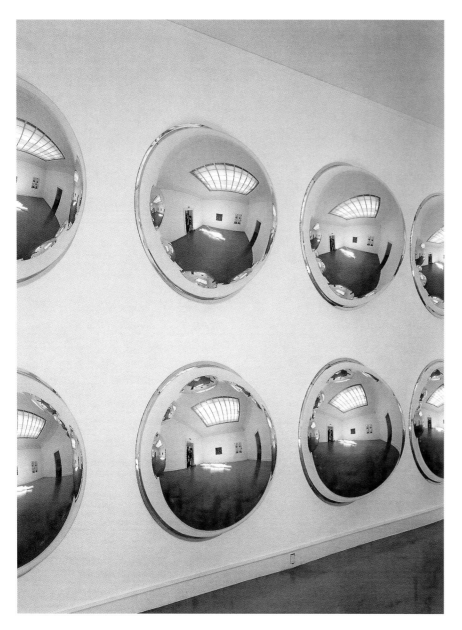

John M. Armleder
Liberty Domes III (FS),
1998 (detail)

the ideal forms of institutions and spaces for museums at any given time.

At the beginning of the twentieth century one could consider the museum thing fairly new. At the same time, people were trying to get rid of it—you know, the Dada protest type of vision, equating museums with prisons. Today, the general idea would be to go completely electronic, and perhaps have fun with the spaces, turning them into bars and discothèques. At least this fits with an era in which visitors spend more time in upgraded museum cafeterias and shopping malls than in the actual exhibition halls, which serve as a quick segue to a catalog purchase. There is something telling in the way—now, more than ever—a main concern about museums is talking about them, describing them, building them, and wondering what they could be, what and who they serve.

It's obvious that the turn of the clock has no power to change all this, or even to introduce new perspectives. I've always been an advocate of the maniacal aspect of museums—of their ability, for example, to collect, keep, and freeze. After all you can't preserve things for quite as long at home in your own refrigerator, and there you're dealing mostly with your personal idiosyncrasies. In that perspective, museums are collective holdouts for every idiotic fetish and a desperate effort to withhold and study memories. This is good. In this sense, it's just storage, storage and access to it. If it were electronic, it would be science. Keeping the real stuff is being addicted to the fascination of the real-life dimension, keeping up the questionable reality that we do indeed live in a real-life dimension. It's also fun because real-life objects decay, they break, rot, and turn into dust. Other types of safeguard crash and vanish as well. We need this to happen, of course, and there's going to be a lot of it in the coming millennium.

I've always loved the story I quote again and again about the cartographers in *Sylvie and Bruno*, Lewis Carroll's last novel. In an effort to be precise, they enlarged their maps to a scale soon fitting the actual size of the territory. The 1:1 scale map, once unfolded, covered the whole land, annoying the farmers so much that they ended up using the land itself for the map describing that

Well, it's morning, and once again there's the tough task of waking up. It's always the waking up—in the morning, after a century, in 1984, in 2001, in a billion years. Tomorrow is always some kind of a new millennium. I believe we have known for a long time that the museum, any museum, is in our head, our mind, or somewhere down the alley. Fantasies, fetishes, dreams sustain the idea that it's possible to find some kind of concept that would describe

land. Allegorically, that offers plenty to think about when it comes to establishing such things as museums. The best museum has of course always been the street, or even the countryside. Its endless transformation is a combined effect of knowledge, wear, replacement, update, or whatever flavors the juice of the day. Drinking it gives you the full aroma of the inherited cultural load, and a hint of what lies in the future. So yes, the best museum is out there. But then again it's real. The museum we know has nothing to do with reality. It's an exception, it's abstract. This is why we like it. It is a temple, a kind of a box where we store our goodies and spiritually enjoy how they rot. That's why museums produce some kind of mental mushrooms that leave us intellectually addicted and physically exhausted. No wonder artists turn them into discothèques today: they've been looking like that for ever. You have tickets, fliers, even bouncers at the entrance. It's a disco life handled by taxidermists. It's the prop stage for real life. It's B movies for a Z society.

Despite all that, I am a freak. I indulge myself; I spend as much time as I can in those museums. Whether it's MOMA, the National Gallery, or some dumb, corny, crazy museum along a highway, I just do it. So, I'll never criticize large clinical spaces celebrating one big masterpiece painting, or stupid postmodern efforts to fill up spaces with architecture features, or what have you. I just want more.

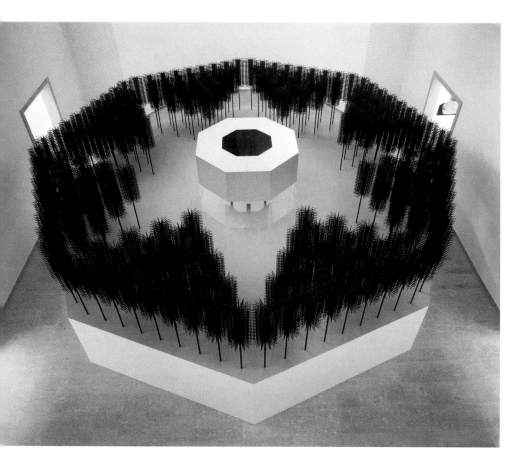

web of bare branches surrounds the building; in summer, it is a leafy green wreath. The trees form a negative star in the grass, with the museum at its center.

The museum has no permanent collection; the exhibitions of contemporary art on view there should be designed specifically for that museum. They remain there for one or two years. Administration and the technical department are housed in adjacent buildings.

A Special Place

I find a lot of exhibitions disappointing. You try to do something right, to make it work in every respect, and then you have to put it up in an ugly space, where nothing is right. Where are the museums that match my work? Not only are the places unsatisfactory, so is the way in which many exhibitions come about. They are often meaningless "gigs" that fill spaces, presentations that are spooled off to suit the scheduling of museums and galleries. Openings are supposed to be special events but usually turn into agonizing musts. You start out at age twenty full of enthusiasm as a "free artist"; by the time you're forty you feel as if you have pursued a career as a civil servant who has to keep producing without any of the perks. Your constant companion is the unjustified feeling that you can't satisfy expectations (invitations to shows) and that your life is dictated by the schedules of curators and galleries.

But there are certainly examples of artistic endeavor. A few encounters with places where everything seemed to work made a great impression on me and stirred my desire to create such a place—at least as a model.

I would like to mention three examples: Vierzehnheiligen, the Baroque church designed by Balthasar Neumann in Upper Franconia, Germany; The "Earth Room" and "The Broken Kilometer" in New York and especially "The Lightning Field" in New Mexico (Dia Center for the Arts in New York), all by Walter de Maria, U.S.; and the Chinese Tea Pavilion designed by Johann Gottfried Büring in Sanssouci Park, Potsdam, Germany.

Vierzehnheiligen and "The Lightning Field" are places of pilgrimage. You have to make an effort to get to sites of

Katharina Fritsch
Model of museum, 1995
scale 1:10
wood aluminum, Plexiglas,
foil, paint
1040 x 1040 x 330 cm

The museum is a two-story, octagonal pavilion 24 meters in diameter and 16 meters tall. The ground floor, designed for the exhibition of sculptures, is glazed on all sides; the outer walls on the second floor, designed for paintings, are gold.

The walls of the stairwell are white on the ground floor and glazed in eight different colors on the second floor—red, blue, green, black, white, yellow, light green, and orange. Eight doors lead to the inner stairwell, which climbs cone-shaped up to the middle of the first story, where another eight doors lead to an unroofed, octagonal inner courtyard. From there the stairs leading up to the second floor are funnel-shaped.

The land and lawn around the museum are octagonal. Twenty-five deciduous trees are to be planted on each eighth, forming an exact triangle, the tip of which is aligned with a corner of the building. In winter, a black

1 From time to time in crime and formula films on German television, "modern artists" are shown in their studios with hideous constructions consisting of painted polystyrene or some other foamed material, which the set designer has made according to the pious fiction: "This is inspired art, even if it looks as though anyone could do it." One of the best examples of how far this state of confusion goes was seen in the TV production *Eine Frau will nach oben*, broadcast by the German TV channel ARD, at 8:15 p.m. on March 1, 1995. The way this show dealt with clichés about the art world was, sadly, not far removed from reality.

This essay was first published in the catalogue compiled for the exhibition of Katharina Fritsch's museum. The 1:10 model was shown in the German Pavilion at the Biennale in Venice in 1995.

revelation. Both sites convey a sense of epiphany because of the special way they relate to their natural settings, the way they occupy space that conveys another, higher reality. When I visited Sanssouci Park, the Tea Pavilion (before it was restored) appeared like a vision behind the bushes. Because of its curious, playful whimsy, which reminded me of childhood days long ago, like a kind of archetypal memory, it became a model for the museum.

A museum is supposed to be a special place, a place of sudden turns where we sense, as if mirrored, the strangeness and melancholy of things through the absolutism of artistic decisions made in the face of the ineffability and unfathomability of being. This is an experience that should be important to everyone, in everyday life and life in society. There is no "neutral" arrangement of space (I think it is an illusion anyway); there is only a sculptural concept of a building. I want to make a stand that is beyond "design," which is the greatest weakness of most museums. I think that a subjective, specific choice of form is easier for an artist to respond to than a museum in which more or less disinterested postmodern quotations of style are senselessly lined up with "sophisticated artistry."

Unfortunately, a kind of taboo has spread in the art world over the past few years. Artists have been taking less and less responsibility, becoming increasingly uninvolved in the design of their "environment." They do have poetic license, but only within the confines of a given space; "stepping across the border" is tantamount to violating an unwritten law.

Artists like Henry van de Velde or Donald Judd have created places for their colleagues with great bravura, and these thrive on their special aura.

Places of Concentration

It takes a special kind of artist.

This can't be a building for every artist. But can the building that I have in mind work for other artists, too? Is there common ground among artists above and beyond grungy classifications like "postmodern"? And could certain artists accept this museum?

Probably not the "TV artist," who creates works of art by misinterpreting the expanded concept of art of the seventies by which the more incomprehensible and random the works are, the more they are considered good.[1] But it might be possible for artists in search of an artistic concept that leads to binding pictorial quality to accept this. Art is not literature, advertising, or educational illustration of ideas. The same goes for artists interested in identity, not in art-historical, in-house speculations, in cynicism, in over-

drawn egomaniac self-representation. It would be necessary to get involved with the space; the artist's work should not be autonomous but incorporated as part of a whole. The same again for artists who try to develop accessible imagery that draws on our archetypal heritage but also creates new pictorial means of addressing contemporary problems, fears, and hopes. Instead of opting for the easy way out, namely nihilism, they work at finding a new ethic; for us, that means finding a new form in an attempt to challenge chaos and disintegration, without falling back on rigid, traditional forms.

No integration, no misunderstood democratic sentiment, but art that is not easy to consume, just as every confrontation with the self is both frightening and exciting.

Faced with rapidly declining individuality, we need a place for retreat and concentration. The museum is not a totalitarian model but just one place among others. Because one place or point has been posited, others will follow or replace it, yielding an ever sharper picture, sharper than the murky mess we have now. Artists should liberate themselves from the infantile isolation generated by the art market and the art industry over the past few years and become active, responsible, exemplary human beings again.

Gerhard Merz

In 1992 Edgar Morin declared that modernism was running out of steam.[1] The world, he said, was once again that which the word *planet* had originally signified, a wandering star.

Essays on history are entitled "The End of History." The principles of rootedness in the past seem to have been lost. In the process, art becomes a subject for negotiation, its predominant principle being "indoor-outdoor." Placed in the protection of the museum space, objects readily recognized as trivial elsewhere unleash a discourse that leaves nothing intact: suddenly, there it is, the difference between wit and pretension to wit. Negotiation creates art in the context of the museum. Rudolf Carnap has written about spurious problems in philosophy, emphatic in his judgment of metaphysics. He reached the conclusion that traditional metaphysical theses were not only useless, they were devoid of meaningful and insightful content. He unmasked metaphysical statements as casuistic, albeit enormously useful to many in the art world, then and now. Giorgio Grassi mentions the superstition of modernism. This is justified. Upon reception, modernism realized is but a single chain of misconceptions with the "unintended image" at the end of the chain. It is easy to agree that art must promote knowledge and even be up-to-date in its arguments; that it should resist that which is commonly held to be true outside of art. How else might art presume to soar like a soprano above the humdrum tune of ordinary human activity? How else might the artist dare to steal even a second of the viewer's life as he contemplates a work? A mature artist surely does not count upon altruism or a friendly interpretation of private hieroglyphs. But just for the fun of it, draw a line between the artists of this century who think astronomically and those who argue astrologically. The century belongs to the occult, the absurd, the cosmic brew (T. S. Eliot). The real tactic of art has no intention to mystify, has no pretensions to being a seismograph of the soul, knows the difference between bricolage and construction, resists rumors and simulacra—that is, staying with the established image: art that follows the astronomic line of thinking. This art disappoints, for it promises, reconciles, and consoles nothing and no one. Ad

Reinhardt says it clearly: It is not the purpose of art to uplift relations with humans. Let's return to the cause: Cézanne. Using a logic of color, he realizes a pattern that runs parallel to nature, and, with stunning simplicity, states that a painting is primarily a construct of canvas and color. In his last letter to his son he wrote, "Compared to myself, all my compatriots are assholes."[2] He isn't being arrogant. On the contrary, he was always conscious of his own impoverishment as an artist; he knew what he had renounced. Yet today, the "unintended image" is present. In an exhibit of Cézanne's *The Bathers* in Basel, genitalia are counted, sorted into male and female, and studied as to obsession and secret illness. In 1918, Malevich wrote: "I have painted the naked icon of my time, as a symbol of separation from the entire history of culture"[3]—a farewell whose tragic and radical nature was understood by few. A farewell to the visible world; we're not dealing here with diagrams of nature or geometry. Take Kandinsky, where three dots become a face and—after prolonged gazing—reveal a horse or a cannon. The nonrepresentational rules and not abstraction—no insidious naturalism and no secret heartbeat. And the nonrepresentational no longer reveals itself in the act of looking, immersing oneself. Now the viewer must know as much as the author; the viewer is neither instructed nor consoled. The black square is not complete art, it is a fragment of the greater knowledge, of a greater realization. Even today, the black square is not fully understood in its emptiness—emptiness in the true sense of the word—in its sparsity. Countless attempts have been made to soften the shock, to mediate. It has become an object for contemplation; sunk to the level of the devotional, our taste succumbs to it.

It serves not to enlighten; instead, atavistic yearnings and philosophic kitsch deliver proof. And it's made easy; the means of modernism permit only a walk on the razor's edge, securing the meaning of a thing over premeditated sensibility, over connoisseurship, over secrets, rescuing us from the fall into the abyss. The secondary senses promote, as Konrad Fiedler warned us, "a blind reading of art."[4] The realized artwork is not used to launch a clever discourse. The moment is felt only

1 Edgar Morin, *Einen neuen Anfang wagen* (Hamburg, 1992). 9f.
2 Paul Cézanne, *Letters*, John Rewald, ed. (Zurich, 1926).
3 Kasimir Malevich, *Suprematism—die gegenstandslose Welt*, Werner Haftmann, ed. (Cologne, 1989).
4 Konrad Fiedler, *Vom Wesen der Kunst*, selected writings, Hans Eckstein, ed. (Munich, 1942).
5 Jean-François Lyotard, *Philosophie und Malerei im Zeitalter ihres Experimentierens* (Berlin, 1986).
6 Gottfried Benn, *Soll Dichtung das Leben bessern?* in *Collected Works, Vol. 4 (Speeches and Lectures)*, (Wiesbaden, 1969).
7 Samuel Beckett, *Stirring Still—Immer noch nicht mehr*, (Frankfurt/Main, 1991).
8 Friedrich Nietzsche, *Jenseits von Gut und Böse*, in *Werke in zwei Bänden*, 4th edition (Munich, 1978), Vol. II, p. 51.

Gerhard Merz, *People of the Future*, Kunstverein Hanover, 1990

momentarily (Lyotard on Barnett Newman[5]) and only then if you're well prepared, like a diligent pilot who checks his engine before takeoff. Reaching the point of no return on the runway, he radios "Flight" to the control tower and completes the most critical part of his journey. This is the unveiling, the lightning bolt, epiphany. In Barnett Newman's language, it is the sublime. And now, the lightning bolt over, we continue. For this is no surprise attack on the retina. This is a dialogue between equals and I (the viewer) acknowledge not only that which I see but also that which has deliberately been omitted. Absence should not be taken amiss. There is no lack of artistry here; this is not asceticism, design, or taste. This is absence willed to be legitimate art, born from factual pressure. For the nonrepresentational is a blind, empty ground, as Malevich said, and all of a sudden we've come full circle, back to Edgar Morin and his view of our world as a wandering star, deserted by the gods. Gottfried Benn comments that the gods were silent, having better things to do.[6] So let's accept that while life is free, art is not; it reveals itself intuitively, but everyone can inch closer through knowledge and study. Or else, let's not worry about it and trust that the author, the artist, has pursued his chosen work in a precise and sober manner. I like the notion that great art is the smallest possible deviation from the norm. Trust, and thus ethos, is one way of coming to terms with the complexities outside of the *métier*, which is complex in itself; and it protects us from a false security and neofundamentalist morals—in short, from progressive reactionaries. This is no vindication of the Sprenglers and the Sedlmayrs. On the contrary: this is modernism that makes no promises, that is cold and agnostic, a stranger to regionalism of any

kind, remaining aloof, and, yet to be seen by anyone; a modernism whose first artifacts are decay in banal museum rooms, producing the lamented unintended image. Beckett's wonderful final text is entitled *Stirring Still*.[7] This is not a threat; it is like it is.

"Every artist knows how far from any feeling of letting himself go his 'most natural' state is—the free ordering, placing, disposing, giving form in the moment of 'inspiration'—and how strictly and subtly he obeys thousandfold laws precisely then, laws that precisely on account of their hardness and determination defy all formulation through concepts. ... What is essential 'in heaven and on earth' seems to be, to say it once more, that there should be *obedience* over a long period of time and in a *single* direction."[8]

Mies van der Rohe is said to have studied this paragraph from Nietzsche's *Beyond Good and Evil* at length, and we should keep it in mind as we stand in front of Mies's *chef-d'œuvre*, the National Gallery in Berlin. This is a building that reveals all, that illustrates how susceptible modernism is to disruption. It will never be a beautiful ruin; let's remember our walk on the razor's edge—a broken pane, and the fall into the abyss begins. Inside this building, many complain, one cannot exhibit. But shouldn't art withstand that which is known of art on the outside? As soon as we set our trust in Mies van der Rohe, the task presents itself differently. Perhaps he's handing us a kind of litmus test. I've often seen the test hit home and unmask a work of art on a more subtle level of thinking than we are capable of, revealing its atavistic side. As for myself, I dare say that anything that cannot be realized there, should not *be*. There is an imaginary museum and a high court of artists of the past, allowing us to do what we do, for we have dignified as art only that which is most important and then only after much effort. Mies van der Rohe, and many others, feel that one need only continue that which has already been done *right*, refine it, and bring it up to date.

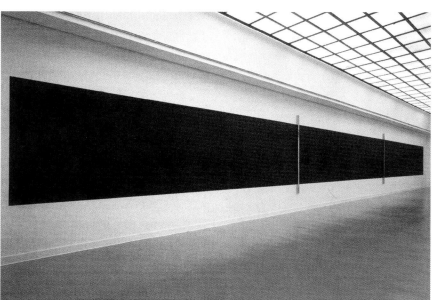

Norman Foster
Carré d'Art
Nîmes, 1984–1992

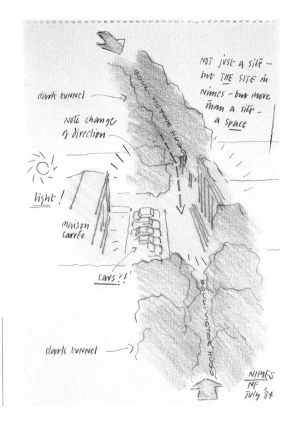

Analytical sketch of location, 1984

Aerial view of museum
in its urban context

Jean Bousquet, sometime mayor of Nîmes, liked to think of the Carré d'Art, which he was instrumental in establishing in his native city, as "the Pompidou Center of the South," a prime example of the "combination of specificity and open neutrality" (as Douglas Davis saw it) "that characterizes virtually all the museums that are responsive to our lives here at the end of the century."[1] Like the Pompidou Center, the construction of which Bousquet had observed from the window of his Paris office during the seventies, the Carré d'Art is not really a museum at all, in the conventional sense of the term. In the wake of Beaubourg, the *mediathèque*, combining conventional exhibition galleries with libraries containing books, recordings, and videos and space for performances and conferences, became fashionable in France. Beaubourg was clearly the inspiration. Piano and Rogers had set out to build an antimonument and an antimuseum, a flexible structure which, for Rogers at least, embodied the spirit of 1968 (albeit that it was constructed in memory of a conservative president). Their competition-winning scheme incorporated huge screens on the façades—highly suitable for projecting political slogans (and later vetoed).

The mix of uses may be similar, yet the Carré d'Art—promoted by a business tycoon turned centrist politician—is, in many respects, the antithesis of its supposed prototype. While the Pompidou Center promotes debate, discourse, and disorder—the piazza has had to be recast to discourage drug dealing and other activities not foreseen by the idealistic architects—the Carré d'Art reinforces the classical order of the city, recalling old

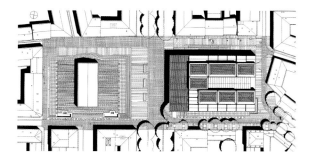

Site plan

Maison Carrée und Carré d'Art

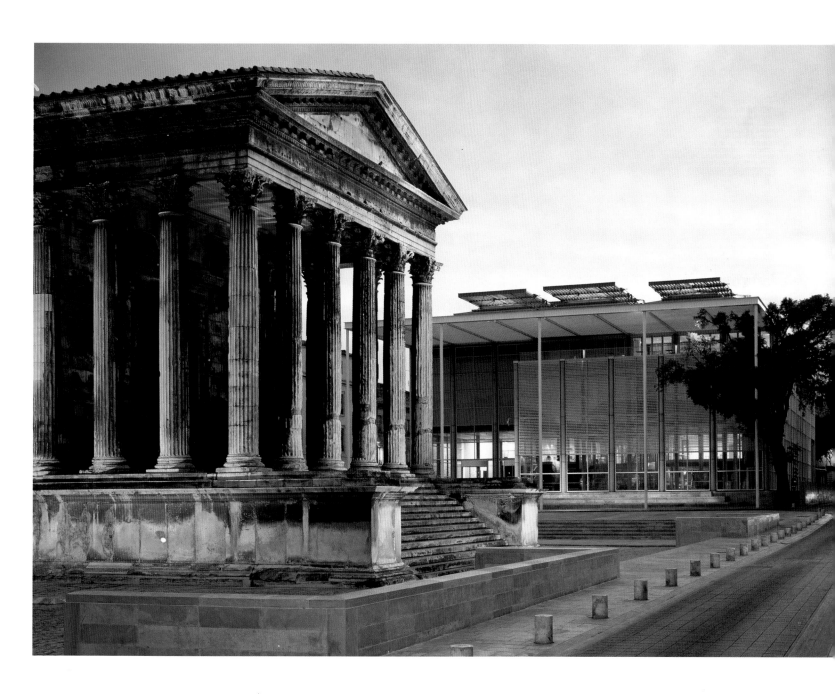

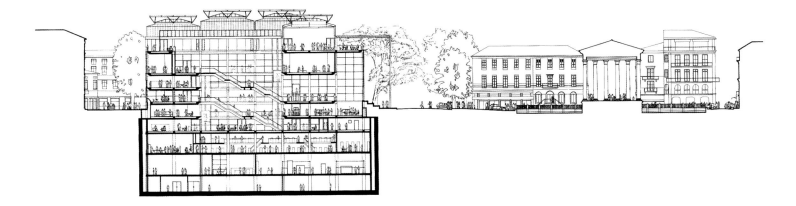

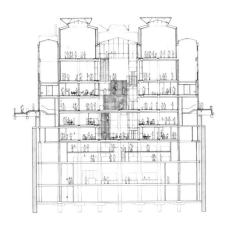

Longitudinal section and surroundings

Cross-section

virtues and paying barely disguised homage to Nîmes's greatest treasure, the 2,000-year-old Maison Carrée, probably the best preserved of all Roman temples.

Jean Bousquet's approach to urban development was formed by his business experience. "Years of experience in the fashion industry teaches you what added value means," he explained. "To achieve it, you have to raise your sights and think globally."[2] The huge success of his Cacharel empire allowed Bousquet to spend much of his time back in Nîmes, which he had left to make his career in the early fifties but had subsequently favored with one of the Cacharel factories, and in 1983 he stood for the office of mayor on a platform of cost cutting and increased efficiency. His election ended a long period of left-wing dominance. Bousquet saw himself as a liberal, independent of party ties, but his incumbency saw the philosophy of business applied to municipal government. Nîmes was a

pleasant old town, with some important historical monuments, but it could not compete with nearby Montpellier, with its ancient university, as a regional center. Economically and culturally, it was stagnant, and there was every reason for its young to do as Bousquet himself had done and head north to find a career—to Paris, probably, which President Mitterrand was now further enriching with his *grands projets*.

The Carré d'Art was ostensibly "a forum for the young" (though the latter subsequently swarmed in even greater numbers to the rock concerts at the Zenith, set amid flashy new industrial sheds on the outskirts of Nîmes). It was also, however, a marker for the revival of the old heart of the city and a boost to the property market and the tourist industry, as well as a vital lifestyle component for attracting new companies to the city. If Nîmes was to have a new arts center, the site was obvious. The town's fine early nineteenth-century neoclassical theater, facing (and even outfacing) the Maison Carrée, had been destroyed by fire in 1952 and never rebuilt—evidence, perhaps, of the decay of the city's cultural life. Only the handsome colonnade survived, masking a car park. In 1984, Bousquet launched an invitational competition for the design of an arts and media center on this site. He set his sights high. James Stirling, whose acclaimed Stuttgart Staatsgalerie had recently opened, was invited to submit; he declined, but subsequently served

on the jury. From France, Paul Andreu, Jean Nouvel, and Christian de Portzamparc were included on the list of invitees, along with Gehry, Meier (who also decided not to participate), and Pelli from the United States, and other international leaders—Hollein, Rossi, Siza, Isozaki, and Norman Foster. The latter had completed only one museum. His Sainsbury Centre, completed in 1978, was a new sort of art gallery, but it stood on a greenfield site, next to a sixties' university complex, not at the heart of a *secteur sauvegarde*. Foster, whose masterly Hong Kong Bank was already on site, had addressed the historic city only in his scheme for the BBC Radio Centre in London—a troubled project that was canceled in 1985.

The Carré d'Art was an important landmark in Foster's development as an accomplished urbanist and a master of the marriage of old and new. He was named winner of the Nîmes competition in the autumn of 1984, his proposal being selected over those prepared by the shortlisted Gehry, Nouvel, and Pelli. For Bousquet, Foster's scheme was "the most classical in the sense that he seemed to have looked at the city and to have been inspired by it." Of the other finalists, Pelli came closest to Foster's controlled calm, while Gehry's scheme hinted at the inspired geometry of Bilbao—in a location where romantic disorder was inappropriate. Nouvel proposed to build entirely underground.

Norman Foster had begun his customary process of intensive research soon after receiving the invitation to compete for the commission. He admired Nîmes's "strong, simple routes and good spaces," especially the one around the Maison Carrée. "What is the site?" he asked, suggesting, alone among the competitors, that the land once occupied by the old theater had to be considered alongside the famous temple and the square around it, the rundown Place de la Comédie, and not in isolation. Foster was equally convinced that the

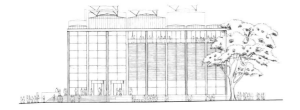

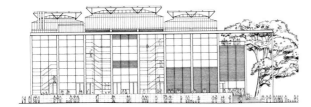

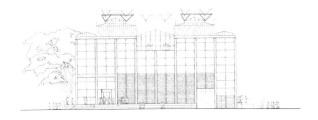

Detail of *brise-soleil*

East elevation

South elevation

West elevation

relationship between the Maison Carrée and the theatre façade was "just right," providing a cue for the new building replacing it. (Putting much of the accommodation required below ground allowed the height of the latter to be kept in check.) Assuming the colonnade would be removed, Foster proposed a new frontage clad in stone—the flat elevation could be used for video projections—and topped by a great projecting canopy, a device intended to provide sun screening but equally giving the elevated entrance platform something of the character of a stage. Behind, located off center, was a striking galleria at the heart of the building, part of a public route across the city. The old colonnade, of course, rapidly became an issue. Foster was instructed to incorporate it, following a public petition and pressure from the Monuments Historiques. Only the eventual intervention of culture minister Jack Lang (in 1986) allowed Bousquet to order its demolition, a move Foster greatly welcomed. "You could have done a wonderful art gallery behind that colonnade," he later recalled, "but not the mix of uses and spaces that was wanted." Funding problems, overcome by the decision of the Chirac government to provide a subvention of 60 million francs, delayed a start on site until 1988, providing time for the plans to be revised and refined.

In its final version, the entrance front was the product of a long process of redesign, with the proscenium/stage deleted; the internal plan remained remarkably constant. What Foster describes as "a conscious exploration of classical forms" took place. Ideas of a dramatically cut-back, all-glass façade, designed to drag people into the building, were dropped, but the element of transparency survived in subsequent reworkings.[3] Finally, in January 1988, a definitive plan was published. It bore a close resemblance to what was constructed in 1988–92, though the entrance canopy was shown resting on two (rather than five) slender steel

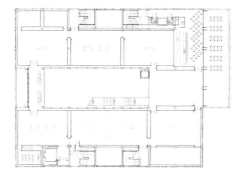

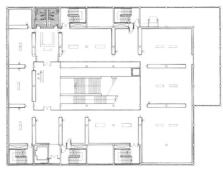

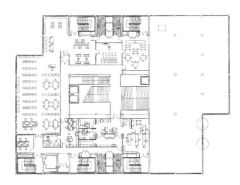

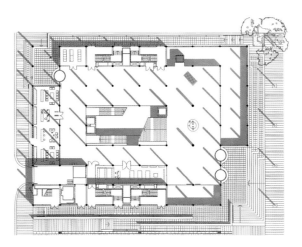

Plan of upper gallery level

Plan of lower gallery level

Mezzanine plan

Ground-floor plan

columns. Superficially, at least, the plan as built came close to the competition-winning proposals in its serenity and calm— Foster favors the adjective "timeless." In line with his initial analysis of the site, Foster was commissioned to rework the Place de la Maison Carrée (significantly renamed), giving the monument a dignified but sociable setting and linking it to the Carré d'Art.

Under its first director, Robert Calle (who was enticed from Paris), the Carré d'Art began to fulfill its projected role as "the Beaubourg of the South," while the relatively meager permanent collection was steadily augmented. Calle's acquisitions policy focused on Mediterranean art, reflecting Nîmes's perceived position as a Sun Belt city of the future, looking to Spain and Italy as much as to Paris. As was always intended, displaying art is not the sole *raison d'être* of the building; the libraries are heavily used, and it is the mix of uses that animates the Carré d'Art. On the top floor, there is a bar, with an external terrace providing a marvellous vista of the historic core of Nîmes. As a new component in an old center, the building works well on many levels. Foster's intention to develop the interior as a galleria, a modern version of the ancient Nîmes courtyard complete with opening roof, was modified in the final scheme. The galleria became a six-story atrium, with a fixed roof. The route is vertical rather than horizontal, and it links the spheres of the visual arts, books, music, and film. In the process, the interior became less obviously monumental. Working with Claude Engle (a regular collaborator) and capitalizing on a skill for which he is renowned, Foster brought natural light down through the building into the basement library levels and achieved a calm luminosity throughout the public spaces.

As an engine of regeneration, the Carré d'Art is an unqualified success, the star component in an ambitious program of new architecture and public art

Sketch: east face and
detail studies, 1985

Sketch: study for façade, 1984

East face of building

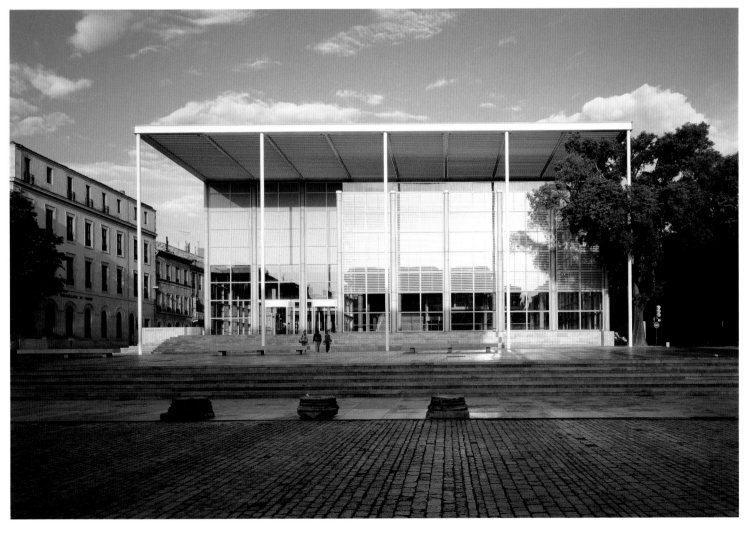

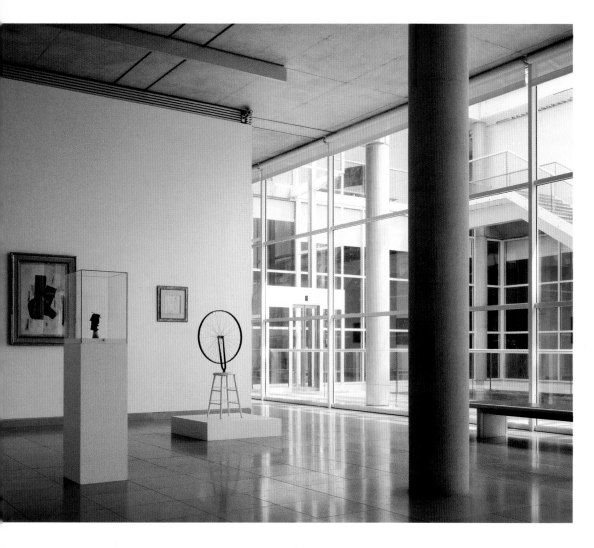

pioneered by Bousquet. Yet it is not a Beaubourg. When Foster's competition-winning scheme was unveiled, some of his supporters were disappointed at its reticence—why was there no dramatically late twentieth-century gesture? The critic Peter Davey argues that the "ghost" of the Maison Carrée haunted the project from the beginning. Foster's clear intention was to build contextually, to elevate considerations of urban and historic propriety over those of self-expression. As the Carré d'Art enters the twenty-first century, it remains a classic expression of the dialogue between old and new and has worn and worked well. It did not set out to be revolutionary but to reinforce an established urban culture, to contain potentially subversive ideas within an elegant and controlled framework. The Carré d'Art is a regional monument, yet the seamless unity of French culture is also firmly reasserted within a timeless temple of the arts.

Kenneth Powell

Exhibition space on
upper gallery level

Main staircase

1 Douglas Davis, *The Museum Transformed: Design and Culture on the Post-Pompidou Age* (New York, 1990).
2 Interview with Charlotte Ellis in Ian Lambot (ed.), *Norman Foster: Buildings and Projects, 4, 1982–89* (Haselmere, 1996), p. 104.
3 The unbuilt versions are well documented by J. Glancey in *Architectural Review*, May 1985.

Richard Meier
The J. Paul Getty Museum
Los Angeles, California, 1984–1997

External view

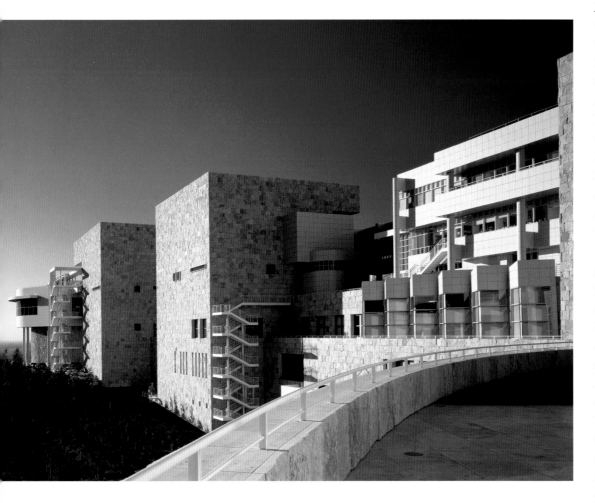

Richard Meier's Getty Center opened to the public in December 1997. It was fourteen years in planning and construction, the result of a decision to build a campus that would house the functions of the Getty Trust, the arts foundation brought into being through the bequest of oilman J. Paul Getty (1892–1976). Built at a cost of more than $1,000,000,000, the Getty Center was designed to provide a second home for the J. Paul Getty Museum (to supplement the existing Malibu building), and, as planned, new quarters for the Research Institute for the History of Art and the Humanities, the Conservation Institute, the Information Institute, the Education Institute, and the Grant Program. Meier distributed these programs in six buildings, in which approximately 1,200 employees work.

Although the project was under the general direction of the Trust's founding president Harold Williams and the direct supervision of Stephen Rountree, Building Program Director, the directors of each of the Trust's separate programs also interacted with Meier as individual clients. Among them, the most significantly engaged were the museum's director John Walsh and the Research Institute's founding director Kurt Forster, who both determined that Meier's buildings would articulate their distinct but strong senses of purpose and propriety. Critics and architect alike acknowledge that, of all the buildings on the site, the Research Institute most fully expresses the architectural qualities that Meier has pursued in his practice and for which he is known—a crystalline tectonic clarity, made possible through steel, reinforced concrete, and

glass construction, which dynamically expresses innovative functional planning. In the case of the Research Institute, this was the ramped, open design of the library reading room as a two-story volume around a skylit, circular well. Designed as a group of five linked, two-story pavilions, each with access to dramatic city views and a serenely beautiful central courtyard, the museum might also have been acclaimed as a canonical masterwork. However, the traditional treatment of its interiors, outfitted by architect Thierry Despont, masks the architectural concept and compromises the integrity of the museum as a whole.

The Site

In 1983, the Getty Trust acquired the hilltop site on the city's famously wealthy Westside, where it is surrounded by bucolic residential hideaways and where it lies close to the intersection of Sunset Boulevard and the San Diego Freeway—two of the area's most visible thoroughfares. While this site was heralded as one of the last dramatic, unbuilt view sites in the city available for a large-scale public building, the Trust's choice of this site was also greeted with criticism for its connotations of elitist withdrawal from the sprawling urban fabric below. The choice of the site was fraught with practical complications as well—not only the resultant costs of developing a hilltop, but also the ensuing negotiations with neighboring property owners. Their concerns resulted in an agreement that allowed the Getty to develop only 24 acres on the 742-acre site and that influenced a wide variety of design decisions, from the height of the buildings to exterior claddings.

The Trust named Meier as its architect in October 1984. As early as August of 1984, he wrote about the site, "The spectacular site … invites the architect to search out a precise and exquisitely reciprocal relationship between built architecture and natural topography. This implies a

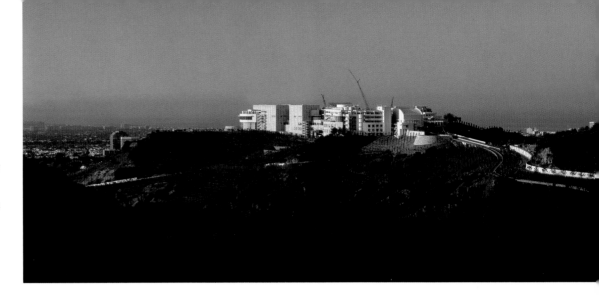

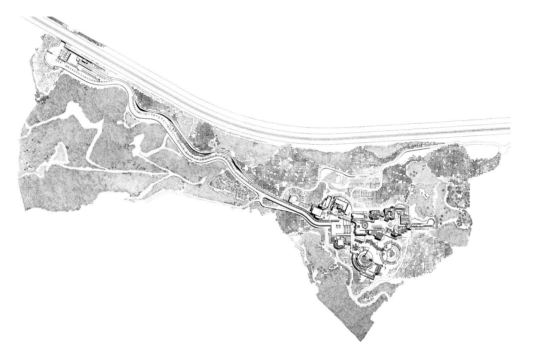

Overall view of museum

Plan of site and surroundings

harmony of parts; a rational procedure; concern for qualities of proportion, rhythm, and repose; precision of detail, constructional integrity, programmatic appropriateness; and, not least, a respect for human scale. … In my mind's eye I see a classic structure, elegant and timeless, emerging serene and ideal, from the rough hillside, a kind of Aristotelian structure within the landscape."

Both Meier and his clients desired to create a canonical masterpiece with strong classical and classical-modernist pedigrees.

The Parti

A proper understanding of Meier's design concept for the Getty Center must begin, as he did, with the generating topography of the site. His respondent plan established

the grids and geometries that guided his parti for the Getty's programs. An early orientational decision was to create two overlapping grids that tied the site and Meier's buildings to the larger geographical and urban contexts. One grid reflected the dominant grid of the city spreading to the east and south, and it governed the disposition of the Arrival Plaza, the Food Services Building, the museum, and, eventually, Robert Irwin's Central Garden. The other grid followed the diagonally inflected turn of the adjacent San Diego Freeway as it courses through the Sepulveda Pass in the Santa Monica Mountains; it organized the complex of three structures at the northern end of the site—the Auditorium, the North Building, and the East Building.

Meier's complexly layered parti makes dramatic use of underground or externally sealed programmatic elements and interconnecting passageways. Above the 896' datum, which establishes the "ground-plane" of the building site, Meier's masses are open but reach no higher than three stories, as stipulated by the municipal building permit. However, many buildings

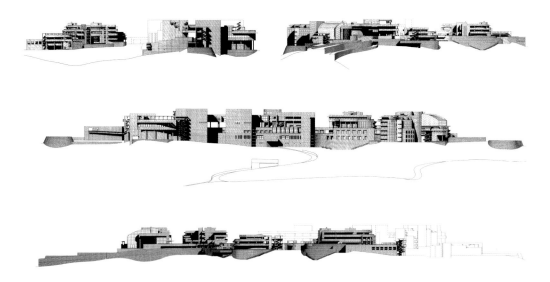

South elevation

North elevation

East elevation

West elevation

Entrance area

at the Getty Center extend as many as three stories below the 896' datum. The Getty's subterranean layers required strong order. Meier not only manipulated the adjacencies of underground volumes and paths to achieve harmonious internal relationships, but also created many patios, sunken gardens, and skylights that bring light and air into these crucial parts of the buildings, which are filled with staff offices and work areas. In its interlocking spatiality, the Getty Center makes reference to densely built Roman urban spaces and reminds us of the imperial forums.

The Architectural Image
As built, Meier's Getty Center reconciles the open and columnar bodies of Greek temples, the bold and tactile stereometric masses of Roman construction, and the white-washed surfaces of Spanish villages, as well as the California modernisms of Rudolf Schindler's and Richard Neutra's spatially dynamic buildings and Frank Lloyd Wright's inventive concrete-block structures. Meier filtered his allusions through the admiration of the "classical modernists"—Le Corbusier and Louis Kahn—for such archetypal monuments as the Athenian Acropolis, Hadrian's Villa at Tivoli, and Mediterranean hill towns. Through them, he gave the Getty the "urbane" image the complex wanted.

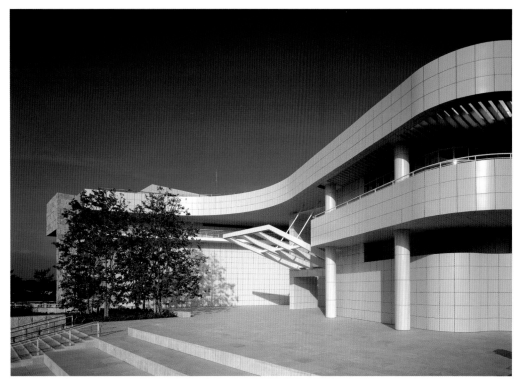

While Meier's sense of the "urbane" was clearly shaped by reference to Roman and Renaissance precedents, he surely did not discount medieval examples, from Assisi to Orvieto and including such a chronologically and culturally heterogeneous site as the Alhambra.

Meier's site plans for the Getty Center reveal a composition in which figure and ground are conceived as integral units. His compositional strategies, rooted as they are in classical tradition, also recall the twentieth-century artistic experiments in the fifties, sixties, and seventies of Robert Rauschenberg, Jasper Johns, and Frank Stella. Indeed, a case in point are the diagonally inflected, shaped and textured canvases in multiple planes of relief that Stella, with whose artistic production Meier has long been intimately connected, executed in the early seventies.

In light of earlier, "pre-Getty" trajectories of Meier's rigorous design vocabulary and given the centralized administrative structure that emerged in the Getty Trust during the design process, it is remarkable that Meier orchestrated such different architectural vocabularies for the individual buildings within the densely configured site. His distinct solutions responded in many ways to the existing urban and site conditions.

Meier sought forms that might help each program of the Trust realize its goals and express its institutional identity. For each, he developed an appropriately "modernist" geometry, concept, and formal vocabulary to generate unique form—an Aalto-esque arching volume for the Auditorium, a mini-highrise for the North Building, Wrightian (and also echoing Neutra and Schindler) planes cantilevered from a service core for the East Building, Kahn-like rectilinear geometries for the museum, a Meier-esque cylinder with a spiral ramp around an open center for the Research Institute, and a playful, open pavilion for Food Services. The forms of each were, of course, integral to the whole

Central courtyard

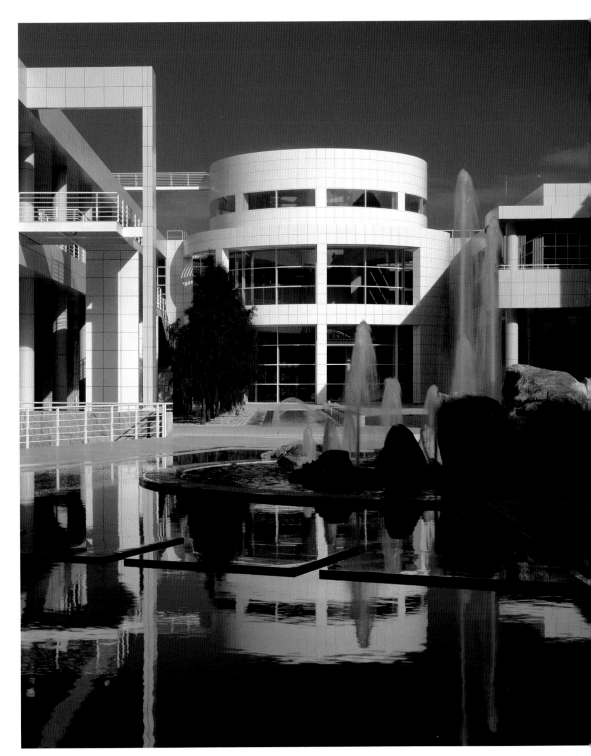

and were manifested most emphatically at the plaza level.

Long views from below the Getty site and roadway approaches reveal massive elevations dictated by the Center's program and specific provisions of the building permit. Nevertheless, neither Meier nor the Getty seemed uncomfortable with the symbolic connotations of hilltops, citadels, fortresses, and walled cities. Indeed, they were a crucial prototype for the expression as early as the first trips by the program directors to central Italy. Furthermore, they provided to Meier a unique opportunity to express the monumentality and essential unity of the complex as a whole. At the edges he could position the big forms and monumental movements of the masses that enclosed the museum and basement stories of the other buildings as the image of the Getty. These masses, truly Roman in scale and weight, house vast areas of program, except in the museum, and serve as platforms upon which the recessed buildings in their more architectural trabiated systems are seated.

The Getty Center Museum

At the Getty Center almost all roads lead to the museum, and Meier's composition focuses attention toward, into, and through the museum lobby's rotunda and culminates in views of the Pacific Ocean beyond the museum courtyard. Visitors enter the museum through a magnificent backlighted lobby—an open structure defined by spectacular plays of circles, squares, and sweeping arcs of staircases that seem to float in the air.

Meier and his clients conceived the museum in response to the popularity of the Getty Museum in Malibu, where visitors have reacted enthusiastically to the relaxed scale and the balance between architecture and landscape. The new museum's program, therefore, called for independent pavilions to "organize the collections logically and provide the visitor with routes of travel which are rewarding

Upper floor plan

Plan of entrance story

in their variety, surprise, and beauty." Meier's design created informal processional itineraries along which visitors could choose to travel. They could decide to make an ambling circuit on one level or the other, passing into and out of pavilions through either the courtyard at the lower level or through glazed skybridges at the upper level. Alternately, they could choose to explore both levels of a single pavilion before moving on to another.

A three-by-three square parti generates the design of each of the Museum's five pavilions, in which galleries are composed of volumetric groupings of units. Gallery units, whose geometries are based on the site's governing 2-foot 6-inch module, sometimes contract or expand; sometimes stand alone or connect in twos and threes. They sometimes escape the "tick-tacktoe" frame to be deployed nearby or sometimes rotate to echo the site's secondary axis. The general rule governing their disposition is that galleries for the permanent collections obey the grid established by the dominant site axis that parallels the San Diego Freeway, while galleries for temporary and orientation galleries follow the grid established by the diagonal turn of the Freeway through the Sepulveda Pass. Another general compositional rule is that at least one of the nine units rises like a cortile through both floors of a pavilion to achieve vertical integration and circulation. Avoiding sequential enfilades of symmetrically orchestrated spaces, circulation is generally peripheral and favors modernist, almost Wrightian, plays to the corners. Volumes and processional sequences do not follow any singular geometric order. Each series of spaces creates an experiential domain appropriate to the works of art on display and to processional sequences through the galleries—those twenty-nine on the courtyard level, which are devoid of natural light for the display of light-sensitive works of art, and those twenty skylit volumes above for paintings and other

works that benefit from viewing in conditions of controlled natural light. The galleries, however, are most powerful where coved ceilings and/or distinctively shaped skylights give critical and powerful definition to the formal character of the spaces, providing variety throughout the museum experience.

During the design process, Meier never ceased attempting to meet the aesthetic requirements of the museum, which apparently did not return the gift of good faith in its ability to compromise on issues fundamental to the integrity of his work.

Axonometric of north pavilion

Axonometric of east pavilion

Axonometric of south pavilion

Axonometric of west pavilion
viewed from north

The fate of Meier's gallery interiors was perhaps predictable from the outset of the commission. The museum's programmatic and public statements about the ideal museum-goer's experience pointed strongly to the eventuality that Meier's surfaces would be covered by the decorative wall treatments and color schemes associated with some of the grandes dames of European and American museums—a tradition for which the museum's staff had never disguised their esteem. "We need a museum building that plays skillful accompanist to the collection. The building should subordinate itself to the works of art in the galleries, assert itself with dignity and grace in the public spaces. ... We hope that the building can give modern form to the well-proven virtues, aesthetic and functional, of the great museums of the past. We require settings for the works of

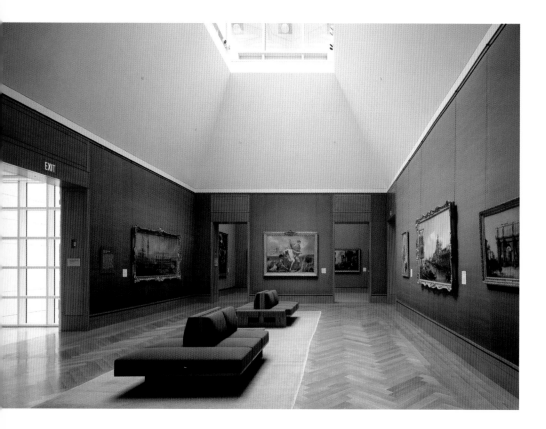

Gallery space

art that bear some relation to their original context, with lighting, scale, décor, and materials chosen to make works of art look at home—albeit in a home of the 1990s. Visual competition needs to be kept to a minimum."

As early as 1989, the Trust commissioned New York architect and decorator Thierry Despont to design period-inspired, historical sets for the fifteen museum galleries dedicated to the display of the decorative arts collection; suddenly in 1994, his commission was extended to include the materials and finishes for the museum's other galleries. Despont and his clients chose to cover the walls with fabrics that would, in their view, mediate between Meier's architecture and the collections, creating a third medium that could bring harmony to the aesthetic ensemble. This represented for Meier a painful compromise of foundational principles upon which rest his modernist commitment to tectonic expression and to the values of "materiality" and "surface" over "illusion" and "decoration." Consequently, only a few signature spaces remain

in the museum as remnants of Meier's unremittent desires for the galleries—most unadulterated is the space in the southwest pavilion, which was reserved for the expected acquisition of Canova's *Three Graces*, but, after the denial of a British export license, is temporarily empty.

Indeed, the museum's architectural concept survives primarily in the pure volumetric geometries of the galleries where the cove vaulting and skylight structures hover splendidly above the comfort zone that Despont created to protect the works of art from architectural competition. So, too, does it survive in Meier's powerfully modernist passageways among pavilions that frankly express their concrete and steel construction and glass and metal panel cladding. These unique zones of pure architectural expression create poetic transitions that link interior and exterior forms and tie the buildings to the landscape. Ironically, the museum imagined these transitions as furnishing "intervals of relaxation" to many visitors. Instead, they provide intervals of architectural excitement between the decorous but anomalous covered surfaces reserved for works of art.

Nevertheless, the museum's courtyard is one of the consummate ensembles of Meier's Getty and of his career. Its drama derives from the subtle orchestration of a structural vocabulary that juxtaposes cleft travertine blocks with smooth metal and glass panels. The rectilinear stone masses demarcate the volumes of the museum's galleries and signify security and permanence. The free-form metal and glass shapes are subtly deployed in the bridges linking the pavilions and in their separate entrances, where they connote passage and transition. A long, gently rising ramp that sweeps visitors up to the temporary exhibition gallery enhances the patio's quiet grandeur. Polished, translucent travertine pavers and tranquil water channels record changes in the California light, which, in turn, brings to life the patio's textural

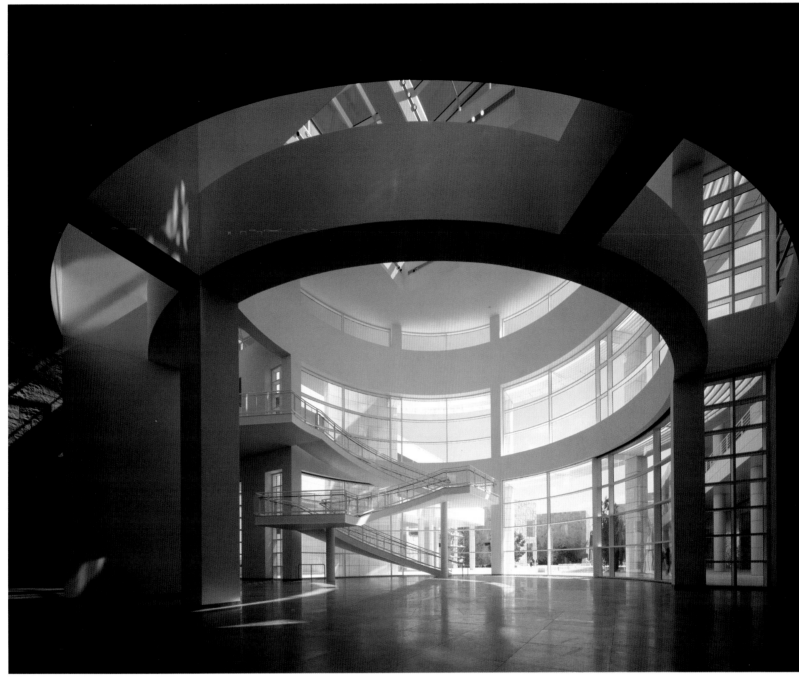

Main hall

contrasts and proportional dynamics. Soft plantings and seemingly incidentally placed stone benches, which Meier rescued as discarded fragments from the Italian quarry, provide a calm and poetic effect. In every direction are sequential opportunities for views of the Central Garden and the Research Institute, as well as of the Pacific Ocean to the west and of Bel Air, the San Gabriel Mountains, and downtown Los Angeles to the east, all of which Meier carefully framed with the buildings' masses. In this patio stonescape of sublime power, he achieves a poetry of material expression that is perhaps unsurpassed since Louis Kahn. It is here in the museum courtyard that Meier's architectural achievement at the Getty Center is most clearly and unequivocally realized.

Thomas Ford Reese, Carol McMichael Reese

Oswald Mathias Ungers
Gallery of Contemporary Art

Hamburg, 1986–1996

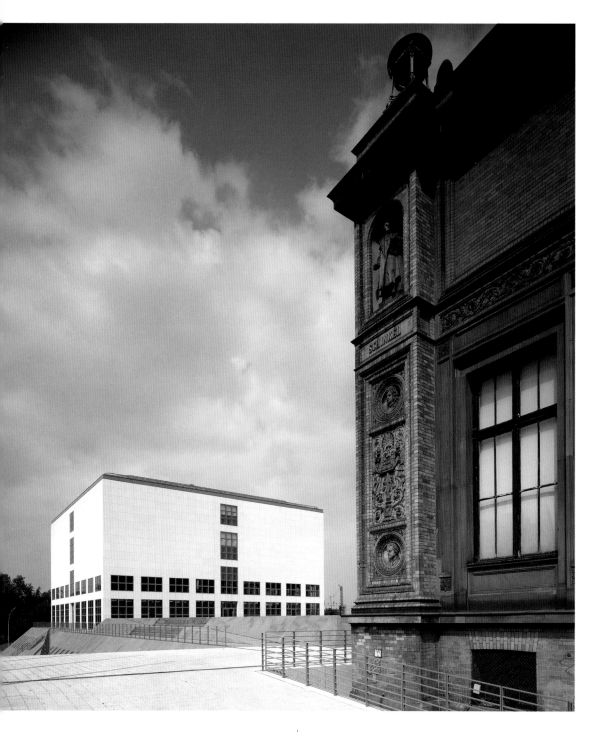

View from existing building (Kunsthalle) to Gallery of Contemporary Art

A museum is really just a piece of architecture, nothing more. Nothing more? If one takes it seriously, that's no small thing. Every building commission is public by nature. It finds its audience in an environment that is mostly urban and with which it communicates: by way of its own function, by way of the demands of the other participants in the dialogue, by way of the place and its history, and—last but not least—by way of the act of building itself.

In this regard every building commission possesses its own symbols and its own history. The museum, too, the vessel for art or other entities on show, is always something more than the bare envelope, more than a container or a black box. Certainly, one may demand that it withdraw into the background with regard to the art on exhibition. But what does this really mean? Must one really emphasize this, considering that the last ornament already disappeared decades ago from the outermost edges of the exhibition surfaces?

A museum cannot disappear either. And here the paradoxical tenet of architecture is valid as well: the more the wall as relief withdraws into the background, the more substance and structure capture the foreground. One will always perceive them, just like the proportions and the atmosphere of the space. One must recognize that it is exactly here, in the emptiness of the museum, that the building exhibits itself. Briefly put: a museum is always a museum of architecture as well. Yet it's still a long way from being a forged work of art attempting to compete with the works on exhibit. What, then, could cause an architect to become disconcerted here?

Oswald Mathias Ungers has always worked on the most direct relationship between the envelope and its symbolism. The same design methodology that can entice countless variations from the square grid can at once appear simple, and in another moment precious: from the pragmatic convention centers for Frankfurt and Berlin to the representative residence of the German ambassador in Washington. What does this mean for the museum as such and—posed more concretely—where can the Gallery of Contemporary Art in Hamburg rightly take its place here?

One could initially take the question literally; then it points at the relationship to the core of the whole, to the old and noble Kunsthalle. The beautiful and unusual masonry building in forms from the neo-Renaissance is now over 130 years old. It was already expanded once, at the beginning of this century, with the cubical and classical addition in light limestone connecting directly toward the main train station. The other side remained for the Gallery of Contemporary Art, a long plateau with a view of the dam between the Binnenalster and Aussenalster waterways. The dreary boxes of the Kunsthaus and the Kunstverein, which had stood here since the sixties and degraded the exclusive site to the level of a service court, were able to be razed in 1992 in order to commence with construction of the gallery. Five years earlier, and one year after it won the competition, Ungers's project was even presented at the Documenta in Kassel as the "museum in a box." The explanatory text itself was already provocative in its lapidary self-demarcation: "As architecture, the museum is wall—space—light. The wall bounds the spaces. The flow of spaces effects the transformation between generosity and intimacy, uniformity and free form, light and dark, confinement and expanse, as well as inside and outside. The room sequence—the enfilade—is a museum."

View up to glazed roof over central hall

Aerial view of entire complex, showing existing Kunsthalle with extension and new Gallery of Contemporary Art

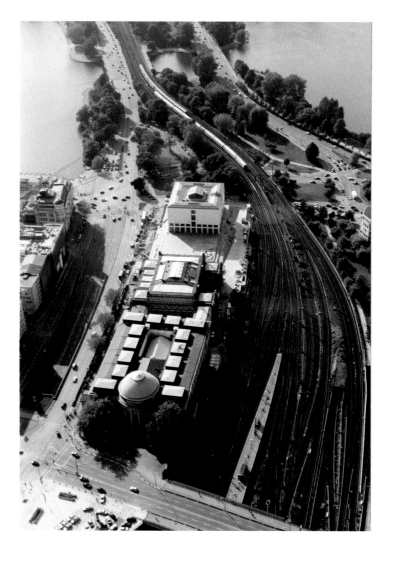

Ungers advanced the new Gallery of Contemporary Art up to the front row and made it the terminating element in the row of buildings bordering the water of the Binnenalster like an inner-city square. The manner in which the radiant solitary is placed in this panorama while retaining its own exclusive distance is just as precisely fine-tuned as its relationship to the Kunsthalle.

The beveled base of red Swedish granite plays with the memory of the Glockengiesserwall (bell foundry rampart) that once ran through here. The bevel belongs in equal measure to the street space as well as to the museum. Sitting on top and identical on all four sides is the cube, clad in light-colored Portuguese limestone. Joints and window divisions trace the square as design module on the façade while a rising window axis establishes the building midsection.

Slightly raised, the base reaches to the front of the Kunsthalle, with the artificial island rising once more and crystallizing into a connecting platform. Ian Hamilton Finlay inscribed the base—in Roman type, and in four languages—with the first work of art: "Homeland is not a country; it is a community of feelings." What is blowing here, then—in the heavens above us, and in the art before and behind us—is the wind of enlightenment. Although only its wind, this is not a place of assembly for fraternal convocation. Rather, it is a place of sentimental empathy for humanity, which now finds its highest expression and hope solely in art.

The seismic uplifting of the tectonic plates is a hint as well of that which lies hidden beneath. The more appropriate entrance into this underworld offers itself, then, not through the foyer in the cube, but once again through the point of departure, the Kunsthalle.

From here, Jenny Holzer's light band draws us down the long stair to the lowermost exhibition level, into a labyrinthine and cavernous space for the exhibition of

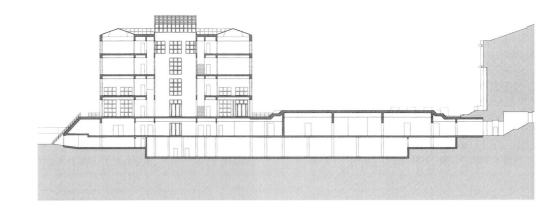

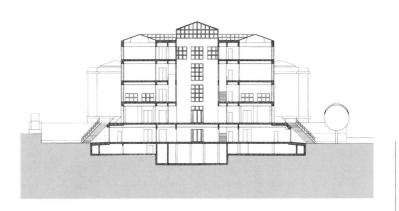

Longitudinal section

Cross-section

Elevation from Ferdinandstor

Elevation from Glocken-
giesser Rampart

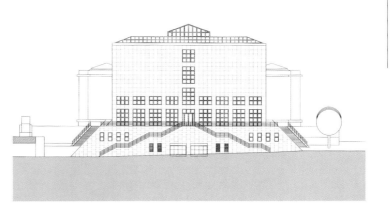

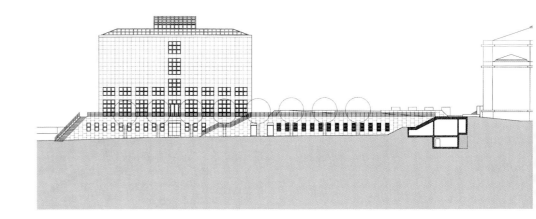

art. Despite the considerable room height, one cannot fully forget the oppressiveness and the constriction unique to both genuine and false underworlds. An enfilade would have opened a passage and a view to the cube, had Richard Serra not blocked the path with an installation titled *Splashing, Seeing is Believing.* "Art first!" is another disarmingly ambiguous message in this small intervention.

The black floor, made from industrial ceramic tiles, patiently cooperates even with works like this one in poured lead. Possible damages to the floor can be easily and inexpensively repaired. The floor appears at once workshop-like and then again elegant. For this reason one will find it in (nearly) every space in which art is on exhibition while ascending through the cube.

Nonetheless, our first impression would have been much different had we chosen the stately, ground-level entrance into the gallery. Once inside, the central hall directs our view upward through all levels to the very top, where it is drawn out by a house-like skylight. Two flights of stairs, leading upward while knowing nothing of each other, wrap themselves simultaneously around this space. Here, too, their proportions are steep and nearly sublime in nature. The exhibition spaces form a second outer circuit—white, of course, and with the possibility of flexible division.

The light changes from floor to floor. On the ground floor, with its floor-to-

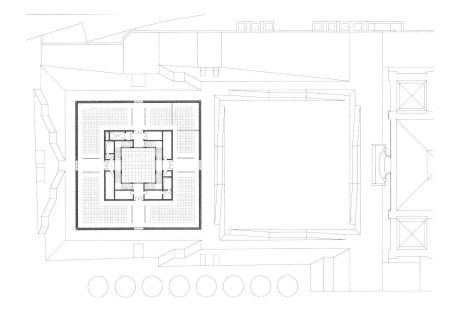

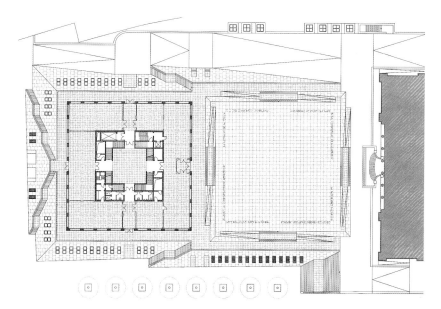

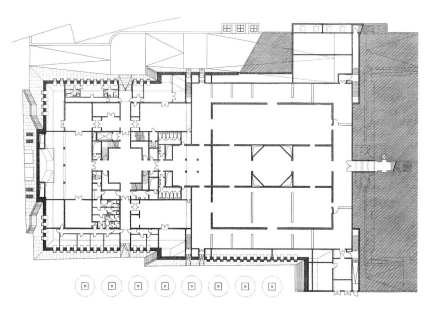

Fourth-floor plan

Plan of entrance story

Plan of plinth story

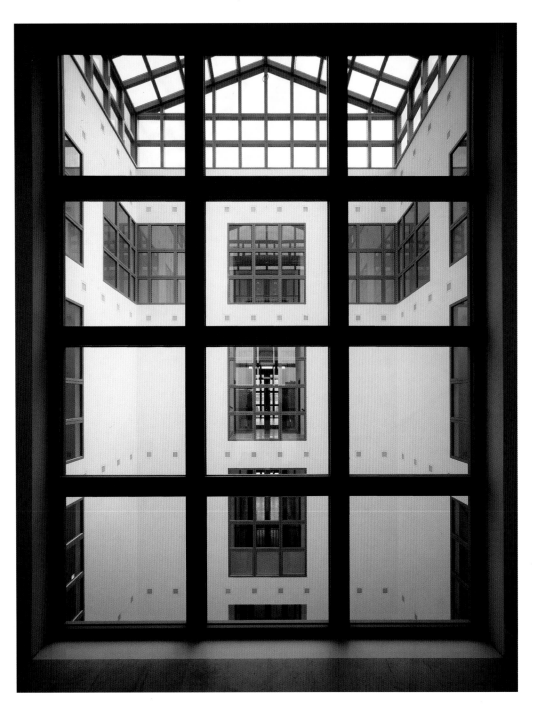

View into central top-lit hall

ceiling fenestration, a first gallery space lies between the bistro and the auditorium. Here, Ungers already suggests that he won't hesitate to project art into the city: art as a part of the museum once again becomes a part of the urban culture whence it arises. This is particularly evident on the second floor, where the windows reach from the floor up to half of the room height, admitting light rich in effect around the sides. Even when pure artificial light from the neon bays predominates in the floor above and skylights supplemented with artificial lighting illuminate the uppermost floor, the continuous fenestration of the middle axis always establishes contact with the outside world and with the inside world via the central hall running straight through the building. At least as long as the sensor-driven cloth sunshading remains open, the Gallery of Contemporary Art is also a compass, offering orientation and a lookout tower replete with perfect picture-postcard views.

Here in the cube the square as the unit of measurement is omnipresent, from the ground plan to the flooring and the furnishings up to the sunken lighting fixtures, including those for the emergency exits. The fire extinguishers and other installations have, like much else, disappeared into the walls. Everything is already in place in the concept. That offers quietude and the necessary concentration, without the design degenerating into meek incognizance or an unconscious collection of unrelated solutions.

If the interconnectedness with the outer world holds out to the domain of artistic self-reference that there is indeed life outside art, then it can be interpreted within the wealth and diversity of the elementary realm, that there is equally an idea of architecture that withdraws from art (and life). But only when art is in this triangulation does it, too, receive that of which it is needful: resistance and free space.

Ulrich Maximilian Schumann

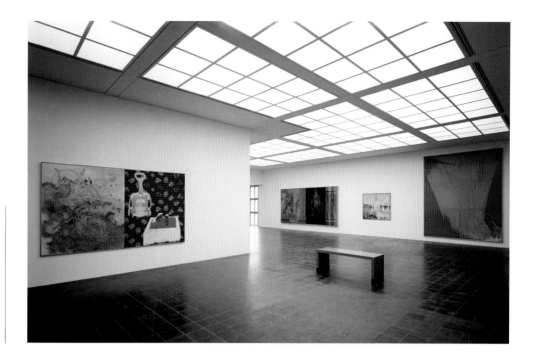

Exhibition space on
4th floor with works
by Sigmar Polke

Exhibition space in
plinth story for
Arte Povera and Minimal Art

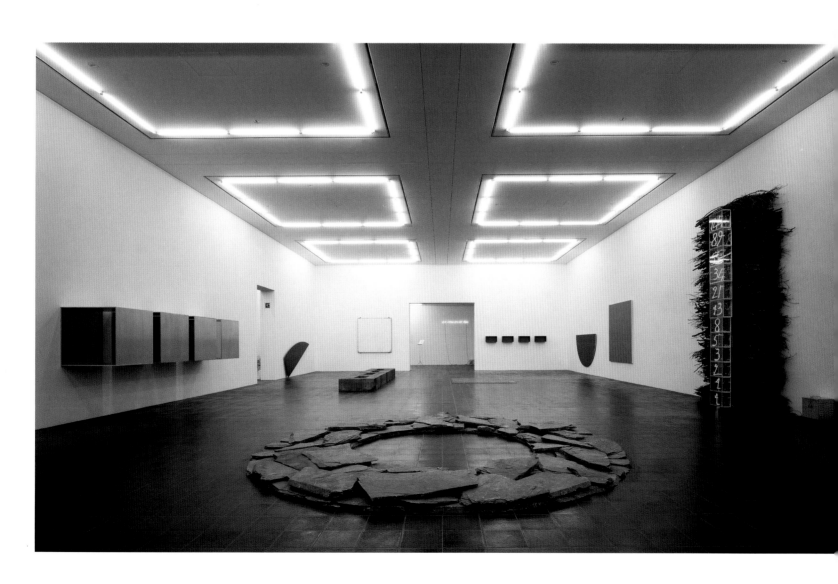

Robert Venturi, Denise Scott Brown
Museum of Contemporary Art, San Diego
La Jolla, California, 1986–1996

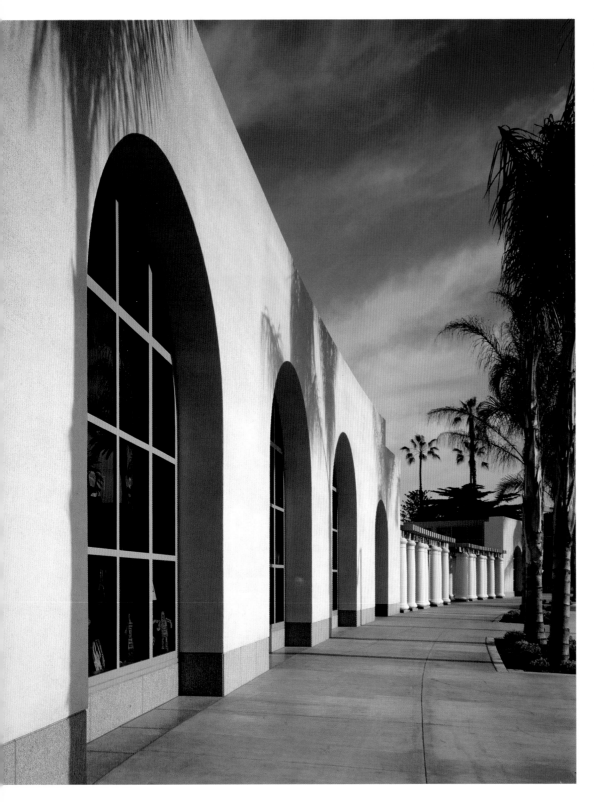

It's strange to think of an art museum as the work of a noted architect when he didn't design its exhibition galleries, and probably stranger still to praise it as one of the high points in his recent œuvre. But how else to describe what Robert Venturi has just done at the Museum of Contemporary Art, San Francisco?

The museum, which maintains a small exhibition space in downtown San Diego but has its main quarters here, a few miles up the coast, has occupied the landmark Ellen Browning Scripps house, a triumphant 1916 work of the great California architect Irving Gill, since the institution's founding in 1941. During the fifties and sixties, as the museum grew, local architects oversaw the evolution of the building from a house to a public institution by adding a series of gallery and service wings. None of these were distinguished, and they had the collective effect of almost obliterating any sense of the magnificent structure that was the museum's core.

Enter Robert Venturi, the senior design partner of the Philadelphia firm Venturi, Scott Brown & Associates, who was hired in 1986 to, as he put it, "accommodate the extremely complex program of a modern museum and to make of the outside a new civic building for La Jolla."

In other words, he was to make the museum bigger, more modern, more coherent and more respectful of its history, a set of goals that contains a built-in contradiction. Taking a hodgepodge and giving it some order is difficult enough; giving more prominence to the house while expanding the complex all around it is tougher still.

The transformation took ten years, in part because of problems with raising money, in part because Venturi was sidetracked by much larger commissions, including the Sainsbury Wing at the National Gallery in London. But La Jolla, small as it is, turns out to have been very much worth waiting for. This is an exquisite project, overflowing with those qualities that make Venturi a designer of extraordinary gifts.

The expanded museum is respectful of every piece of its complicated history, yet it has a strong and clear identity as a different building. It is a sharp and lively presence on the street, yet it is woven into the fabric of La Jolla with consummate delicacy and grace. The sense of balance between old and new, between object and context, is as subtle and as sure as anyone could ask for.

In a sense, the program Venturi has been given here is not so different from

View from street

Layout study

Elevational study, 1987

Street face

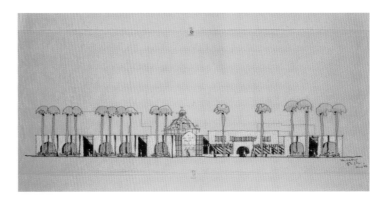

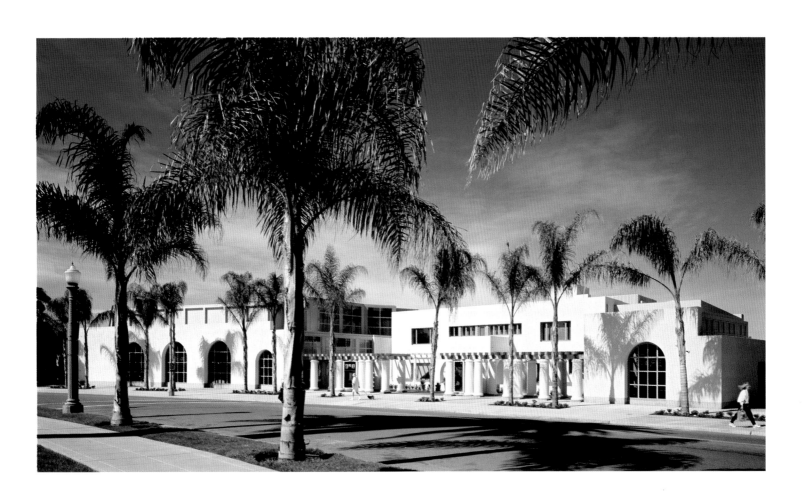

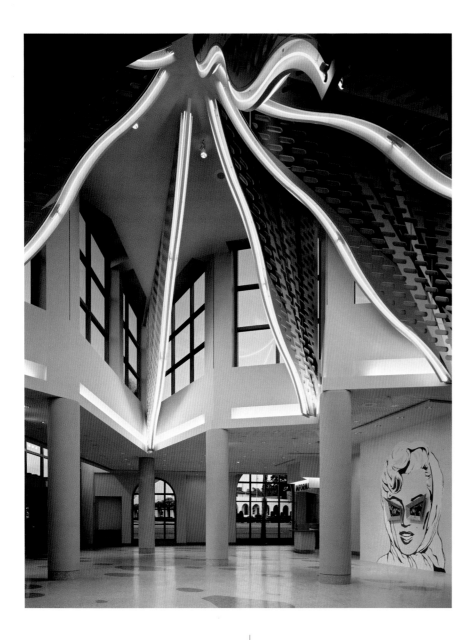

Foyer

what I. M. Pei was asked to do at the Louvre: add a grand entrance and lots of fresh public space, and do some behind-the-scenes fixing up, all intended to bring a series of disparate sections together into a coherent whole. Yet in La Jolla the solution is not an abstract object intended to excite by total contrast, as Pei's glass pyramid aims to do beside the classical pavilions of the Louvre, but a series of smaller architectural additions, subtractions and alterations intended to play gently on the themes of the earlier wings of the museum building. Venturi has not directly imitated the architecture that preceded him—few visitors will have trouble figuring out which sections are new—but he has allowed it to set the themes.

And what wonderful themes they are! To understand why Venturi was so at home on this site overlooking the Pacific Ocean, it is necessary to speak first of Irving Gill, one of the great figures of early twentieth-century American modernism.

Gill, who had worked with Louis Sullivan in Chicago, settled in San Diego in 1893 and slowly built a career that by World War I had yielded a remarkable group of concrete buildings that magnificently balanced the starkness and clarity of modernism with the sumptuousness and urbane order of Spanish mission architecture. Gill's architecture, with its arches stripped down to their clean, pure essence, seemed to combine comfort with technology and modern life with a respect for traditional urbanity.

Ellen Scripps was one of Gill's great patrons, and she commissioned him to design not only her own house in the center of La Jolla but numerous other buildings including the San Diego Woman's Club and the La Jolla Recreation Center and playground, both across the street from the Scripps house.

Together, the Gill buildings and the Episcopal Church of St. James-by-the-Sea

Exhibition space

Plan at street level

Plan at garden level

If there is any problem with the museum's façade as it now stands, it is in the way visitors enter. The door to the Scripps house remains front and center, exerting a strong magnetic pull. Yet it is not the front door to the museum; visitors must enter an outdoor courtyard and make an illogical turn to the left to arrive at the front door that Mr. Venturi has created. The contradiction is hard to get away from: the Scripps house has pride of place, but its wonderful arched doorway is but an artifact. Mr. Venturi was unable to resolve the conflict between the requirement that the great old house have visual pre-eminence and the need for the new wing to serve as the museum's real front door.

constitute a remarkable grouping: an agglomeration of architecture made up of different civic and private functions coming together to create a public presence that is larger than any of them could have achieved alone.

The group feels almost Italian in the way its delicate scale and repetitive architectural motifs join comfortably, and if this collection of buildings is organized around automobile-filled streets rather than a piazza, well, this is Southern California, not Italy. But rarely in Southern California is there any cluster of buildings so serenely civilized.

Venturi has cleaned up the front of the Scripps house, revealing it again as the centerpiece of the composition of the museum. Then he added one large wing to the left, containing an expansive entry court, museum shop, and lobby, and a smaller wing to the right, containing a café. Each uses Gill's trademark arches, but on a larger scale. Sleek windows and walls of glass poke out from the sides, as if to underscore that these wings are not truly Gill's. The Venturi wings also have a slight curve to them, reflecting the bend of Prospect Street along the building's front, which both distinguishes them further from Gill's rectilinear shapes and weaves them even more effectively into the cityscape.

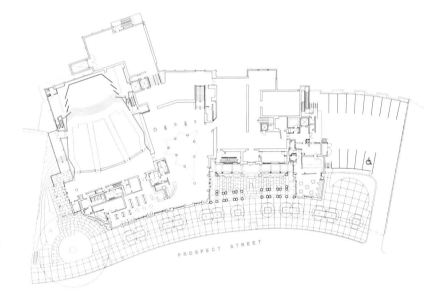

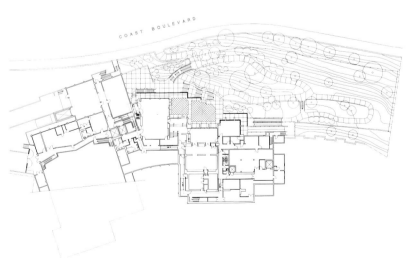

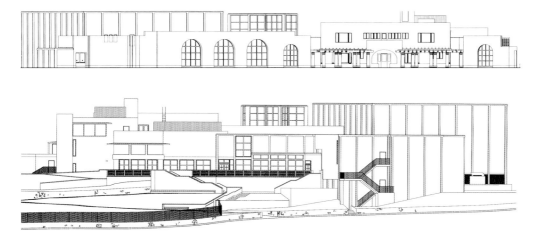

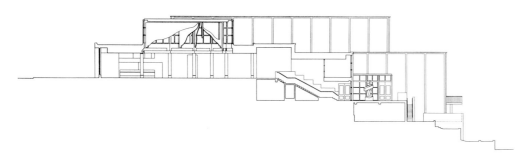

East elevation

West elevation

Cross-section

View from garden

Entrance from garden

So be it. More important is the way this graceful composition adds to the museum's public presence on the streets of La Jolla. Only Robert Venturi could have got it so right, I suspect; the building is a riff on all the complex and subtle rhythms of the streetscape, rhythms not only of architecture but also of time.

There is no wish here to blend in so fully that the building seems always to have been there, as with Robert A. M. Stern's pleasant and exceedingly well-mannered group of shops at the other end of Prospect Street in La Jolla's commercial center. Venturi wanted the building to be of this moment, which he sees as asserting its meaning by reaching across time to embrace other periods, and taking them all into its grasp. He struggles to tease out of a highly complex context a kind of serenity that does not deny complexity.

Thus the shapes of the building are complicated and uneven; thus there are accents of neon signs in the windows; thus the starburst of glass and metal over the new main hall, a jazzy element that replaces a dome originally proposed. And thus the self-consciously "modern" fenestration peeking out from behind the arched stucco walls.

Irving Gill is prime Venturi material: his architecture is simple, almost dumb at first glance, and wonderfully rich and deep the more you probe into it. Responding to a Gill masterwork that has had years of awkward additions and subtractions, all within a busy urban context, is an architectural problem tailor-made for Robert Venturi. And the result is a good demonstration of what Venturi, often misunderstood as more of a theorist than a designer, has always been trying to make his architecture do.

Paul Goldberger

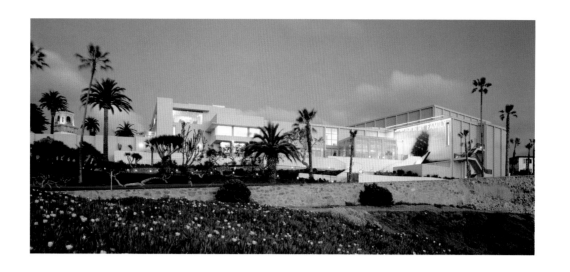

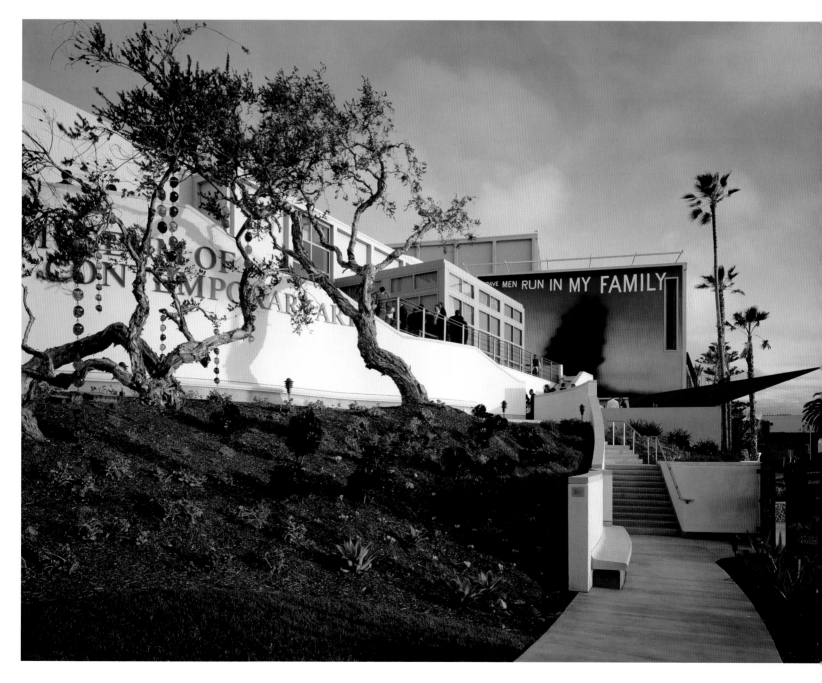

Vittorio Gregotti, Manuel Salgado
Cultural Center of Belém

Lisbon, 1988–1993

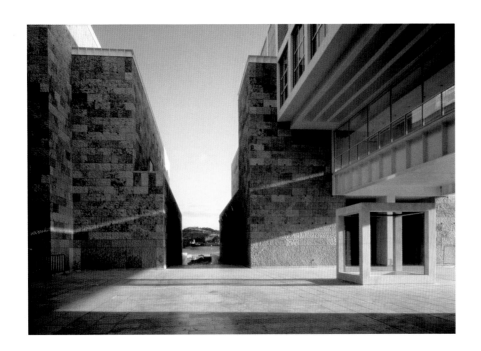

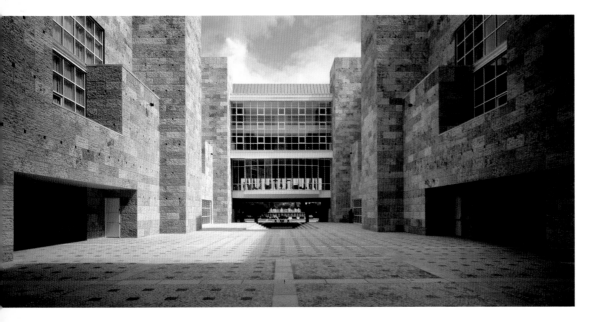

Cross-route to River Tagus

Main pedestrian route
near Praça do Império

What certainly distinguishes the Cultural Center of Belém in Lisbon from other recent cultural buildings is its diverse user program. Consisting of a mixture of high art and high politics, popular culture and commercial functions, a hotel and pedestrian areas, it would suffice to enliven a smaller city quarter. The facility was built as a cultural center on the occasion of Portugal's presidency of the European Union in 1992, offering the framework for its events and conferences.

The building site was well chosen. By way of its location on the River Tagus, which is both peripheral and privileged, the building complex could become the driving force for future development in the formerly independent suburb of Belém, forming an attractive complement to the historical city core of Lisbon. One didn't just plan in no man's land, however. The Monastery of the Hieronymites and the Tower of Belém, Portuguese cultural monuments from the first half of the sixteenth century located nearby, already lend the place meaning as a cultural and tourist center. The grounds of the *Exhibition of the Portuguese World* from 1939–40 along the banks of the Tagus remind one of the period of dictatorship just as much as the Padrão dos Descobrimentos, the monument to the Portuguese conquests raised in 1960 on the occasion of the 500th anniversary of the infante Henrique's death. The site is characterized by an absence of spatial boundaries, being separated from the mouth of the Tagus to the south only by the exhibition grounds and separated from the monastery to the northeast by a large park. The large areas that bound the building site are not neces-

sarily fallow urban zones in a conventional sense. The open spaces—small-scale in structure and carefully planned—are bisected, however, by the heavily traveled exit roads. In addition, a heterogeneous housing and commercial structure lies to the northwest. The new edifice should clarify the urban context, which—while characterized by attractive objects—is unclear in its totality.

Vittorio Gregotti's project was chosen from the two proposals that reached the final competition round in 1988. The proposal succeeded in a remarkable manner to strive for a high degree of urban clarity by means of a project that was actually quite ambivalent and heterogeneous. He placed a nearly symmetrical entrance tract on the site of the razed pavilion from the exhibition of 1939–40, making reference to the north–south axis of the adjacent Praça do Império, its axis having heretofore been unsatisfying in its disconnectedness. In addition, the park as a whole receives a clear demarcation by virtue of the solid building volume. The entire complex is articulated into readable zones along the axis dictated by the park: conference center, theater, museum, hotel, and commercial street. Gregotti's competition project was not fully realized; the westernmost part, with its smaller court for the hotel and the shopping street, was not built. This would have enriched the facility with several additional urban functions while integrating it more successfully into the neighboring housing structure.

The decision to form the ground floor as a base with minimal window openings—housing a garage and service functions requiring no daylight—contributes above all to the massive appearance of the complex. In a similar fashion Gregotti had created compact and internally articulated large forms with the *insulae* of the housing complex in the Quartiere Zen in Palermo (1969–73). In Belém the upper termination of the base marks the ground level for the public open spaces of the complex,

from which the individual building elements are then defined. This is indicated on the exterior by the "hanging gardens" that form the transition between the actual building volumes and the streets. Despite the articulation of singular building elements, the architect does not attempt to have the real volume of the complex appear smaller. The massiveness is additionally strengthened by completely cladding the cultural center with light-colored limestone, forming a reference with the material to historic Portuguese architecture.

Despite its predominant base, the complex is not an impregnable obstacle, since transverse thoroughfares in the north–south direction open it up to pedestrian traffic. The actual circulation takes place along the main east–west axis that corresponds to the run of the riverbank. Inside, an exciting sequence of

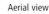

Aerial view

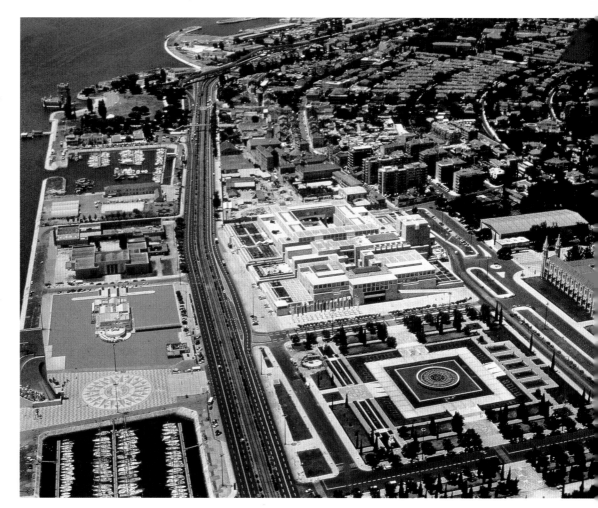

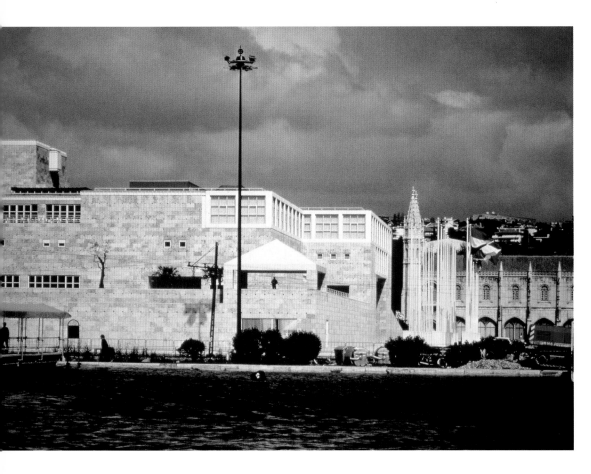

View from the Tagus

foyers and public open spaces then develops, whose spatial qualities oscillate between courtyard and open space. In order to emphasize the public nature of the open spaces, they were provided with cazada, the intricate flooring made of black and white paving stones that also characterizes the appearance of Lisbon's city center. In addition, the compact placement of the individual building volumes contributes to the "urban" character of the inner spaces.

Vittorio Gregotti himself viewed his project, in addition, as a contribution to the theoretical debate concerning the relationship between architecture and the city. He designed it as a possible way of dissolving the antagonism between monuments (primary elements) and the city at large, which Aldo Rossi had established as the primary constant of his urban observations in *L'architettura della città* (1966). The cultural center really does pretend to be a piece of city placed on a base, while yet remaining a megastructure. The question of integrating megastructures into an urban context forms a central pursuit of Gregotti's recent works. In Belém the architect was able to use the force of history as the legitimization for using a megastructure; and indeed his cultural center exceeds neither the footprint nor the height of the neighboring monastery. Large historical structures, too, such as monasteries and above all castles, exceeded the dimensions of their surroundings while turning away from them and allowing a marked variety of uses within their walls. Gregotti does not hold fast to structural similarities in this case. Indeed, the idea of a fortress is actually strengthened by a few, though explicit, details in the Cultural Center of Belém. Like bastions, landscaped terraces extend to the banks of the Tagus, while an abstract bulwark tower marks the boundary to the Avenida da India and a marked donjon clearly stands out from the stage tower of the large auditorium. The highly diverse internal circu-

Façade overlooking River Tagus

Façade to Praça do Império

Façade to main pedestrian route

Façade to Rua Bartolomeu Dias

Courtyard façade

Longitudinal section

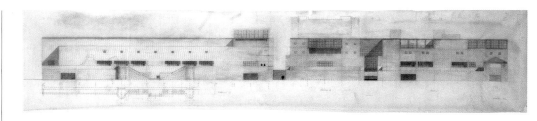

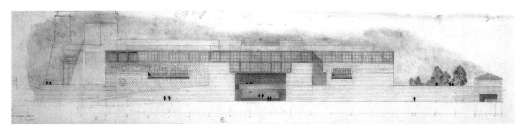

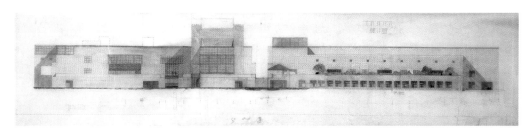

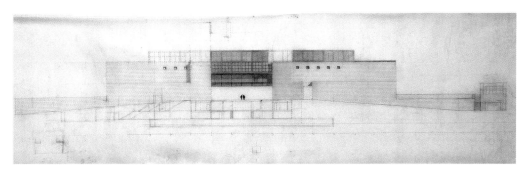

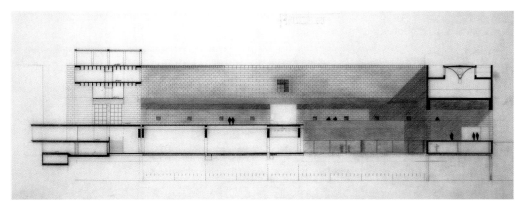

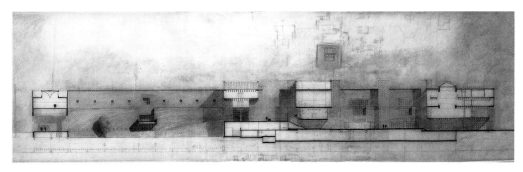

lation system with its ramps, bridges, moats, and stairs contributes the castle-like character as well. The center wants to be a monument in the sense of a unique, unmistakable building with its architect apparently having made use of the "classical" resources of monumentality, grandeur, and volume in an intentionally rhetorical fashion.

The question whether monumentality is suited to a democracy or even a cultural edifice has often been posed, not surprisingly, in connection with the Cultural Center of Belém. Yet, it is exactly for this place that the question can easily be answered. Here, at a center characterized by monasteries, towers, and exhibition grounds of catholic, absolutist, colonial, and (recently) totalitarian self-presentation, it was simply a question of self-affirmation, leaving few other possibilities open. The construction of a new cultural center, which was one of the largest state commissions in recent history, was not able to avoid the challenge of the political topography of the place. Here, all of the important historical political systems in Portugal's history are evidenced by representative buildings. For Vittorio Gregotti the question of monumentality is, however, not just one of simple affirmation. His historic building elements are not carriers of meaning of a fixed message; rather, they offer through their abstraction the possibility of an assignment of meaning. This means that he would like to create build-

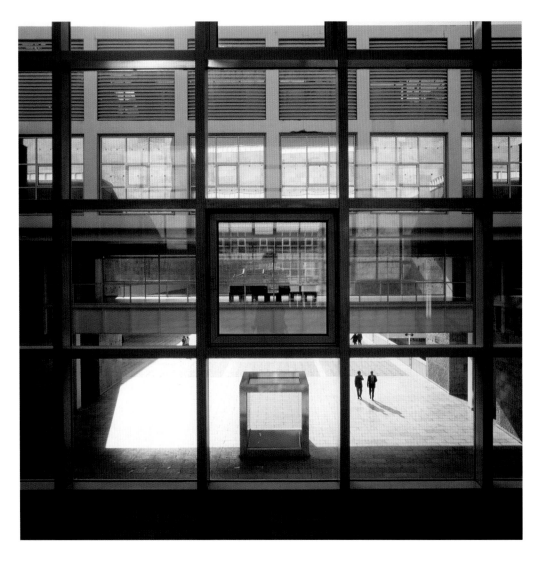

is consequently able to develop further the self-created challenge in the morphology of the exhibition spaces. He organizes the spaces for the rotating exhibitions as classical galleries by means of enfilades. These are set, though, in direct visual relationship with the museums spaces immediately below as an open mezzanine, wherein a room constellation arises that is at once complex and unclear. The proof that Gregotti possesses concrete ideas about how to present works of art can be seen not only in countless exhibition designs, but in the renovation of the Pinacoteca di Brera in Milan (1983–94) as well, particularly in the Sala Raffaello.

Despite all the differences, the approach is comparable in both cases: large white wall surfaces form the quiet background for the works of art in spaces that are strongly articulated and made dynamic by means of the articulation of the light and the use of different levels. As such, Gregotti negotiates a compromise between the autonomy of the work of art—which he leaves be, and whose interpretation he does not touch—and the autonomy of the architecture. Unlike, for example, a Carlo Scarpa—with his interpretative designs for museums and exhibitions—Gregotti allows all possibilities in a compromise of distanced architectural respect.

With the complete integration of the museum into the self-made urban context, Gregotti prevents the museum from possessing the customary position of an autonomous cultural building. The museum has become a part of a complex as in the time before the Enlightenment, the difference being that this place is open to all for learning and pleasure.

Ruth Hanisch

ings that could become monuments with time. Here, the subsequent growth of meaning with time should not be impaired from the outset by mediocre design. Instead, the meaning should be furthered by its "integrity, tension, subtlety, depth of relationship, and discovery," according to the architect.

Gregotti works consistently when placing the museum into this "city-monument." The edifice takes both a minor as well as a remarkable position since—while not being intentionally evidenced in elevation—it is located at the largest and most prominent court. As such, it functions in the internal "urban" relationship, becoming a kind of Galleria, such as one knows from the historic residence facilities of, for example, the Palazzo Pubblico in Florence with its attached Uffizi. Gregotti

Detail of glazed façade to foyer with view of museum courtyard

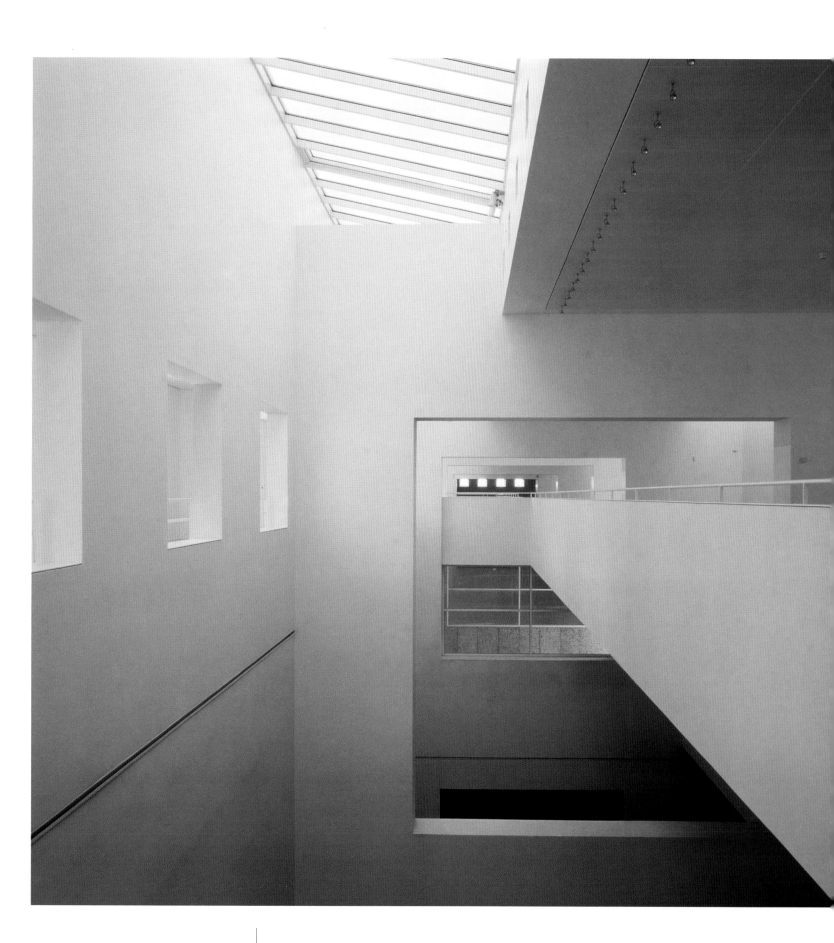

Exhibition space

Álvaro Siza Vieira
CGAC, Centro Gallego de Arte Contemporáneo
Santiago de Compostela, 1988–1993

Sketches: urban context, external
form and internal spaces

External view of entrance area

Art is the religion of our times, and museums are its churches. Within the monumental nucleus of Santiago de Compostela, the Portuguese architect Álvaro Siza Vieira built a new pilgrimage site between 1988 and 1993. Across from the convent and the church of Santo Domingo de Bonaval, the Centro Gallego de Arte Contemporáneo (Galician Center of Contemporary Art) is a holy building that shelters the ceremonies and rites of contemporary artistic piety. Sponsored by the new autonomous administration of the region of Galicia as the major future patron of creativity in the plastic medium within the community, its commission to the master from Oporto illustrates the symbolic importance of the institution. As did Catalonia with New Yorker Richard Meier's MACBA in Barcelona and the Basque country with Californian Frank Gehry's Guggenheim in Bilbao, Galicia commissioned its temple of the arts from a renowned international figure whose brilliance of contextual form would bestow artistic legitimacy to the so far mostly undetermined future contents of this center.

Awaiting well-defined permanent collections and lacking a constant public, most of these art collection centers rely on their ability to attract visitors based on the distinctiveness of the edifice and the publicity for their programs. For this reason, the architects are often selected from among those professionals with the most prominent artistic profile, an achievement firmly established by Siza. A great designer, draftsman, and sculptor of courage, Siza evidently has ties to, and a fondness for, the geographical setting of

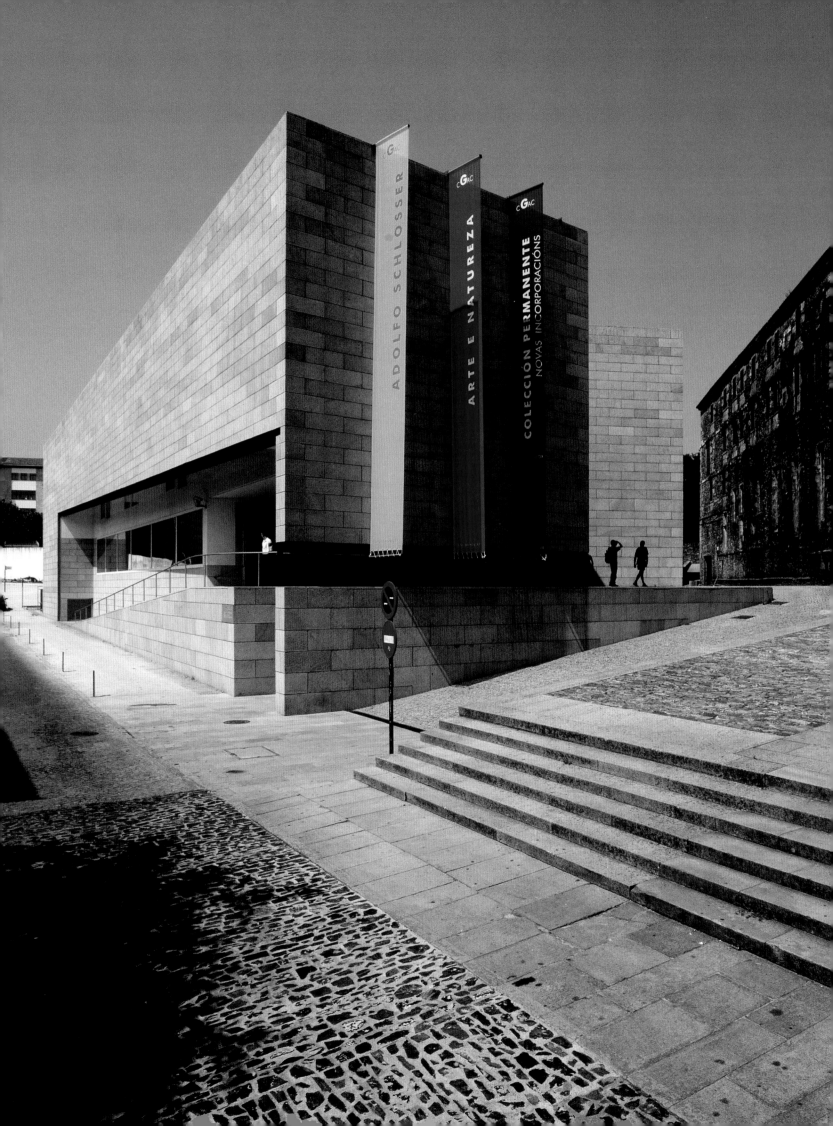

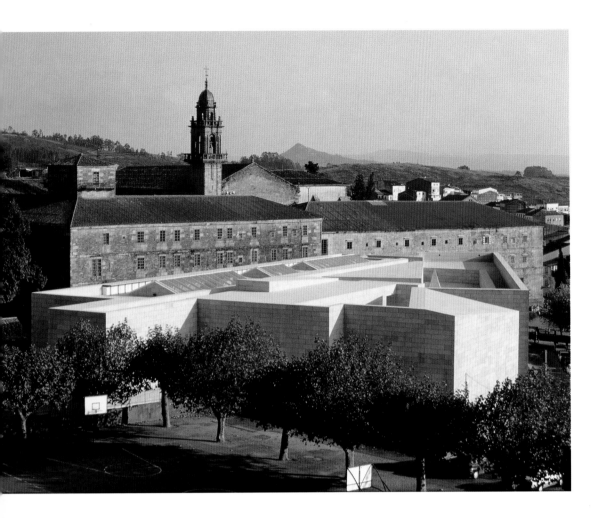

together with Saramago, the most universal of Portugal's sons, with whom he shares his social consciousness and Iberian spirit—also stands face to face with a Baroque convent situated along the indistinct boundary of the historic center of the city, and rises with determination and sensitivity, above the fiendish difficulty of the site to construct a gravid and airy building that floats without resorting to flying machines.

The site certainly presents a fiendish problem, for the difficulty of the rugged topography is compounded by the irregularity of the perimeter; by the need to create a "dialogue" with the convent and the church of Santo Domingo de Bonaval (in whose former garden the building sits) without emphasizing the west façade of the complex that had for long remained hidden behind the high walls surrounding the grounds; and by the expediency of encompassing the beautiful terraced garden that contains the convent cemetery while breaking up the sightlines to some unfortunate nearby structures of undesirable visual impact (including a deplorable school built in this century). The twisted urban memory is the problem that Siza is faced with, which he miraculously solves with a single conjurer's gesture, so apparently simple and evident, but in reality the product of a prodigious intuition characterized by synthesis that need not envy for a moment the inventive imagination of Saramago's Padre Bartolomeu.

The spark of inspiration is not found, as we might think, in any of the hundreds of preliminary freehand sketches for the project, but rather, in a detailed plan drawn in pencil that reproduces on a scale of 1:1,000 the site and its surroundings and in which Siza highlights with lines of different colors the most important alignments and sightlines of the complicated urban environment. This careful analysis leads him to the critical decision to organize the building as two elongated rectangular prisms that form an acute angle,

this Atlantic edge of Europe. Shortly before the completion of the center, he saw his prestige in the plastic arts endorsed with the award of the Pritzker Prize that his US colleagues Meier and Gehry had received in 1984 and 1989 respectively: the architects of the temples of art must be conferred a priestly office within their demanding métier.

In his *Memorial do Convento*, José Saramago—the first Portuguese-speaking author to receive the Nobel Prize for Literature—describes both the painstaking construction of the Mafra Convent, a colossal structure aspiring to imitate the Escorial that João V built in the early eighteenth century, and the love story of the soldier Baltasar and the visionary Blimunda, who rise above the hardships of the construction work physically and symbolically, thanks to a flying machine and their stubborn determination born of love. In Santiago de Compostela, Álvaro Siza—

Elevated view

Site plan

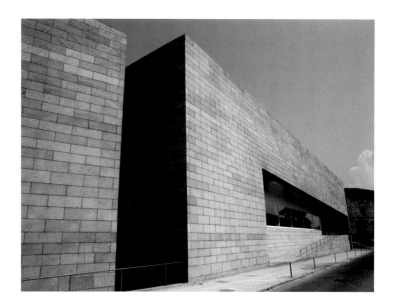

External views

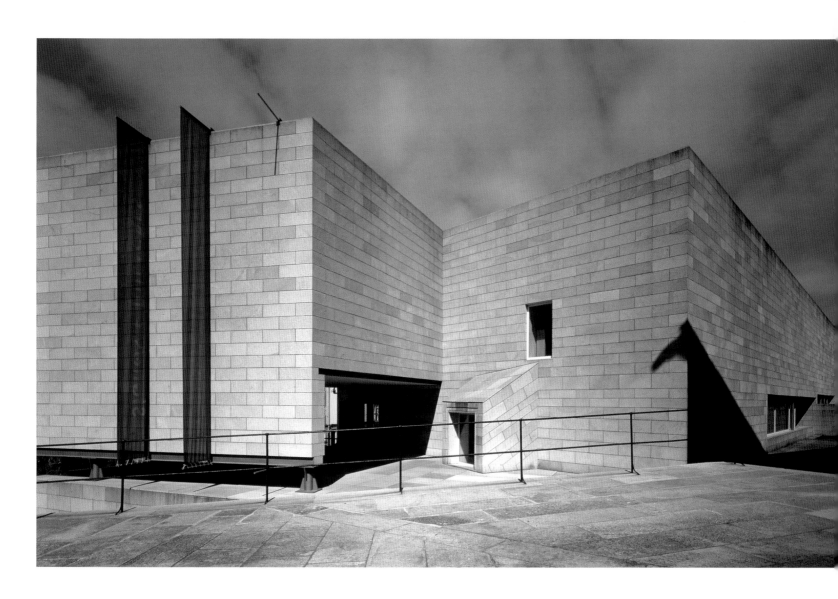

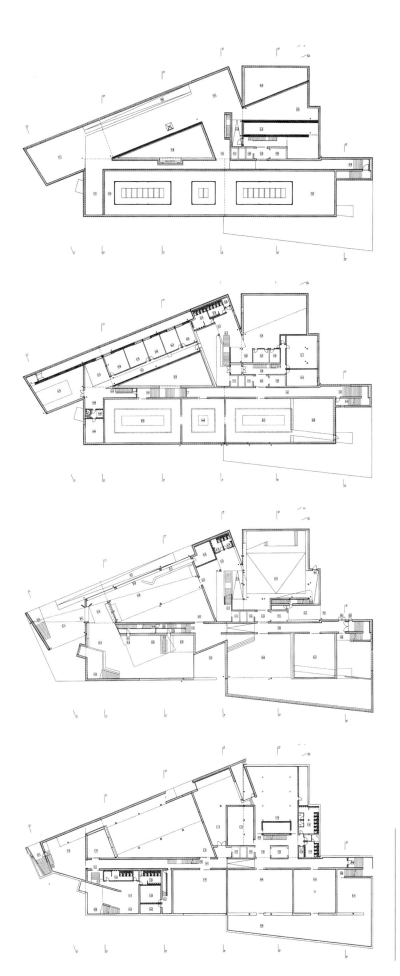

Third-floor plan

Second-floor plan

Ground-floor plan

Basement plan

joined at the corner to conform the access. One of the prisms is situated along the existing street, and the other leaves a flared space between the art center and the convent, leading to the terraced garden, while the intersection of both forms a covered entry just steps from the monumental doorways to the church and convent of Santo Domingo.

The countless subsequent sketches are limited to developing, as the latter-day Siza is so wont to do, the impeccable initial decision. The empty triangular space between the two sections is a scenographic atrium of soaring height that separates the administrative area (and, after a sharp turn, the auditorium) of the streetside wing from the exhibition areas in the garden wing. Traffic is directed mainly along a theatrical longitudinal stairway parallel to the prism of the galleries that provides access to the different levels as it climbs upwards from the entrance vestibule to the flat roof, which can be used as an open-air terrace for sculpture exhibits. Below it lie some magnificent views of the old center of Santiago. Each of the ancillary areas, from the temporary exhibit space to the library, from the restrooms to the bookstore, is taken advantage of for repeated diagonal articulations.

In fact, it is in this exacerbated trapezoidal or triangular composition that projects like a geometric echo the irregular terracing of the garden that Siza's talent for working with the topography stands out: the building becomes the link between the random landscaping of the garden and the compact volume of the city, allowing both to influence it. These, precisely, are the vague elements that best fit the manner of the Portuguese master, so fond of making careful folds on his blank canvases with a sculptor's sensitivity. That same subtle and disconcerting look is present in the skylights of the galleries from which hang surreal, upside-down tables to diffuse direct light. It appears again in the mannerist proportions of the

open spaces, which waver between the emphatic verticality of the access elements and the flattened horizontality of many of the galleries; in the profusion of acute angles of the rooftop scagliola; and in the plaster coating of the walls, benches, and low walls, as well as the pale marble of the floors.

The homogeneous whiteness of the materials used inside the building—whose only accents are the dark wood of the gallery floors, some interior cabinetry, and the rungs of the main stairway—bathes the interior with a luminous glow that imbues it with the lightness of a building made of artfully folded paper. The exterior, tiled with squares of granite—the traditional building material of Santiago when used in the form of ashlar—gives the same impression of weightlessness by the use of large horizontal dintels. These emphasize the epithelial nature of the stone, whose continuum is interrupted on a diagonal, leaving no doubt about the nonexistent supporting function of the dintels. The nature of the contrived covering—applied for contextual reasons, and one that has not aged well in the rainy climate of Santiago—endows the structure with the fragile and abstract appearance of a model that gives expression to the ill-defined sense of unease that is inseparable from contemporary art.

Luis Fernández-Galiano

Sections T1 T2 SJ1 SJ2

Sections T3 T4 SJ3 SJ4

Sections T5 T6 S1 S2

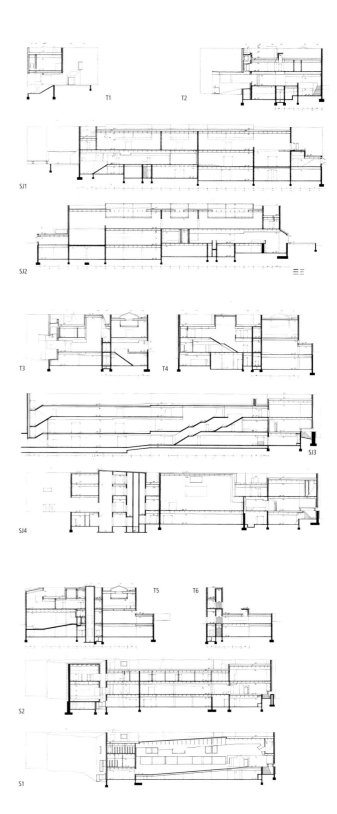

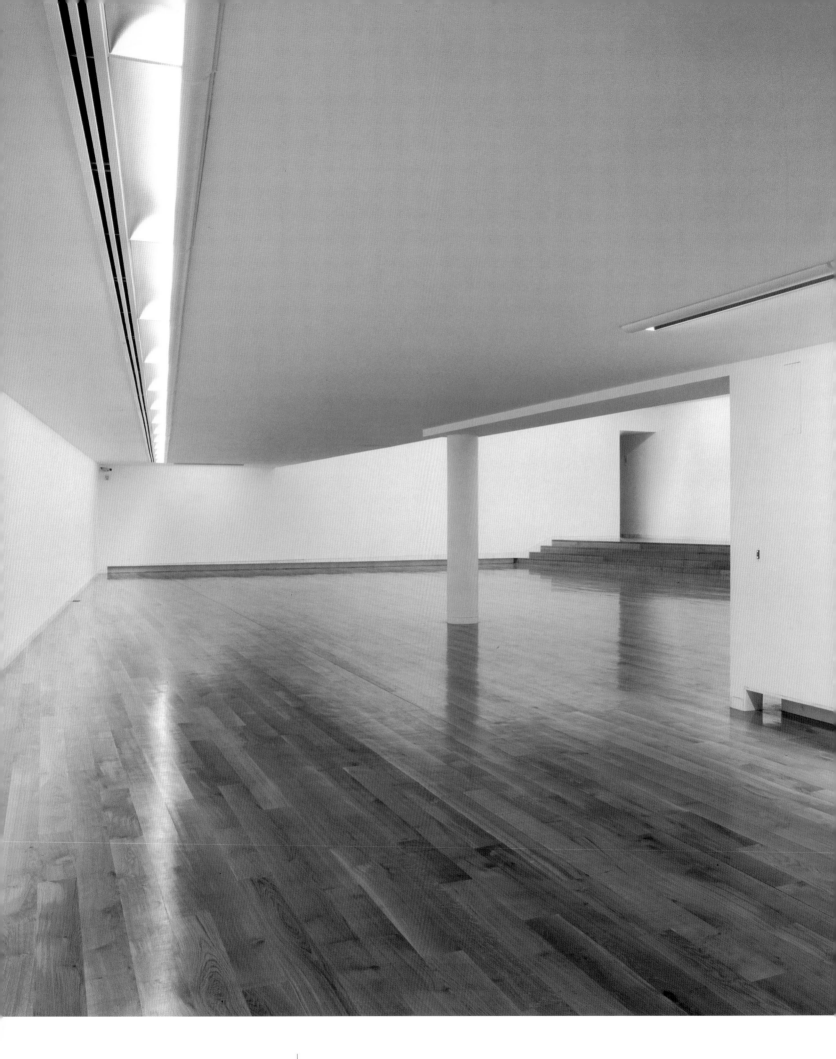

Exhibition space

Interior view

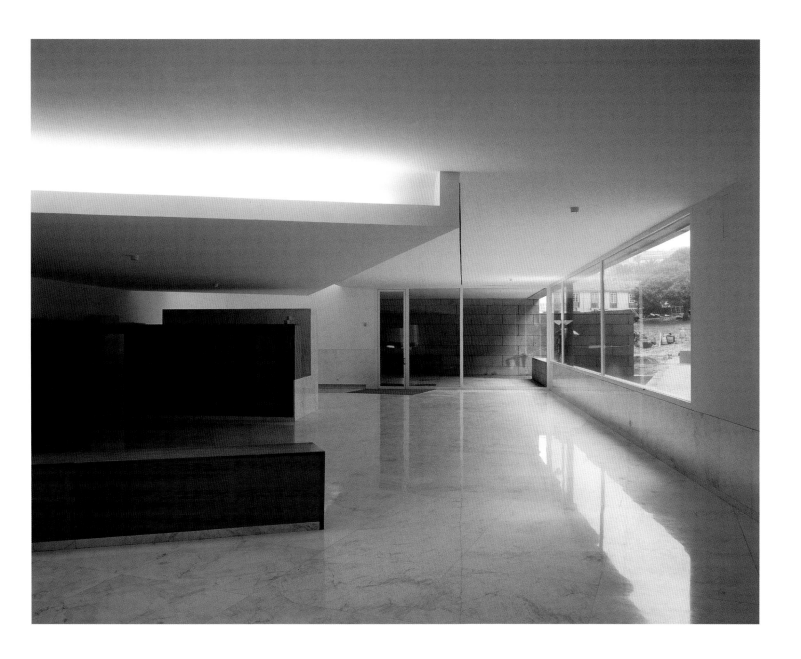

Mario Botta
San Francisco Museum of Modern Art
San Francisco, California, 1989–1995

Preliminary studies for main
façade on Third Street, 1989

View from east

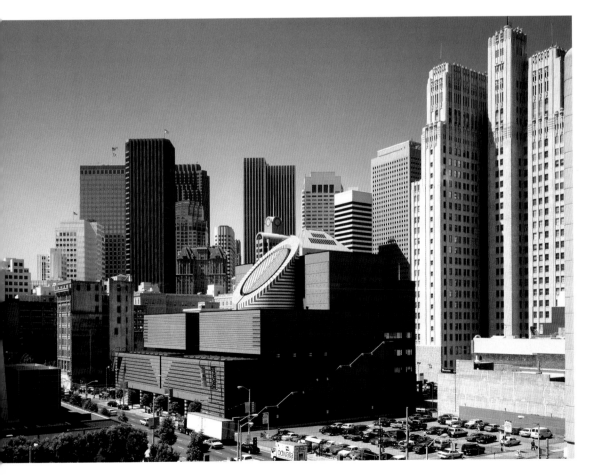

Archaicity Revisited

Few museums realized during the nineties have been so well conceived from the curatorial standpoint as Mario Botta's Museum of Modern Art in San Francisco. Two possible comparisons are Axel Schultes's *Kunstmuseum* in Bonn or Alvaro Siza's Galician Center of Contemporary Art in Santiago de Compostela, but certainly no works of this caliber have been achieved in the United States in recent years. Botta has been able to recall, without nostalgia, what the museum as a civic institution has been in the past, and to suggest what it might become in the future. Thus his San Francisco museum, cradled within the Yerba Buena Center, now stands as a challenge to its trustees, for the one chronic problem that remains, as with most new museums, is how to fill its halls with quality work—and how to establish within its confines a truly vital cultural program.

Far from the now-fashionable habit of narcissistically regarding the museum as a building without a program, the San Francisco Museum of Modern Art has a gallery sequence that unfolds before the visitor with such gracious inevitability that one cannot help wondering why this ease and logic has proven so hard to achieve in many other comparable works. Here the architect has adopted a highly responsible attitude toward one of the most delicate tasks confronting any art museum, the maintenance of an appropriate balance between artificial and natural illumination. To this Botta has added an architectural promenade in which the conditions for viewing art are volumetrically varied and sufficiently flexible in themselves to

remain open to modification through the deployment of temporary walls. The model for all this, including the lighting monitors set on a regular grid, seems to have been Alvar Aalto's exemplary Aalborg Museum in Denmark (1972). Botta has ingeniously transformed this paradigm to accommodate a classical *enfilade* laid out in accordance with the coaxial system of circulation and the stepped stacking sequence of the galleries. This arrangement is particularly evident on the first floor and on the next tier above. With three monitor lights per room, where they are top-lighted, these spaces are easily subdividable. The same principle could have been easily applied to the second floor had it not been decided to exclude natural light from the photographic section.

Clearly the architect has assumed a mediatory posture in the debate that has consumed the museum field for the past forty years—the twofold problem of (1) prioritizing either natural or artificial light

Site plan

Main face of museum seen in its urban context

and (2) mediating between cellular, the traditional gallery format of discrete rooms in *enfilade*, and the modern paradigm of open loft space. The masterpiece of Louis Kahn's life, his Kimbell Art Museum of 1972, was precisely compounded out of a synthesis between these two opposing models, with Kahn deciding to screen out most but not all of the natural light and to orchestrate his galleries in such a way as to provide vaulted rooms in one direction and loft space in the other. While Botta implies a similar oscillation in his San Francisco museum, he ultimately favors the traditional museum format and thus comes closer to the model of James Stirling's National Gallery in Stuttgart of 1985.

As I have already indicated, the calm of Botta's spatial organization derives from the lateral circulation that always brings one back to the central staircase, situated under the zenithal light. This circuit is augmented by elevators placed discreetly

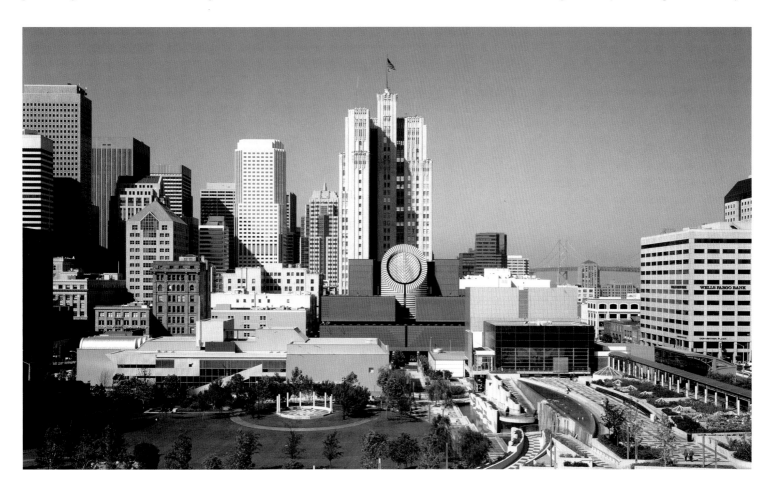

to one side of the main axis. Here, however transformed, one is also returned to the precedent of Frank Lloyd Wright's Guggenheim Museum; to the early interchangeability between negotiating the stairs and using the elevators. Thus the San Francisco museum is structured about an honorific public stairway from which the promenade spills out onto the respective floors, thereby facilitating the act of voyeurism, an essential pleasure in all exhibition openings, namely the art of both seeing and the act of being seen. Without entering into such niceties Botta captured the critical parti of his museum when he wrote:

"… The use of natural overhead light [gives] … the gallery space a special character that is linked to the climate and light of a specific place. It is a unique environment which cannot be repeated elsewhere and which inevitably stamps a very definite identity on the gallery. … [The museum ensures] that after entering the building the visitor can understand its layout at a glance. Contrary to current practice, in which contemporary architecture transforms the interiors of buildings into labyrinths, an attempt has been made to give order and a hierarchy to the gallery space so that the visitor will be able to find his bearings at once." [1]

Among the master builders of the late modern world few can rival the Swiss for their sheer mastery of the art of building, particularly where this concerns that which we commonly think of as tectonic form. This applies no less to the Ticinese architects at their best than it does to the high Swiss German technocratic tradition. There are no working drawings in the world that are quite so laconic and precise as those of Mario Botta. This refinement derives from his profound knowledge of the modern building process as it lies suspended today between high technology and the reinterpretation of craft. Thus while Botta, in the fullness of his career, may well lapse at times through excessive

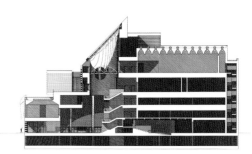

Main elevation on Third Street

Southeast elevation

Cross-section

Longitudinal section

Façade detail

Entrance hall

Preliminary studies for staircase and entrance hall, 1989

talent into gratuitous formalism, he will never be caught building badly.

It is difficult to overemphasize the tectonic expressivity of a work such as this in a building culture that has been so overwhelmed by the proliferation of postmodern kitsch. Within the technological know-how applied to the San Francisco museum, one needs to note the way the brick was laid up in the form of wall panels cast onto a reinforced concrete backing. These prefabricated elements were hauled into position by tower crane and thereafter permanently anchored against the steel frame superstructure. This rationalized assembly of compact components has long been part of Botta's *montage* approach to construction, although here, as in previous works, this strategy is often to be found at its tectonic best in his interiors. Thus, the moralist may be disturbed by the appearance of a stereotomic mass that on close inspection is nothing more than a skin—a cladding that is bonded in such a way as to create an ambiguous reading.

This was already evident in the Ransila Building, erected in Lugano in 1985, in which panels of bonded brickwork were applied as though they were the elements of a Sol LeWitt minimalist pattern in which the piers were coursed horizon-

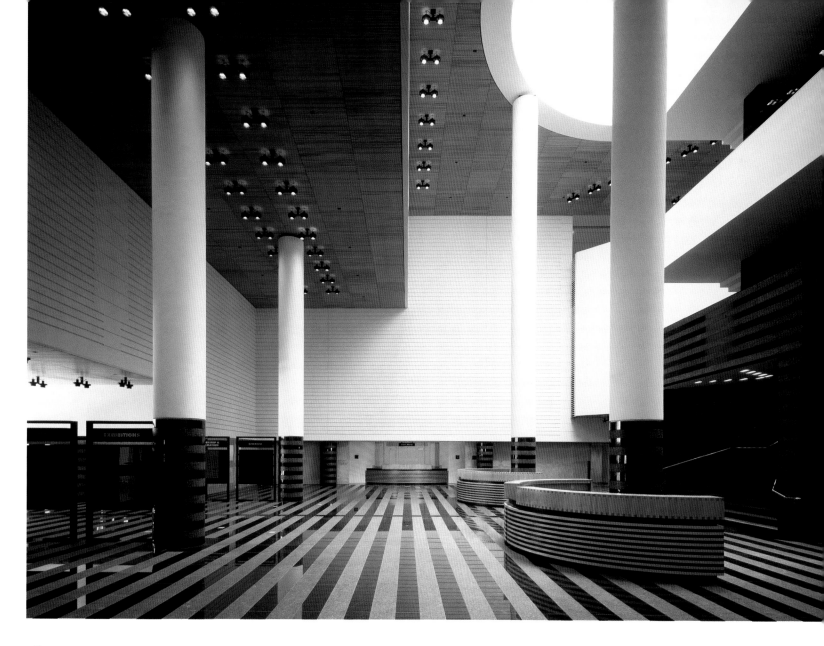

tally and the spandrels vertically, involving a counterchange of mitered brickwork at the intersection between the two. Botta's brick cladding would be augmented in the Ransila Building with such conceits as the tree on the roof or the dramatic corner cantilever where the building breaks apart to reveal a second membrane within.

Needless to say, the budget for the San Francisco museum was nowhere near that of Ransila. Hence its patterned brickwork followed a more sober principle, one that lay closer to Botta's obsession with Adolf Loos's villa for Josephine Baker of 1927. I am alluding to Botta's habitual use of a two-toned, ironic cladding strategy, which he has regularly indulged in ever since his horizontally striped, pink and gray Ligornetto House of 1976. In San Francisco, we

may be grateful for Botta's decision to restrict the revetment to a monotone dark red brick surface with matching concrete mortar. Botta would inflect this surface in subtle homage to Wright with horizontally orchestrated stripes, five courses high, separated by single inset courses; a reference perhaps to the syncopated horizontal coursework applied to Wright's Arthur Heurtley House of 1904. This reference to Wright's "corduroy" brickwork is augmented in this case by other equally syncopated modulations that start and stop in such a way as to provide the illusion of quoins at the corners and of a stepped inverted ziggurat pattern about the point of entry. Since none of this brick is load-bearing one cannot help asking oneself why it is not stack-bonded so as to indicate its nonstructural character.

As I have already intimated, this obsession with horizontal banding is less problematic on the interior, largely because it is more readily decodable as an appliqué ornament. This is certainly the case with the fair-faced, off-white blockwork that lines the lecture hall and the same masonry treatment that is deftly applied to the

walls of the events room, opening off the entry hall. It is doubtful, however, whether this banded treatment is as successful in the foyer, because the black and gray marble collars to the four free-standing neo-Palladian columns under the central roof light tend to undermine the tectonic probity of the structure itself. This bonding echoes the treatment of the columnar peristyle that runs along the portico flanking the entrance on Third Street. Nothing is more guaranteed to destroy the legibility of a column as a bearing element than to break it up into layers, just as nothing is more assured of reducing a giant order to absurdity than resting it on a pedestal. Are we expected to enjoy these ironic sophistries on the grounds of our seeming tolerance for the same in the work of James Stirling and Arata Isozaki? Whatever the response, it is clear that these conceits quickly pale since they undermine the tectonic probity of the work. Thus the totality seems to fall somewhat short of the formal authority of Botta's Ransila Building of 1985 even though the jazzy banding of the foyer in lacquerwork and light wood displays that ornamental richness that we have come to expect from Botta's interiors.

Of these decorative indulgences and risks Botta seems to be aware particularly in his all but autocritical essay *The Archaicity of the New* when he writes that the possibility of building seems to be "inversely proportional to the worldly din of publicity which sustains the most diverse initiatives."

In the same essay, with reference to Stirling's Stuttgart, he continues, in a vein that would prove to be prophetic of his own future achievements in San Francisco.

"… The architect contemplates the suggestions whispered by the bad conscience of this opulent society. Behind the enticements of a greater comfort, he catches a glimpse of the need for increasingly stronger images and expressions that connect him to his past, … he discovers

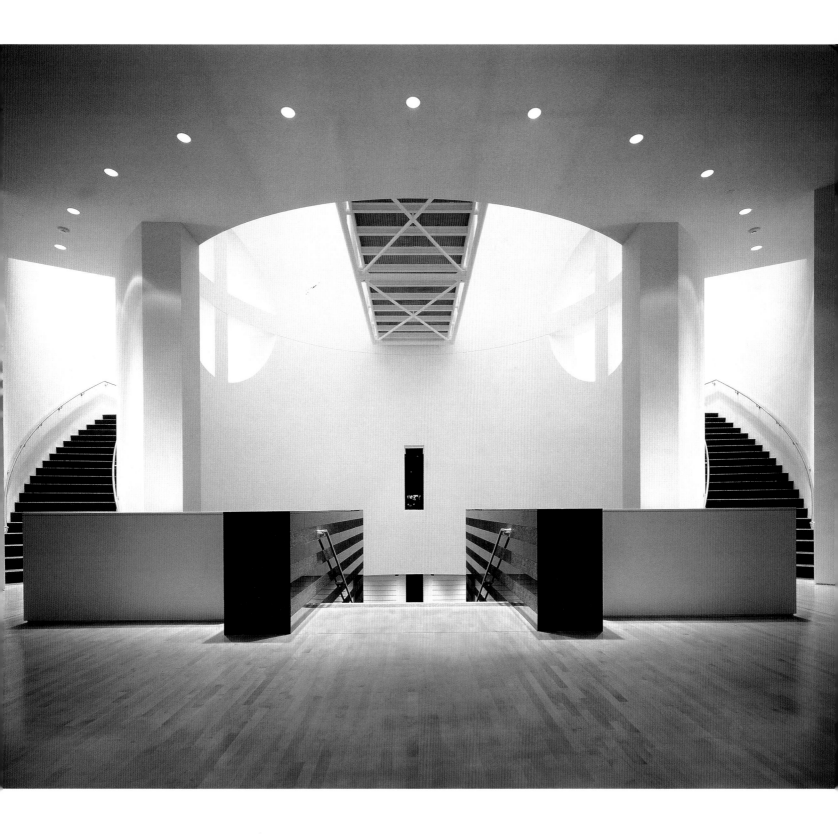

Stairs at 5th-floor level

the strength of totemic representations—still and hieratic—to set against the endless and meaningless race of today's society…."[2]

In this perceptive passage, addressed as much to himself as to Stirling, Botta reveals the hope that his architecture will remain endowed with a capacity for recalling archaic values. If anything is totemic here, it is surely this *occhio Lucemario* that has, by now, assumed an orthographic status in his work, sometimes to the extent of consuming the entire volume of a building, as in the church at Mogno dating from 1992. Certainly one cannot imagine this museum without its crowning centerpiece, in black and white banded marble, although one is nonetheless grateful that the initial proposal to plant trees around the rim of this circumference was discreetly abandoned. The plastic strength of the sliced cylinder has been increased by this decision and this, together with the leaflike structure of the skylight, imparts to the form a magnetic presence that serves to bind the dualistic composition into a single entity. It is appropriate, as Botta points out, that the laic temple of our secular age should be crowned by an all-seeing eye, even by the masonic eye as this is featured on the American dollar bill, proclaiming the *novus ordo seclorum*. And it is this, together with the entirely closed façade, that gives to the overall mass the sense of its being a cult building of an American, not to say pre-Columbian, provenance. Certainly there is not a building for miles around that has the monumental presence of this work, and there is not a building in San Francisco of any date that matches its single-minded power and conviction.

The imperium is left behind, however, once one is inside the cylindrical oculus that hovers over the central staircase as a world to which one might never gain access. Here for the final rise up to the temporary exhibition space the planning criterion abruptly changes, particularly as

far as stair access is concerned, for nothing could be more labyrinthic and hermetic than the requirement that one can only reach the final level by stair, by going up inside the thick walls of the crowning cylinder and then passing back across a bow-spring, tubular steel passerelle, suspended above the void, under the zenithal light. The winding darkness of the drum walls followed by the transcendental whiteness of Botta's "light modulator" are the twin experiential preconditions, as it were, for gaining access to the final prestigious exhibition space, unless one circumvents the whole thing, as many people will, by taking the elevator.

Whether one really needs to cast all this in such a rhetorical, brick-faced manner is surely open to question. Indeed one wonders whether a certain lightness of touch, along the lines of the Swiss tradition of *Konkrete Architektur*, might not have had a certain liberating effect not only on the membrane of the building but also on its architect.[3] Be this as it may, the rational Ticinese Tendenza line has brought us here to this substantial achievement, situated on the Pacific Rim of yet another latter-day empire on which the sun has started to set.

Kenneth Frampton

1 From an unpublished typescript provided by the architect.
2 *Quaderni de Casabella*, Milan, 1985, Nr. 1.
3 See Hans Frei, *Konkrete Architektur? Über Max Bill als Architekt* (Baden, 1991).

Sixth-floor plan

Fifth-floor plan

Fourth-floor plan

Third-floor plan

Ground-floor plan

Exhibition space

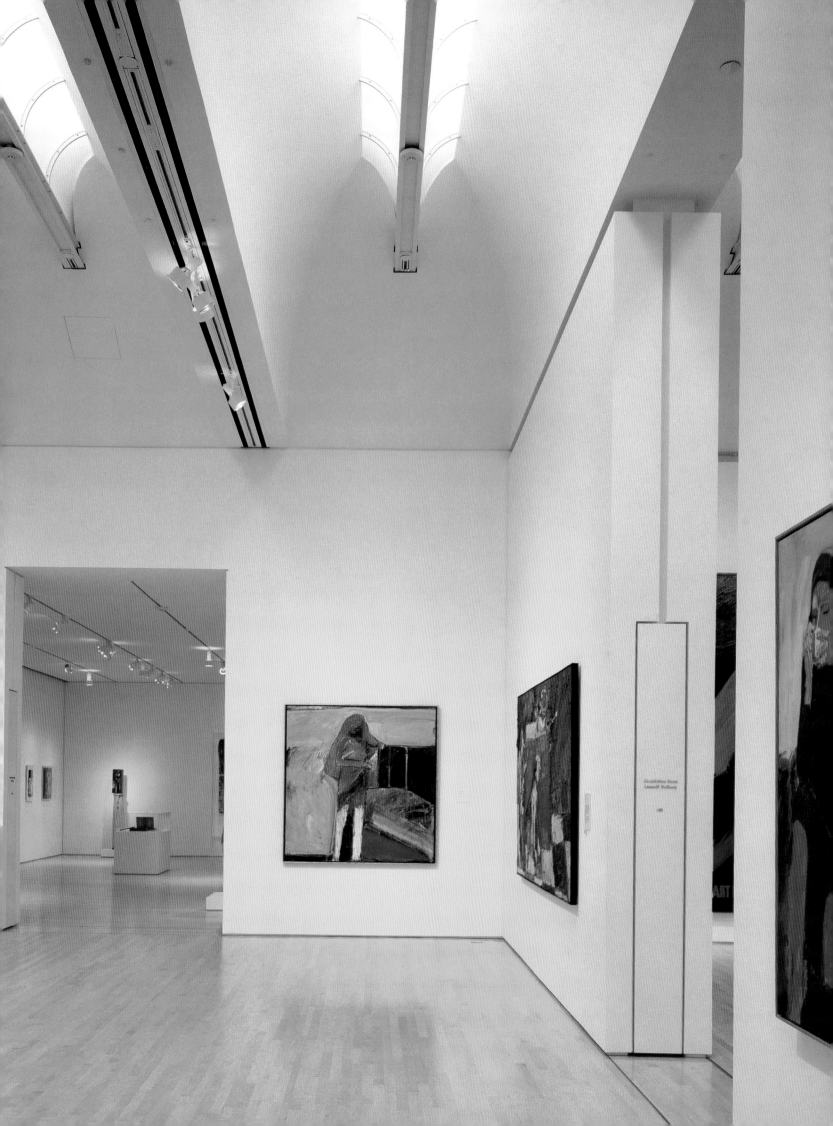

Rem Koolhaas
ZKM, Zentrum für Kunst und Medientechnologie (Project)
Karlsruhe, Competition 1989 (1st Prize), Final Design 1991

Architecture's final function will be to create symbolic spaces that correspond to the most enduring longings of the community.

The above statement represents one of the aims that Rem Koolhaas had in mind in his extraordinary project for the 1989 Bibliothèque de France competition. The same ambition permeates his prizewinning design for the competition to build a Center for Art and Media Technology (ZKM) in Karlsruhe that was produced at the same time as the French National Library project, though its development continued up to 1991.

Situated on the far side of the local station on a narrow elongated plot running along the railroad tracks, the center lies at the interface between the city center (whose famous Baroque town plan has streets radiating from a central palace block) and its outskirts. It comprises a vast and somewhat enigmatic "cube," 40 meters plus along each side and more than 50 meters high, whose four outer sides simultaneously hint at and mask what might take place within.

It goes without saying that the center could not be conceived of as a conventional museum made up of rooms intended simply to house artifacts and provide exhibition space. Instead it had to be able to accommodate many different kinds of activity and fulfill a number of divergent aims. The goal was for it to become a kind of contemporary Bauhaus that could be used for staging events, organizing conferences, and undertaking research and experiments, and for training in upcoming communication technologies: in short, it was to be an electronic Bauhaus, where art

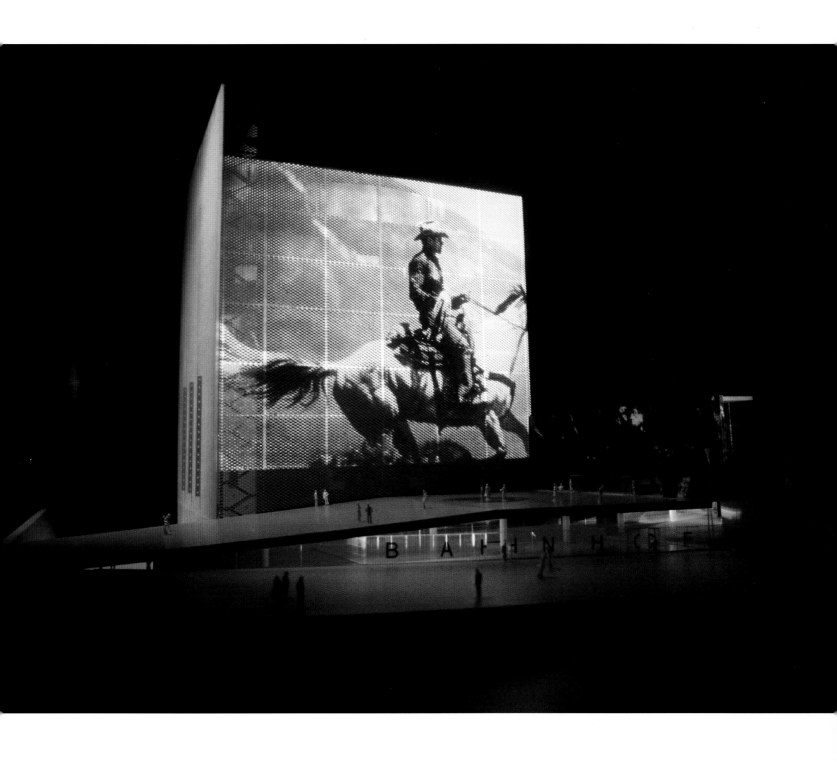

Computer simulation of
façade corner detail

Computer simulation of
east façade

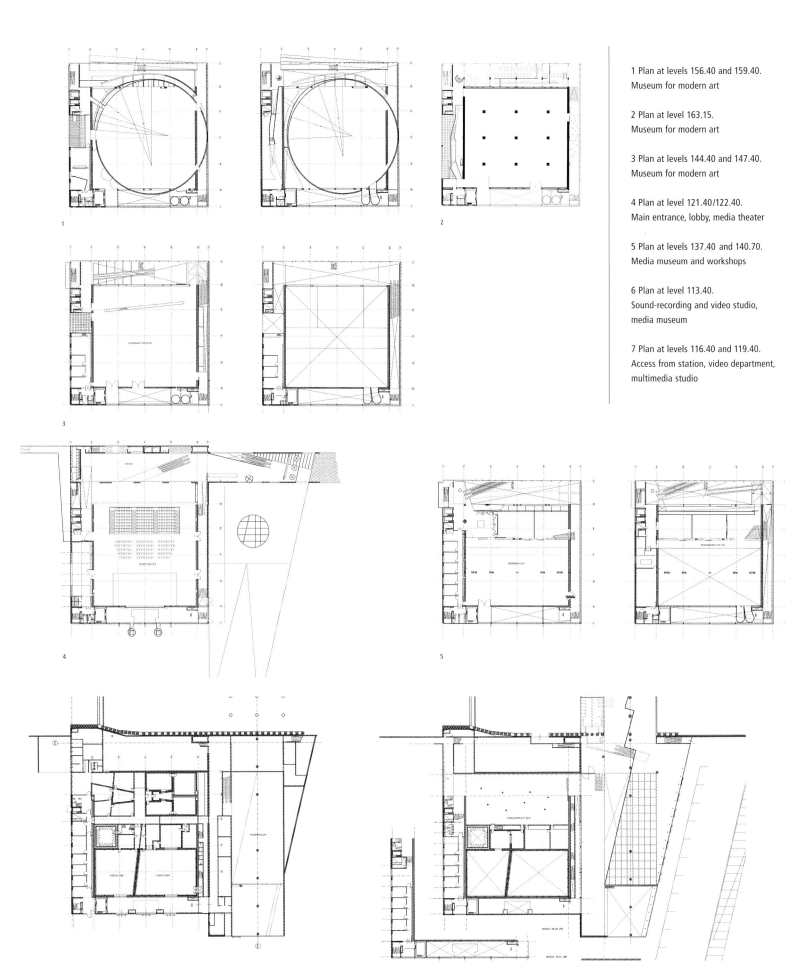

1 Plan at levels 156.40 and 159.40.
Museum for modern art

2 Plan at level 163.15.
Museum for modern art

3 Plan at levels 144.40 and 147.40.
Museum for modern art

4 Plan at level 121.40/122.40.
Main entrance, lobby, media theater

5 Plan at levels 137.40 and 140.70.
Media museum and workshops

6 Plan at level 113.40.
Sound-recording and video studio,
media museum

7 Plan at levels 116.40 and 119.40.
Access from station, video department,
multimedia studio

and the new media technologies meet head-on. The prizewinning project of 1989 appeared as follows. A long gallery running beneath the tracks linked the Karlsruhe station concourse to the center itself. The gallery was bisected by a glazed partition: one side provided a thoroughfare giving access to the station platforms; the other side was occupied by a "time tunnel" presenting a chronological overview of the history of technology. Bordering the tracks and extending in perpendicular bands from the platforms lay the research departments with their studios, laboratories, and workshops, together with a library and multipurpose hall. At the end of this "professional" area and beyond the gallery confines lay the contemporary museum "cube" itself, including a theater equipped with the latest technology and a number of floors with exhibition spaces, conference halls, and seminar rooms, while the rooftop (like an updated equivalent of the area in front of the rail station) housed a restaurant and an open-air terrace suitable for many kinds of event or for the presentation of scientific or artistic work in progress.

The center's "cube" was moreover banded by "rings" that made up the building's four façades. Toward the station (and therefore in the direction of the city) a network of elevators, walkways, and escalators move up the side of the building, providing an ever more impressive view of the cityscape below. On the opposite side—that is to say, toward Karlsruhe's outskirts—a "robot façade" incorporated technical equipment and moveable construction elements that could display public information or be arranged into "electronic décor" for each space; a visual device amounting to a declaration of intent, outlining the center's activities and readily visible from the nearby freeway. The two other opposing sides constituted 1) a strip containing the services necessary for the proper functioning of the whole, and 2) a circulation strip upon

Model in site context

whose frontage giant pictures could be projected.

This brief description of what is a "machine building" brings out a dialectic that has been at the center of Rem Koolhaas's concerns as a town planner and an architect since the beginning: the dialectic between "architectural specificity" and the "instability of the program." Fulfilling the criterion of specificity amounts to ceaselessly probing what exactly our "modernity" consists of and to questioning the given requirements of planning programs so that buildings may be designed that allow for novel uses as they arise. Fulfilling the criterion of instability implies an attempt to allow architecture to remain unfixed, so that a discrepancy, a near state of flux, exists between planning and the formal solutions arrived at. Preserving indetermination and even injecting it in a heightened dose combats the unholy tendency of architects to do so much (even too much) architecture.

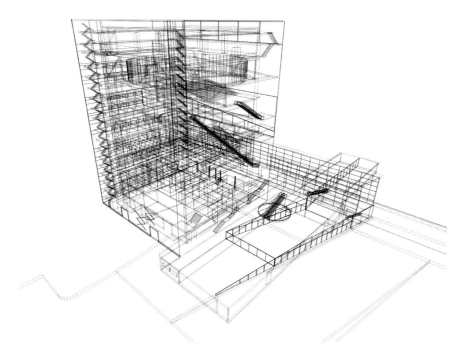

The Karlsruhe project thus displays an approach to architecture that Rem Koolhaas has in the past sometimes sought to summarize in four at once overlapping and interconnected tenets:

1. Whenever a building mass is possessed of large dimensions, no "humanistic" relationship between the interior and exterior can exist. The pre-eminently "modern" formula holding that form proceeds from function is well and truly jettisoned. Architecture indulges in a carefully calculated schizophrenia. The container need

Overall perspective

not readily reveal the nature of its content; the carcass is a project in itself and as such can directly confront the local environment.

2. Individual parts are autonomous within the overarching unity of the building. Viewed from the outside, there is no knowing how the interior space is divided up. If it comes to it, a building need not articulate its various components but instead can superpose in an overall plan a number of fragmentary projects.

3. Transportation systems between stories (elevators and escalators) establish connections between the parts so they no longer have to be designed as a suite of interdependent elements. The elevator has eroded architecture's traditional power base: it also performs a liberating role, since it removes the need for fixed architectural links between different components that—now "undisturbed"—can simply be placed one on top of the other.

4. The preceding conditions mean that a large-scale construction, a very big building, adopts an almost "amoral" position ("beyond good and evil," as Rem Koolhaas himself will put it), its urban impact being perhaps quite independent of its intrinsic quality.

Rem Koolhaas was soon to feel the need to add a fifth point to the four already cited. In 1994—as the Grand Palais

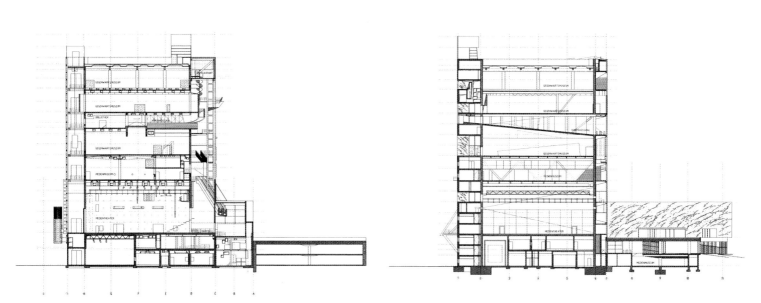

at Lille (his first large-scale building to be actually constructed) was nearing completion—Koolhaas encapsulated the conclusions from the "Theory of Bigness" he advocates in an untimely fifth proposition of singular violence and radicalism: "Fuck context." Rem Koolhaas, as he hammered out these by now five architectural propositions, was in the end simply trying to explore new possibilities far removed from the hackneyed processes of architectural composition, be they historical or "modern." At the same time, however, he harks back to the preoccupations aired in his 1978 publication *Delirious New York*. This book-cum-manifesto proposed a method of investigating architecture and urban planning, a blueprint for a "culture of congestion," in which exploiting the density of the planning program was acknowledged as the paramount value of today's urban space. The foremost architectural symbol in New York was the skyscraper: it is an "auto-monument" that thrives on the schizophrenic separation exemplified in its separate floors, that permits (perhaps demands) instability in any program—all the while offering a cityscape of breathtaking self-evidence.

With these "buildings of the third kind," such as the Center for Art and Media Technology (ZKM) in Karlsruhe, Rem Koolhaas wishes to recapture the lost

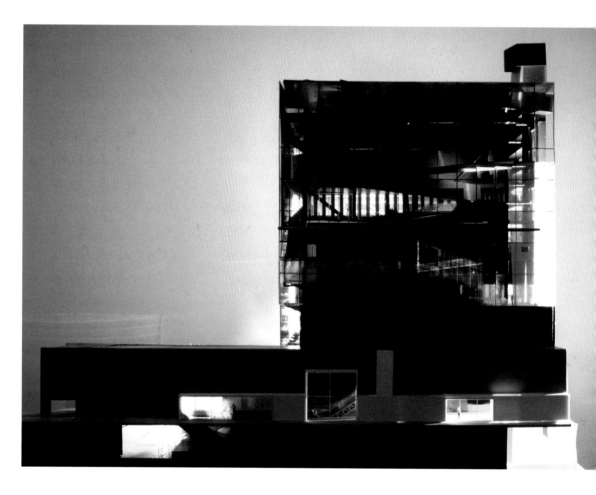

Model: north façade

Sections A, B, C, and D

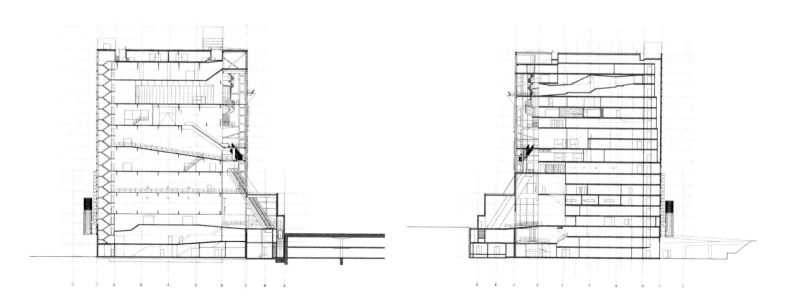

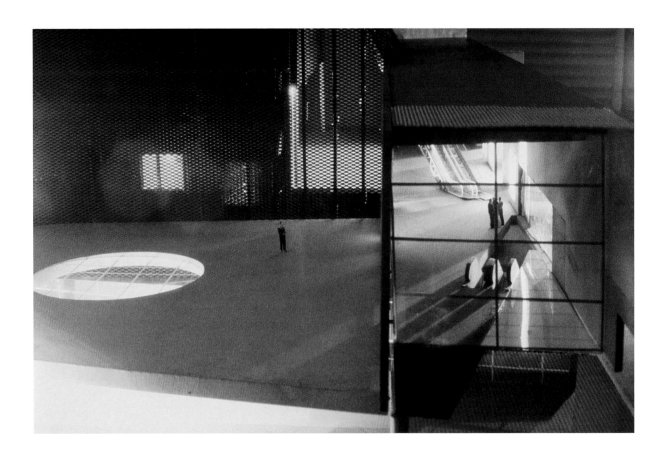

Computer simulation of
views of interior

innocence of the architects of Manhattan. No bland naïveté this: on the contrary, it is a new-found lucidity for today, an optimism capable of transcending ironic distance, of going beyond mere commentary (postmodern attitudes both characteristic of the seventies and eighties). As the century draws to a close, such clear-sightedness and positive thinking strive to return to what Rem Koolhaas has called the "real fire of modernity."

Jacques Lucan

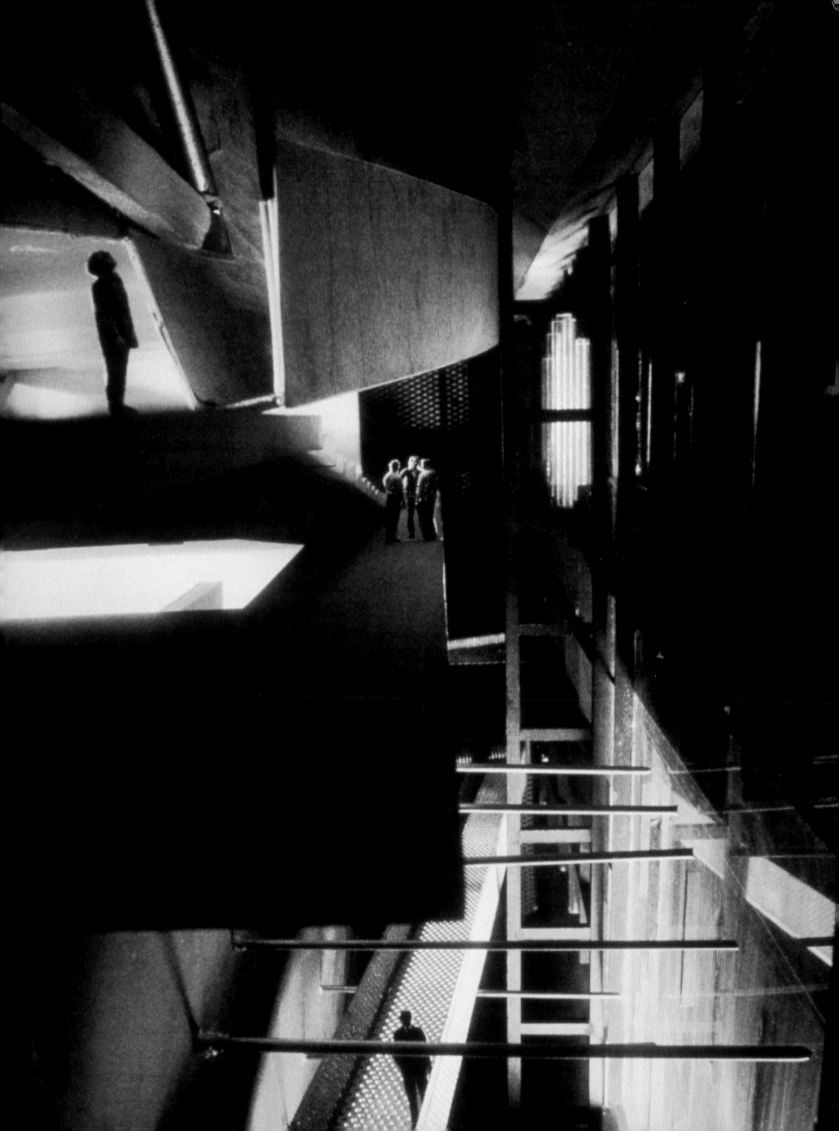

Ricardo Legorreta
MARCO, Contemporary Art Museum

Monterrey, Mexico, 1989–1991

Main entrance with
sculpture by Juan Soriano

West face

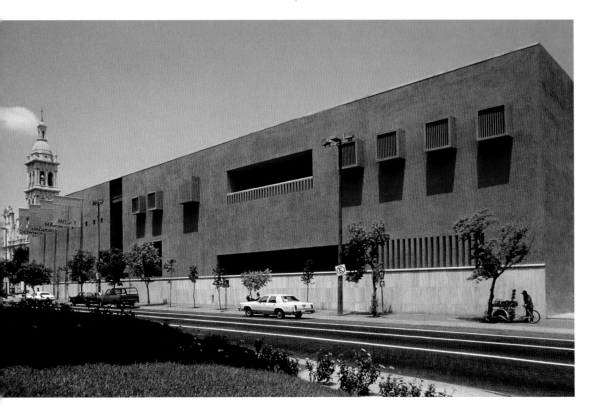

If you study Legorreta's architectural vocabulary carefully, as seen at MARCO, its depth and meaning can be read. The clarity of his architecture is a result of his use of the basic architectural elements of wall plane, column, vault, geometry, and light, but it is his deft handling of these elements in his search for the essential meaning of the wall plane, and their fusion into a language of space, that satisfies the eye so well. He is also aware that spaces acquire various meanings when imbued with the memory of the viewer. And this is just the beginning, a backdrop for him to be slightly mischievous, as he layers the spaces with emotion, mystery, and mysticism. This combination is what makes his architecture so magical.

People have often referenced Legorreta's architecture to that of Luis Barragan. While similarities may exist, especially in the use of the wall plane and how light is used to modify space, one can also say that their architecture is based primarily on a vernacular tradition. This is certainly true in the abstract power of the wall plane and the intensity and use of deeply saturated colors. You just have to visit the hillside town of Guanajuato to realize that color is in use in all walks of Mexican life. According to Legorreta, Barragan's primary influence on him was in the integration of landscaping, both hard and soft surfaces, into his architecture, and this influence is reflected in the sculpture court.

The design of the museum was inspired by the traditional plan of a Mexican house; an active central courtyard, flooded with natural light and edged by a shaded arcade that provides direct access to the adjacent spaces. The external walls of the

Mexican house are flat planes penetrated only by an entrance and by minimal openings. This design parti has been repeated as a central theme in several of Legorreta's projects. This design was then integrated with the urban setting—a key corner of Monterrey's Macroplaza flanked by the cathedral and the slightly more pretentious palace (Governmental Buildings), and facing Monterrey's bustling hotels and business district on the opposite corner. The museum corner was cut away to create a void, an urban plaza in which was then inserted a monumental abstract dove by the Mexican sculptor Juan Soriano, signifying peace.

The design of the rear of the museum is just as carefully detailed as its more popularly known front. From the narrow, quiet streets of the modest neighborhood you see the less glamorous side and a corner that contains the parking garage entrance. But the astute handling and attention paid to this façade has resulted in a convergence of flat planes in one of its purest forms. The walls are solid, blank, undecorated planes perceived as a series of masses pierced by small, stark rectangular openings. From a distance the planes appear as singular masses, but upon approaching close up you can distinguish the subtly dimensional texture of the rough plaster. Each plane is painted in a single uniform color of misty mauves or intense beige/oranges, with shadows cast across the planes, shifting in time. The magical quality of the early morning and late afternoon Mexican light wreaks wonderful havoc with the color planes and enlivens the surface as the plaster absorbs and reflects the changing colors of mauve/blue in the early morning and yellow/orange toward sunset, as if the wall plane has a strange life of its own. It is a backdrop to the neighborhood as mystical scenery.

The main pedestrian access to the museum is through the entry plaza in which Juan Soriano's gigantic dove appears to pay nostalgic homage to Luis

Second-floor plan

Ground-floor plan

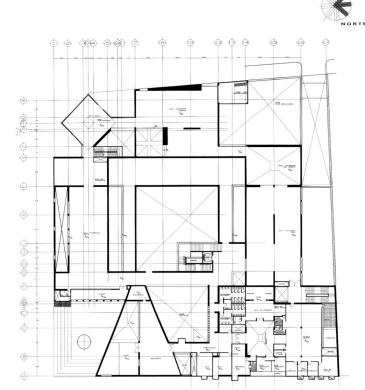

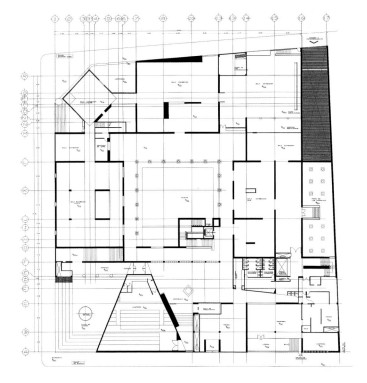

Barragan's pigeon house. Legorreta has collaborated with the artist extensively in his public projects. The fan-shaped entry plaza is enclosed by two towering wall planes that direct you to a colonnade with oversize blue columns that denotes the commencement of the entry sequence. Above the entry colonnade, a contextual connection is heightened by an arcaded balcony that pays reference to the arcade of the cathedral rectory across the street. But Legorreta's balcony is not meant to be functional but simply a contextual memory. The openings are square in a regulated pattern along a straight line, as if capitals to the columns below. The colonnade leads you to the entrance doors located at one end of the colonnade.

One walks through the inconspicuous entry doors to the vestibule, which is a high space with carefully controlled light and color. This change in spatial sequence, the large entry plaza and the visually small-scale entry doors, heightens the sense of spaciousness of the entry vestibule, a sense of illusion. Initially the space is easily readable and is perceived as a singular space. But after pausing in the space you realize that the vestibule is a more complex and layered space, and ever changing due to the shifting light patterns as the natural light passes across the wall planes. The space is not bathed with light uniformly, as the dark of the entrance at one end is counterbalanced by the brighter light of the skylight at the opposite end. In this space one can see Legorreta's elements of architecture begin to blossom. Flat plaster walls act as planes that form geometric masses that engage each other to form a composition that becomes the perimeter of the room. A bright yel-

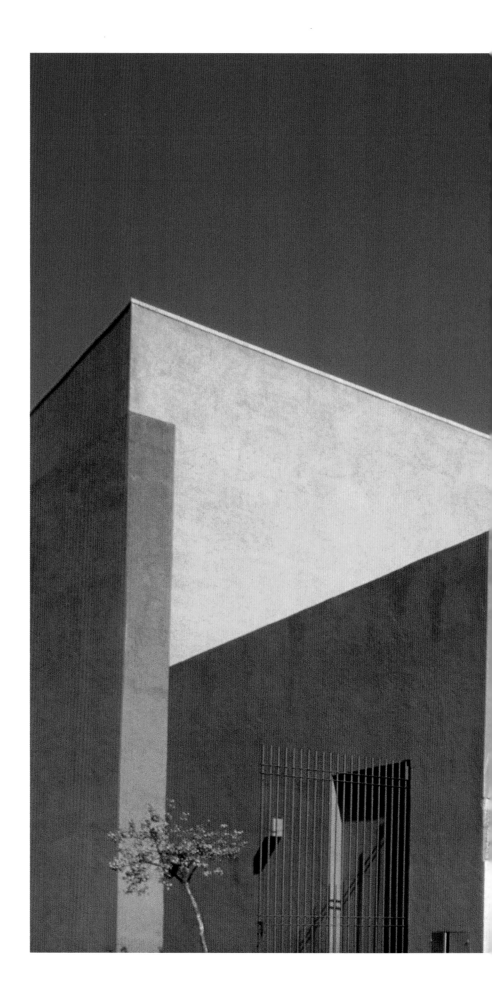

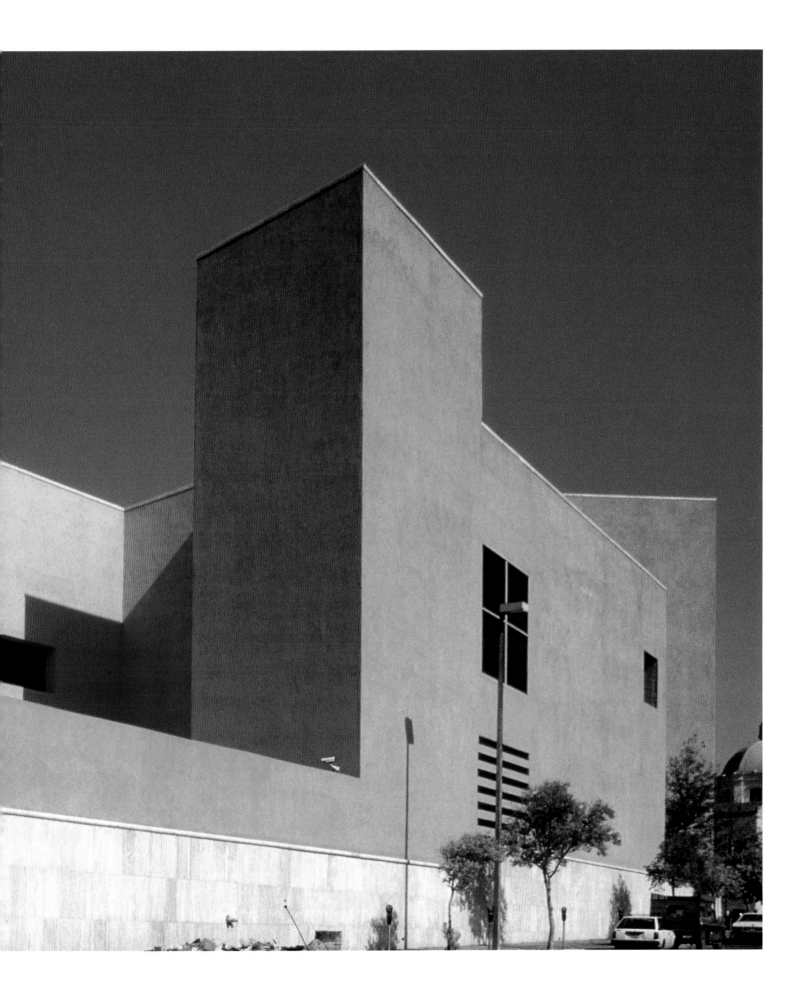

low square column that hangs from the ceiling and floats above the floor penetrates the space, provides light to, and notates the information desk. A lattice, a wall plane perforated by regular rectangular openings, another Legorreta element, filters light passing through the skylight and diffuses a singular strong source of light into a myriad of smaller rays, and several openings of different sizes cast varying shafts of light across the space. A wide honeycomb screen allows the visitor fragmentary glimpses of the central court that is the visual center and heart of the museum. This previewing technique allows the viewer to see the adjacent space without actually entering, while simultaneously sensing that the second space is connected to the first space.

After visitors pass under a sculptural lattice, they arrive at the two-story central court that also serves as the focusing element, circulation center, and access point to all the galleries. As you pass into the central court, you realize the enormousness of the space, with the monumental columns of the colonnade on three sides of the court providing a sense of formality

West elevation
North elevation
East elevation

FACHADA PONIENTE

FACHADA NORTE

FACHADA ORIENTE

and of the importance that this central space holds in the design of the museum. The influence of the surrealism period of the painter Giorgio de Chirico may be in evidence here, with his paintings illustrating subtractive monumentality with the skewed scale and the ascending perspective that is often fictitious. The initial impact is one of severity, but as you pause in the space, it takes on a different character, one of serenity. This sense of change of the impact of a space over time is a characteristic trademark of Legorreta. He purposely layers a space with different meanings that are realizable only over time. A trickle of water flows constantly into the courtyard, which doubles as a shallow pool and, when drained, a functional place for special concerts and receptions. The water emanates from a vivid red recess cut into the side of the grand staircase, the primary vertical movement system of the museum. Periodically the courtyard is flooded with a torrent. This sudden movement of water is designed to energize and refresh the environment of the museum's focal point, the opposite of the eternally frozen space.

The interior of the galleries is off-white, in stark contrast to the color-saturated wall planes of the building's exterior and of the two courtyards. On the second floor, natural light penetrates the galleries evenly and indirectly through parallel rows of narrow, elongated half vaults that cover the ceiling wall to wall. The floors of the galleries are finished in natural woods in a square grid inlay pattern. These exhibition galleries are spaces and environments of different proportions, forms, and heights, with strategically located shafts of natural light penetrating the spaces. Natural light succeeds, but there are momentary lapses, as at most museums, with rays of light interfering with the presentation of the art. Carefully placed openings in the walls of the galleries frame a view of the city or the mountains and also keep the visitor in touch with the public space and central court without distracting from the art.

Section 1-1'
Section 2-2'
Section 3-3'

Section 4-4'
Section 5-5'
Section 6-6'

Section 7-7'
Section 8-8'
Section 9-9'

Section 10-10'
Section 11-11'
Section 12-12'

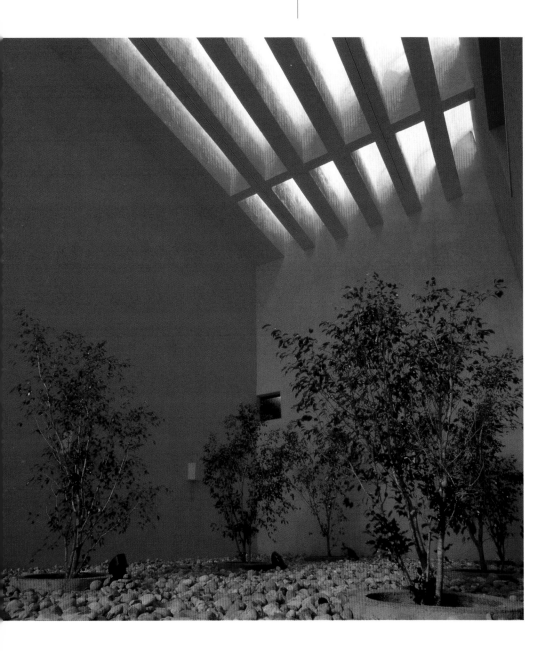

Pink Patio

These voids appear to occur everywhere in the walls of the galleries. This is the opposite of most museum spaces, which tend to contain you and force the visitor to concentrate on the art at hand. At MARCO, while viewing the art of one gallery, you have glimpses through lattices, grilles, and windowless voids of the art in the adjacent galleries or back to the central court. You cannot pass through, but you are connected to the adjacent spaces and you are made aware of your present place. A gallery may open out onto the orangerie courtyard with deep purple walls, or the two-story space of the sculpture courtyard with its vivid magenta walls, lattice roof, and river-washed pebble floor. The exhibition galleries have resulted in exciting and successful exhibits that challenge the Mexican artists who are displaying their art. The materials of the building and the intense colors complement the informal and elegant characteristics of the building and challenge the curators to take advantage of the natural light, texture, and color.

The museum has become a cultural center for Monterrey, an active place and a positive contribution to the city. As you leave the museum, sunset may have crept in. The walls of the entry court have become iridescent, radiating intense color, the colonnade is lighted, emphasizing the void in the wall, and the dove, dominating the cityscape, appears as an elusive form in outline against the sky. Peace has again returned, and you realize that on your visit to MARCO, Legorreta has toyed with your emotions.

John V. Mutlow

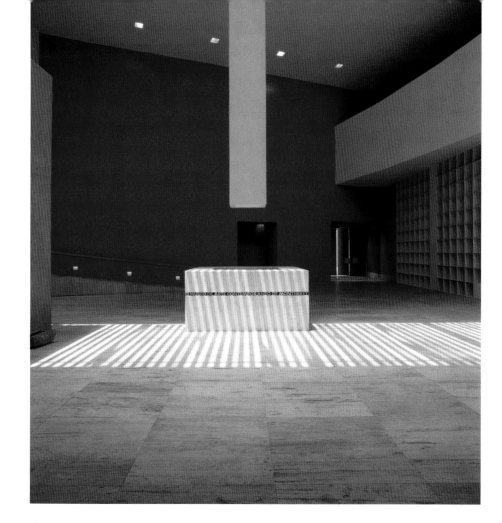

Vestibule

Gallery space

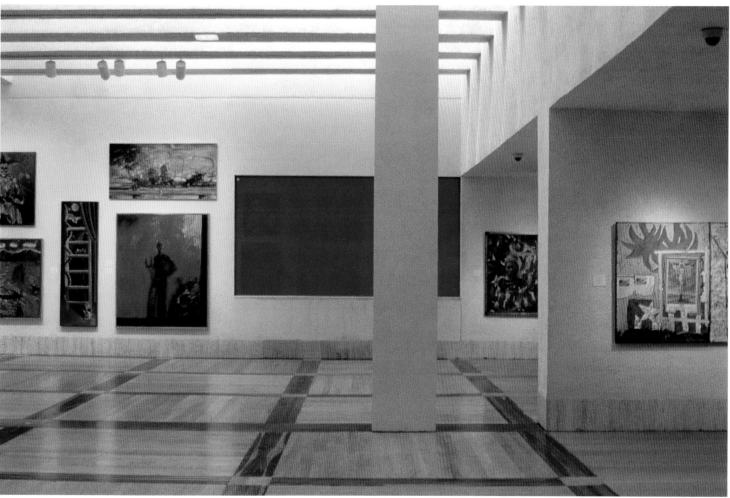

Daniel Libeskind
Jewish Museum
Berlin, 1989–1999

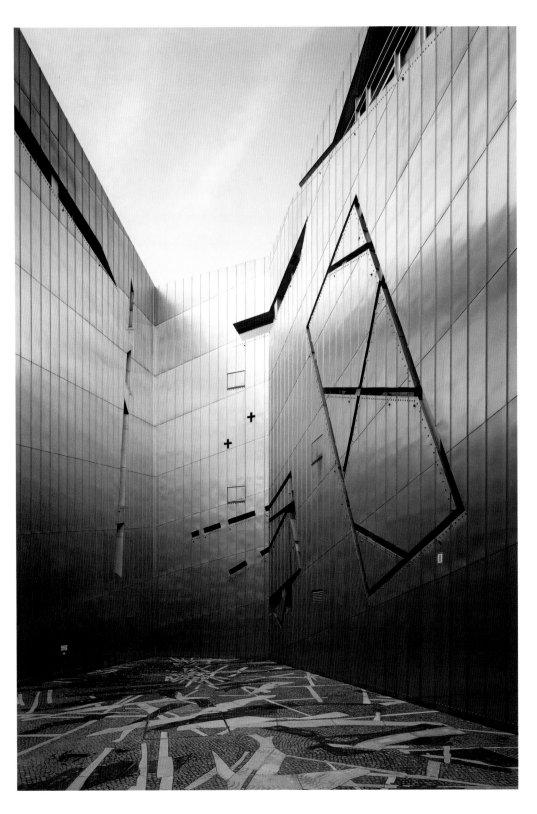

In Daniel Libeskind's Jewish Museum in Berlin, a particularly noteworthy phenomenon can be observed that has grown more prevalent in the last few decades: the form, above all, determines the museum, more so than its contents. So it's not particularly surprising that the building—as an embodiment of the memories of the Jewish history of Berlin—was already open in 1999, well before becoming an actual museum in the year 2000 with its own concept for a collection and an exhibition.

The form is built upon an extraordinarily complex matrix of meanings that is connected in manifold ways with the Jewish tradition of Berlin. In bestowing the first prize upon Daniel Libeskind in 1989, the competition jury's review had already honored the project's conceptual idea—how it makes the invisible visible, and connects Berlin's history with Jewish history. This connection was translated into spatial sequences and movements, while the form of the building reflects an "analogue expression of the inner conception" in a design exemplary in its innovative quality. [1] At the onset of the project there were, however, quite different parameters for its contents. The project was titled *The Expansion of the Berlin Museum with the Jewish Museum Department* and was thought of as an integrative model. A Jewish Museum was to be tied into the existing city-historical museum in the original Kollegienhaus, which was to be preserved in its original substance. Parallel to the history of the city, the history of Jewish Berlin and the Jewish religion as of 1871 were to be presented. After much debate, the decision was reached in 1998

that the new edifice would be used solely
as a Jewish Museum. But back to the
beginning: the radicalness of Libeskind's
competition design, with its increasingly
eastward-pitched walls, exceeded the
expectations of the competition brief.
With regard to its contents and its archi-
tecture, no other design linked the history
of Berlin with its Jewish history so clearly.
And in its concept, no one else succeeded
in integrating the "visible" of Jewish cul-
ture with the "invisible," the absence of
fellow Jewish citizens and the extermina-
tion, during the time of National Social-
ism, of a world so meaningful to Berlin.

Libeskind named this concept *Between
the Lines*, meaning not just between the
visual lines, but between the written lines
as well. The ground plan of the museum is
based upon a dialogue between two dou-
ble lines. One line, which can be seen as
the backbone of the building, is straight
though fragmented in many pieces; the
other line runs in a repeated zigzag form
across the first straight line, like a streak of
lightning. The building's multiple angular
form arises out of this line. The intersec-
tion with the straight line generates a total
of five empty spaces, so-called voids,
which run through the museum in an
irregular sequence. According to Libes-
kind, "the non-visible manifests itself as
emptiness, as the invisible." Simultaneously
he connects his project with its urban
context and with the history of Berlin.

The museum lies in Kreuzberg, more
precisely in South Friedrichstadt, a part of
the city expansion of 1732–38 that was
heavily destroyed during the Second
World War. During postwar reconstruc-
tion, the few extant historical traces were
almost fully eliminated by housing projects
(some very large-scale) while old traffic
routes were changed. One of the few
remaining historical buildings in this
area, the Kollegienhaus, built by Philipp
Gerlach in 1734–35, accommodated the
Berlin Museum after its restoration in the
years from 1963 until 1969. At the same

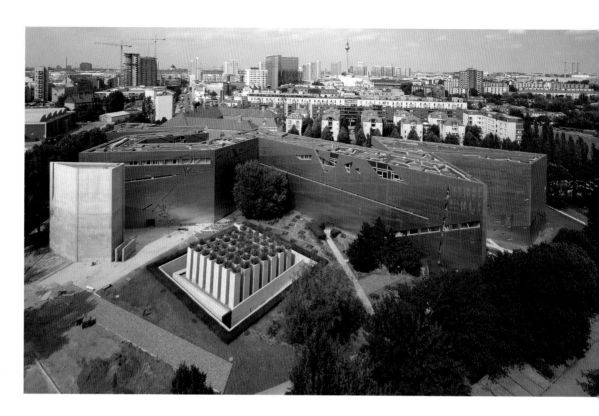

Paul Celan Courtyard

The Jewish Museum
in its urban context

Site plan und axonometric

time, the neighboring parcel was reserved
for future expansion. The edifice was iso-
lated within an urban context of building
gaps left by the war, while confronted
with large housing projects nearby. From
1979 until 1988 the International Building
Exhibition (IBA) took on this area for a
"critical reconstruction" of the historic
structures with the aid of contemporary
architecture. Hence, in the competition a
stronger connection of the Kollegienhaus
with its urban surroundings was required,
as well as a balance between the block
structure to the north and the solitary
buildings to the south. At the same time,
as much of the greenery on the parcel
was to be retained as possible. Libeskind's
design reacted to this heterogeneous con-
text with an autonomous and radical
architectonic statement on the one hand
while connecting the building on the
other hand with its urban context through
its manifold contextualization.

The architect supplemented this urban
context by means of a second layer, the
context of Berlin's intellectual history, and
developed an "invisible matrix or a pre-
history of connections." He used the

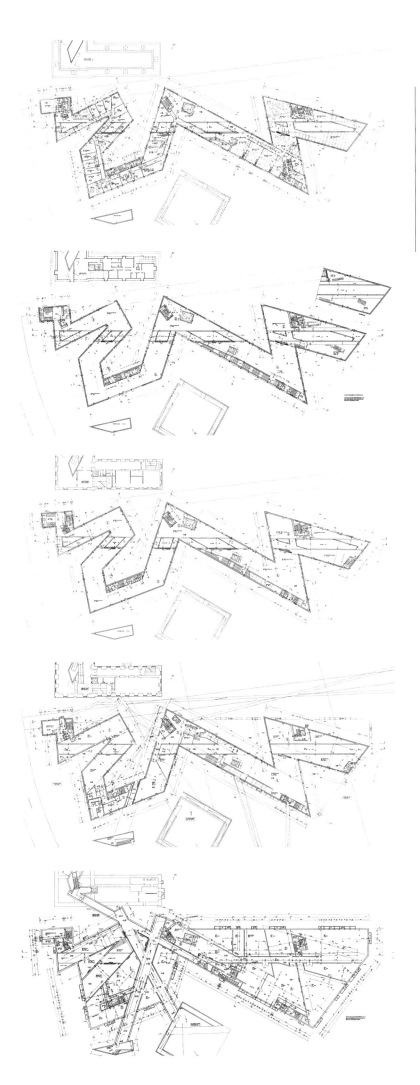

Fourth-floor plan

Third-floor plan

Second-floor plan

Ground-floor plan

Basement plan

earlier addresses of personalities in sci-
ence and art, such as Heinrich von Kleist,
Heinrich Heine, and Rahel Varnhagen; or
personalities of the twentieth century, such
as Arnold Schönberg, Paul Celan, and Wal-
ter Benjamin. Libeskind viewed them as
"connecting links between Jewish tradi-
tion and German culture." Based upon
these connections, he designed an "irra-
tional matrix in the form of a system of
right-angled triangles, which would allow
a recognizable similarity with the emblem
of the compromised and distorted star,"
the Star of David. This was not only a
symbol of Jewish identity but also a sym-
bol of separation during the period of
National Socialism. A further intellectual
basis for the design of the Jewish museum
was Arnold Schönberg's uncompleted
opera *Moses und Aron* from 1930–32.
Here, the relationship between image and
word, between the visible and the invisi-
ble—which only takes on form in the
imagination—plays an important role. In
the museum the invisible manifests itself in
the voids. In addition, he uses a register of
Jews from Berlin who were deported from
the city during the Holocaust as a basis, as
well as Walter Benjamin's *Einbahnstraße*,
which appeared in 1928. Under the head-
ing of the street, the book was a collection
of philosophical texts ordered in image-
like fragments,[2] which—as part of a revo-
lutionary history of philosophy—views the
unfolding of history not as a continuous
development, but as something within the
context of a dialectical dynamic. This
intellectual context is more or less explic-
itly represented in the museum.

The competition design for the Jewish
Museum, which had a gross floor area of
15,500 square meters and a net area of
12,500 square meters (of which 9,500
square meters are planned to be exhibition
area), had to be reworked to meet the
budget of 120 million German marks set
by the Berlin Senate. Here, the slanted
walls as well as three of the four planned
exterior towers that were to mirror the

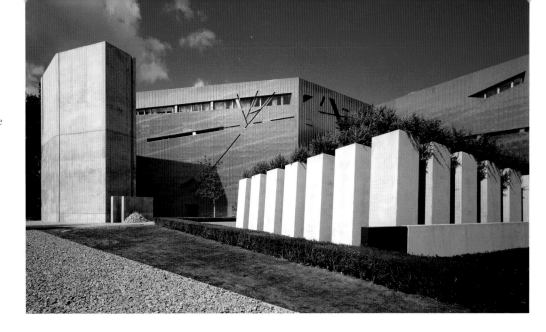

interior voids in the outdoor space fell victim to the budget. The floor plan of the lower level and the transition between the existing building and the new building were simplified. The existing building received a void that completes the underground transition to the new building. Above ground, the new edifice—four stories in height and multi-angular—comes close to the existing building at three places. Inside, two courtyards are formed, one of which is dedicated to the Jewish poet Paul Celan. The floor relief refers to a graphic work from Gisèle Lestrange-Celan, Paul Celan's widow. The narrow side of the new building jumps out slightly toward the Lindenstraße, somewhat shielding the existing building from the high-rise structures on the Mehringplatz as well as from the multi-lane road. Of particular note in the outdoor facilities are the E.T.A. Hoffmann Garden, also known as the Garden of Exile and Emigration, and the free-standing concrete structure called the Holocaust Tower.

The façade of the Jewish Museum is clad with zinc. Libeskind substantiates this choice of materials with references to Berlin, especially to Schinkel. With time the façade will not reflect the light so strongly, taking on a dull gray patina instead. This will cause a more reserved effect for the Jewish Museum while perhaps rebalancing the relationship between the new building and the existing building. The zinc façade is incised with various openings and window bands that seem to cross each other arbitrarily. They follow neither vertical divisions nor floor divisions, allowing the façade to become an autonomous, symbolic design element independent of the inner structure of the building. The increased number of openings in the upper area of the building reflects the location of offices, workshops, and the library on the third floor—all rooms that require more daylight than the exhibition floors.

As already mentioned, access to the Jewish Museum is through the main entrance of the existing building, where the common foyer and other facilities for both museums, such as the bookstore and café, are to be found. A void has been placed to the right of the entrance by means of a stair that leads to the lower level. On this exhibition level, the original concept foresaw housing the history of the Jewish community of Berlin and the presentation of its religion. While the form of this level partially follows the outline of the new building, it also takes on its own form in connection with additional space beyond the building's floor plan. Besides the exhibition spaces, a large part of the area is reserved for storage and technical

facilities. Shortly after the stair ends, the path forks into two corridors that are soon crossed by a third one, while skylights strengthen the circulation effect. The right axis—defined as the axis of exile—leads to the Garden of Exile and Emigration, while the corridor climbs slowly upward until it reaches the main stair to the upper floors. As the axis of the Holocaust, the cross-axis leads to the Holocaust Tower, reflecting the first inner void, just as the second void at the entrance of the Berlin Museum is referenced once again.

While certainly one of the museum's most impressive elements, the Holocaust Tower is a memorial in a museum that itself is almost a memorial. The high, unheated tower in exposed concrete,

Holocaust Tower and
E.T.A. Hoffmann Garden
of Exile and Emigration

Matrix of the star in the
topography of Berlin

which has only a vertical light slit on one side, possesses something sacred and extraordinarily dramatic. On the one hand total silence prevails, while on the other hand the sounds from the exterior are heightened. The visitor to the concrete sculpture is exposed to these impressions while being forced to reflect upon them. The other axis leads to the Garden of Exile and Emigration. It is composed of 49 columns that lean at a 12-degree angle and are set closely together within a square. They are enclosed within a concrete wall that is lower in height toward the street. The columns contain earth and are planted with bushes that remind one of olive trees. Associations of the olive branch, of hope and peace are awakened, while the garden becomes a symbol of the tabernacle and a sign for the trek of Israel's people through the desert and the disquietude of a homeless existence. Parallels to the design from Peter Eisenman and (originally) Richard Serra, too, for the central memorial of the Federal Republic of Germany are undeniable. Traversing the Garden of Exile and Emigration gives rise to a strong physical as well as psychical experience, for one has the impression of having lost the ground under one's feet within the field of leaning columns.

At the end of the primary axis in the lower level is the main stair that leads to the uppermost of the three exhibition levels in the new building. The stair, which is bisected by various sloping concrete cross-braces, rises up spaciously while simultaneously remaining narrow. Its impressive natural lighting is attained by means of a long horizontal window band and openings in the ceiling. Natural light entering through these openings, which is strengthened by spotlights, forms vertical stripes on the walls that lend the space a rhythm.

The unusual floor plan of the museum creates impressive but confusing room sequences with unconventional exhibition spaces of varying quality—spaces that may

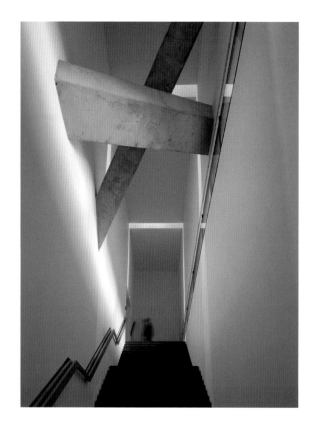

Main staircase

Gallery space

The final void

prove difficult to animate. The spaces are done in white plaster, to the regret of many who have seen the interior of the building in exposed concrete, since so much of the radicalness of the architectonic statement is revoked. Here especially, the accumulation of particularly significant elements is noticeable. One example is the cross-like cuts in the walls, which—besides the irregularly cut window bands that run mostly in the diagonal—act as markings in the landscape of meaning designed by Libeskind. This is similar to the way in which the openings for light and ventilation grilles, which run in all directions, contribute to an impression of overloadedness in their manifestation as symbols. The overloadedness leads to a situation where the distraction is lifted by virtue of a bulk of intrusive details, weakening the entire statement. This is true not just for the impressively manifested idea of the voids, which intersect every level of the museum and are lit from above. They are marked from the exterior by having been painted black. The bridges that lead across a part of the voids are black, too, while the interior here has been left in exposed concrete. One can set foot in the last of the five voids, the only interior empty space. Once

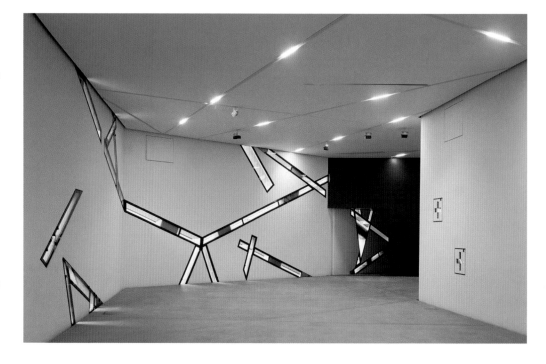

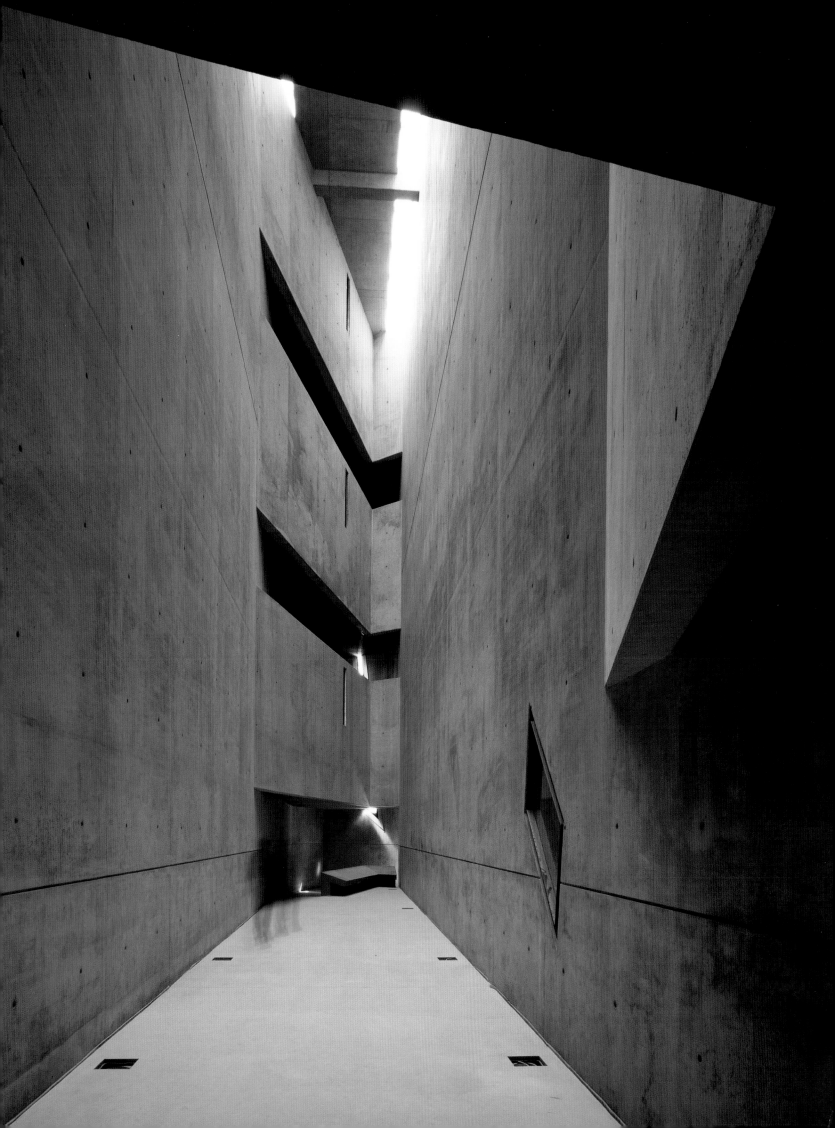

again, it is possible to experience the emptiness here that resulted from the extermination of the Jews of Berlin and their culture during the time of National Socialism.

Not only are singular elements of the Jewish Museum sculptural, such as the voids or the Garden of Exile and Emigration; the entire edifice evokes a sculptural effect, which is particularly impressive when one walks about the building. But, despite its impressive and solitary appearance, Daniel Libeskind's Jewish Museum obviously did not arise without model references and influences. At the same time, the form raises questions as to its own

meaning. First, the form of the Jewish Museum is based upon earlier works by Libeskind himself, such as the Line of Fire, which he installed in 1988 in the Centre d'Art Contemporain in Geneva. The project itself was a reaction to his own 1985 project *Drei Lektionen in Architektur [Three Lessons in Architecture]* in Palmanova, which was destroyed. For Libeskind the Line of Fire is an "architecture 'ON line': the furrow line cut by dragging a plowshare along the ground, and the line that defines the boundaries between things that one does not want to cross over." [3] In this project as well, the fundamental line is defined by incisions. The term boundary

refers to setting boundaries, and, if for no other reason, the association with fortifications is obvious. Elke Dorner has assembled a series of historical examples that show surprising similarities to the floor plan of the museum. They stretch from the fortification plan of Palmanova from the early eighteenth century and the fortifications by Vauban up to a drawing by Michelangelo of the Fortification of the Porta al Prato in Florence (?) from 1528. Furthermore, the architecture possesses references to buildings in Berlin such as the Nationalgalerie by Mies van der Rohe and the Trade-Union Building by Erich Mendelsohn. The stairway could well have been inspired by Konstantin Melnikov's 1925 Soviet Pavilion at the Exposition des Arts Décoratifs et Industriels in Paris. And with regard to the design methodology, a reference to the New York Five is appropriate, above all to Libeskind's teachers at the Cooper Union in New York, John Hejduk and Peter Eisenman. The overlaid grids, the references to topographic points and the building's lack of a center were undoubtedly quite influential,[4] just as Libeskind's relationship to deconstructivism and his own intellectual concept, which has references to French structuralism and post-structuralism, such as that of Jacques Derrida. Kurt W. Forster has compared the form of the museum to various works by Paul Klee that deal with menace and destruction, such as the 1922 work *Betroffener Ort*. He made reference to the theme of lightning,[5] to which the form of the Jewish Museum corresponds. The flash of lightning can be read as a metaphor of remembering while simultaneously mark-

ing a boundary in time. As with most of
these metaphors, it appears ambivalent,
while standing for destruction and obliv-
ion. On the other hand, that which has
passed and which has disappeared, mani-
fested here in the voids, can be recalled
once more through a flash of illumination.
Hence, a connection of various times is
made possible, which corresponds to one
of the fundamental intentions of this place
of remembrance.

For this reason, voices were repeatedly
heard claiming that the Jewish Museum,
still empty yet full of meaning, would be
suitable as a central Holocaust memorial.
The construction of a long talked-about
central place of remembrance would
therefore no longer be necessary. In the
meantime the decision has been made that
both will be built and that there is a defi-
nite need for a place where Jewish history
and culture can be presented and experi-
enced parallel to remembering the Holo-
caust. This is particularly appropriate in
Berlin, which, then as now, is home to the
most significant Jewish community in
Germany while simultaneously being the
place where the National Socialists
planned the Holocaust. In Jewish belief,
remembering is of central importance.
Remembering the history of the Jewish
people is a living aspect of Jewish identity,
a view of things that should also hold true
for how Germany deals with its own so
very tainted history. At the same time, the
act of remembering manifests hope for a
future without suppression, banishment,
and annihilation. For this reason Libeskind
views the Jewish Museum in Berlin—like
his other museum designs for the Felix
Nussbaum House in Osnabrück (built
from 1996 to 1998, parallel to the Jewish
Museum) or the expansion of the Victoria
and Albert Museum in London—as an
example of a new and innovative museum
type for the future. For Libeskind, it is no
longer an issue of the museum as a neutral
container for a collection; rather, it is an
issue of new experiences in the reception

Longitudinal section
Cross-sections

Longitudinal sections

of art and history, "[an issue] of new pro-
grams for the museum of the 21st century,
[and] of a new relationship between the
museum and the general public."[6]

Angeli Sachs

1 Compare: *Museen, Kulturzentren, Bibliotheken, aw –
architektur + wettbewerbe,* no. 143 (1990), pp. 54–57.
2 Compare: Kristin Feireiss, ed., *Daniel Libeskind:
Between the Lines,* from a lecture at the University of
Hanover on December 5, 1989, in *Daniel Libeskind.
Erweiterung des Berlin Museums mit Abteilung Jüdisches
Museum,* exhibition catalog (Berlin, 1992).
3 Compare: Alois Martin Müller, ed., *Line of Fire. Daniel
Libeskind. Radix—Matrix. Architekturen und Schriften,*
exhibition catalog (Museum für Gestaltung Zürich,
Zurich, Munich, New York, 1994).
4 Compare: Elke Dorner, *Zwischen Geometrie und
Sprache. Zwei Gespräche mit Daniel Libeskind, Berlin, Juni,
1998. Daniel Libeskind. Jüdisches Museum Berlin* (Berlin,
1999), pp. 23, 39–59.
5 Compare: Kurt W. Forster, *Monstrum Mirabile et
Audax. Daniel Libeskind. Erweiterung des Berlin Museums
mit Abteilung Jüdisches Museum.* Kristin Feireiss, ed.,
exhibition catalog (Berlin, 1992), pp. 17–23.
See also: Elke Dorner, *Daniel Libeskind,* Jüdisches
Museum Berlin (Berlin, 1999), pp. 48–49.
6 Ibid., p. 21.

Aldo Rossi
Bonnefanten Museum
Maastricht, 1990–1995

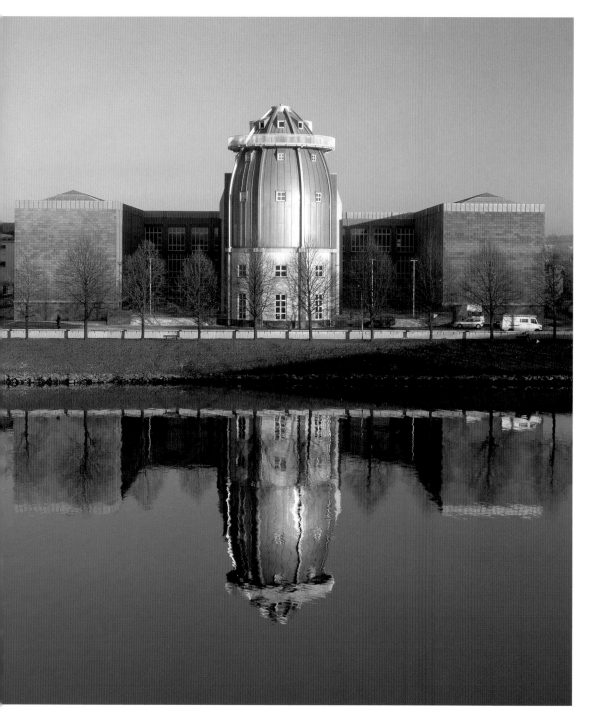

View from river

The museum as a vital monument

There is no greater mystery in time, this endless network of yesterday, today, tomorrow, ever and never.

Jorge Luis Borges

Convention, a type of memory, is the most severe impediment to the enjoyment of life and art.

Piet Mondrian

The Italian architect Aldo Rossi's Bonnefanten museum stands on the banks of the Maas, just across from the old center of Maastricht. From a distance its enclosed character makes it look like a red building built as a single unit, but as one approaches it becomes apparent that this is no more than an impression. The building is divided into three rectangular blocks set parallel to one another, each clad in red brick and red stone.

The blocks are connected to one another on the east but not on the west, leaving two courtyards between the blocks facing the Maas. Against the middle block stands a lofty, oddly-shaped tower, its high zinc dome resting on a low concrete plinth, the whole clad in slabs of off-white stone.

Spatially the two courtyards succeed in involving the building in the area dominated by the river and the towers of the old town on the other side of the Maas. By using these simple typologies, rectangular volumes and round towers, Rossi has succeeded in linking the Bonnefanten museum with the river and the town, so interweaving it into Maastricht's history.

Around the top of the tower's glistening dome is a panoramic terrace, from which a splendid view can be obtained over the river and the town. The tower is flanked by two much smaller round steel

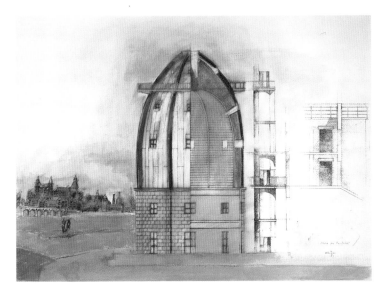

that makes a building a museum, but the things that are put in it.

The building is, of course, reminiscent of Schinkel's Altes Museum, even of Von Klenze's Alte Pinakothek, but it would be too simple-minded to see this building as no more than two classic architectonic types combined to construct a completely new and unprecedented museum. Rossi had not the slightest intention of designing a typical museum, but he did want the building to provide a space in which it would be art, above all else, that would find a home. The architecture of the building is expressive of the town, not of art or indeed of anything else. It provides a space for art in the same way as a town provides space for architecture.

The Bonnefanten museum stands on the Sphinx-Céramique site, so called because of the factory of that name that formerly stood there. The Dutch architect Jo Coenen was responsible for preparing the town plan for the area as a whole. He argued that parts of the factory, in particular the Wiebenga halls,[1] could be left standing, renovated, and included in the new plan. In the end only a fragment of the building, the first industrial building in the Netherlands to be constructed entirely of reinforced concrete, was left standing. This striking edifice stands immediately beside the main entrance to the new museum and provides about 3,000 square meters of floor area spread over three floors. It is not air-conditioned. The attic floor, immediately under the magnificent vaulted roof, is used for temporary exhibitions. The three lower floors are used to

lift shafts, giving the building an uncompromising, almost nineteenth-century industrial character, making it more difficult to see at a glance that the building is in fact a museum. Rossi would not dream of designing a museum that looks like a museum. It is after all not its architecture

Two studies, 1991

Overall view

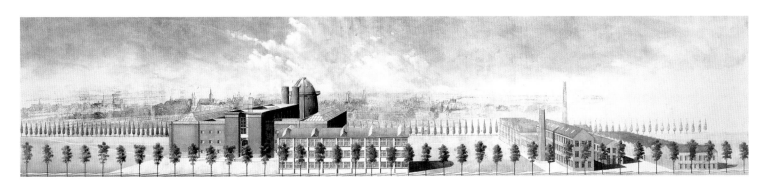

house permanent installations by Sol LeWitt, Luciano Fabro, and Richard Serra. A restored building of this kind, containing what it does, creates a profound impression on its visitors and would be a luxury for any museum.

Rossi designed a new frontage for this historic fragment—in the tradition of Leon Battista Alberti, who did the same sort of thing for existing churches—in a style comparable to that of the entrance to the new museum. For some reason or other, probably financial, this scheme did not go through. This may perhaps seem a pity, but the effect has been that this fragment of the modern Wiebenga halls looks totally unlike the frontage of Rossi's building. The two pieces of architecture can be seen as two unequal quantities in an equation, an equation that solves no problem but that does create a particular critical effect. This does at least frustrate a completely straightforward identification with Rossi's architecture, for after all the tension between the two buildings arises precisely because of the autonomous force of the difference between the two architectonic styles. It recalls the way in which architectonic fragments from different periods appear alongside one another in Rossi's concept of the analogue town, as if the recollection of a town, of this particular town, can exist only in an accumulation of different styles of architecture, gaining strength as its autonomous quality increases.

The entrance to the museum consists of a two-story-high steel frame in the elevation, topped by glass, lying wedged back between two totally blind brick wall surfaces, most closely resembling towers, which blend with the mass that stands behind them. This duality is in fact repeated in another, less hybrid, form on the other side of the building, in the way in which the great domed tower is flanked by two round lift shafts. In the entrance hall the visitor is greeted by a vertical shaft of light falling through the cone-shaped void from the roof to the ground floor,

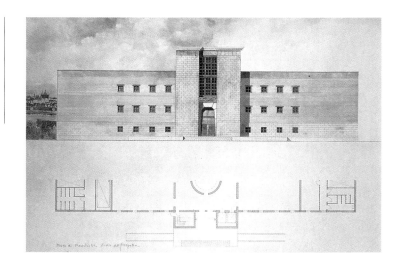

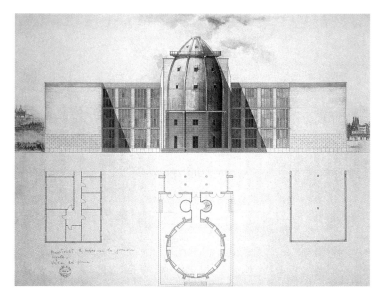

and by Marcel Broodthaers's work *L'Entrée de l'exposition*, exhibited there, which on a clear, sunny day is literally bathed in light. This piece consists of eight palm trees, erected in the middle of the cone-shaped void, surrounded by a series of photographs mounted on the wall. It is a truly fantastic experience to see all those palm trees standing there in that light, but in retrospect the experience also has a certain ambiguity, because this work of art is so wonderfully well suited to its location that it makes it seem as if its autonomous and critical character has almost evaporated in the heavenly light, reducing it to a secondary attribute of the museum's architecture.

In short, this is an entrance to give one pause, an entrance that seems to be

designed to initiate the visitor into an artistic extreme. The initiation ritual is impressively continued by the grand staircase in the central block between the two courtyards. This staircase leads the visitor halfway up to the actual exhibition floors and ultimately to the most extraordinary room in the whole museum, the room under the dome. This room was conceived by Rossi as a kind of workshop in which temporary projects could be exhibited, providing a confrontation between the artist and the most "religious" room in the building. If there is anywhere in the building that can be seen as an interpretation of a museum, a place in which art and architecture blend, it has to be the cone-shaped void and the dome-shaped room, where the architecture is tailor-made to suit the

art and, conversely, where the art is tailor-made to suit the building.

A natural comparison with the relationship between art and architecture is the relationship between architecture and the town. After all, when one goes out onto the panoramic terrace that runs round the dome, the town itself looks like a museum, a gathering place for all those special buildings, a kind of work of art capable of breathing new life into the recollection of the town over and over again. Rossi is well aware that a town is pre-eminently a place of constant change, but also that ultimately the town is the place where each change is doomed to become petrified in the stone of its age.

The construction of the domed tower is remarkable because as compared with the classic triangular construction of the frontages of the other blocks, a central section is missing. The domed tower consists of a lower and an upper edge standing on one another without creating any central section, effortlessly suggesting a connection between earth and sky, a reference to a bridge between mortals and gods, between the finite and the infinite, between the café on the ground floor and the art that lies above it in the room under the dome. In this comparison the tower appears predominantly as a gathering place for the town, people, and art; in a word, as a sanctuary where these different domains can be thought of collectively, as a recollection of existence as a whole.

The sketch that Rossi made of the domed tower and the Onze Lieve Vrouwe church on the other side of the Maas can be taken as the latest in a long series of ways in which Rossi expressed his continuing research into the concept of the analogue town. In one of his articles Rossi wrote about theory and design, "The beginning of a theory is, I believe, the insistence on certain themes, … in particular the ability to hit the center of a theme to follow, to operate a choice inside architecture and to always try to

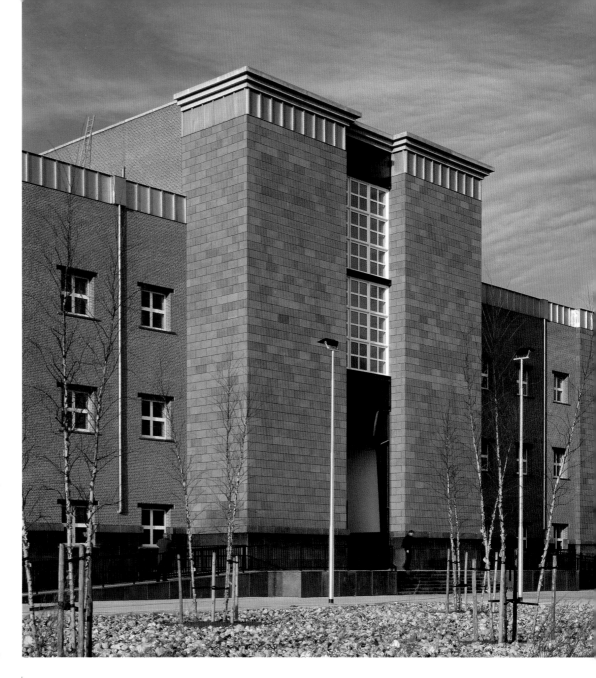

Main entrance

solve that problem."[2] The Bonnefanten museum is another product of the tenacity with which Rossi has for decades aimed to give his designs and buildings the character of timeless architecture and to meet the demand for something original, something specific in each design, met by Rossi over and over again by reference to an archetype, something that was once original.

Perhaps this is why at first sight topicality seems to play no part in Rossi's architecture; but the surprising paradox is that Rossi's architecture is topical because it is urban architecture, more precisely the architecture of an analogue town, whose silent character makes visible the daily vitality of the town and whose "slow

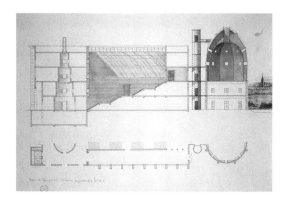

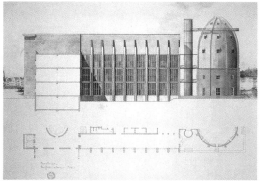

Longitudinal section
and part plan

Section, elevation
and part plan

motion" effect makes it an indicator of new developments in the town. Rossi's architecture, however autonomous it may be, can be effective only in a town, and can survive only by marking time.

The entire ground floor of the central section of the building can be thrown open, connecting this new part of the town to the historic center. Once inside the building, the visitor can walk on either side of the grand staircase through the museum café to the banks of the Maas, from which one can see and access the historic town on the other bank. Rossi has used these particular architectonic operations on the axis of the building to ritualize movement so that it literally becomes still. The visitor constantly finds himself in a different kind of daylight, whether on the grand staircase in the fantastic light court or in the room under the dome with its many small window openings high above.

It is a striking fact that there is hardly anywhere in the building from which it is possible to see out, not even on the side facing the River Maas. It is as if Rossi was constantly on the lookout for different ways of saying that this museum is meant to be introverted, a building that provides space for meditation and contemplation. The overpowering setting does not entirely avoid a certain pathos, as also emerges from Rossi's writings from time to time, as for example in his scholarly autobiography, in which he writes that "architecture was one of the means that humanity sought out to enable it to survive; it was a way of

Third-floor plan

Second-floor plan

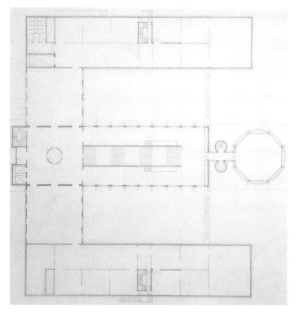

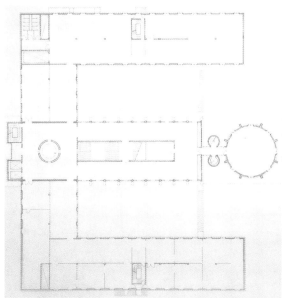

giving expression to the fundamental pursuit of happiness."[3] But one might equally well say that this form of expression is itself the expression of the sublime rationalism for which Rossi was arguing. And on the subject of the staircase in the Bonnefanten museum, Rossi writes, "… Pointless to repeat that this staircase, made in the old Dutch tradition, steep and awkward, is connected with the Gothic world of Shakespearean taverns or with Conrad's casual characters and all the shipwrecked sailors from the north, washed up on the shores of the southern seas." For Rossi, a staircase is not just a staircase but also an instrument to stimulate the memory, just as the telescopic space above the entrance is a *Lichtraum*, a reference to the light court of the university in Zurich. "I am unquestionably deformed by relationships with everything that surrounds me,"[4] as Rossi quotes Walter Benjamin.

All this makes Rossi's architecture heavy and ambiguous, pregnant with the personal references which Rossi uses to anchor his architecture in general and this building in particular in the history of architecture. But here is something that Rossi wrote about the tower: "If you were to ask the most simple soul in our continent what he finds the most striking, there would be only one possible answer: the dome."[5] That sounds almost reassuring.

Inside, the exhibition halls for archaeology are on the south side of the first floor; and for old art on the north side. All the rooms on the second floor are for modern art. The way the atmosphere

changes from room to room is truly amazing, yet quite simply achieved. The rooms on the first floor have a large number of small window openings in the longer elevations, while the rooms on the second floor are simply surrounded by solid walls so that the daylight can come in only through the glass roof. The solid walls are 70 centimeters thick and contain the air-conditioning system that combines with the treated wooden floors to keep such factors as temperature and humidity at the required level. The plain walls and the top lighting give the rooms a serene character and display the inexhaustible strength of a modest interior in which the different departments are marked by subtle spatial distinctions.

Just as Rossi collects architectonic fragments and goes beyond the conventional character of the type by bringing together those fragments in a type a posteriori, so also he collects architectonic details that always make a special composition when combined in an elevation. One need only consider the steel profiles in both the long elevations of the middle section of the building, which have no constructional function whatsoever but are applied to concrete buttresses solely as cladding, or the way in which the rainwater pipes are routed along the exterior of the elevation and disappear into the wall just above the basement, or the great door in the side elevation which is included in a composition extending over two floors but which functionally could have made do with half the height. These formal solutions are not to be seen merely as constructional or functional but as a sort of signature, a way of using specific detailing to give the building an autonomous character connecting it with the tradition of the town but also creating an individual identity. Rossi appropriates architectural discipline to himself by adding it in whatever way he thinks fit to a type a posteriori so that it can no longer be seen as a piece of radical nostalgia but

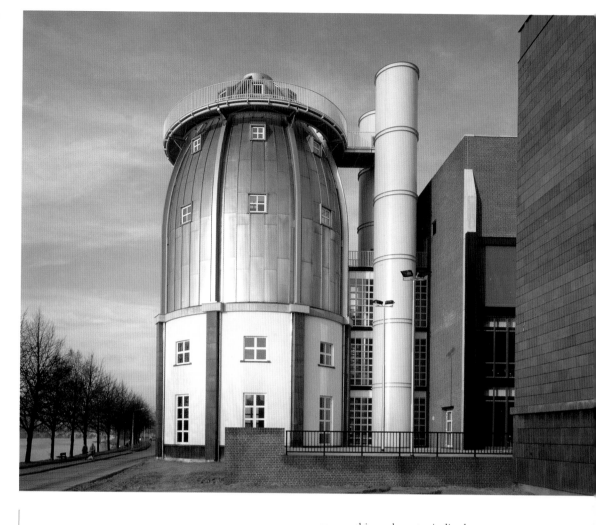

Domed tower

as something whose topicality becomes apparent the moment that the design is realized in a town, in this case Maastricht. In the Bonnefanten museum, Rossi has produced a building that links the past with today in a ritual architectonic experience, a building in which a powerful combination of space and time has provided a new, vital monument in which the museum has found a new home.

Herman Kerkdijk

1 Marijke Martin and Ed Taverne, "Het Bonnefanten-museum: van binnenstedelijke kloostertuin naar perifeer industriegebied," in *AKT* no. 52/53, December, 1991, p. 24.
2 Aldo Rossi, "Architecture for Museums" [1966], in *Aldo Rossi Selected Writings and Projects* (Dublin, 1983), p. 16.
3 Aldo Rossi, *Een wetenschappelijke autobiografie*, (Nijmegen (SUN), 1994), p. 11.
4 Aldo Rossi, "An Analogical Architecture" [1966], in op. cit. (note 2), p. 60.
5 From Aldo Rossi's commentary on the Bonnefanten museum on the occasion of its opening in March 1995.

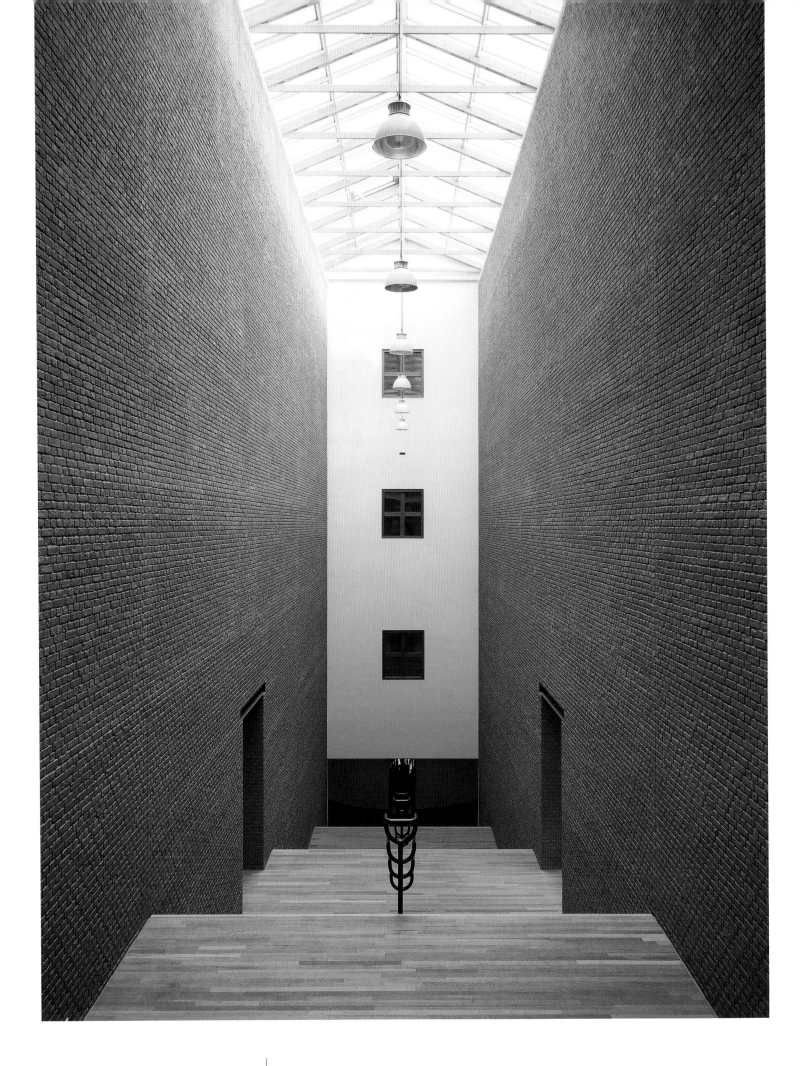

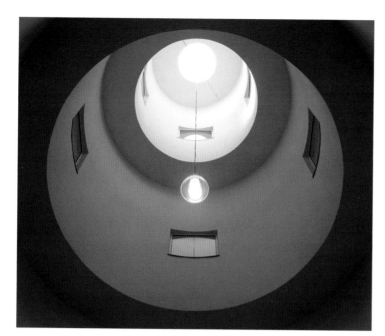

Main staircase

View up light well in tower

Gallery space

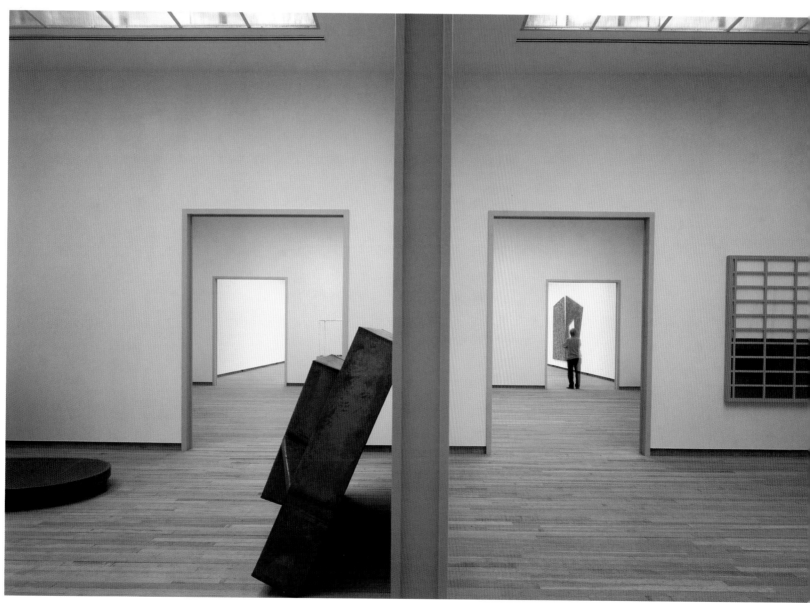

Peter Zumthor
Museum of Fine Arts
Bregenz, 1990–1997

Sketch

Sectional sketch

Conditioning Perception

Peter Zumthor's Museum of Fine Arts is not specifically a museum building, although it obviously delivers an essential thematic contribution. What seems new to me in this regard is the role of the architecture, which neither makes itself the object nor the content of the building, nor disavows itself opposite the art. Zumthor has succeeded in a considerable balancing act of coexistence, indeed one of mutual, oscillating influence: a building as art exclusively for art.

The Place

Without exception, Zumthor's works are investigations of concrete places. That this can become fruitful only via a universal concept of place, through the densification of countless memories and experiences and the greatest possible distance from the givens at hand, belongs to those "truisms" that are the only way to reach the exceptional. The ensemble between Kornmarktstrasse/Kornmarktplatz and See-Strasse has a singular character. It seems as if the city had only moved toward the lake with caution. There is no closed edge, but rather individual elements put in place since Baroque times (Nepomuk Chapel). It is also not a case here of a "Gründerzeit" building (which in any case had exercised strong influence with solitary objects) but rather of a spatial construct that had grown slowly and was provided with sensitive points of contact.

Peter Zumthor's "intervention" is just as decisive as it is sensitive. The emphasis brought by the glass tower focuses this modest "skyline," making us conscious of it and really visible for the first time.

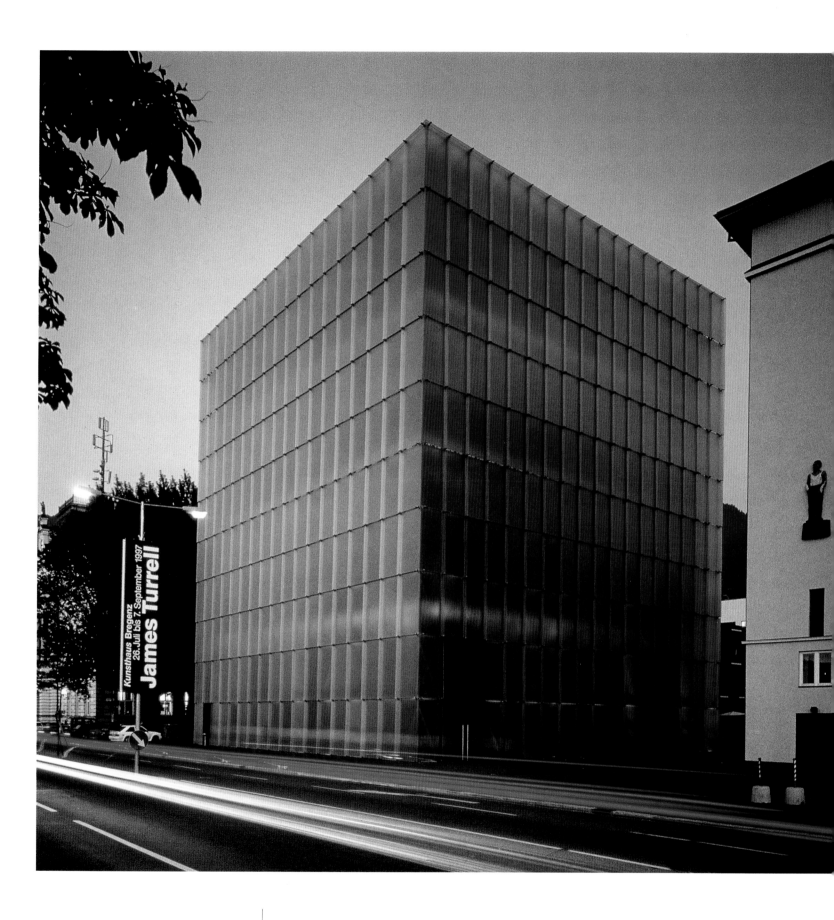

View of Museum of Fine Arts
from See-Strasse

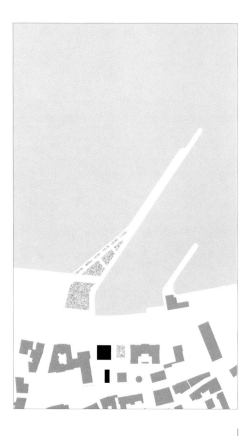

At the same time a further place is created by setting the lower administration and service building perpendicular to the Kornmarktstrasse. This not only enormously enhances the communication between the two new structures, it also refers to the dialogue with the street space while structurally completing the ensemble. Because of the old building (the Forsterhaus, which originally was to be saved and renovated) that had stood parallel to the street, the area behind it was akin to fallow urban land. With only a few measures, the space has been transformed into a highly valuable urban zone, indeed becoming the center of Bregenz. The same goes for the green, tree-lined square with the monument to Dr. Anton Schneider. On the one hand it is open, while on the other hand it keeps its remote dreaminess, now solidly established. For such a minimal intervention, an optimal urban effect has been reached. Nobody should claim here that the modern movement is not capable of creating urban spaces.

The Staggered Enfilade

By removing the secondary and service functions, such as administration, library, museum shop, café, bookstore, etc. (there are, however, spaces in the lower level for museum educational programs, workshops, and storage), it became possible to conceive of the museum as a pure and flexible museum and exhibition building. This had the effect, however, of having to take leave from the classic enfilade with skylit exhibition halls—meaning a horizontal row of exhibition spaces for the sake of a stack of exhibition spaces—because of the narrow building site.

Zumthor wouldn't be Zumthor had he not made a virtue out of the characteristic constriction of the site. A vertical chain grew out of a linear sequence of spaces, and the principle of "walking through" remained intact. The spiral-like line of movement does not connect the exhibition spaces axially, but rather tangentially or centrifugally. One has an overview of the space with but one glance. Through the location of the structural panes, there arises a slight clockwise turning motion oriented toward the line of movement. Whoever happens to search for the shortest path along the "stair pane" moves for a short distance "against the current." This spatial concept of a "static made dynamic" (as if Zumthor wanted to emphasize the ceremonial quietude of his spaces with a small movement) corresponds to the spirit of a museum of art to a particularly high degree. To a certain extent, the space prescribes the rhythm and the tempo, both of which correspond to the contemplative movement through an art collection.

What corresponds to the changes in the size of the exhibition spaces or direction in a conventional museum is expressed here in the treatment of the walls and in the height of the exhibition spaces. The high entrance story (with its own special character and light) is followed by two nearly identical exhibition

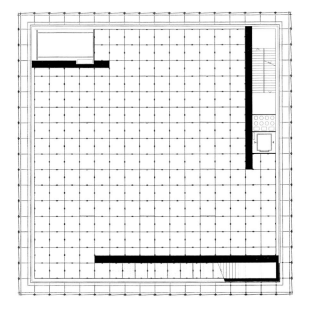

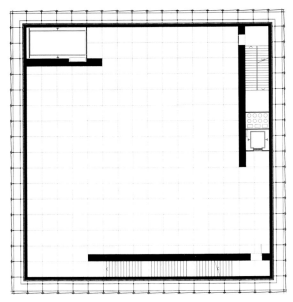

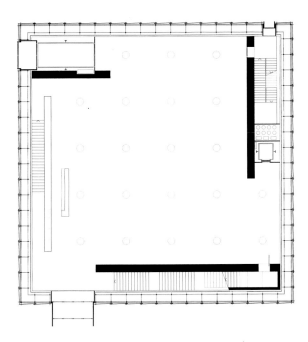

spaces, whose repetition is terminated by the "finale" of a higher space. In poetical terms one would characterize this subtle sequence as "a b b c."

The Light

Without wanting to dabble here in questions of light, the situation presents itself to the uninitiated observer more or less as such: the competition project worked with the coordinated direction of rays of light along the ceiling into the interior of the building. Apparently, no particularly satisfying results were reached with the trials. The built solution works with a fundamentally different quality of light. Scattered light that is doubly filtered through a spatial layer fills out the space almost (put in lay terms) "corporeally," thus reaching a different "physical state," such as with a gas. Thus, while various light zones do arise in the space, there are no shadows. The eye meets upon natural conditions (such as by slight clouds in movement), must "work," and thus has to accommodate. Zumthor is rightly against a sterile, absolutely uniform quality of light that only tires the eye with time and that discharges the quality of physical matter in the space into visual immateriality.

Dealing with the light in a manner that approaches natural conditions (this is not to say that artificial light is not just as much in use) obviously contains an architectonic intention: through its changing consistence, the light remains a constitu-

tive element of the space. The space is not reduced to well-lit surfaces and by no means dissolves into a state of volume-lessness.

Peter Zumthor does not even allow the ceiling of light to take on this volume-lessness. Mounted with clearly visible joints, the square elements show a structure like a flat solid, with the ceiling also allowing a view into the installation space above. Thus the light space is continued horizontally in the ceiling (with the exception of the ground floor) in which the entire building has been placed.

The Materials

While the construction, the location of the structural walls, and the corresponding control of the light allow a transformative play despite the conceptual rigor—one perhaps even consciously planned—the selection of materials moves toward quietude and balance. While the "surfaces of light" nonetheless reveal their spatial influence and plasticity, the terrazzo floor remains a large gray surface area (in various shades of gray depending on the space) without joints, with the concrete retaining its customary velvety gray shade as well. Since the load-bearing concrete walls function as both a heating and a cooling system by virtue of a system of water pipes held at constant temperature, the visual force is supplemented by an additional impulse of physical as well as psychic stability. One can not claim that Zumthor's tendency to push toward the essential and the laws of nature seeks to supplant the technical, the mechanical, and the mechanistic realms. But in this reduction, in the repression of this visible "world," there lies a strong psychological moment, to a certain extent offering an act of liberation toward a deeper view of things.

Because of this, the question arises once again with regard to the complexity of the apparent and presented simplicity. In the concise reduction of space to floor,

A｜ Horizontal section at skylight level

Second- to fourth-floor plans

B｜ Ground-floor plan

Southeast elevation with main entrance

Section A

Section B

wall, and ceiling and to a minimal defini-
tion of their performance in a kind of
universal materiality, there lies an immense
"compression," a densification, which in
reality strains the perception and distrib-
utes it to other impulses. Art does not
meet here upon an architecture reduced to
zero, but rather a quiet but intense sphere
of tension in which it must exist. Thus
the visitor's perceptions are conditioned
and sensitized, so that one is "forced" to
go through the building with awakened
senses.

Zumthor's spaces are neither neutral
nor communicative. They neither cower in
front of the art nor do they thrust them-
selves as architecture into the foreground.
If something is not to be exhibited here
then let it be architecture; nonetheless, art
must hold its own opposite this architec-
ture.

On the exterior volumes of the art
museum and the administration pavilion
the two great themes of the modern
movement—here just as antagonistic as

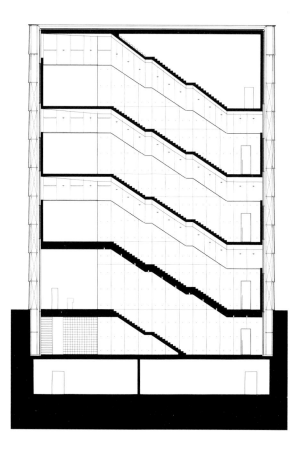

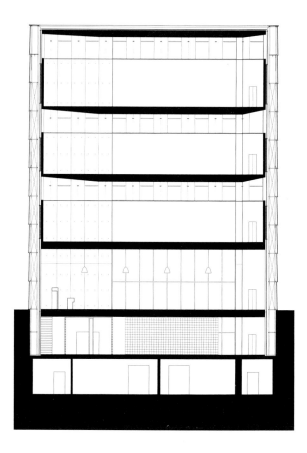

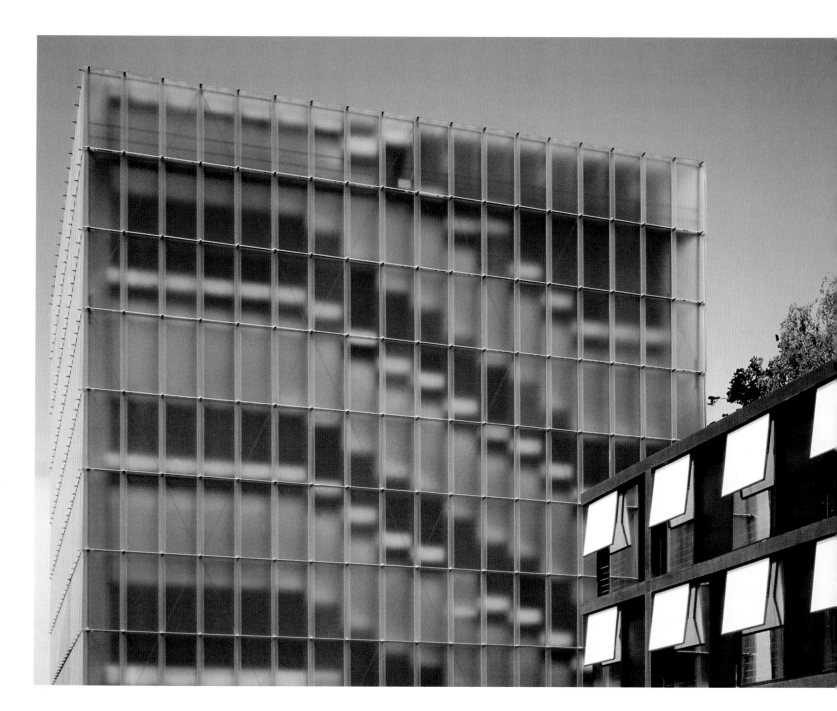

External view

reconciled—appear once again in the urban room: the frame and the skin. The black, two-story frame structure with its large sliding elements and the narrow front side toward the street quietly announces the antithesis that lies behind and that becomes an architectural event. The prism "shingled" in large glass panes—equally soaring and warehouse-like—already indicates by its surface that here is a building that makes light its spatial theme. During the day the building appears as a glass body rising up from the

Peter Zumthor has blocked the view to the lake. And anyone who has set foot upon the roof of the new landmark knows of the sacrifice that is required here. Zumthor is right. A terrace café would degrade the art museum to a lookout point for tourists, while adding nothing to the omnipresent view of the lake from Bregenz. Thus, nature and the landscape have no business being in the art museum; and that is just fine. If one is to champion something here on this beautiful shore, then it is clearly art. And the Museum of Fine Arts in Bregenz is a building that takes art seriously in its most radical form: it subjugates itself to art's laws.

Friedrich Achleitner

ground while void of any apparent base, reflecting the atmosphere and guiding the eye afar. At night it appears as a body of light, showing a new presence for art in Bregenz.

The comparison is only half true: neither is it an issue of the "skin" with regard to the art museum, nor an issue of skeleton construction for the pavilion. The glass-shingle architecture is a light filter translucent to the air and the weather. It is the outer boundary of a spatial zone that allows the eye to penetrate to various depths while simultaneously marking a boundary from within. The "skeleton" in the administration building is in reality an outwardly readable building structure with strong contours. Thus, it is an issue of two primarily changed principles, which allow memories of an old antagonism, but no more.

The visitor whose concentration is not just directed toward the art will note that

Façade detail

Detail at eastern corner

Stairs to foyer

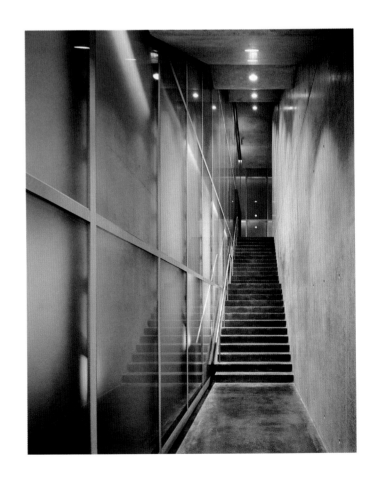

Entrance hall

Frank O. Gehry
Guggenheim Museum
Bilbao, 1991–1997

Computer-generated
models, 1993

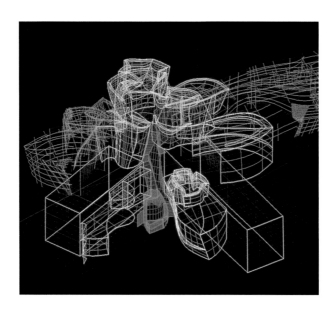

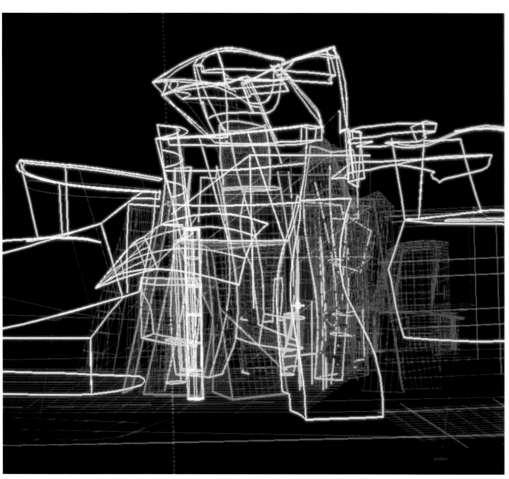

The Museum as Civic Catalyst

Museums emerged as public institutions in the early nineteenth century. As long as only one wing of a noble residence, or even an entire building, was designated as a picture gallery, the museum in the modern sense of the term had not yet taken form, for only as an independent structure on a prominent urban site could it begin to play its role as cultural protagonist. Not unlike the grand theater buildings that preceded the museum, and the railroad stations that followed it, the first shrines of art made their appearance in a number of cities within an astonishingly short time.

While the history of collecting is long and complicated the museum is a relatively recent institution and yet it has already witnessed dramatic transformations.[1] Museums found their initial identity in the royal treasure house and the private cabinet of curiosities. They gradually expanded to accommodate ever larger accumulations of artifacts and increased public access through the nineteenth century; only recently have they assumed a much more spectacular role in cultural life.[2]

Also in the twentieth century, a new kind of exhibition inspired by the experience of temporary exhibitions at the world's fairs of the nineteenth century came into being. The "loan exhibition" burst onto the scene, stirring the public with its theatrical nature and its often nationalistic or otherwise partisan aims. Although rare and ephemeral at first, loan exhibitions have completely transformed the modern museum and permanently altered the public's perception of art in general. No longer is the museum's

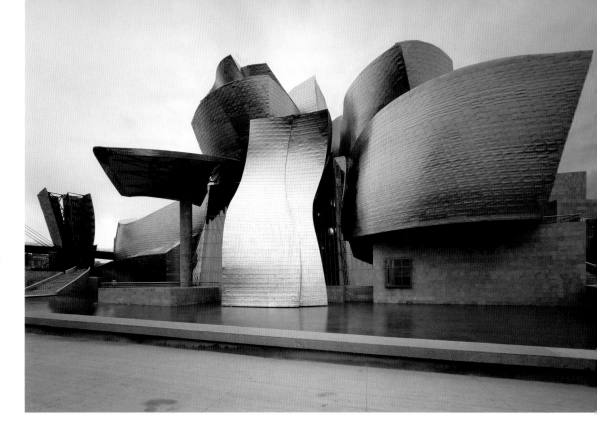

primary mission to uphold the exclusive value of highly select works of art; rather it propagates knowledge of many diverse and often competing—if not mutually exclusive—artistic practices.

The maintenance of permanent collections and the fairly frequent modification of their display remain central to many institutions, yet the presentation of a museum's traditional core collection has been deeply affected by recent events.

The Guggenheim Museum in Bilbao extends this general development a step further. Conceived to form a link in a possible chain of institutions under the aegis of the Guggenheim Museum in New York, Bilbao becomes the test site of an entirely novel museological concept. After Peggy Guggenheim's death, her private museum in Venice reverted to the mother house in New York in 1976. Director Thomas Krens began to envision further expansion of its ambit to yet other cities: in 1989, he tested the waters in Salzburg, and, after Hans Hollein's operatic project of a museum hewn from a rocky cliff failed to materialize, Krens moved on to open a temporary branch of the Guggenheim in Berlin and laid the groundwork for an affiliated museum in Bilbao.

The "modern" idea of developing a chain of museums is both startling—when considered in light of the innate conservatism of museums—and disarmingly simple. If museums are indeed the unsuspecting heirs of the theater, then the idea of a chain of houses is only a logical consequence of their new condition. Instead of confining works of art to the place where they have found a permanent home, more often than not as a matter of accident rather than design, they would be periodically rotated, shown in changing assembly and under differing local conditions. This new "franchising" of museum collections represents one response, and a precisely calibrated one at that, by which museums might react to the conditions

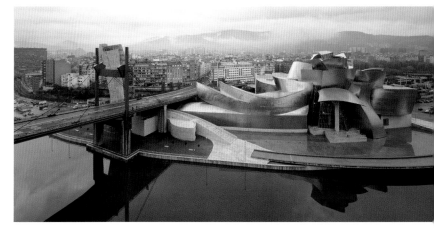

Exterior view

View from river

Site plan

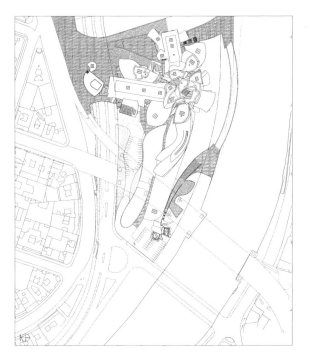

that define their operation throughout the world.[3]

These expectations for the Guggenheim Museum in Bilbao surely played a role in its architectural conception. In 1991, Thomas Krens invited four architects to Bilbao—Hans Hollein, Arato Isozaki, Coop Himmelblau, and Frank Gehry—asking them to sketch out their ideas for a museum building in keeping with this novel purpose.

His choice of architect was tempered by his previous experiences with museum projects and the ways their architects had of conceiving of them in terms of their recent typology and urban role.

Almost two decades earlier, the opening of the Beaubourg museum in Paris

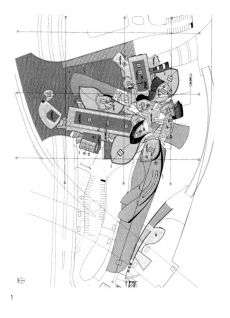

1 Plan of roof

2 Third-floor plan

3 Fourth-floor plan

4 Ground-floor plan

5 Second-floor plan

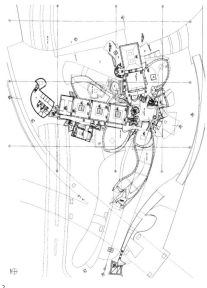

marked the advent of museums that owe their identity less to permanent collections than to viceral impact.[4] Comparable to an "aircraft-carrier of culture," the Beaubourg berthed the idea of the "maison de la culture" in one of the neglected precincts of Paris, playing up its purpose as an attraction for the uninitiated as well as sophisticated elites. Just as Les Halles were once the place where the bourgeoisie went for oysters and champagne at midnight, the new cultural tourism now finds its mecca among collections dedicated to industrial design, film, video art, and a spectacular rooftop view of Paris thrown in for good measure.

Ever since the Beaubourg opened in 1977, not only do new museum buildings need to stand the test as adequate repositories of art, but they are also expected to act as catalytic agents of urban transformation.

Gehry's projects for the Walt Disney Concert Hall and the Museum in Bilbao are both located in what had become derelict urban zones, places scored by traffic and trade arteries, criss-crossed by major sight lines, but lacking in any clear manifestation of character. The compromised conditions of both sites are an apt metaphor for the complex circumstances under which the Bilbao commission was precipitated by the regional and municipal governments in negotiations with the Guggenheim Museum in New York.[5]

Such grand projects as the Bilbao Guggenheim place extra burdens on the traditional institution of the museum.

As museums have been forced to find new ways of financing themselves, they resort to the kind of gambits with which Phineas Taylor Barnum filled his circus tents. The exaggeration of the public status of museums—not in all cases dependent on new buildings, though rarely accomplished without them—has also led to important changes in their architectural character. New museums require a grand and ever more impressive public presence,

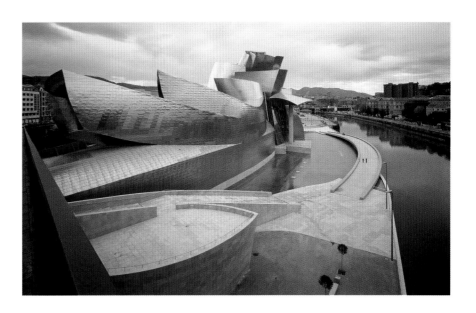

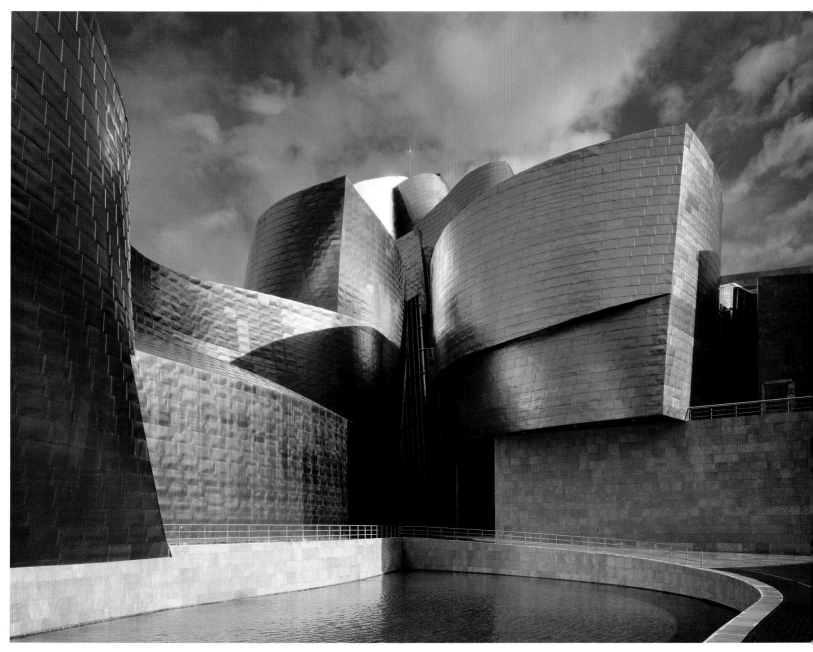

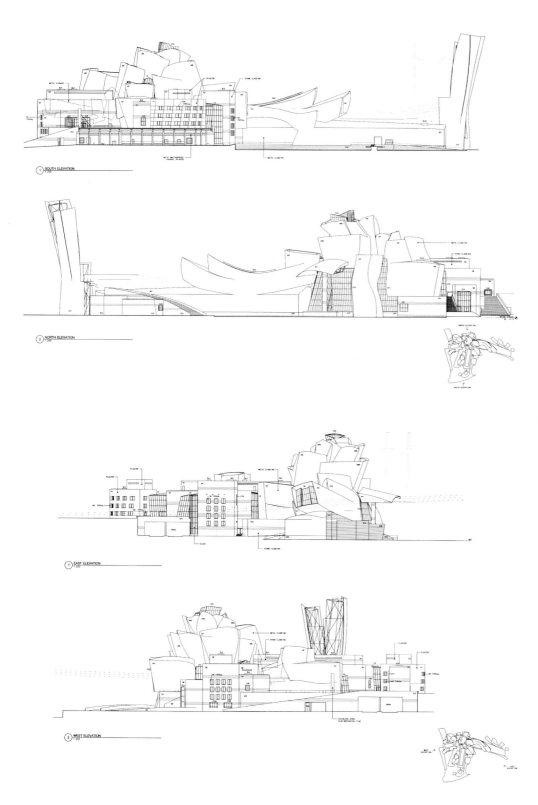

South elevation
North elevation
East elevation
West elevation

and equally inventive and varied interiors. The achievement of volumetric presence on the outside and a partial expansiveness on the inside calls for dramatic transitions, even magical transport, of the visitor's experience.

With his buildings of the 1980s, Frank Gehry returned to an architecture possessed of powerful corporeal qualities. He does not think of the volumes of his buildings within the confines of abstract space (which is also the space of economics); rather, he engages these volumes in intimate relationships with one another. One need only observe Gehry's manner of drawing to gain an immediate sense of his way of thinking: the pen does not so much glide across the page as it dances effortlessly through a continuum of space. His affinity for the transitory and his conjurer's grasp of minute displacements are fueled by his knowledge of performance art and enriched by his collaborations with artists, such as Claes Oldenburg.

At Bilbao, Gehry has been planning with and for artists, providing spaces for specially commissioned installations as well as flexible galleries for the inevitable variety of exhibition displays. The building complex includes generously proportioned areas for public events and unforeseen opportunities that vastly expand the purposes of contemporary museums.[6] It is entirely purposeful that the museum has been anchored in the cityscape of Bilbao like a vast circus tent surrounded by a congerie of caravans, for the variety of events anticipated to take place there requires large and ever varying venues. Subsidiary spaces are clustered together, squeezed through the bottleneck between river and embankment, made to duck under bridges, and finally allowed to soar over the building's core in a spectacular canopy.

If it is possible to speak of a spatial realm that lacks figural contours yet possesses powerful bodily qualities, if ambulation can unlock the complexities of a

building's order beyond the cutlines of the plan, then the Museum in Bilbao revives an architecture that has lain dormant for centuries. If one examines historic architecture in search of buildings that might presage what Frank O. Gehry has been able to achieve, one is likely to pay attention to Francesco Borromini. Because the sheer effect of the Bilbao Guggenheim overwhelms and continues to intrigue, not unlike the fascination Borromini's buildings held for his fellow architects and even his sometime-employer Bernini,[7] the phenomenon of its excessive nature deserves some consideration. Before it can be considered anything else, the Bilbao Guggenheim must be reckoned overweight, overdone, and overwhelming. It is an immovable pile in the city and a sinuous creature draping its body along a narrow ledge above the river. As a luminous cave on the inside, and a metallic mountain from without, the museum appears to be both a perfect fit and a perfect stranger in its site.

The vigor and resolve with which Gehry attacked the Bilbao project sprang, initially and violently, from his disappointment over the Concert Hall.

When it became clear that years might pass before the concert hall would be built, Gehry was saved from an all-too-familiar decline into resentment by the even more challenging opportunity in Bilbao. Here, Gehry tapped the full capacity of computer-assisted design. Leaving its auxiliary role far behind, he and his collaborators made use of programs that were originally developed for the design of airplane fuselages, but which in this case provided the matrix for the shaping of every part and the refinement of every element in the design and construction of the museum. The age-old distinction between the hands that design and the instruments that execute has been overcome: the separate phases and techniques of conceiving and executing a building here were woven into an unbroken "loop." Only in this way

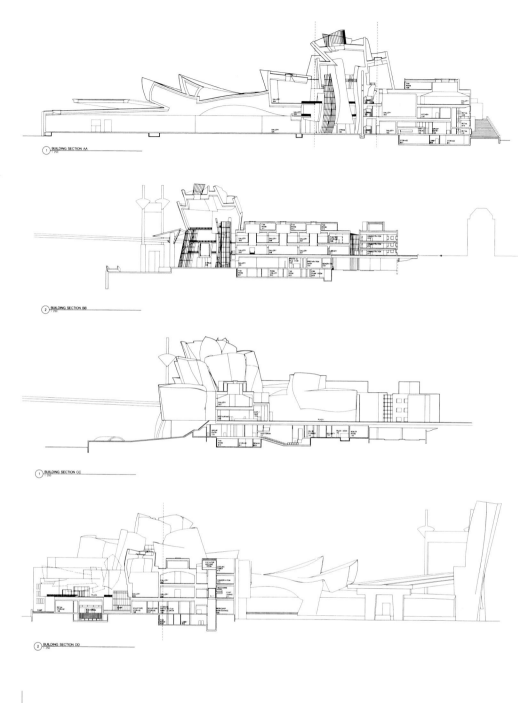

Section AA
Section BB
Section CC
Section DD

can the inaccurate fit among the conventionally separate phases of invention, transcription, and execution be perfected, and the exponential degree of geometric complexity of such a structure be realized without costly trial and error.

Not only will the Bilbao museum go down as one of the most complex formal inventions of our time, but it will also stand as a monument to the productive capacities that are now at our disposal, insofar as an architect like Gehry pushes them to new heights of imaginative use. When complexities of an order commensurate with our understanding of the world can be restored to architecture, we shall no longer have to be content with the subsistence diet dictated by economics any more than with the impoverished aesthetics of an earlier era.

Kurt W. Forster

This text is based on an essay published in Forster, Kurt W. *Frank O. Gehry: Guggenheim Bilbao Museoa* (Stuttgart and London, 1998). It has been abridged and revised by the author.

1 Compare: Krisztof Pomian, *Der Ursprung des Museums* (Berlin, 1988); Horst Bredekamp, *Die Geschichte der Kunstkammer und die Zukunft der Kunstgeschichte* (Berlin, 1993); Ekkehard Mai, *Expositionen, Geschichte und Kritik des Ausstellungswesens* (Munich and Berlin, 1986).
2 See: Kurt W. Forster, "Shrine? Emporium? Theater? Two Decades of American Museum Building," *Zodiac*, 6 (1991), pp. 30–75.
3 The following offer useful surveys: Heinrich Klotz and Waltraud Krase, *New Museum Buildings in the Federal Republic of Germany* (Frankfurt a. M. and Munich, 1985); Josep M. Montaner, *Museums for the New Century* (Barcelona, 1995); "Contemporary Museums," *Architectural Design* (London, 1997).
4 See: Nathan Silver, *The Making of Beaubourg: A Building Biography of the Centre Pompidou, Paris* (Cambridge, MA, 1994).
5 The evolution of the museum in Bilbao has been chronicled by Coosje van Bruggen in her book *Frank O. Gehry: Guggenheim Museum Bilbao* (New York, 1998).
6 See note 2.
7 Critique often cuts closer to the nature of certain phenomens than praise, and Bernini's somewhat envious description of Borromini's way of invention is very much to the point when he characterized Borromini's methodical search as "dentro una cosa cavare un'altra, e nel altra l'altra, senza finire me." For a more detailed comparison of Borromini's and Gehry's method of evolving architectural forms, see the monograph on Gehry: Francesco Dal Co and Kurt W. Forster, eds., *Frank O. Gehry* (New York, 1998). Cf. also Christof Thoenes, "Die Formen sind in Bewegung geraten—Form Has Been Set in Motion," *Daidalos*, 67 (1998), pp. 63–73.

Gallery space with works
by Anselm Kiefer

View to foyer

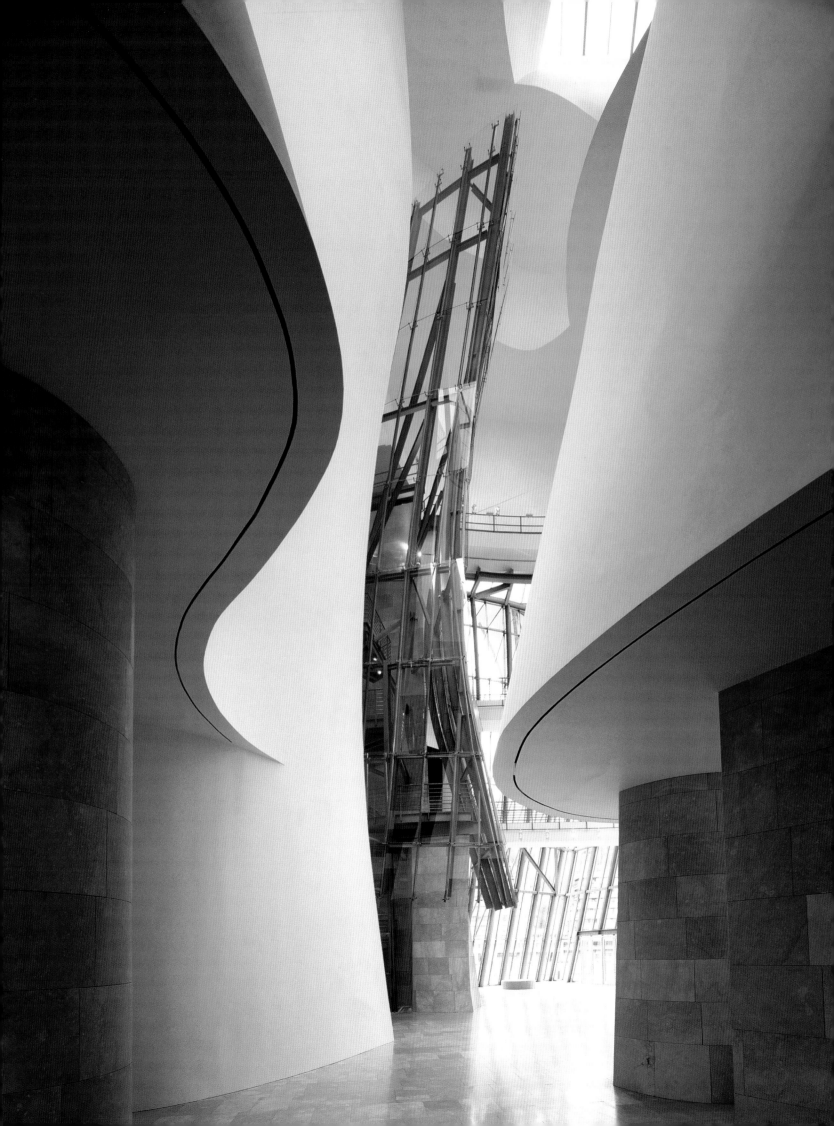

Josef Paul Kleihues
Museum of Contemporary Art
Chicago, 1991–1996

View of museum in
its urban context

Chicago's Museum of Contemporary Art is the first and thus far the only building produced in America by the Berlin architect Josef Paul Kleihues. To those familiar with his efforts both earlier and later, it is easily recognizable as his own. Elements as large as his customary square modules and as small as the steel screw-head that normally fastens each panel to his building frames are much in evidence in Chicago. In view of this, and recalling statements Kleihues has made about the museum, the viewer is likely to ask to what extent the work is uniquely responsive to its specific setting.

Kleihues has said that his design was greatly influenced by the architecture of Chicago, a city he also affirms as having affected his thinking more than any other except Rome. There is some merit in that claim, which nonetheless warrants further examination. Simply described, the building is sternly symmetrical, with its west, or main, façade reached via a tall, one-story-high stair and flanked by two three-story wings. The prevailing color is the gray of the two top cast-aluminum-clad floors that perch on a white limestone base. While such an account suggests the classical tradition, the style is clearly modernist in its simplicity and lack of period decoration. The square is the dominant and uniformly readable shape, governing those parts of the building that are fenestrated and those that are not.

Does this description accord with "Chicago-type" architecture? Not especially. The most notable classicist associated with the town is Mies van der Rohe, who happens also to have been the most famous modernist in the city's history.

Kleihues's museum does bear some similarity with Mies's well-known rectilinearity, but it is noticeably more opaque than the vitreous towers for which Mies is best known in Chicago and the rest of the United States. To the degree that Chicago architecture is reputedly pragmatic and functional as opposed to historicistic and decorative—a generalization open to question in its own right—there is nothing strikingly pragmatic or functional about the museum, either in its exterior or interior. The attribute that most attaches it to Chicago is its modular grid, a bow to the layout of the city streets, which is notable for its consistent reliance on squares and rectangles. Indeed that fidelity is not only the most perceptibly Chicago-like trait about the museum but perhaps the museum's most winning feature.

That is to say, Kleihues's chief success is urbanistic. The building occupies an uncommonly splendid space in one of the choice neighborhoods in the city, the glittering residential and shopping area east of North Michigan Avenue that Chicagoans call the Gold Coast. The land, owned by the State of Illinois but leased for $1 a year to the museum, extends east to Lake Shore Drive. It is flanked to the south by the Collegiate Gothic structures of the Northwestern University Chicago campus, to the north by a row of buildings—mostly apartment blocks—of varied use and roughly equal height. Into this area the museum fits comfortably and unobtrusively, reminding the viewer of the statement made by the chairman of the Board of Trustees of the museum, Allan M. Turner, "We did not want to drop a spaceship on that wonderful piece of land." Kleihues succeeded in avoiding any hint of self-referential arrogance in his building. There is nothing startling about the museum in its setting, although some of the notions he toyed with during the planning process, including a ramp that would have extended east from the site, literally above Lake Shore Drive and ending at the edge

Initial study of site layout, 1991

Sketch of entrance façade, 1993

Axonometric sketch of sculpture garden, 1995

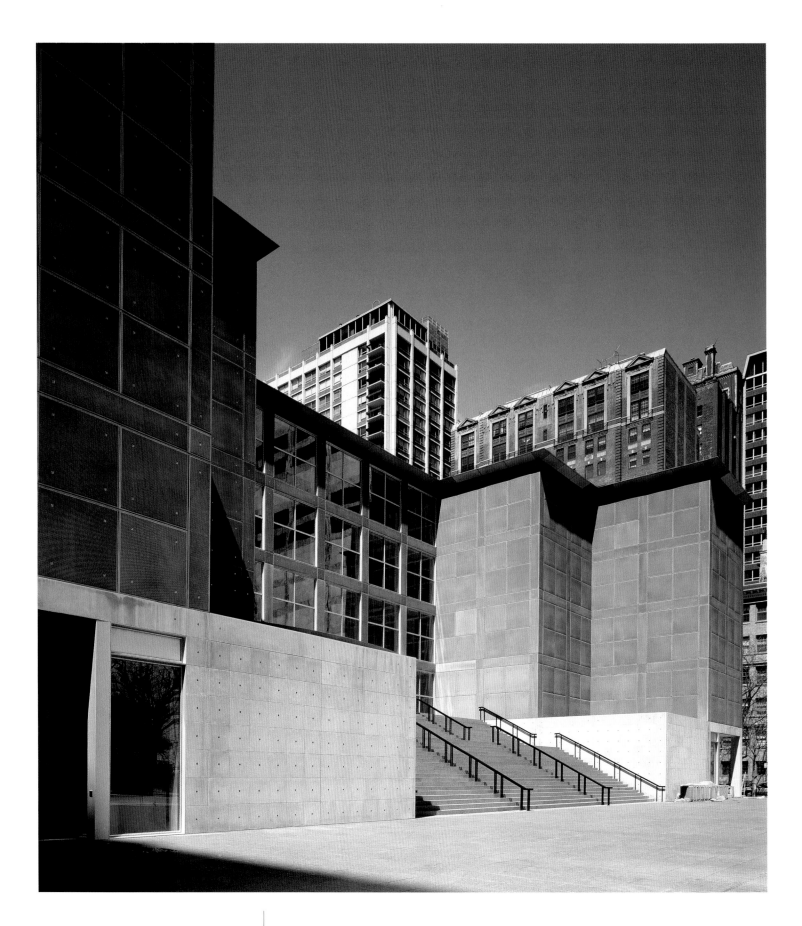

Entrance front

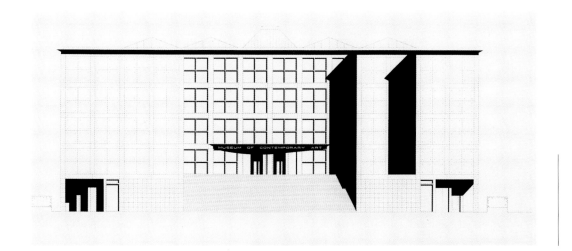

Elevation of entrance front

Window detail in
entrance front

of the lake, would have been not only exotic by Chicago standards but probably impossible to achieve, since the city has historically, jealously—and successfully—guarded its spectacular lakefront against nearly all architectural intrusions.

If the building is at home in its neighborhood, it has nonetheless been greeted by more than occasional criticism. Many visitors have seen it as cold and severe, so ruthless in its symmetrical massing that one searches in vain for any sign of warmth, especially on the western front. The single exterior passage of relief is the sculpture garden, which lies just to the east of the main block. Here Kleihues wisely granted the overall design a kind of informal freedom of plan and terraced elevation. As one surveys it, the easy descent to a lower level is animated by sculptural objects that, together with the vista toward the lake, add up to a fetching panorama.

Local response to the interior has been decidedly more favorable. In the parlance of the profession, the museum is an "inside" rather than an "outside" building. Once visitors have climbed the slightly intimidating front stair and entered the foyer, they are struck by the brilliance of the light, by the high, wide, and deep sense of space all around them, and by the use of bone-white paint on all the walls, a device that only adds to a quality of chaste luxury. Turning around and glancing back through the entry and its immense, persis-

tently square-shaped windows yields a view of a small park beyond which stands the city's historic and much beloved nineteenth-century Gothicized folly, the water tower. There again one appreciates Kleihues's thoughtful reaction to the special site he built upon. The sensation provided is pure Chicago, with the aforementioned walls of buildings flanking the park and the museum underscoring the city's consistent rectilinearity of plan and elevation. Kleihues's geometry also seems appropriate in the light-drenched foyer. He has relaxed the dominant symmetry somewhat, adding a two-story museum store to the southwest, and opposite it, to the northwest, a rather handsome stair, the plan of which is shaped like a mandorla.

Before one follows it, however, a long corridor to the east beckons, tracing the museum's longitudinal axis and serving to bifurcate the main space into two huge galleries that are meant to accommodate temporary exhibitions. The decision to separate these areas has led to more criticism, chiefly by those who find the division not only arbitrary but spatially disunifying. Kleihues's purpose was, of course, not only to reinforce the symmetry of the plan but to provide an inviting view toward the lake beyond, which is visible again through more of those vast modular windows. Before visitors get that far, they have entered the museum refectory, well sited, since the long, wide vista can be not only enjoyed but studied at length over the boon of food and drink.

The museum's permanent collection occupies the top floor, a space given over mostly to two pairs of barrel-vaulted galleries laid out parallel to each other and separated by the two-story-high central corridor. Skylights illuminate both exhibition areas, which are connected by a particularly winning small gallery that looks east to the lake, west to the hall below. This may be the most exhilarating passage in the museum, as light, airy, and spatially expansive as the building's exterior (which

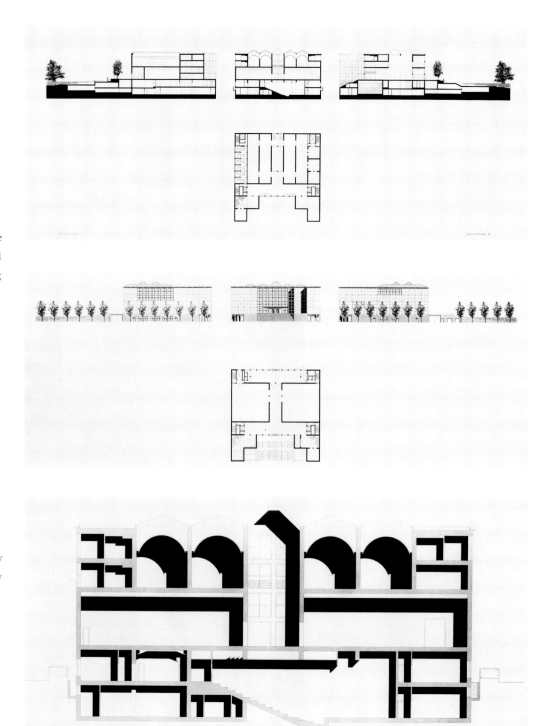

Sections and 4th-floor plan

Elevations and 2nd-floor plan

Cross-section through auditorium with galleries for temporary exhibitions on 3rd floor and for the permanent collection on 4th floor

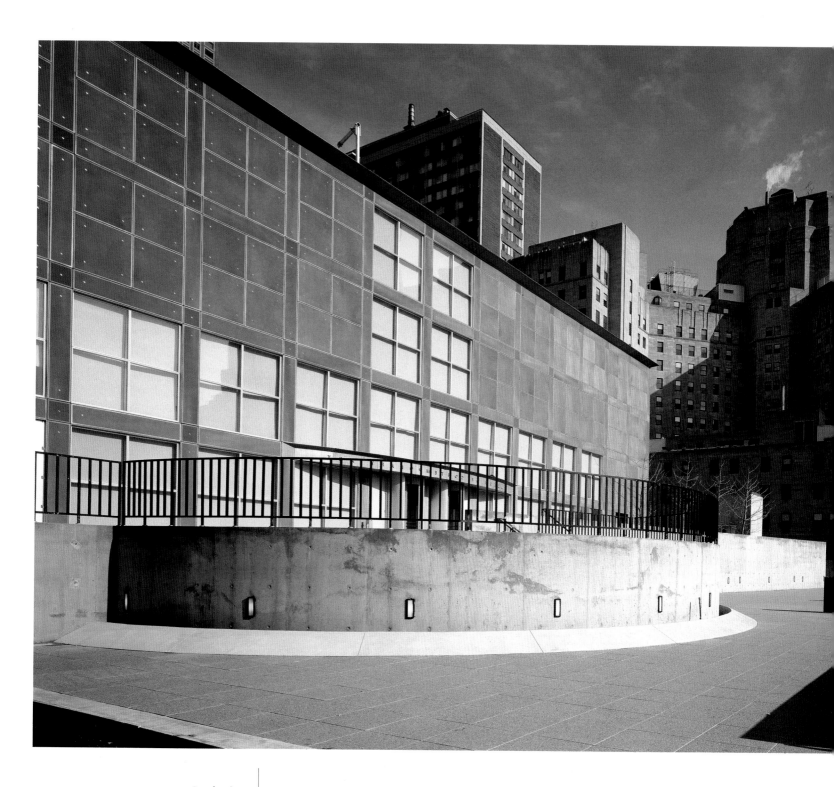

Rear façade

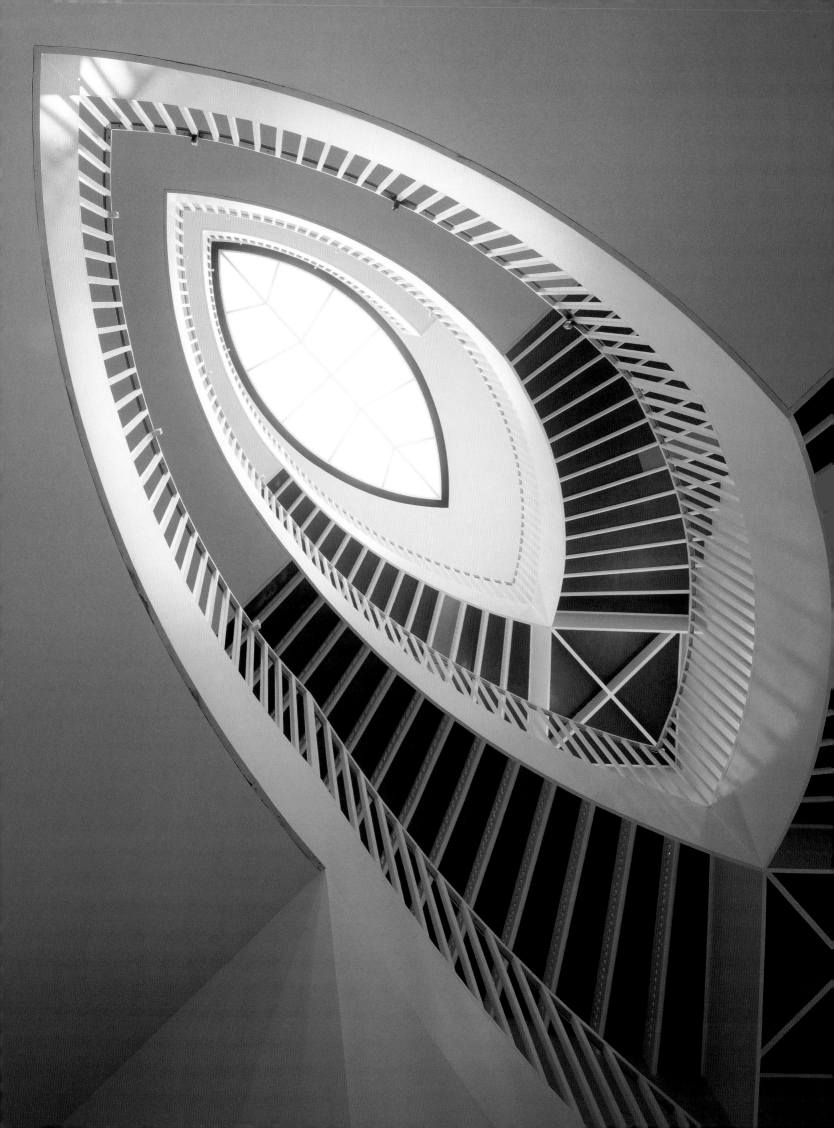

a visitor may almost have forgotten by now) is glum.

The ground floor comprises for the most part the education center and the auditorium. The emphasis there is perceptibly functional but effective. A parking garage is attached to the building at this level. Since it descends below grade, curving past uncomfortably narrow parking spaces, the viewer may wonder why none of the main parts of the building is underground. Had it been so designed, the exterior entry stair might have been less austerely steep and the whole structure correspondingly more ingratiating. By the time this thought occurs, it is purely idle speculation; the building would have borne an altogether different character and scale. As it stands now, some three years old, it adds up to a formidable work, but one of mixed blessings, which on balance Chicago seems gradually to be learning to accept, if not—at least not yet—to love.

Franz Schulze

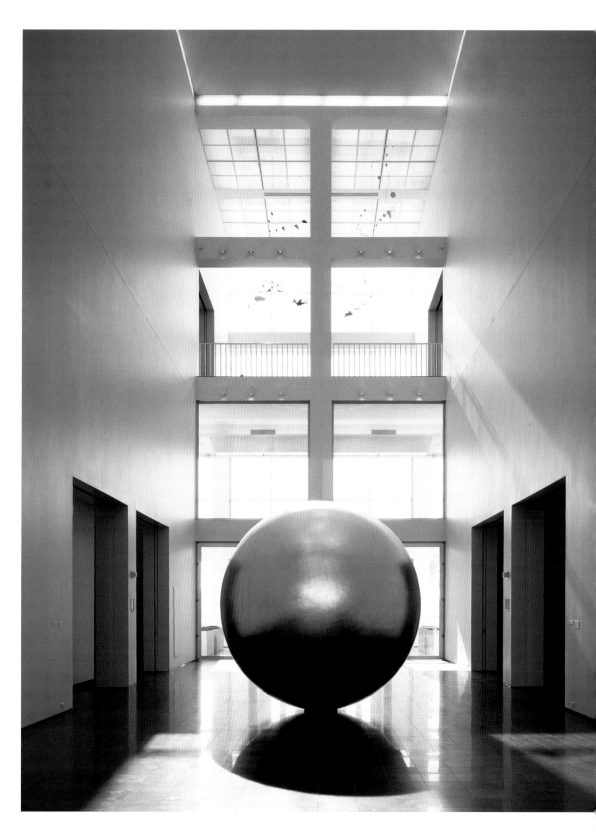

Stairwell

View of third-floor atrium with sculpture *The Monument to Language* by James Lee Byars (1995)

José Rafael Moneo
The Museums of Modern Art and Architecture
Stockholm, 1991–1998

Sketches

External view

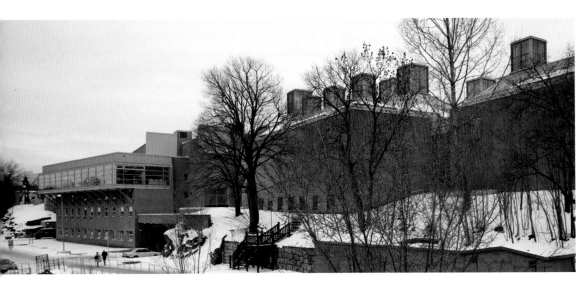

Over time, Rafael Moneo's interest in northern architecture has been an essential part of his training. In 1961, a year spent apprenticing with Jørn Utzon, personal knowledge of Alvar Aalto's work, and proximity to the work of Gunnar Asplund all have strongly influenced the intellectual path of this architect from Navarre. In his professional activity, these interests seem to have been translated principally into an increasingly in-depth investigation of the use of natural light. And yet paradoxically, perhaps one of the most obvious signs of his Stockholm museum's integration into the urban landscape is provided by a night-time view of the artificial light from the lantern skylights scattered throughout the roof of the building. It is an easily recognizable lighting scheme, but it is homogeneous with that of the adjacent buildings and, more generally, of the city. Thus one can intuit the idea around which the design tenaciously revolves: the integration with the site, overcoming every temptation toward monumentality and self-representation—a goal that is not easy, if one considers the characteristics of the site and the program.

In 1990 the city of Stockholm held a competition for the construction of a new complex to house the Museum of Modern Art and the Museum of Architecture on the island of Skeppsholmen. It was an open competition for Swedish designers, but an invitation to submit proposals was also extended to five international architects: Tadeo Ando, Frank O. Gehry (who did not, in the end, participate), Kristian Gullichsen, Jørn Utzon, and Rafael Moneo, who was the winner. The program, while detailed, left the designers

particular freedom with regard to the choice of site. Until the last century the island had been a logistical center for the Swedish navy; subsequently it was converted into a cultural hub. The building fabric is fragmentary, made up of minor historic structures arranged over an irregular and varied terrain.

Rafael Moneo began with a realistic evaluation of this context and its specific dynamics of environmental equilibrium. He developed a solution based on a dialogue with the surrounding buildings and with the skyline of the city, rejecting a conspicuous architectural gesture. He then opted to use the central area of the island, precisely identifying the point where his museum could be sited horizontally along the north–south axis. On the one hand, he wanted it aligned behind the long, regular parallelepiped of a former rope factory, the Tyghuset. On the other hand, he wanted to open up the view toward the sea and the city above, beyond the canal. It is a piece of terrain that slopes down toward the water, offering a particularly varied and advantageous situation in terms of both landscape setting and function, since it allows two different levels of access to the building. But it is also an "interstitial" space, as the architect himself has described it, and as such it presents a challenge, offering well-defined surroundings, both natural and artificial.

Having established the coordinates of the layout, Moneo drew up the plans. He made two significant decisions with regard to pre-existing structures: to demolish the old Museum of Modern Art building from the fifties, and to incorporate the old military gymnasium, a T-shaped structure dating back to 1850–1910. From this point on, he proceeded, keeping in mind both the site and the problems inherent in the construction of a modern museum space.

His respect for the local situation led him to orient the design toward the island's interior. Nothing is revealed to the visitor who arrives by way of the bridge

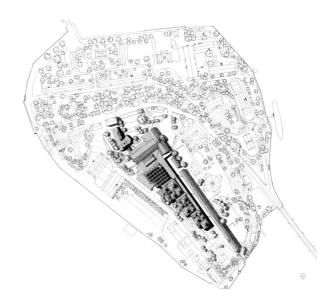

Site plan

External view of lantern lights

Aerial view

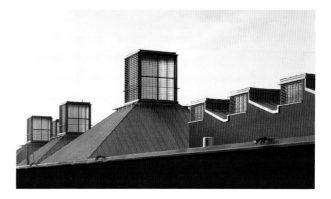

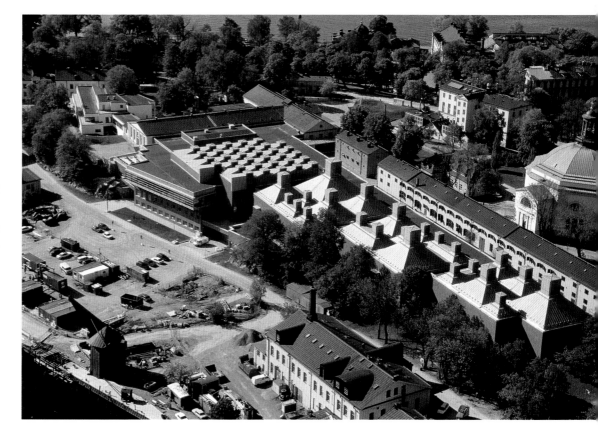

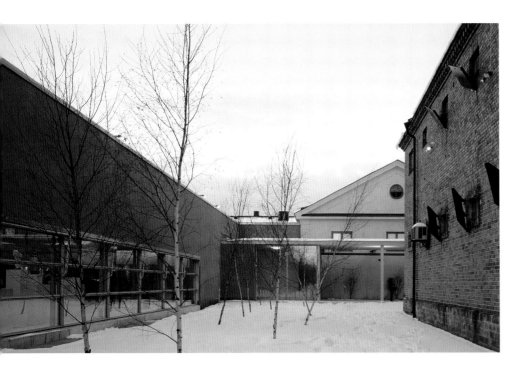

Courtyard

Elevation facing sea

Longitudinal section A

Cross-sections B, C, D, E

that connects the island to the mainland and who then climbs the slope to its summit. Only there, at the top, the main entrance unexpectedly appears, discrete and on the second story compared to the adjacent structures, framed by a flat roof that welcomes exploration.

The view of the complex from the side facing the sea is entirely different and makes an immediate impression. The wing housing the Museum of Architecture (added at a later stage of the competition design) emerges from the south, running northward. It is modernist, white, with bands of windows and a flat roof. The former gymnasium is preserved in its original condition, with a double-pitched roof. The central building element corresponds to the reception hall, with a projecting, glassed-in area for a restaurant. Finally, the Museum of Art pavilions, almost entirely windowless, are covered in red brick, with lantern roofs.

Formally, the fragmentation of the context seems to have been reabsorbed "as is" into the design: a series of interrupted and linked volumes, receptive to the austerity of the nearby constructions and, at the same time, aware of their own identity. In reality, careful analysis reveals the "fragments" to be well consolidated and responsive to a desire for unity that controls the entire intervention, which is designed to reduce any impact on the site. This is a new application of the theme of unity, the result of an investigation of compositional form that Moneo has been working on for some time, as seen in recent projects, from the Murcia Town Hall to the Don Benito Cultural Center in Badajoz, to the Houston Museum.

In Stockholm, the complexity of the compositional scheme is fully revealed in the experience of the interior spaces. The geometric design of the plan is the organizing element, without being constrictive. It allows freedom in the arrangement of the spaces and, consequently, flexibility of use. A great hall acts as a hinge between

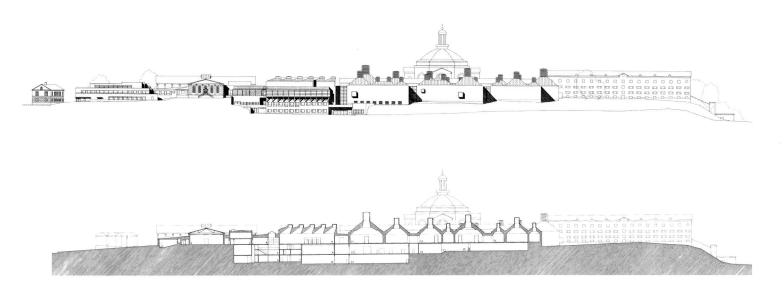

the two museum institutions. The Art Museum is developed northward, organized along a corridor-gallery that faces onto the rope factory and the garden that has been placed between, which introduces a visual perspective and resumes the sightlines of the Tyghuset. The museum itself has a spacious hall for changing exhibitions and three pavilion units for the permanent collection, which includes works of the international avant-garde from the fifties to the seventies and contemporary Swedish works.

The pavilions are organized in blocks, with square and rectangular rooms of different dimensions and proportions, slotted one into the other to form compact configurations. The basic module of the grid measures 6 meters by 6 meters. All hierarchies are annulled, but a rhythm is maintained, thanks to the small spatial intervals that detach one block from another. The neutrality of the geometry of the rooms is reinforced by the natural overhead light, obtained through skylights opened in the truncated-pyramid-shaped ceiling. This is a solution that guarantees an ideal relationship between the diffusion of light and the height of the spaces. From the beginning, Moneo's adoption of a horizontal scheme for the complex was firmly bound to a decision to use an overhead source of light. This is a logical duality, classical in tradition, supported by positive experiences

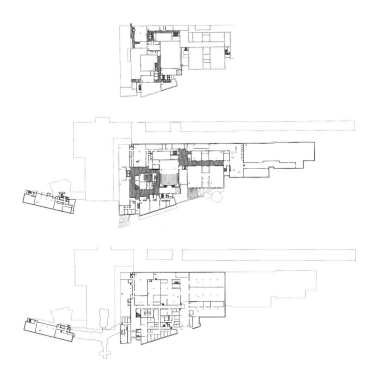

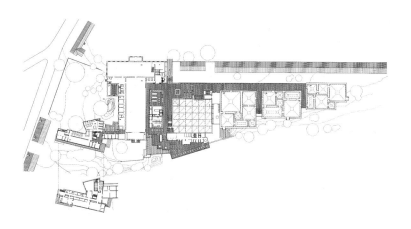

Fourth-floor plan + 11.4 m

Third-floor plan + 8.6 m

Second-floor plan + 4.8 m
and + 3.7 m

Plan of entrance level + 14.3 m

in previous museum projects. Here the optimal relationship between the plan and section of the rooms, the correct slope of the roof and the best effect of light in the spaces have been established through a series of studies using models.

No external interference disturbs the abstract calm of the exhibition spaces, with the exception of one element that recurs once, or twice at most, in each pavilion— a sort of small homage to the museum's panoramic position. A square window, telescoping outward, re-establishes an ori-entation with the outside world, but also proposes a rediscovery of a very particular-ized view of the city.

Throughout the complex, careful attention is paid to the relationship with nature. Museum offices, the art and archi-tecture laboratories for children, and the restaurant have large windows looking out toward the sea, while the library and cafe-teria of the architecture section open up toward the interior garden, where sculp-tures by Picasso have been installed.

The 6,300 square meters of the Muse-um of Architecture (compared to 19,300 for the Museum of Art) also are organized like a perfect machine, in accordance with the dictates of modern museography. A distinctive dimension characterizes them within the overall scale of the project. The generous space of the former gymnasium, set aside for permanent installations, the spaces to the side of this structure, ear-marked for changing exhibitions, the research laboratories, the archive (on sev-eral floors), the small auditorium, the two-story library, the offices, the storerooms: these are the spaces assigned to accom-modate the various and important activi-ties of an institution that contains a collec-tion of two million pieces, including drawings and documents, over 1,000 models, and approximately 25,000 books. Here there is no trace of satisfaction in formal redundancy, but only the expres-sion of a rigorous lucidity of thought.

Rita Capezzuto

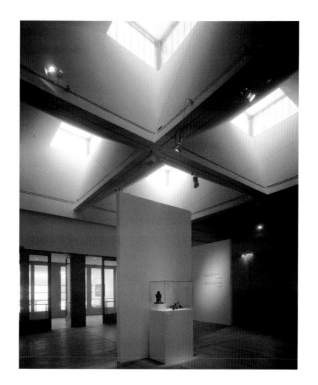

Gallery for changing exhibitions

Gallery space

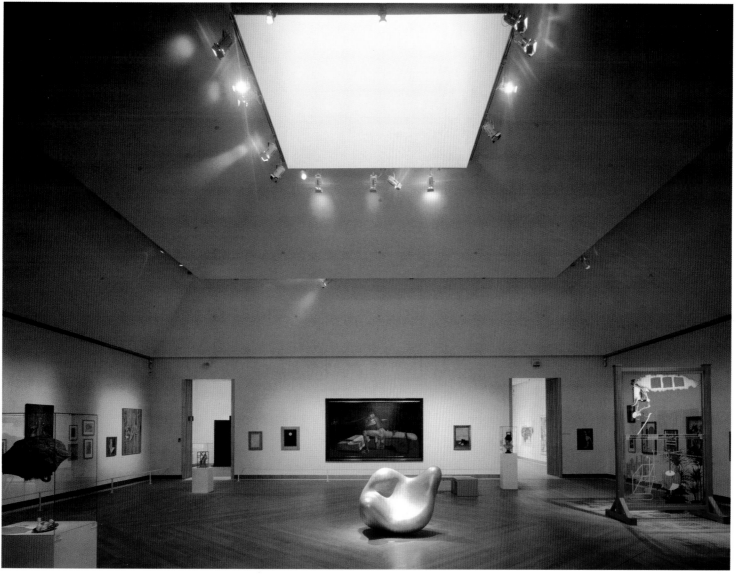

Jean Nouvel
Fondation Cartier pour l'Art Contemporain
Paris, 1991–1994

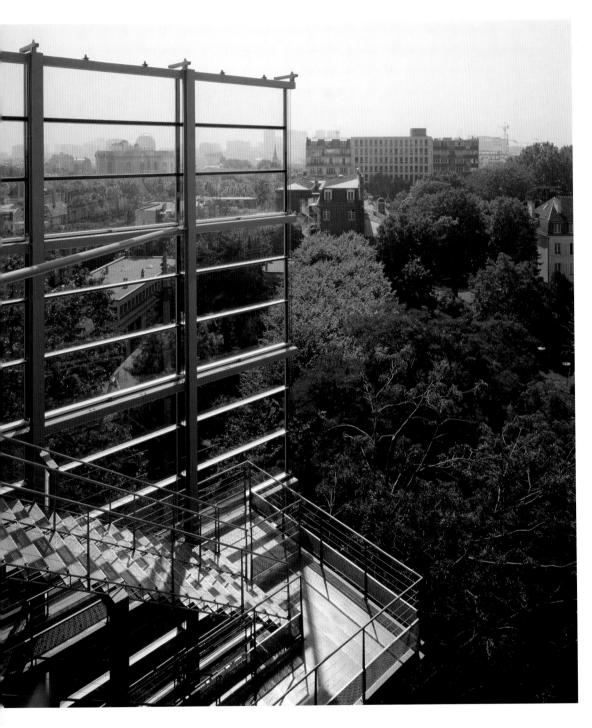

End of façade with
external staircase

The Fondation Cartier is one of the few private sponsors of contemporary art in France. At first, the foundation's studios, exhibition pavilions, and sculpture garden were housed at the château in Jouy-en-Josas. When a new building was planned for the Cartier headquarters in Paris, a decision was made to utilize one third of the building for the changing exhibitions of the foundation. Cartier Chairman Alain Dominique Perrin is a great collector of contemporary art. His foundation aims to be a forum for young artists from France and abroad. In addition, some of the foundation's collection of works by more than 200 artists are regularly shown here or in other institutions.

The building was completed in 1994 and is located in Montparnasse where the Boulevard Raspail ends at the Place Denfert Rochereau. At first glance, neither its full cubature nor its construction is clearly evident. A passer-by notices only an 8-meter-high glass front that runs parallel to the street. The conventional idea of façade dissolves, however, for upon closer inspection the observer realizes, not without irritation, that behind it lies not a building but a garden with cropped chestnut trees. We look into a quasi-terrarium open to the sky. The free-standing wall of clear glass is thus transformed into a display window onto an artificially re-created natural landscape whose dimensions remain unclear. The house itself is twice as high and set back from the street by 12 meters. Its true contour is not immediately apparent, because the glass and steel façade is both wider and higher than the volume of the building, whose width occupies only the twelve middle fields

in a total of eighteen axial fields. The unoccupied fields on either side are also glass clad across the full height of the building. On the top floor with patios, the façade dissolves into a framework construction. Jean Nouvel and his former partner, Emmanuel Cattani, have already designed a production hall and a warehouse (in Fribourg, Switzerland, and Saint-Imier, respectively) for the venerable firm, which was founded in Switzerland in 1847. The client at 261 Boulevard Raspail is an insurance company. Although Cartier was only a "tenant," it was able to choose the architect.

An old tree with a history of its own provided the inspiration for the design concept. As the story goes, Chateaubriand himself planted the tree (a Lebanese cedar) in the forecourt of his home at the very spot where it still grows today, a few meters back from the boulevard, although the house is long gone. Jean Nouvel insisted that the building, too, be set back from the street. Hence the idea of a glass wall in front of an open garden space with a view into the exhibition room. One positive side effect of this inspiration is good noise protection. The entrance is the only wall opening; from it a path leads beneath the imposing crown of the tree to the actual building. On the courtyard side the strong pressure and suction forces that act upon the free-standing glass wall are absorbed by heavy steel supports and horizontal tubular bracing that anchors the wall to the building behind it. The view through the multiple glass walls dissolves boundaries. Light reflections, mirror effects, images of real and virtual trees, a glimpse of art installations in the background, and finally the transformation of the glass surfaces themselves into projection surfaces, all these elements combine to create a fascinating maze. The building is even more enigmatic when it is brightly lit at night. The full scale of Nouvel's mysterious and at times odd play between material and immaterial appearances unfolds before our eyes.

Fondation Cartier in the Boulevard Raspail

Street face

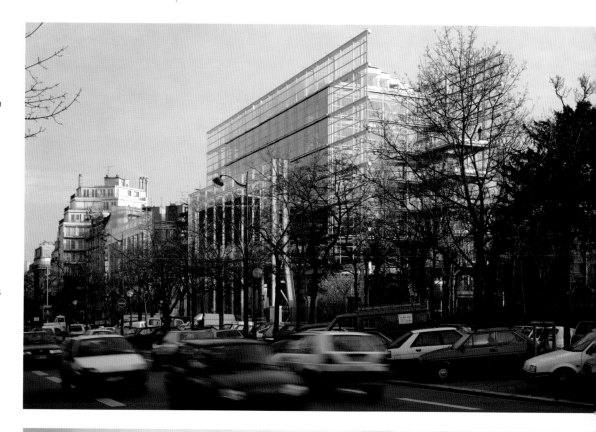

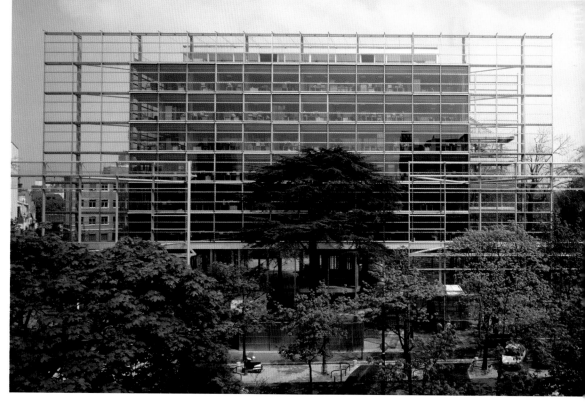

Spectacular façade designs are a trademark of his buildings. The Institut du Monde Arabe, completed in the late eighties, created a sensation with 27,000 photographic lenses that projected ornamental Arabian designs (from) behind a giant glass skin.

In the Fondation Cartier, Nouvel demonstrates once again how theatrical his concepts are, albeit with completely different means. New dimensions of space are presented whose rigor, however, makes no claim to satisfy the traditional demands of a house. The dark-tinted glass skin of the Cartier building itself consists of floor-to-ceiling suspended glass curtains. Uniformly square, each section is divided into three horizontal fields. External rollable curtains clank like rigging in the wind. Once inside, the visitor is faced with a large exhibition hall which occupies the entire ground floor and is almost fully glazed. Behind the entrance, positioned just off center, a mezzanine floor has been integrated to structure the space and function as reception area. To the sides, unpreten-

Site plan

Cross-section

Longitudinal section

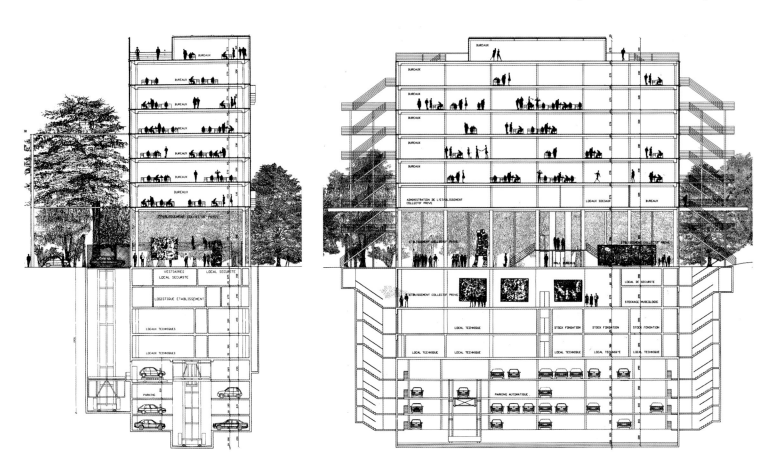

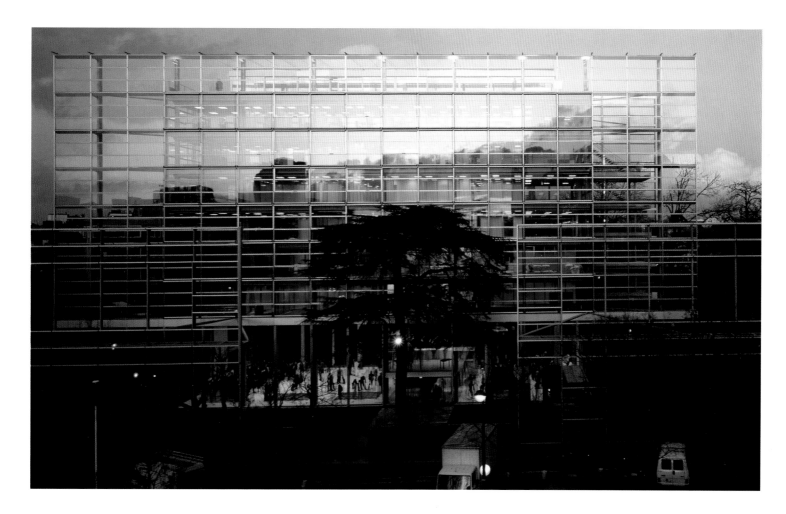

View from road at dusk

tious details worked in steel are a refreshing surprise. To the right and left of the entrance are exhibition areas for large-scale installation works, which are changed every three months.

Nouvel describes the hall as an *espace nomade* that gives artists free rein in the placement of their work. They are invited to interact with or to negate the surrounding space. The wider area, to the left of the entrance, features three square glass panels inlaid into the floor. They can be lifted up to allow for installations across two floors. The hall can open onto the garden at the rear with floor-height glass doors that slide into the external façade framework, making it possible to include the outdoors. Open-air events can be watched from the interior, and, conversely, for spectators seated in the garden, the interior can become a giant stage.

No effort was spared to add new trees to the existing arboretum. These mature

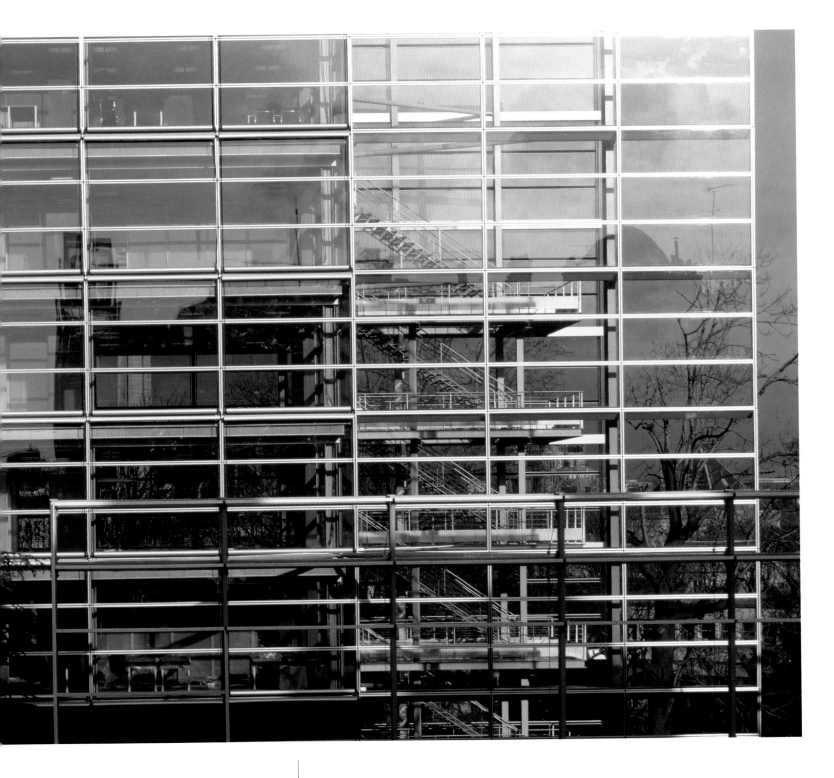

Detail of façade

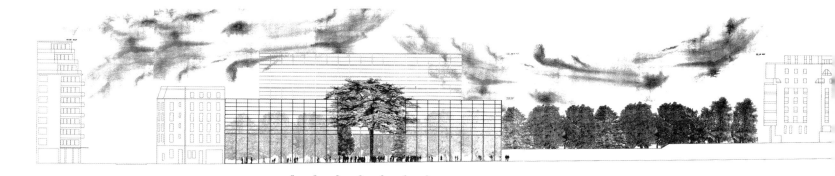

Elevation from
Boulevard Raspail

North elevation

East elevation

South elevation

West elevation

trees complete the garden composition on the property, which ends in a sharp point and is surrounded by an old enclosure wall. Lothar Baumgarten has installed a *Theatrum Botanicum* (botanical theater) in the garden. His concept for the small, gently inclined property was envisioned in response to the glass structure. Wide steps with a slight concave curve meander between the trees, some of which have been newly planted. To the rear, a flight of stairs leads to a meditation room, elliptical in shape and open to the sky. Baumgarten's landscape design is intended as a union of staged nature and of architecture. It is itself an autonomous work of art to which nothing can be added and from

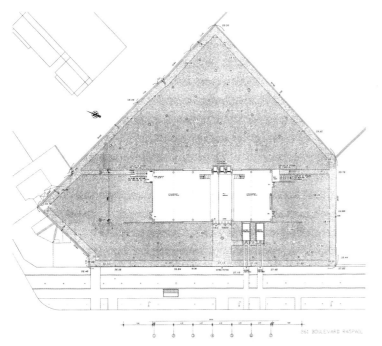

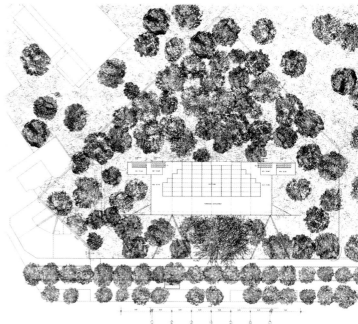

which nothing should be eliminated. The walnut tree, the acacia, the ferns, all are elements in a precise composition. In a matter of minutes the entire glass hall can be transformed into a closed "white" or "black" room with the help of motorized, 8-meter-long rollable curtains. The "art showcase" metamorphoses into an introverted space ideal for projections. The exhibition area below ground is only 6 meters high. Plans for a sunken sculpture garden complete with outdoor lighting—after the model of Mies van der Rohe's National Gallery in Berlin—were abandoned. The result is a whitewashed space with no link to the outside and limited flexibility, with sparse daylight provided only through the three glass panels in the ceiling. The Cartier building has no interior stairs. To reach the seven upper floors with offices, all visitors cross through the exhibition hall on their way to one of three glass elevators. The building's only two staircases are also external, placed along the rear façade, which stretches far beyond the building itself. At the opening in 1994, installations by Richard Artschwager and Ron Arad were shown. In 1999, the program includes among others, Issey Miyake with *Making Thinks* [sic] for *Vête-*

Ground-floor plan

Plan of roof

Exhibition hall

ment[s] par-delà le temps and Gottfried Honegger with *Ma métamorphose*. With the Cartier project, Nouvel has created a "building without design and detail." He even calls it "un bâtiment anti-design" and likes to criticize the shallow, high-tech installations that are so often added to other glass and steel buildings in an attempt to signal newness.

For Nouvel, the Fondation Cartier was an attempt to exercise the theory that the maximum in volume could be renounced in architecture. Rigid boundaries are glossed over. The materialization of this ambition has, however, resulted in rooms that offer only a limited set of new qualities for art. The ground floor does not lend itself to paintings, and the surfaces in the basement area are rather humdrum compared to the building. Nevertheless, artists can take possession of the room in this glass palais—and, like the architect, they have a chance to try out a new scenario.

Sebastian Redecke

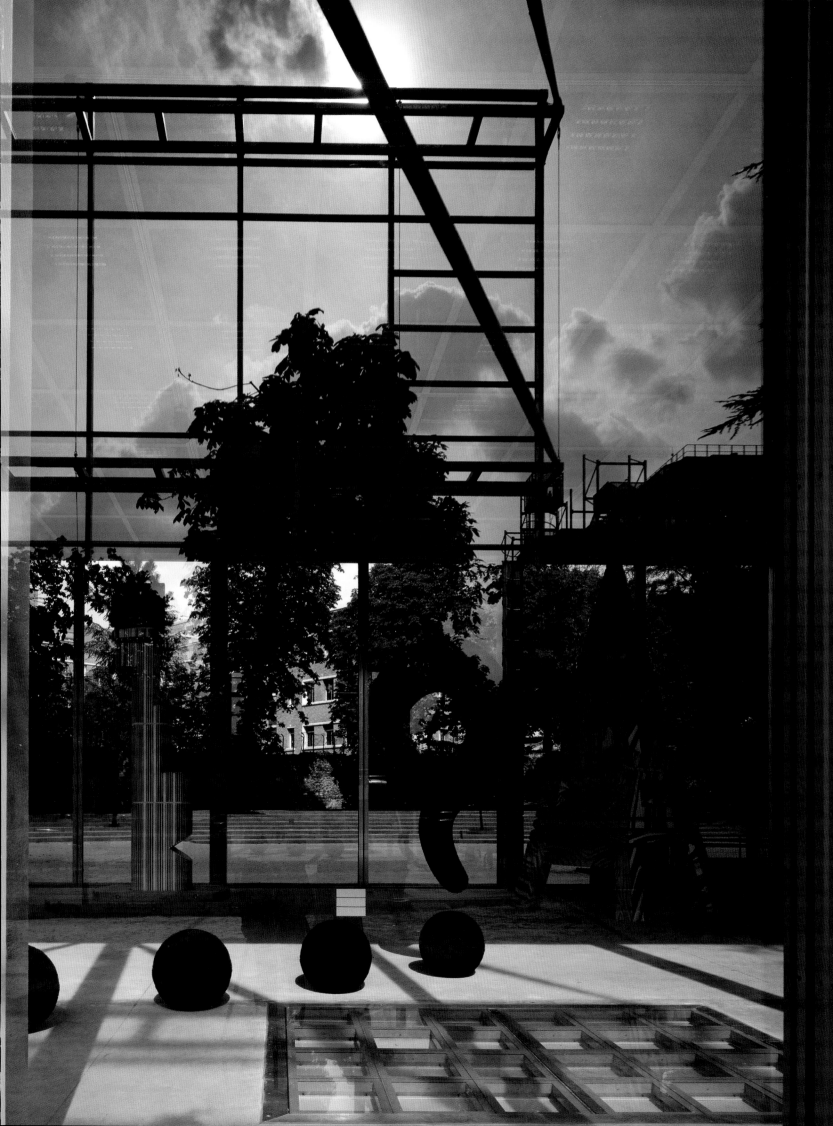

Renzo Piano
Beyeler Museum
Riehen near Basel, 1992–1997

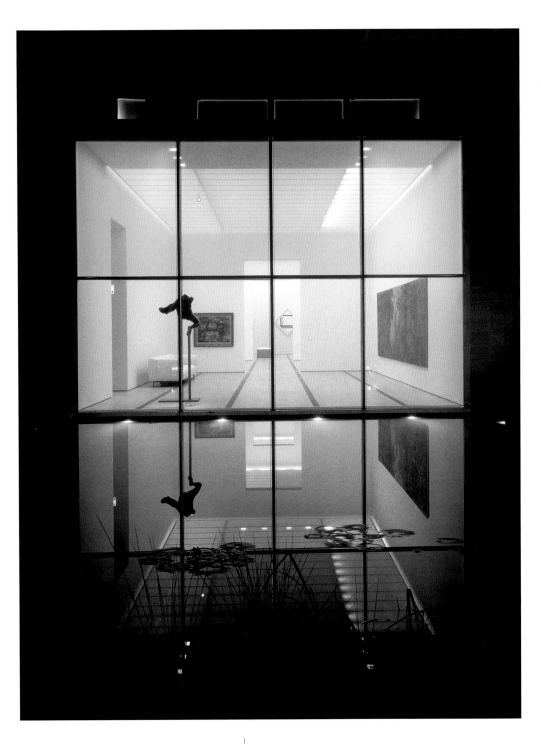

View across pool of water
into Monet Gallery

Architecture, like collecting art, is a long-distance discipline; and for Renzo Piano the path to the Beyeler Museum was a long one. It began with a bang. In 1978, when the Centre Pompidou opened, it was the sensation of the decade. It was no longer a building, but rather a machine, Le Corbusier's "machine à émouvoir." Only upon closer study does the machine reveal itself to be a gigantic stack of artificially lit utilitarian spaces, a six-story, multipurpose hall. Inside are black non-spaces, bare containers for rotating exhibitions. The Centre Pompidou is an exterior building; everything that makes it good happens outside on its skin. But something is radically missing: the light and its control.

Piano is a functionalist of the inventive school and thoroughly studied the lesson of controlling the light after Pompidou. The architectonic and artistic theme of the Menil Collection in Houston, Texas, which was opened in 1986, was natural light: zenith light, daylight from the sky. To that end, Piano developed a technical building element that determined the very nature of the museum: a translucent roof. Wanting to control the ambience, and thus needing to control the light, he invented a clever system of coordinated roof elements. In step-by-step development, the "leaves of light" grew—organically formed concrete louvers that filter and distribute the light, reduce its intensity, and form the wave-like ceiling of the exhibition spaces. The solution of the daylight as a partial problem determined the solution of the museum as the main problem.

Piano deliberated, made assumptions, and tried everything. He does not distance himself from any notion more decidedly

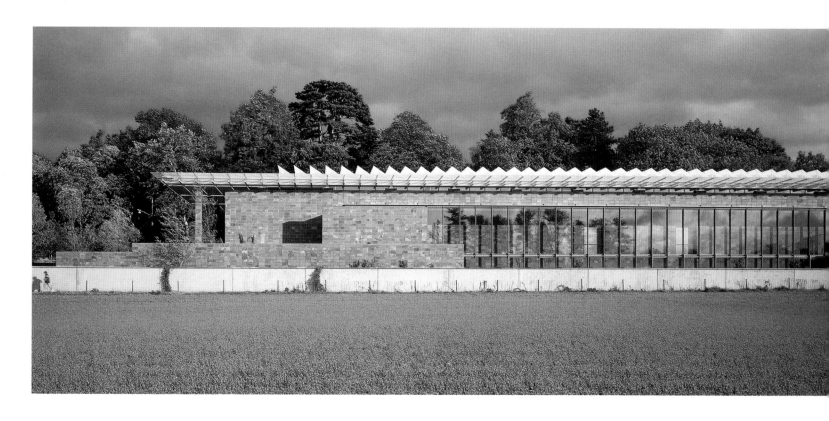

than that of the architect as genius, in whose mind and heart an idea appears as the divine spark. Trial and error—first on paper, then with models, and finally at one-to-one scale in the laboratory—this is Renzo Piano's method as the practical-minded architectural scientist. Ernst Beyeler saw the Menil Collection. It convinced him about Piano.

In Riehen, Piano paid attention to the terrain—a narrow, gently rolling piece of vineyard. He found a wall here. It separated the street from the agricultural land, a clear truism. But this wall does more: it steers our view. It creates a "before it" and a "behind it." It turns its back to the street and peers out into the landscape, looking upon an unobstructed green field and the Tüllinger hill beyond, whose crown is adorned with something medieval. The subject for a postcard.

But the wall follows the street along a bent line, thus emphasizing the parcel's elongation. Still more: the second wall, too, a garden wall that separates the site from the open farmland, runs parallel to the street wall. Thus, Piano found two directions on the land: the transverse view

West face

Site plan of museum in Berower Park showing the existing villa

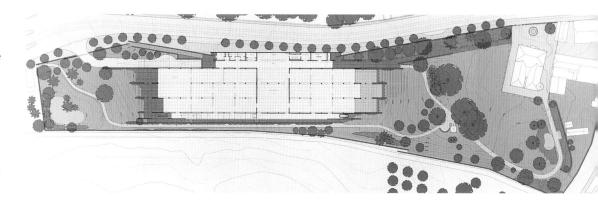

into the landscape and the longitudinal movement of the walls. He reacted to that with the four sides of the building: the closed wall against the street, the winter garden against the distant landscape and the view out into the park at the ends of the building.

The wall is old. It tells a story—a story of the Berower estate as a patrician seat, as a form of dominion, as an agricultural unit of production. It tells of privileges and their downfall. Walls protect, walls exclude, and walls confine.

This wall must have particularly impressed Piano, since he elevated it to the generative element of his design. He built a museum out of a series of four parallel walls. They reach into the park and anchor the building to the land. They establish the horizontal and emphasize therein the movement of the land. The ground waves become readable at the "water line."

The walls are heavy. Piano, the former featherweight builder, found particular joy in giving his walls weight. He cladded them with unplaned red porphyry from Patagonia. Piano emphasizes that porphyry is geologically ancient, having been formed before the continents drifted apart. Must these walls suffice for eternity? Might four fragmentary wall planes—long, parallel, and secretive—be witness some day to the Beyeler Museum?

Above the walls is the roof. Piano enjoys the contrast between the heavy walls and the light roof, "a butterfly, who lit upon the four walls." The connection to the walls remains hidden. The urge to demonstrate how these things are assembled, which was all too clear at the Centre Pompidou, has seemingly been brushed away. Nothing more need be claimed, nothing more need be proven. The construction has withdrawn into the background.

The building form has settled down as well. More exactly, it no longer appears in its totality. Embedded in the park, the building—nonetheless 110 meters in

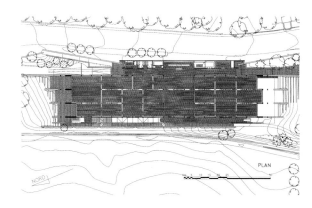

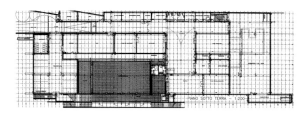

Ground-floor plan

Basement plan

length—ducks down into the ground. It does not want to draw attention, none whatsoever from the street. Piano refrains from big gestures, adapts himself, and even seems to have grown a bit Swiss in it all. One of the most noteworthy private art collections in the country is displayed in a pavilion that is indeed elegant but still as unpretentious as possible. In a discrete place, in a suburb of Basel, art makes no noise. Whereas the Centre Pompidou was an angry overstatement, the Beyeler Museum is the whisper of understatement.

The building is a tailor-made suit for an existing collection. Piano had every piece of art photographed in order to have all of them present in his studio. The interior organization heeds the walls. The package of service spaces lies neatly placed against the street in the closed layer of the building's backbone. There follows the entrance zone, where—here and only here—one feels the size of the building. One proceeds from the entrance portal along the wall, spots the white glass roof for a moment among the trees, and comes down a gentle slope toward the main entrance. One enters and—peering through the entire building—sees far ahead out into the garden. One enjoys the view and vista, with the length of the building on show.

In the center of the entrance zone lies the piazza—a space of reception. Whoever has reached this space has arrived, with the longitudinal movement of the parallel walls now standing still. Here we are retuned. The large landscape panorama retreats as we delve into the museum. Outside stays outside. We find ourselves in another, closed, world.

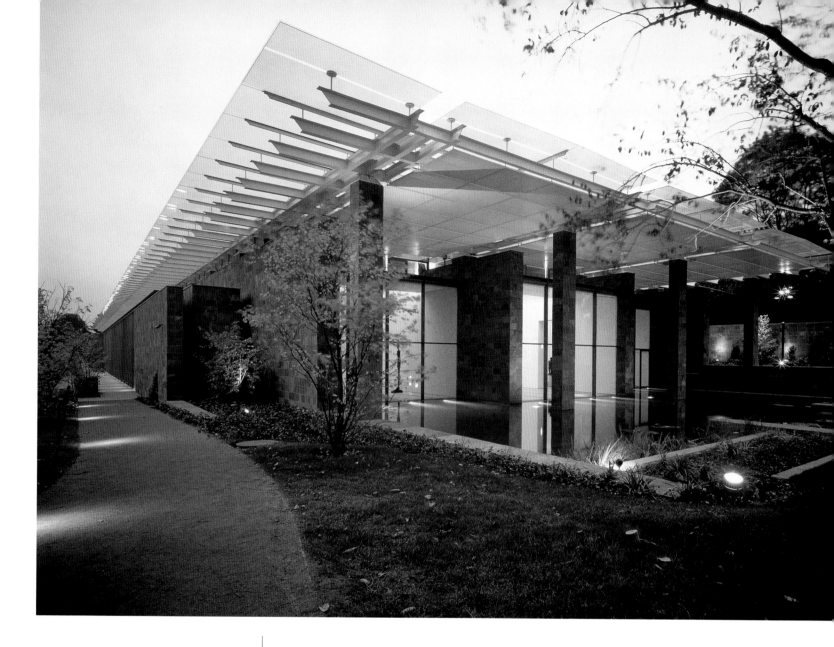

View from southwest

West elevation

East elevation
with existing villa

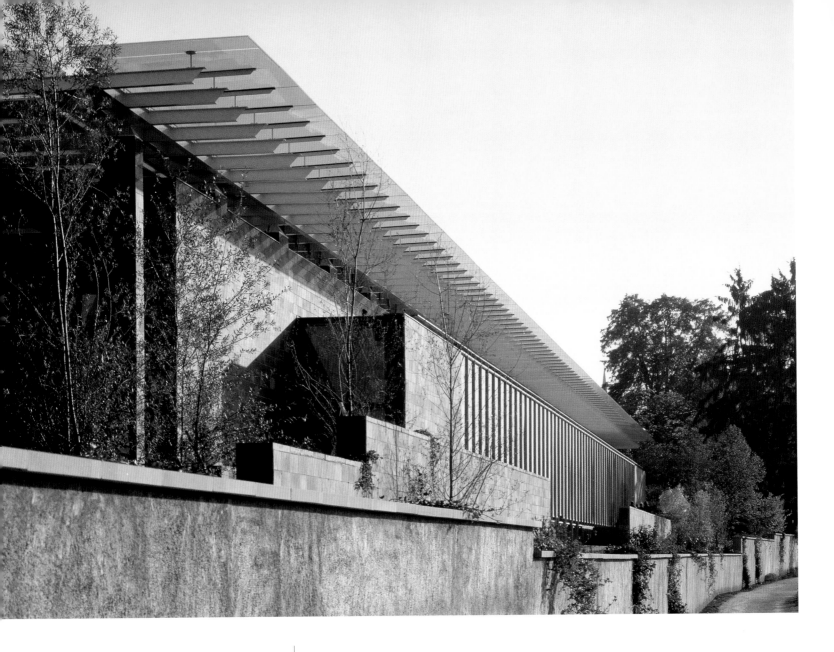

View from northwest

Inside the building there are no prescribed paths and no enfilades. The directions, which had been of such importance outside, are now forgotten, while the walls that informed the design become indistinguishable from the transverse walls. Outside and inside have nothing more to do with each other. One only sees out of the narrow end façades. But one sees only into the garden, and not into the landscape.

In the Beyeler Museum there is no more architectural vanity to be found, trumpeting its self-importance with spatial excess. No ramps, no free-standing stairs, no vistas and no detail games. The architecture can take leave, its job now done. It has generated neutral and bright spaces. The pictures remain. Pictures in light, in natural light. Piano brought his experience from the Menil Collection to Riehen. Yet the light machinery is no longer the spatial generator; it has retreated into a light chamber above the halls. Yet it is still quite extravagant and must be able to do everything, meaning it must allow every possible type of mixed light as well as provide the lighting at night.

Daylight, though, should proclaim the day. The weather, the time of day, and the turn of the seasons—in short, the natural oscillations of the light—are not filtered out, homogenized, and denied. Rather, they remain perceptible within the exhibition spaces. One never sees the same picture, only the same picture in ever-changing light.

The exhibition spaces are at ground level and can be reached by the piazza. Besides the technical rooms and an archive, the lower level has an auditorium equipped with all possible technical equipment, allowing lectures or performances in all possible media. It can also be used as an exhibition space and receives light from the side through the winter garden. The winter garden is positioned like a gallery in front of the west façade. Here one can recover from the work of viewing art. One's eye strays out into the greenery,

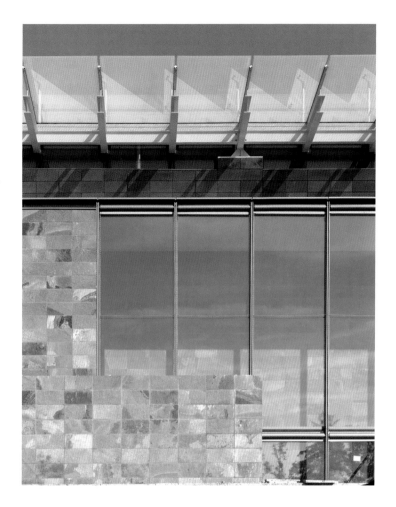

Detail of west façade

Section through roof

Cross-section

Part of longitudinal section

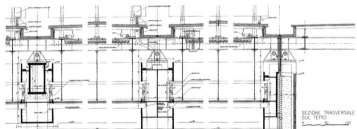

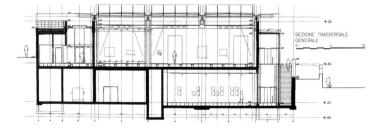

while the mind grows meditative. The winter garden layer also refers to the stair from the lower level, and this is the only place where the architecture is more important than the exhibits. By using the entire height of the two-story space, the straight, cascading stair scenically depicts its ascent and descent while being viewed from the winter garden. And then comes the height of the spaces: Piano made everything high enough. One can move about and breathe freely.

The Beyeler Museum is born of one mold, even when it originated in dialogue with the client. It is complete, with nothing having been left to chance from the site. The architect controls everything: from the interiors to the coatroom, from the technical services to the inner life of the elevator.

Piano tells of Ernst Beyeler's wish for "calme, luxe, and volupté." The quietude is obvious. It is reached by concentrating upon the inner realm, enriched by light from above. The luxury, though, is not visible. It is the absence of detail, the hiding of the technical installations, and the limitation to four surface materials: oak floors, smooth walls, perforated steel sheet, and glass. The expenditure for the invisible is enormous. Even the green electric "Exit" signs required by law, impeccably built into the wall, require ingenuity and the work of persuasion. *Et la volupté finalement?* It is the marriage between the collection and the building—the delight of enjoying art in a captivating space.

Benedikt Loderer

Gallery for American art with works by Sam Francis, Frank Stella, Ellsworth Kelly, and Barnett Newman

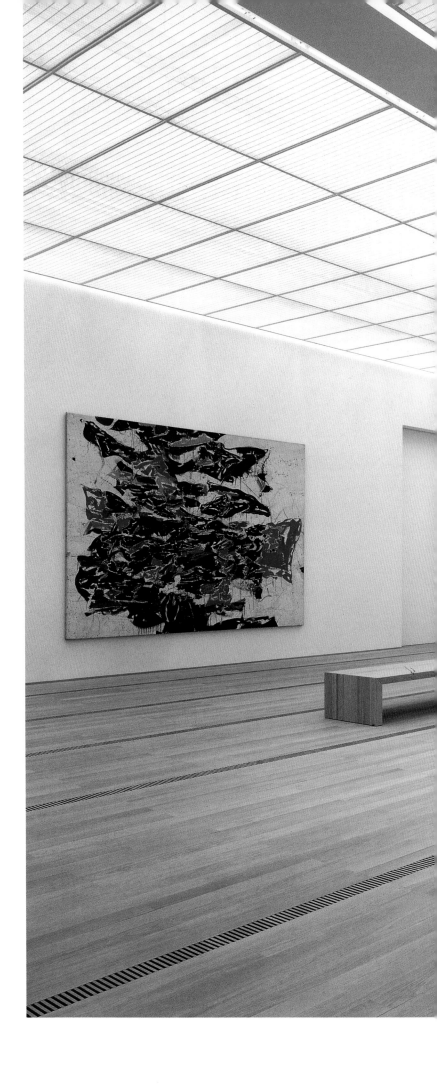

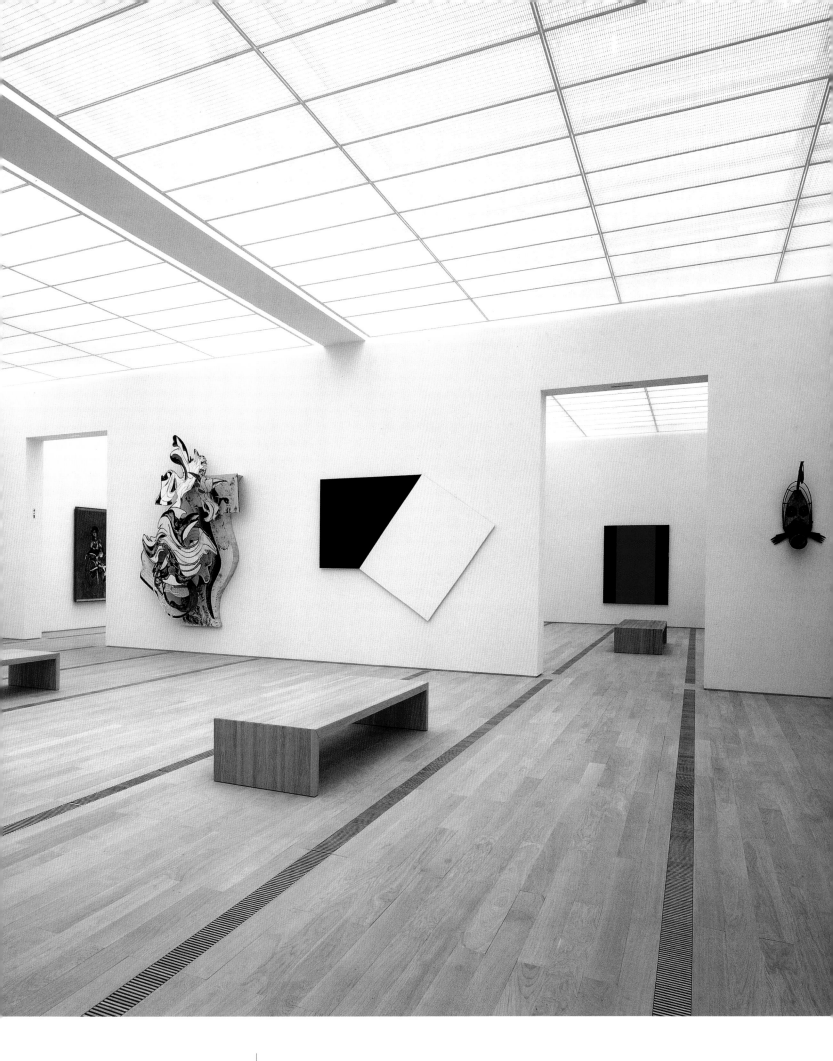

Santiago Calatrava
Milwaukee Art Museum
Milwaukee, Wisconsin, since 1994

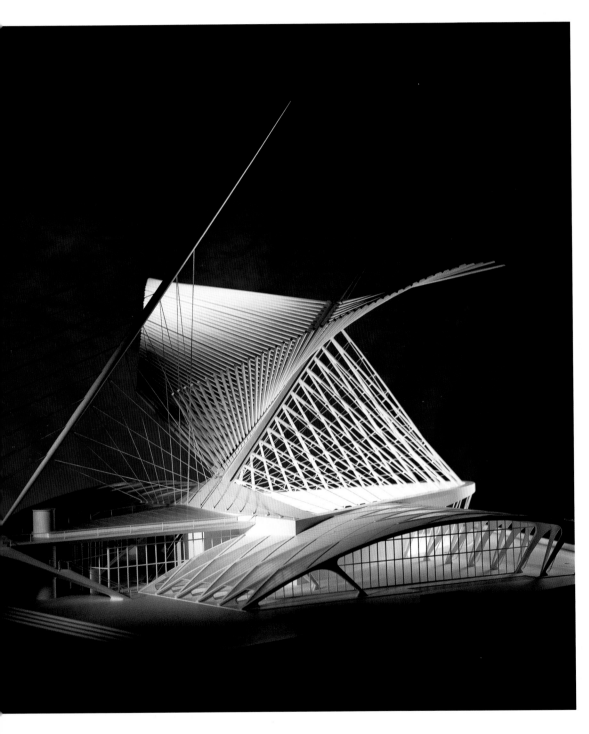

Model

In 1994 the Milwaukee Art Museum Trust announced an invitational competition for a new entrance design and the redefinition of the overall identity of the museum. Santiago Calatrava won the competition after a first round that had narrowed the field to three finalists, who were asked to submit design proposals.

The competition announcement called for the complete reorganization of a museum complex that had expanded over the years and presented a particular challenge: the unification of two distinct projects with very different characteristics.

The first element is a War Memorial designed by Eero Saarinen in 1957. It is a two-story cruciform building in reinforced concrete, suspended on pylons and projecting over the shore of Lake Michigan. It is a strong symbol, recognizable from afar, a "modern" monument perceived as an isolated presence within the heart of Milwaukee's coastal park.

This was followed, in 1976, by David Kahler's project, a "hidden" building element organized on two floors, for a 16,000-square-foot art gallery; it is built into the embankment that separates the War Memorial from the lake. A silent, almost anonymous presence, its sole goal was to contain the new, growing art gallery and many of the pertinent service spaces. Spatially, it was designed to have a direct connection with the surface of the lake, without any visual tie to the city that lies behind.

Since the mid-seventies, the museum has continued to grow, thanks to a significant acquisitions policy and the diversification of its cultural and social activities. Thus the problem posed was the reformu-

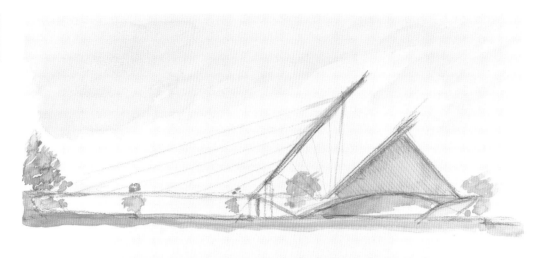

lation of the museum's overall identity, through a new addition that would lead to the functional reorganization of the entire museum complex and also guarantee a different formal and symbolic visibility for the museum's role within the city.

The addition of a new, 7,500-square-foot exhibition hall and conference room and, specifically, the construction of a new entrance designed as a reception area and to house information areas and a restaurant thus became the central theme of the competition.

The designated area is located in a triangular lot, next to the old museum, between the lake and the heavily trafficked Lincoln Memorial Drive. The latter, a main thoroughfare, will be crossed via a pedestrian bridge that leads directly from O'Donnell Park, which lies behind. At the same time, vehicular access to the museum will be provided through a parking area located beneath the new addition and the entrance to the new end of the museum.

Calatrava's winning design is based on two fundamental principles. First, the exhibition hall is aligned in section with the pre-existing building by Kahler, a structure flattened to the ground in an attempt to have direct contact with the lake. Second, the entrance is connected to the footbridge, a monumental, cantilevered presence in relation to the exhibition hall, which is resolved vertically and has a movable roof structure.

This is the second competition the Valencian architect-engineer has won in the United States. In 1991 he submitted a winning design for the completion of St. John the Divine in New York. Several years earlier (1987–92), he built the BCE gallery in Toronto. In 1992–93 his sculp-

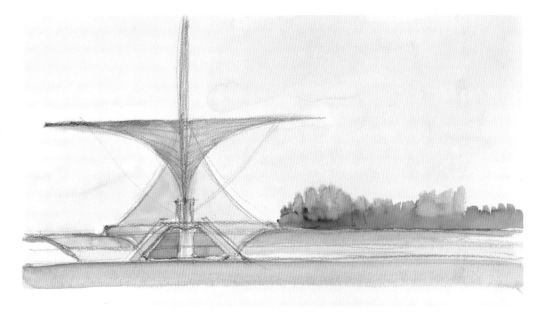

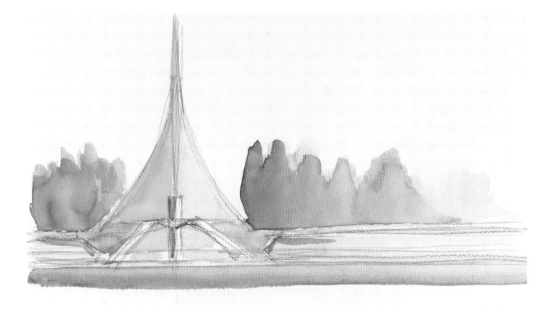

ture *Shadow Machine* was installed in the garden of the Museum of Modern Art, New York.

The Milwaukee design attains, and in some respects goes beyond, the creative threshold maintained by Calatrava's work overall. The consistency of his personal development and the contextual demands seem to have merged, generating a "hybrid" work that bears many of the characteristics that, still today, make the work of this Spanish artist unique.

Bridge design and architecture come together and are integrated to compose a single element, in a way that definitively puts an end to useless polemical quarrels that artificially see oppositions in Calatrava's double background as an artist-architect and as an engineer.

The bridge is resolved through an asymmetrical structure supported with a slanted pier placed perfectly on axis with the midline of the movable roof. The two oblique lines of the pier and the roof are placed at the same slant, to reinforce a unified perception of the entrance and a perfect interpenetration of the two elements "launched" toward the lake behind.

The visitor descends slightly along the bridge, to emerge directly into the large entrance atrium, which is located in the shadow of the striking glass roof, and where the reception and restoration facilities are also housed.

This is a "hybrid" work where various design and research approaches merge, a work that demonstrates an implacable desire to compose a new unified frame-

Site plan

Plan of entrance level

East elevation

work within the architect's own creative experience. As a result, one can see, simultaneously, the recomposed fragments of a heterogeneous work in progress.

The exhibition gallery, with its large depressed arches in reinforced concrete, may seem like a grand homage to the work of Eero Saarinen. Yet behind these broad vaults, there is a developmental line that leads from the tunnel of the TGV station in Lyon-Satolas, back to the Piranesi-like interiors of the Oriente Station in Lisbon, where, in 1994, the architect took his first, decisive steps in this direction.

The same could be said of the new entrance, where the dimensions of a body in motion, addressed earlier in the *Shadow*

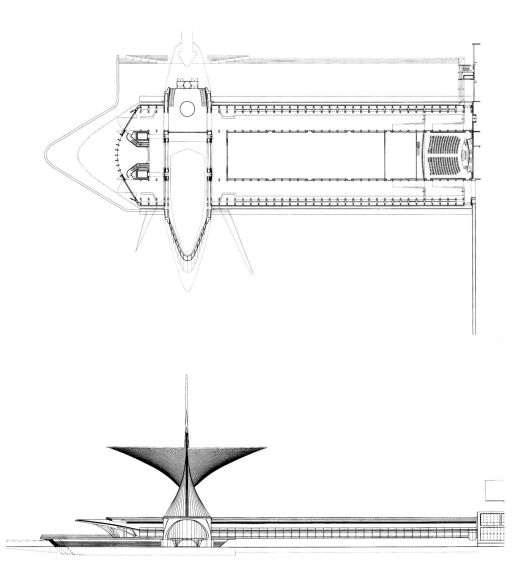

Machine in New York or in the design for the roof of the Reichstag in Berlin, are perfectly integrated with the pedestrian bridge. The bridge design echoes the contemporary Manchester footbridge and the earlier swing bridges in Bordeaux.

There is continuity in his definition of the characteristics of a language that he continues to construct, like a delicate and complex metabolization of earlier experiences. This continuity is superimposed by two conditions that Calatrava's work always seems to satisfy: a strong attunement with context and an affirmation of the public work as a monument within a given territory.

It might seem difficult to find a balance between these two apparently contrasting qualities. However, two earlier projects demonstrate these seemingly opposite poles. The Stadelhofen station in Zurich exists as a skillful cut in the ancient walls of Zurich and reassembles a radical separation between the different parts of the city. In contrast, the TGV station in Lyon-Satolas is a plastic gesture, a strong sign in the center of an area that,

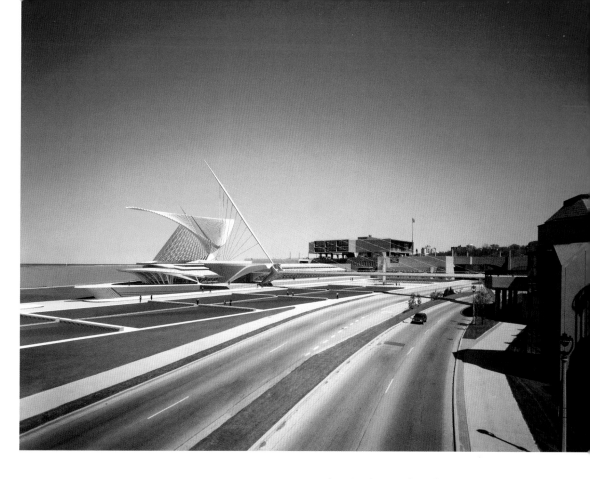

Photomontage: view from southwest

South elevation

West elevation

otherwise, has no clear identity or hierarchy.

The Milwaukee project also displays this conceptual attitude. On the one hand, the new addition is connected to the existing building with extreme naturalness and simplicity, reaffirming a dialogue with the surface of Lake Michigan. On the other hand, the new entrance, with its large movable roof, clearly asserts itself as the center of the composition, in distinct opposition to the existing monument, the Saarinen War Memorial.

However, this opposition could be interpreted as an attempt to balance the final composition of the new museum complex, through the creation of an interesting *monumental duality*.

And, indeed, it is on the roof and its formal and technological definition that Calatrava has focused much of his attention. Through the movement of the large roof, as in many of the movable structures he has created previously, Calatrava sanctions a definitive annulment of the opposition between artistic gesture and technological research and reaffirms the symbolic and communicative value of architecture in contemporary society.

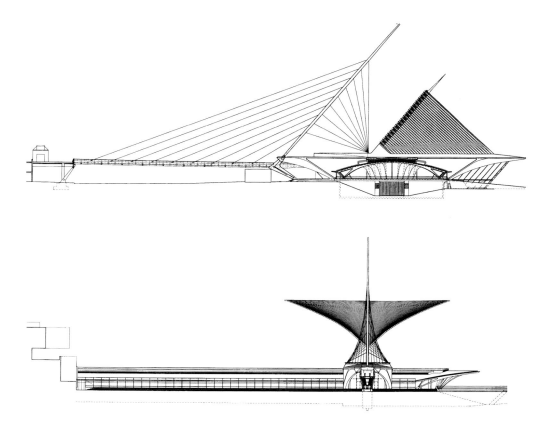

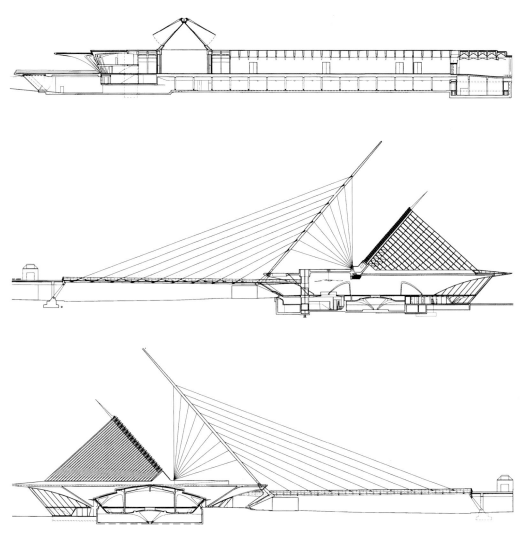

Longitudinal section

Section through
reception pavilion

Section through
exhibition hall

Public architecture's monumentality, a
condition often undervalued in interna-
tional circles, is restored through the defi-
nition of a new identity that revives the
need to astonish and capture the fleeting
attention and glance of the visitor.

Lightness of movement and the need
for stability of every structure seem to
have combined,[1] reaching an extreme lim-
it that the architect pushes further with
every project. This duality is crystallized in
a moment, suspended, stopped before it is
too late.

The continuous interest and study of
organic forms in their growth and devel-
opment is combined with one of the
most extreme qualities of the twentieth
century—movement—generating forms
that are apparently never at rest.

This mechanism, conceived to gener-
ate movement, progressively loses solidity
and seems to disappear in the wake of the
amazement it arouses. In the impressive
wingspan of the roof, which is like a man-
ta ray that circles placidly in the sky, the
values of transparency and material and
structural lightness go beyond any previ-
ous work. This opens a new chapter in
Santiago Calatrava's production, one that
will continue with his designs for the
Father Junipero Serra chapel in Los
Angeles and the Southpoint Pavilion for
Roosevelt Island in New York City.

Luca Molinari

1 An important contribution by Alexander Tzonis and
Liane Lefaivre, *Movement Structure and the Work of Santia-
go Calatrava* (Basel, 1995) deals with the complexity of
the relationship between architecture and movement in
this architect's work.

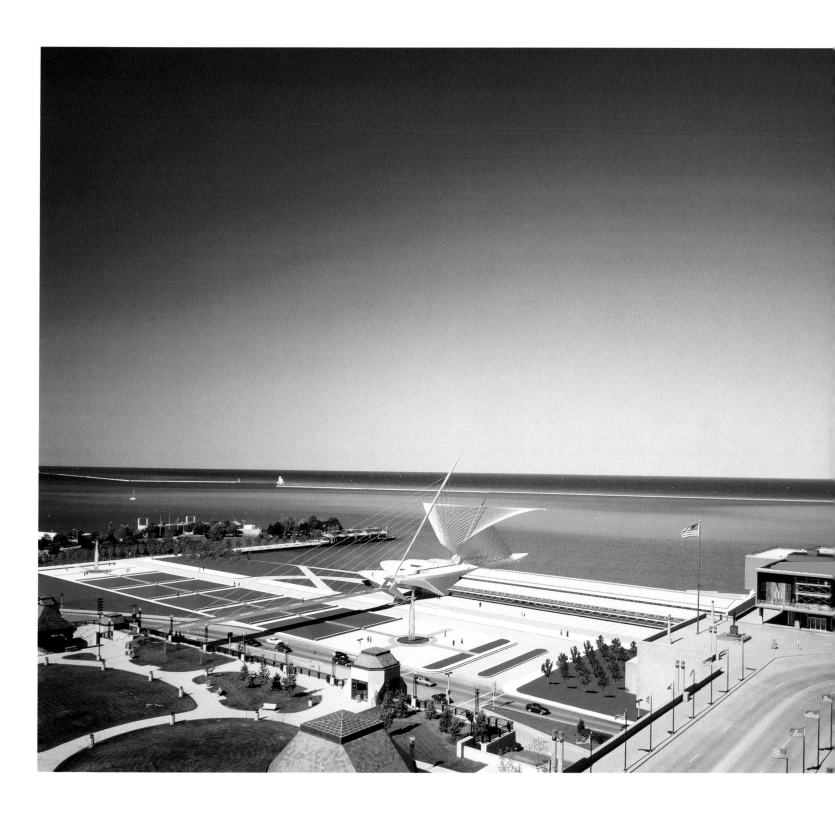

Photomontage: view
from northwest

Giorgio Grassi
Neues Museum (Project)
Berlin, 1st Competition 1994 (1st Prize)

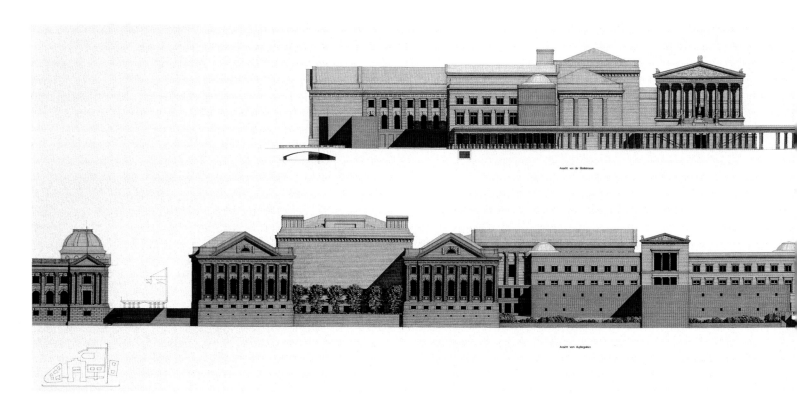

Elevations of Museumsinsel
from Bodestrasse and
from the Kupfergraben

The Museum in History

Giorgio Grassi concentrated on three
particular problems in his project for the
reconstruction of the Neues Museum on
the Museumsinsel (Museum Island) of
Berlin, with which he won an invitational
competition in 1994: the question of how
to deal with a partially destroyed historic
structure with regard to the issue of his-
toric preservation, the question concern-
ing the architectonic and urbanistic order-
ing of new buildings in an existing
high-class ensemble, and the question con-
cerning the functional conception of a
large museum complex with regard to its
cultural history. For all three problems,
which are related to the historic meaning
of the ensemble, Grassi found exemplary
solutions. They foresaw neither a simple
reconstruction of what had been there

before nor a clumsy contrast of contem-
porary manners with those of the past.
Like the good historian, who neither lets
historical facts speak solely for themselves
nor builds only upon his own self-con-
structed narrative, Grassi developed his
plan through a constant dialogue between
his own theory and the buildings at hand.

I. Reconstruction

The Neues Museum by Friedrich August
Stüler (1841–66) had stood as a ruin since
the Second World War, burned out and
half destroyed, between the other recon-
structed and reused buildings on the
Museumsinsel. With its stylized historical
spaces, the structure was an innovative
contribution to museum architecture from
Schinkel's most important student. Should
one minutely reconstruct that which had

been lost, or should one rather regret the loss but then move beyond that to new avenues? Grassi did not respond to these questions with a general answer and a false radicalness. Instead, he built his solution upon a set of answers to individual questions. The fact that some critics felt moved to accuse him of schematicism for the particularly lucid result speaks to the architect's insistent search for architectural consistency.

The building type, an orthogonal form with four wings, a connecting middle tract, and two courtyards, as well as the exterior volumes were all of such importance to the identity of the building that Grassi resolved to reconstruct them. With the reconstructed northwest wing, the building received its appropriate compactness. As for the articulation of the façade with its windows and moldings, he restricted himself to the proportions of the existing building in order to restore the symmetry with the existing southwest wing. While strictly adhering to the archetype and volumes of the architectural logic of the extant building, he dealt with the choice of materials and detailing with considerably more freedom; while forming the façade with brick masonry he also revealed a deeper layer of the building. The newly constructed masonry seems to have emerged as if the stucco layer had been removed from it, entering as such into an inverted relationship with the existing stucco façade. The ornamental details of the window frames and moldings are subjected to an abstract reduction, as if they had fallen victim to a hammer during the renovation of the façade. The façade

View of Museumsinsel from above

Plan of Museumsinsel: level 1

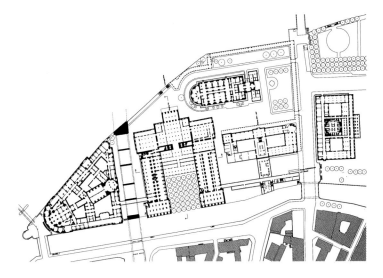

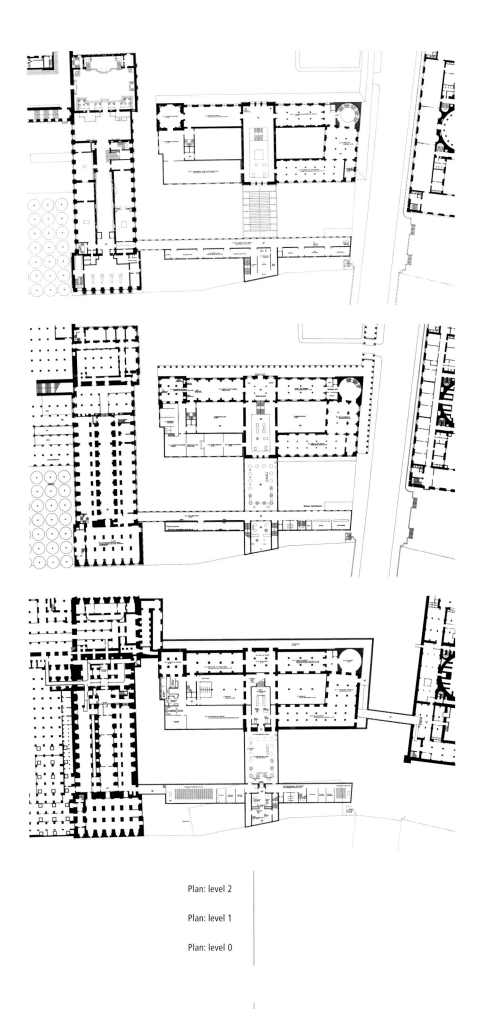

Plan: level 2

Plan: level 1

Plan: level 0

avoids therein any echo of historicization, which would certainly have been present had it been provided with finely proportioned ornament in the year 1994. And it communicates a sovereign humility similar to Hans Döllgast's reconstruction of the Alte Pinakothek in Munich after the Second World War.

Even had small ornamental elements still been available today, the grand staircase with its valuable paintings from Wilhelm von Kaulbach was irretrievably lost. Consequently, Grassi decided to forgo reconstructing the stair space back to its original function. Instead, he transformed the huge hall—using parts of the old museum structure—into an "Antiquarium," a museum of the museum itself. This operation contains the essence of how the architect deals with the existing building: by reflecting its essential qualities, the building comes back, as such, to itself (a museum grows out of a museum, brick masonry grows out of brick masonry, etc.). Hence, Grassi creates something that is not only closely related to the existing building and agrees well with it; it appears particularly appropriate since it allows the building's most intrinsic qualities to become manifest. And something new appears that does not have the superficiality of a spontaneous discovery. Rather, it provides the contentment born of a serious response for which one had always been searching.

II. Context

On the Museumsinsel in Berlin a great variety of different museum buildings had arisen, ranging from Karl Friedrich Schinkel's Altes Museum (1823–30), Stüler's Neues Museum, Stüler and Johann Heinrich Strack's Nationalgalerie (1862–76), and Ernst von Ihnes's Kaiser-Friedrich-Museum (today the Bodemuseum, 1897–1904) to the Pergamon Museum (1907–30) by Alfred Messel and Ludwig Hoffmann. With the Altes Museum having at first played only second

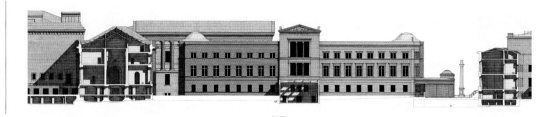

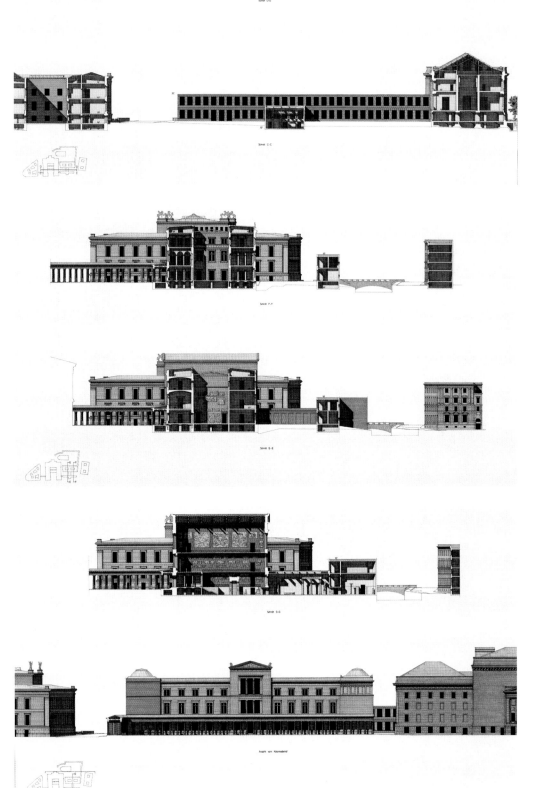

fiddle to the overpowering castle, the ensemble had developed into an Acropolis of art, eventually endeavoring to break the boundaries of the island. What united them despite their differing architectonic conception (although they all nevertheless remained within the sphere of classicist architectural language) was their desire not just to house the development of human culture but to present themselves as its actual zenith. How, then, should this building extension act within such a dense ensemble of the highest pretensions? Should one look upon this historical development as concluded, or attempt to continue it? Here, too, Grassi did not reach a blanket decision; rather, he fittingly answered each question individually.

He began by underscoring the island-like character of the ensemble by shifting the main entrance for the Neues Museum, the Nationalgalerie and the Pergamon Museum to Stüler's colonnaded court (as is well known, nothing had come of the many expansion plans for the surrounding city area, and now such plans were no longer under consideration). The typological re-evaluation of the Pergamon Museum (the entrance court became a garden court) allowed Grassi to remove the bridge over the Kupfergraben (the Copper Moat). He completely oriented the extension to the ensemble and provided it with a rear façade bordering the Kupfergraben. Then he accented the solitary character of the Altes Museum (the most important building in the ensemble, having been the only one built as a free-standing solitary) by forgoing reconstruction of a connecting bridge to the Neues Museum. And

finally, he conceived the extension as a typological continuation of the Neues Museum, to which the new structure should be closely related, both spatially and functionally.

Grassi connected an exhibition hall, identical in width but only one story in height, directly onto the central hall of the existing building. This continues the connective and exhibitive function of the old hall, but leaves the façade and the exceptional pediment of Stüler's building unimpaired. There follows a two-story cross wing with gallery and service spaces, which the middle tract pierces with a further exhibition space. The new building finds its conclusion by virtue of the terrain which seemingly cuts off the hall by chance, as if this typological extension could have continued on forever. However, with the annex space toward the Kupfergraben, a dignified form inadvertently arises that readily offers itself for the exhibition of one of the most superior pieces of the collection: the bust of Nefertiti. This modest extension building—small in dimension, with simple brick masonry and guarded avoidance of ornamentation—wakens, in addition, memories of the former service buildings of the Packhof by Schinkel, once located on the site. Thanks to the almost logical consistency with which it connects to the existing structures, the extension can consequently not be interpreted as historical reminiscence.

The solution thus attained responds aptly to the high contextual demands. No trumped-up contrast, no righteous overkill, no incongruous fragmentation and also no overly modest subordination—such as can be found in the positions of the other competition entrants—characterizes the nature of the intervention. Instead, the substantial attributes of the complex are embraced and clarified: the island character is accentuated by turning away from the water, the ensemble character is emphasized by the

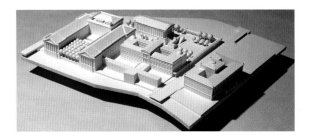

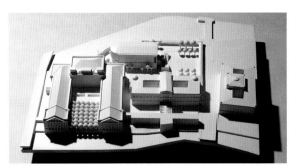

Models

first real extension (the older museum structures appear more like solitary buildings with makeshift connections versus genuine extensions), the continuing historical development is implied through a continuable typology, etc. It is this working out of the significant attributes of the context that generates such a solution, equally coherent and autonomous: coherent, since it elucidates the existing; autonomous, since the investigative process follows Grassi's own rules.

III. Function

The most difficult task was the functional articulation of the entire complex. This had already been implied in the title for the official competition announcement for "planning the reconstruction of the Neues Museum and the construction of building extensions and connecting structures in order to connect the archeological collections of the state museums of Berlin—the Prussian cultural heritage on the Mu-

seumsinsel." After decades of separation it was time to reunite the museum collections after the East/West political transformation. The requirements were extremely demanding and contradictory. On the one hand the diverse archeological collections (Egyptian, Babylonian, Greek, Roman, Byzantine, Islamic, and Germanic) were to be meaningfully distributed as self-contained units in the individual buildings. On the other hand, they should be connected by the shortest possible routes in order to enable a quick tour of the highlights for everyday tourists—a special request of the museum administration.

Grassi's proposal is nothing short of a paradigm in its clear suitability to elucidate the irrelevance of a simplistic functional understanding of architecture. In his design he tries to do justice to the multilayered tasks inherent in the museum complex while not raising one particular usage requirement to the level of doctrine. Besides the required user-friendliness, he saw the function of the Museumsinsel first and foremost in the presentation of the cultural history and the architectonic significance of the museum institution and its edifices themselves. Grassi attempts to fulfill the first demand with two underground connection passages and by connecting a two-story extension to the Pergamon Museum as well as an entrance for quick tours in the new building. He fulfilled the second aspect above all by virtue of his typological consistency, with which he distinguished the Altes Museum as a solitary while connecting the extension to the Neues Museum. Indeed, it is Grassi's own accomplishment to have drawn attention to the architectural-historical value of the ensemble by virtue of an appropriate design position—a task that should have been of interest to the museum administration.

Paradoxically, this particularly complex, functional understanding was to become his doom. With the pretext that he was not able to fulfill the functional

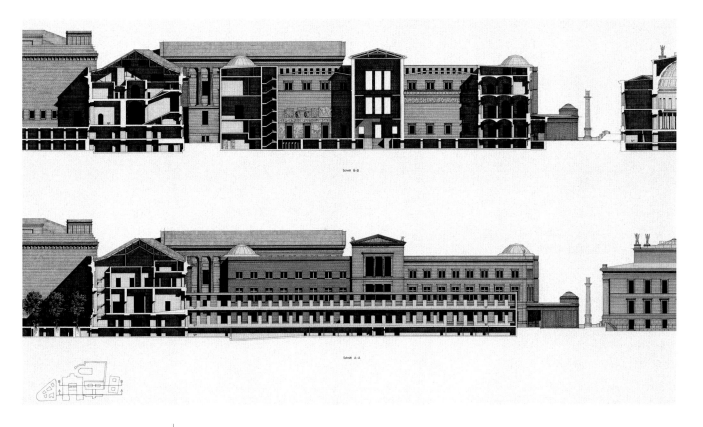

requirements of the museum operations (this meant above all the short museum tour), he was repeatedly required to rework his design. Although responding with bridge structures to the museum administration's wish for close connections while compromising his own architectonic values—such as the solitary role of the Altes Museum—his suggestions were rejected. In 1997 a new competition was announced for the prizewinners, this time dealing solely with the reconstruction of the Neues Museum and new connecting structures, all under changed financial parameters. David Chipperfield, who had previously placed second, won the ensuing contest that same year and his design is now being built. The cause of this long and—especially for Grassi's design—unsatisfying process was actually the preference of the general director for Frank Gehry's design. In its own fashion, Gehry's fourth-place proposal sought to contrast the existing substance of the Museumsinsel with a varied collection of deformed building elements. The design—publicity magnet and inappropriate in equal measure—can

only be interpreted after the fact as a deep cultural misunderstanding: the Berlin Museumsinsel as fast-food amusement park. Despite any relief that the dignity of the museum and its buildings did indeed predominate in the end, it appears a hollow victory. The moderate proposal from Chipperfield to reconstruct and modernize won out at the expense of Grassi's equally complex and convincing solution.

What no doubt remains are the most beautiful architectural drawings generated by contemporary architectural practice. With their exacting veracity—which would do justice to any technical working drawing—and their poetic color—which could well echo a metaphysical architectural capriccio—the most substantial qualities of Grassi's design are connected and made manifest: intelligence and beauty. And they speak in lasting fashion of the befitting solutions he has designed in response to the problems of reconstruction, contextual relationship, and the function of a museum building in a historic ensemble.

Wolfgang Sonne

David Chipperfield
Neues Museum

Berlin, 2nd Competition 1997 (1st Prize), since 1997

Site plan of Museum Island
1. Promenade along River Spree
2. Conversion of street in Kupfergraben to traffic-calmed river promenade
3. Reconstruction of Monbijou Bridge
4. New footbridge to Monbijou Park
5. Reconstruction of Friedrichsbrücke to original width
6. Conversion of Bodestrasse to pedestrian area
7. Redesign of bridge to Pergamon Museum
8. Reconstruction of colonnaded courtyard
9. New structure in Kupfergraben
10. Conversion of Ehrenhof
11. Revamped space between Pergamon Museum and Bode Museum
12. Revamped space east of Pergamon Museum with landing stage
13. Infill construction to street block
14. Museum courtyards
(formerly Friedrich Engels Barracks)
15. Humboldt University Library
16. Redesign of Monbijou Park

The first question that has to be asked about a new design and master plan for the Neues Museum and the Museum Island in Berlin is: why David Chipperfield? Of course he is a well known and distinguished British architect and he did, at the end of the day, win a competition that was both politically and architecturally complex. British talent is popular in Germany—is there something in the climate that encourages British talent to do so well there? Lord Norman Foster rebuilt the Reichstag; James Stirling designed the best building of his career for the Staatsgalerie in Stuttgart; Nicholas Grimshaw is the architect of the new Stock Exchange in Berlin; and now Sir Simon Rattle is the conductor of the Berlin Philharmonic.

The answer is not just that Britain is producing highly talented architects (and musicians); it is also because the British are good at dealing with the problems of working with tradition. Architects are experienced in adding on to and restoring old buildings, and in all three recent examples—the Reichstag, the Stuttgart Gallery and the Museum Island in Berlin—there is a need for pragmatism and compromise as well as talented new design. It is also the case that a foreign architect can, ironically enough, break through the complex network of local politics and produce an objective solution.

The Museum Island in Berlin has been a problem for the city for a long time. War damage, neglect, and communism have worked against the provision of a secure future for Berlin's remarkable collections of antiquities and art. It was the miracle of the reunification of Germany that became the unexpected catalyst for

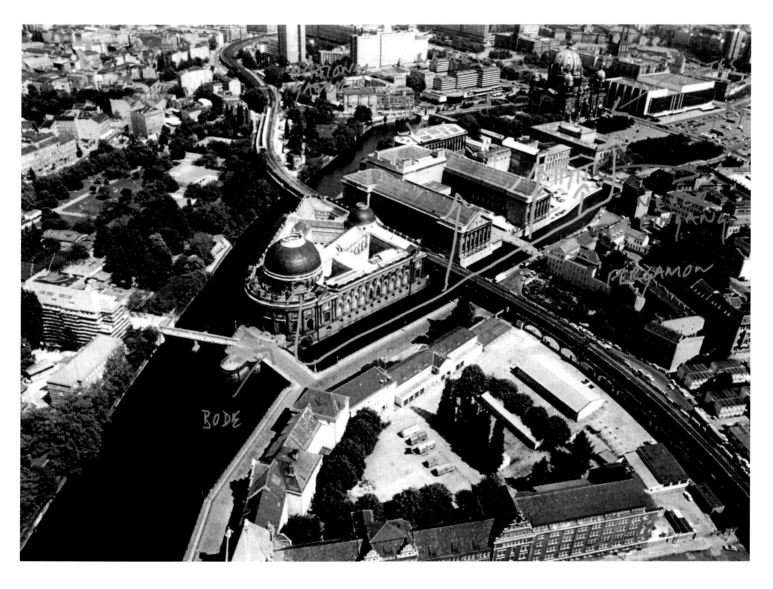

Ideas sketch

the rationalization of the museums of the new federal capital.

The cultural buildings of Berlin have acquired new significance as icons of civilization in the redevelopment of the city. The Museum Island has exceptional European historical importance too—philosophically it represents in its ensemble of buildings a special "omnium gatherum" of cultures that have inspired the West. Berlin's unique island of culture owes much to the triumph of German art history in the nineteenth century and to the architect Karl Friedrich Schinkel and his clients. Writing as the Altes Museum opened in 1830, Schinkel and the director of the museum, Dr. Waagen (who traveled to Italy with Schinkel in 1824), explained the rationale of the museum—"The prin-

cipal and essential purpose in our opinion is this: to awaken in the public the sense of fine art as one of the most important branches of human civilization . . . all other purposes, concerning individual classes of the population must be subdued to this." The first displays in the museum were to follow carefully defined art-historical principles, and the neoclassical architectural style, derived from Gilly and Durand, was employed to produce a temple of art. The eighteen fluted Ionic columns of the Altes Museum create the perfect noble façade for a temple of art and at the heart of the museum is the domed pantheon that Schinkel called "the sanctuary."

David Chipperfield's skills are twofold: he is a designer of integrity and originality, and he is experienced in placing his "architecture of ideas" within existing contexts. He has described England as the "land of pragmatism"—suggesting in fact that ideas come secondary to functionalism. But his successful buildings demonstrate that it is possible to integrate original architectural ideas into existing contexts. He succinctly described his philosophy (almost a creed) in the introduction to his submission for the Berlin Museum Island competition:

"I am not by nature a 'conservative.' I believe in the possibilities of the future as well as in the evidence of the past. Neither am I a formalist. I believe every project must determine its own character, identity and logic. At the cusp of the twentieth century we should be able to deal with the past without parody and look to the future without whimsy.

Our continued work on the Neues Museum over the last years has given me the unique opportunity to come close to this great physical presence and to give some measure to its form and possibility. I believe our proposal is a sophisticated work in the positive meaning of the word. I am grateful for the opportunity to contemplate the problem of the Neues Muse-

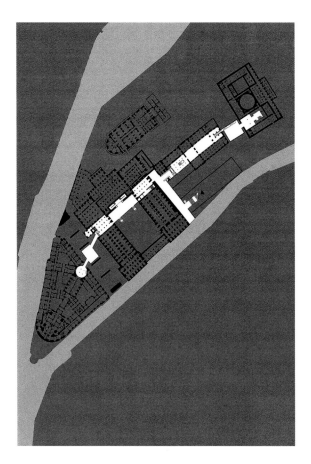

Plan showing
archeological promenade

um; it is a challenge that engages the very significance of memory and the continuity of history."

The history of the competition needs to be briefly described. In the spring of 1994 the Italian architect Giorgio Grassi won the competition with a contextualist solution ahead of four other entries from David Chipperfield, Francesco Venezia, Frank Gehry, and Axel Schultes. However, a long period of modifications and changes called for by the client between 1995 and 1997 led to Grassi's eventually abandoning the project. Two of the runners-up, Frank Gehry and David Chipperfield, were then asked to resubmit to a mini competition, which Chipperfield won. The major sticking point of the long debate during the complicated competition was the exact status of the restoration of the war-damaged Neues Museum itself, which stood as a ruin between the Pergamon Museum and the Altes Museum. The German museologists were originally determined that the rebuilt Neues Museum should be restructured in such a way that it would become the main entrée to the entire Museum Island. They also wanted to ensure that the winning design made it easy to link the three main museums and allow the possibility for visitors to complete a tour of the star items of the collections.

Chipperfield's solution has developed over time into a master plan for the whole site as well as an architectural solution. Stylistically his minimalist approach has enabled him to learn without prejudice from the presence of the neoclassical and neogrec originals without copying them. The Neues Museum was once one of Europe's most discussed museums because of its rich iconographical decoration and its associational spaces like the Roman Hall and the Medieval Hall. Its architect, Friedrich August Stüler, designed a formal and symmetrical building, which was severely damaged in World War II. Chipperfield plans to reinstate the symmetry of

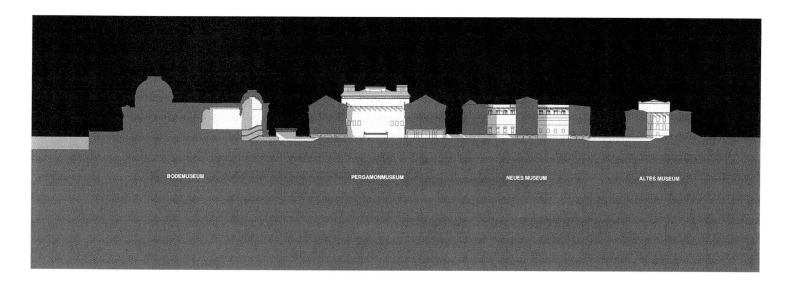

BODEMUSEUM PERGAMONMUSEUM NEUES MUSEUM ALTES MUSEUM

the façade also allowing the re-creation of the internal courts. His plan is to make an archeological route through the entire site which partly takes the form of some critical interventions and new links. Since July 1998, David Chipperfield's firm has been working with local planning experts, Heinz Hilmer, Christoph Sattler, and Heinz Tesar. This team brings together the detailed knowledge of the individual buildings and overall planning skills.

The Planungsgruppe in Berlin has tried to retain the autonomy of the individual buildings and keep their historic entrances. However, the museum requirement is for links between the buildings to ensure that the new arrangement of collections is accessible and comprehensible. The collections of the Stiftung Preussischer Kulturbesitz will be seen in a joint museum complex for the first time in the history of the Staatliche Museen. The following collections will now be brought together from their scattered homes in Berlin onto the Museum Island: the Pre- and Early History; Western Asiatic Antiquities; Egyptian collections; the Antiquities Collection; the collections of the Museum of Late Antiquity and Byzantine Art and the Islamic Collection. Although seen as a group of separate collections they will form together a Museum of Antiquity that will be unequaled in the world. The architects will have to organize the existing

Longitudinal section through archeological promenade

buildings and the new links to enable historical, thematic, and geographic points of contact between the collections to be made easily. The concept of a main tour route that links the major architectural elements of the Pergamon will allow an easy tour of the main attractions without disturbing other visitors following more specialized or more detailed and longer routes (in time as well as distance). Shared temporary exhibition space enhances the concept of bringing together the varied collections.

The provision of new space to the northwest of the Museum Island on the site of the former Friedrich Engels Barracks will allow the removal of much of the administration and storage and workshop areas of the existing museums, thus freeing up large amounts of space for circulation. The Chipperfield plan provides three major new benefits.

1. A link between buildings at the current Level 0 of the Museum Island, which will create, without major new construction, an "archeological promenade." This links the interior courtyards of the Altes Museum, the Neues Museum, and the Bode Museum. It can be entered from each museum and from the new entrance building.

2. A newly constructed entrance building with a new temporary exhibition area on the open space by the Kupfergraben.

3. The north and south wings of the Pergamon will be linked to improve circulation and to allow for the use of the Ehrenhof for large elements of Egyptian architecture—the Egyptian Temple and the Kalabsha Gate—to be dramatically displayed. A new large entrance hall will also be provided for the Pergamon.

This plan has achieved what initially must have seemed almost impossible because it preserves the appearance of a campus of individual buildings—an ensemble of architectural monuments—while effectively unifying the archeological displays in a coherent public display route that will be both informative and visually dramatic. The plan should also allow for the comfort of an increasing number of visitors—up to ten thousand a day—and for improved administration and storage and service facilities.

To return to the original question—why Chipperfield?—the solutions in the master plan demonstrate both his perceptive understanding of the site and an intriguing awareness of the historical and contemporary architectural problems and solutions. His pragmatism has made it possible to unite the wide range of collections, and his architectural skills will produce interventions and adaptations where necessary in the old buildings that will be appropriate. His master plan will also look at the urban and transport issues of the island to enhance it as an important cultural center for the new capital.

Chipperfield's other museum projects to date have inevitably been much smaller. But they are an indication of the architect's approach. The modest private Gotoh museum in Japan and the larger Henley-on-Thames River and Rowing Museum are both distinctive but entirely contextual solutions. The Henley museum especially demonstrates an original use of forms and materials that relate directly to the idea of boats and boat building, and the pitched roofs continue the vernacular tradition of boathouses.

Among his competition projects Chipperfield has several museums. The most important is his unsuccessful submission to the Tate Gallery of Modern Art for the adaptation of a redundant power station into a gallery. Chipperfield treated the enormous existing brick building as an umbrella to cover the inserted new concrete elements. His new cubic tower would have been as dramatic but more dignified a landmark as the former giant chimney.

The Diocesan Museum in Cologne also incorporated the ruins of an older church, the church of St. Kolumba, as the entry cloister to the new art museum. The new building was to have been constructed of wood with very controlled sources of natural light.

Both these projects and others demonstrate the architect's concern with utilizing and adapting existing buildings. They also show that Chipperfield is a master of introducing his own contemporary design in such a way that it retains its own integrity and enhances the earlier architecture.

The Grassimuseum in Leipzig is also a master-planning project for the restoration of the largest museum in the city and the incorporation of its three separate collections—musical instruments, ethnology, and arts and crafts.

All this experience has culminated in his success in the competition for the Museum Island in Berlin. His skills have eased the complexities of the site and will, by the year 2010, make the island one of the most remarkable assemblages of architecture and antiquities in Europe.

Colin Amery

Jacques Herzog, Pierre de Meuron
Tate Gallery of Modern Art at Bankside

London, since 1994

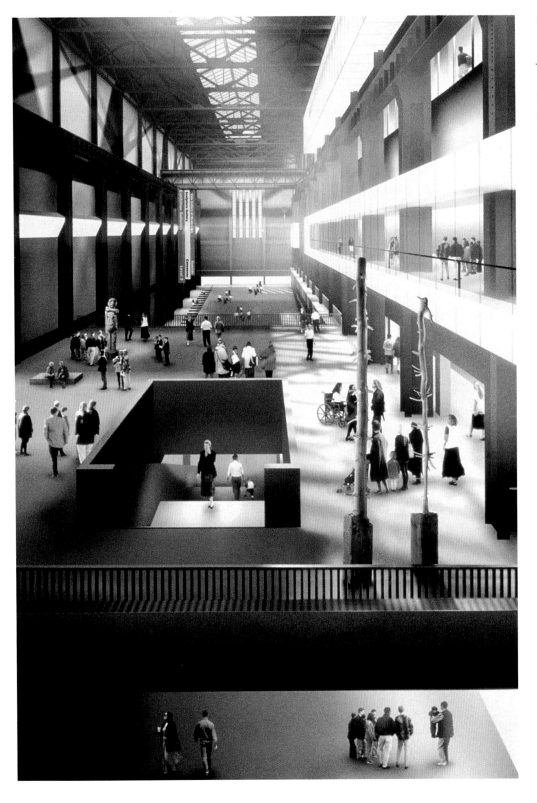

Something remarkable happened to Britain as the Conservative government of John Major crawled to its ignominious end in 1997. The Conservatives had been persuaded to introduce a national lottery, an innovation which the Anglo-Saxons had previously always seen as a somewhat demeaning practice, one that was the exclusive preserve of less-favored southern Europeans. Britain had previously believed in a more dignified approach to funding its essential infrastructure. But John Major promised that the lottery would allow the building of a whole range of cultural projects that would otherwise never have had any chance of being realized.

And in some ways, he was right. The lottery has had the unexpected effect of overturning all the preconceptions of British cultural life. A society that once believed in an almost puritanical way in financial probity turned the weekly draw into a national ritual. And perhaps even more extraordinary was what the state chose to spend its share of the proceeds on. A number of charitable causes were established to channel money into construction projects ranging from sports stadia to cycle tracks. And one fifth was earmarked for the most un-English idea of all, to celebrate the dawn of the third millennium of Christianity by spending several billion pounds on 20 landmarks. Having set in train this astonishing, and astonishingly out of character, idea, Britain started immediately to carry out the program in the most English way—in disorganized, pragmatic confusion.

Much of the money is being poured into schemes of utter futility, such as the creation of giant water fountains in

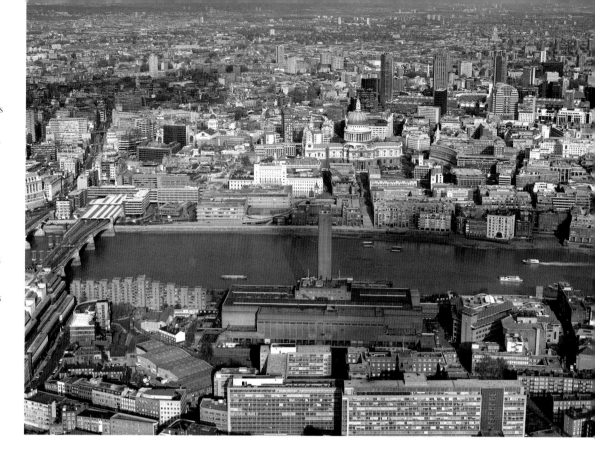

Portsmouth harbor and a number of sports arenas of unpardonable banality. Out of all this, the reinvention of the Tate Gallery of Art stands as a towering exception. The original Tate was a private bequest. It stands on the north bank of the Thames, just upstream of the Houses of Parliament in a Palladian Victorian structure that guards Britain's finest collection of Turners and Gainsboroughs. Under the direction of its present director, Nicholas Serota, it is evolving into a new kind of institution with outposts in Liverpool (designed by James Stirling) and Cornwall (Evans and Shalev). But its biggest transformation will be unveiled next year when it opens an entirely new conception, the Tate Gallery of Modern Art, carved out of a disused power station just across the river from St. Paul's Cathedral by Herzog and de Meuron. And most of the money has come from the lottery. Unlike some attempts to expand museums around the world, the reinvention of the Tate at Bankside is rooted in an intelligent appraisal of the nature of the new museum rather than in any search for size or novelty for its own sake. The museum first asked itself why it wanted a new building instead of pondering other questions such as where to put it or how it should look. The answer was partly that it needed, as so many institutions do, more space: space to show its reserve collections, as well as the space it needed to keep up its intellectual claims to leadership.

The Tate in the early years of the twentieth century developed its own identity as distinct from the National Gallery by concentrating simultaneously on the modern and on British art. Serota's vision was to separate the two: to maintain the original site as a gallery of British art and to establish a new building that would concentrate on modern art in all its forms. From the point of view of art it meant dealing with a wide range of difficult questions. Would the old site atrophy into a historical collection, or would it con-

Computer simulation of turbine hall

Aerial view of gallery in its urban context

Bankside Power Station: the turbine hall, 1995

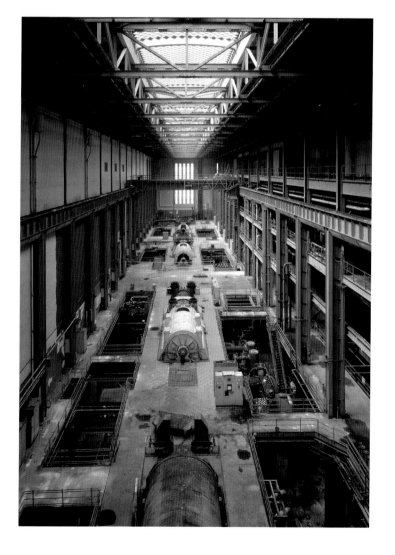

tinue to acquire new works? If the latter, how would the two venues apportion work by living British artists? Would the new building acquire prestige that Millbank would lose?

And what form should the new building take? An extension, a new building, or the conversion of an existing structure? It was a series of decisions that explored most of the concerns which have been echoed around the world in the epidemic of museum building that has characterized the last two decades. It touches on the shifting balance of power between architect and curator. On the one hand is the kind of landmark museum that probably began with Frank Lloyd Wright's Guggenheim, and which is echoed most recently by Frank Gehry's Guggenheim in Bilbao. Such structures have proved their power in helping to shape the identity of entire cities, as well as to build an audience, almost as if they were giant architectural sculptures. Such projects, however, have created unease among the artists. They may establish a high profile, but are they the best place in which to show art? Many artists and curators have felt the answer is no, ever since the bitter opposition that Wright's egotistical design for the Guggenheim attracted. Forty years later it's one of New York's most famous landmarks, but most of the collection is shown in a new wing, with discrete rectangular walls.

In the art world, architecture is too often seen as intrusive and overbearing. Yet art can be just as egotistical in its demands

on a gallery. Imagine the reaction from an artist asked to rework a piece to make it small enough to fit a specific space, and to rethink the color to accommodate a new carpet. But this is the essential nature of the architectural process. It is this ambiguous burden of utility that has tended to give architects a certain sense of cultural inferiority and mistrust of art. They can't participate in it as equals, so they shut it out. On the other hand the work of certain artists, such as Donald Judd, with their measured sense of order and proportion, has specifically architectural qualities.

Are we attracted to galleries by art or architecture, by scholarship or urban spectacle? Clearly, for any cultural building that takes its civic responsibilities seriously, both aspects are important. But it is not an easy balance to get right. And the conflict between art and architecture is a phenomenon that goes right back to many of the most famous buildings of the twentieth century, or even to the moment that sculpture came off the pediment and onto the floor.

It's a two-edged process: the curators and the artists themselves, of course, want to attract the audiences that museums use to measure themselves against one another, but they don't want to be upstaged by architects. Dull buildings, on the other hand, don't pull in the crowds. That tension helps to explain why so many new cultural institutions are housing themselves in recycled industrial buildings. They offer the possibility of great big spectacular spaces, like the Tate now taking shape. But they don't carry the insistent signature of a contemporary architect. In many ways the most important decision taken by the Tate was to move into the old power station, designed by Sir Giles Gilbert Scott, an architect whose career spanned the transition from the closing stages of the Gothic revival to the wide acceptance of the modern movement. The power station is a heroically scaled exercise in monumental art deco brickwork that clearly owes a

Longitudinal section through turbine hall

Cross-section through northern entrance

Cross-section through double-height gallery space

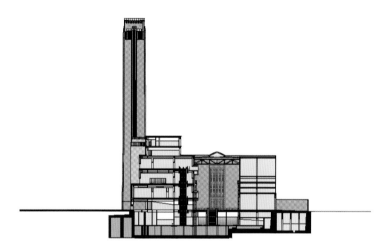

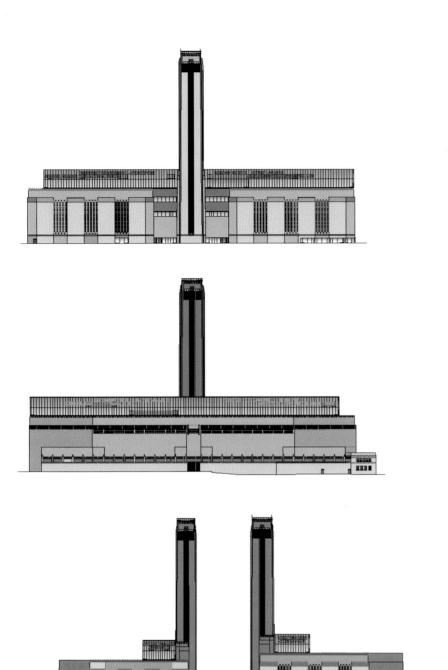

North elevation

South elevation

East elevation

West elevation

debt to Dudok but that was only completed in the fifties. It became redundant in the late eighties, an echo of a past era, once seen as a utilitarian intrusion in the center of some of London's most historic views but now regarded as an essential piece of heritage. The Tate embarked on a long-drawn-out competitive process to select an architect for the project. The first stage was an open request for credentials, and on this basis a short list was drawn up of architects who were invited to present more detailed proposals. The short list included Tadao Ando, Rem Koolhaas, and David Chipperfield, as well as Herzog and de Meuron. All of them had to struggle with the sheer physical presence of the original building and the desire to signal a new function and to accommodate a major collection of art. Chipperfield proposed demolishing the single most recognizable feature of the power station, the giant central chimney, but to respect the rest of the structure. Koolhaas's design was for a more visible transformation. But Herzog and de Meuron won with a solution that was to do what appeared to be almost nothing but that will in fact create one of the most dramatic public interiors in London, simply by giving it an internal logic and capitalizing on its inherent qualities.

The building as Herzog and de Meuron found it was an immense, symmetrical, windowless brick box, with a single giant chimney almost 100 meters high aligned directly with Sir Christopher Wren's great seventeenth-century masterpiece just across the Thames. It was a remarkable confrontation, the greatest civic landmark that London has ever built directly opposite a giant industrial object, the kind of installation normally kept out of sight in city centers. In deference to its position, Scott gave the box a certain austere architectural character. But its façade was just a single brick thick, concealing a vast, steel-framed interior made up of two giant halls. One had housed the old

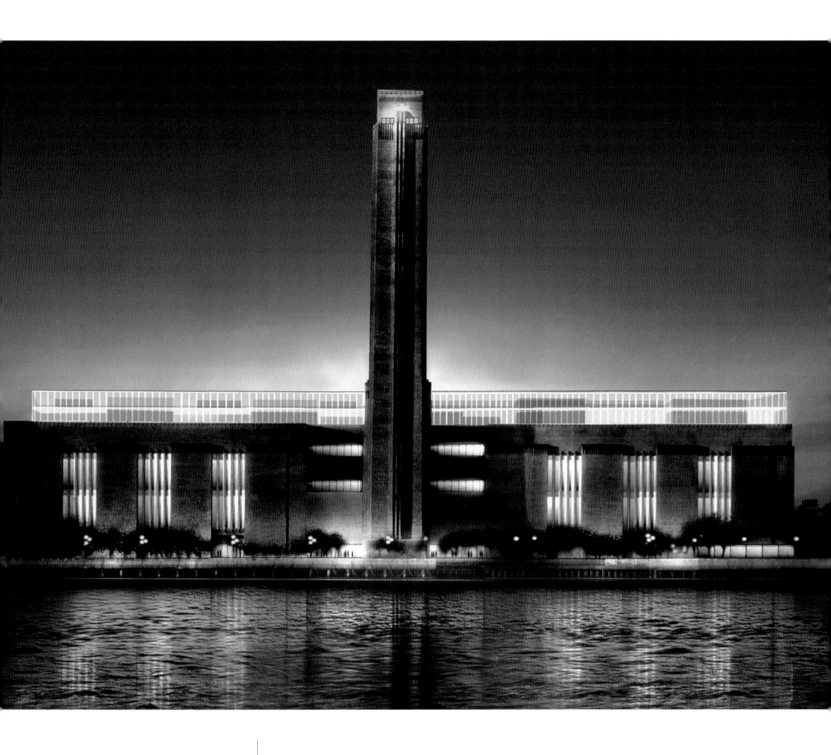

Computer simulation
of north face

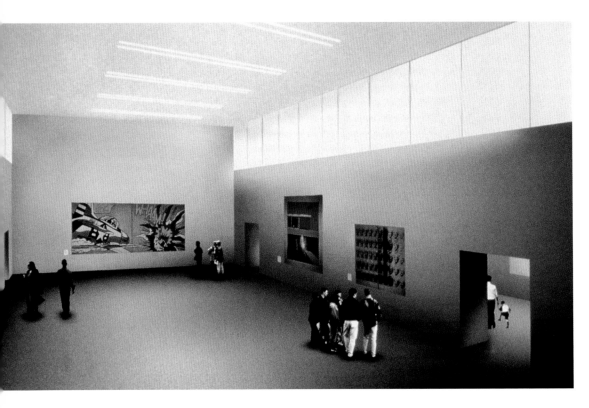

Computer simulation of
gallery space

Computer simulation of
double-height gallery space on
second floor

boiler house, the other the turbine hall (152 x 24 x 30 meters) that will make this one of the largest conversions of an industrial building to gallery use ever attempted, with almost 11,000 square meters. The budget is £130 million, an investment that it has been calculated will create 2,000 jobs in the new museum itself and in the surrounding, rundown district of Southwark.

The architect's strategy has been to retain the essence of the giant turbine hall as the major orienting experience for visitors. They will enter on a piazza level and find themselves in a soaring space in which the ancient steel gantries are still in place high above. It will be a semipublic space, with the character of the piazza in front of the Beaubourg. One level above is the access bridge into the galleries themselves, which will be pristine, top-lighted rooms inserted into the old structure. Externally, the transformation of the building from its original use is marked by the creation of a double-height glass box running the entire length of the building, offering spectacular views over the river for the museum staff and looking at night like a giant beam of light. The other big urban innovation is the creation of a new footbridge designed by Norman Foster, working with the artist Anthony Caro, linking the Tate to the North Bank. For all the restraint of Herzog and de Meuron's architecture, this will clearly be a spectacular place to visit, one that will leave visitors with the most memorable of experiences of spatial gymnastics. Indeed, the Tate is already nervously revising its estimates of visitors upward. Predictions have more than doubled to four million in the first year. What the Tate hopes is that the quietness of the gallery spaces themselves will not be disrupted by the impact of such enormous numbers, allowing the Tate's collection to speak for itself.

Deyan Sudjic

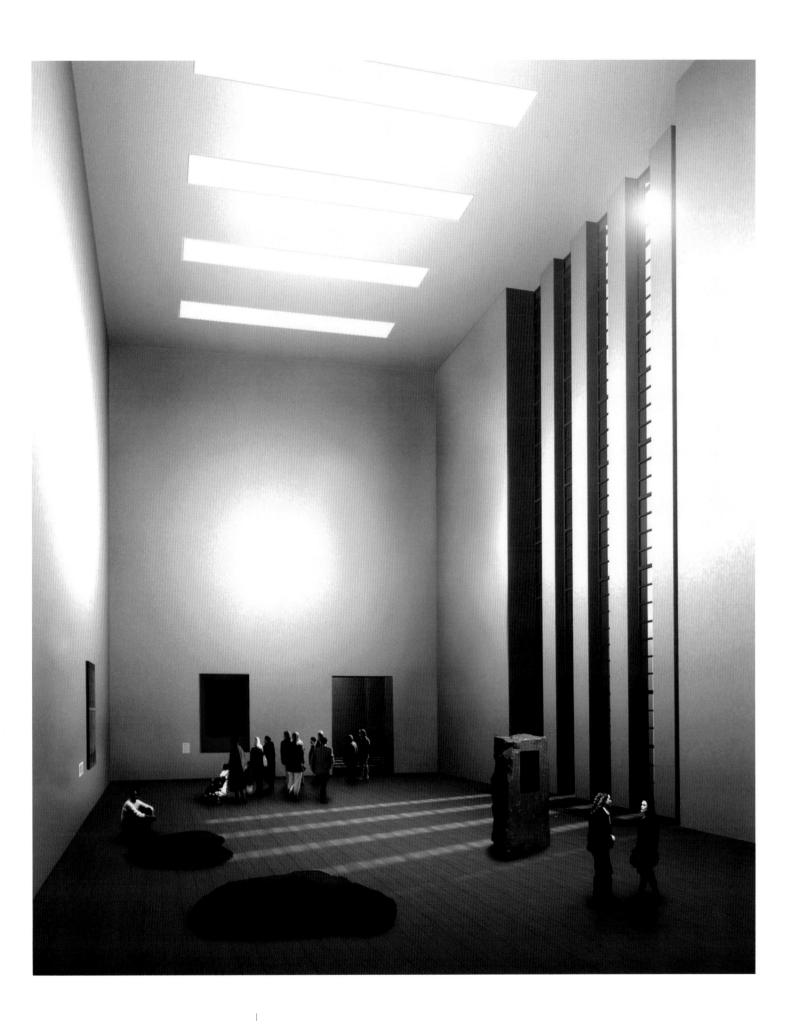

Juan Navarro Baldeweg
The Altamira Cave Museum
Santillana del Mar, since 1995

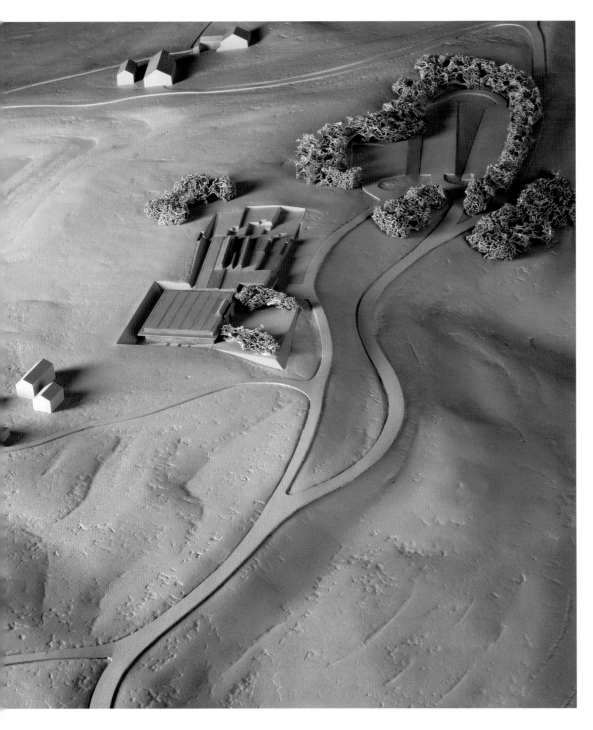

Site model

The challenge that Juan Navarro Baldeweg faces in the Altamira Cave Museum project seemingly could not be more outlandish. Indeed, the project consists of constructing a facsimile reproduction of the cave and the paintings on its walls next to the very same venerable spot on which the prehistoric cave sits, all for the purpose of welcoming the thousands of tourists that flock in ever increasing numbers to the famous site where from henceforth they will no longer be able to see the original, only a copy.

A strange and even paradoxical subject this is, although, at closer inspection, perhaps it really isn't. Well thought out, the Altamira Cave Museum would be, on the contrary, a paradigmatic example of what museums are in this age, what they collect and shelter, what they exhibit, whom they attract, and how they do it: it would certainly be difficult to find another more immediate and more schematic example of the characteristic estrangement taking place in our times between a work and its exhibition or, more appropriately, between the work itself and the paths of consumerism that evolve from it. In this project we see clearly how—and to what extent— the masterpiece must be hidden in order to reap any benefit or profit from it. The more a work remains hidden by virtue of the impenetrable security measures that protect it, the less it can be seen and enjoyed, while at the same time, approaching the other extreme of the spectrum, the farther will the image, the infinite reproduction of the original, be spread: postcards, notebooks, pocket calendars, scarves, ties, pins, souvenirs of every ilk, … The more the illustration or repro-

duced image is copied, the less the origi-
nal is seen; the more the consumption of
the imitation spreads, the less the original
deteriorates; the more widespread the dis-
tribution of copies, the fewer are the pos-
sibilities of experiencing the original. The
latter, of course, is hidden away in the
darkness of its safe haven, where curators
and technicians dutifully watch over it, a
guarantee that protects all copies of the
original; for the copies, the entombment
of the original represents an open-ended
security bond. Thus, we could say that the
"democratization" of the original art-
work—that is, the arrival of busloads of
tourists, an audience that pays to be enter-
tained—automatically demands its shelter-
ing, its seclusion far at the back of a vault,
to provide the needed and appropriate
conditions for its effectiveness.

The Altamira Cave Museum, in addi-
tion to serving as an example, also looks to
the possible limits of the situation. The
object is unique; there is only one thing—
the cave—that tourists come to see. Not
only will that one specific work be repro-
duced thousands of times in the form of
souvenirs that will be bought and then put
in their proper place, but from the very
outset, by exhibiting only the duplicate,
the museum will offer, in principle, at
least, a means of preserving the original
as the numbers of its visitors increase ad
infinitum.

Obviously, Juan Navarro is aware of
the problem, and once he accepts the con-
ditions it imposes, all his efforts will aim to
succeed in having the architecture of the
museum perceived as independent of "the
situation," to prove that it can stand on its
own merits and state its own eloquence.
This, however, will not cause the architect
to adopt an escapist attitude. Indeed, on
the contrary, his project will give itself
over to the "theme," and will metaphori-
cally offer architecture the opportunity to
conquer its intrinsic intractability. The
architecture of Juan Navarro will not
speak of the distance between the original

Site plan

Preliminary studies

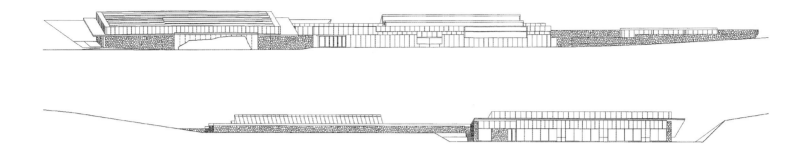

North elevation

South elevation

Site model

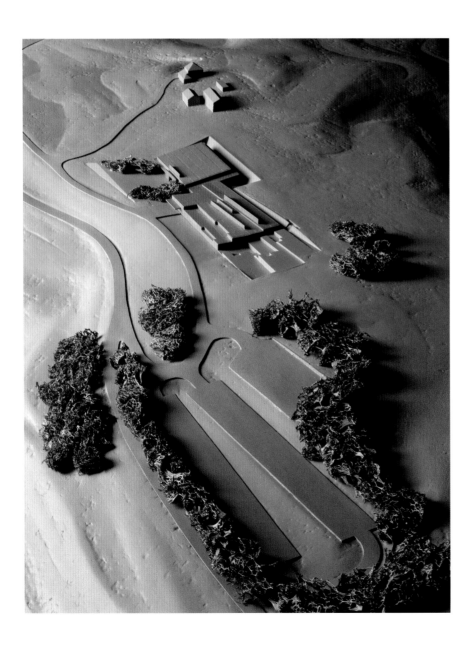

and the copy, but only of the advantages of "a place" and "a museum," not of conflicts "in the cave," but of the virtues "pertaining to its history."

Herein lies the explanation of the most important decision: the partial underground placement of different sections of the building. Navarro justifies this action by the need to preserve the landscape, concealing any interference as much as possible, and that is also the reason why the sodded roof of the nave housing the reproduction of the cave will slope along the incline of the terrain, with the wings of the museum likewise spreading out slightly in the form of a fan so as to conform to the lie of the land. In reality, however, these are merely contingent issues. The partially buried museum speaks of other things, for example, hinting at a "notion" of excavation. The original cave is located underground, and the stories and legends linked to its discovery always emphasize the prodigious feat of descending beneath the surface of the earth within the folds of this dark wrinkle on its skin, where a great treasure had lain shrouded, forgotten for thousands of years. Juan Navarro's museum also rises from an excavation site stirred up by earthmovers, and it adapts to the shape of the land and its

natural degree of incline as if it had "always" been there. A projecting roof marks the entrance to the museum, which leads into the large hall. Similarly, a slightly slanting, projecting roof indicates the position of the narrow opening into the cavern, with dressed side walls. These formal elements successfully enhance the significance of the two main openings into the structure. From there, the downward sloping way to the interior begins. The cut into the ground at the mouth of the cave—the frame, as Juan Navarro himself calls it—is so precise that the time-resistant building appears to be the result of a simple earth-removal clean-up. Rather than the land, the building itself gives the impression of being on a slant. This building plunges into the earth, perhaps awaiting new excavations on ground that forever hides, but suddenly reveals, its great marvels.

So, what is the real shape that Juan Navarro has given to this building? The corpus that harbors the reproduction of the cave is, obviously, the only entirely "certain" motive within the whole of a program that includes other, more "vague," functions—museum, research center, public areas … This feature determines the layout of the components of the project: a structure of considerable dimensions, grounded in the quadrangular form of its huge covering, is converted into a "de-centered center" of a panoptical building, whose fragility is evident in the stratification of its roofs and in the upward thrust of its skylights, which take on an aura of open covers. In this way, a traditional theme of Juan Navarro—that of a "point" and a "fleeing"—is transformed into an allegory of the difficulties and the vices of "that" program; a perfect example, as we

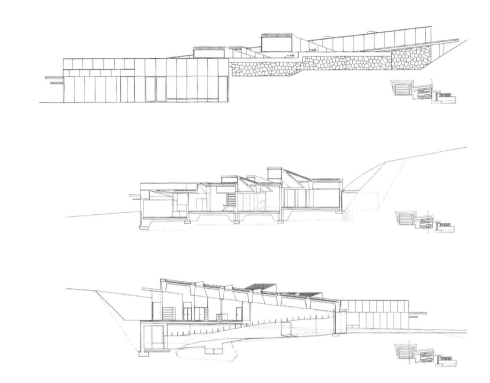

East elevation

Section through museum

Section through cave

Plan at level
− 1.00 to + 1.55

Plan at level
− 3.20 to − 1.00

View from north

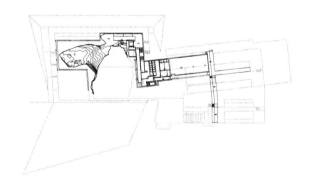

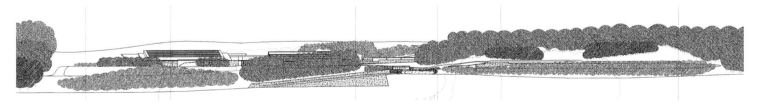

have seen, of the museum that, in gathering unto itself everything, really contains nothing. Juan Navarro's building, in essence, flees from the cenotaph and its ambiguity, driving itself into the ground, stirring it up, to save itself.

But we cannot speak only of allusions; we need to touch also upon illusions. Navarro insists on presenting to us the replica of the caves as a "virtual environment" or, more specifically, as a "mirror image." To be sure, Narcissus has always been one of his favorite subjects. In fact, does not architecture strain in this museum to attain the impossible: to embrace its own reflection?

Juan José Lahuerta

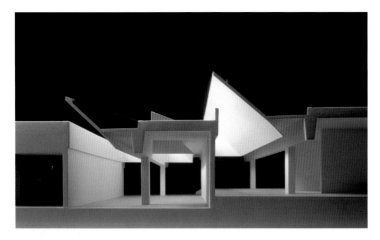

Sectional models

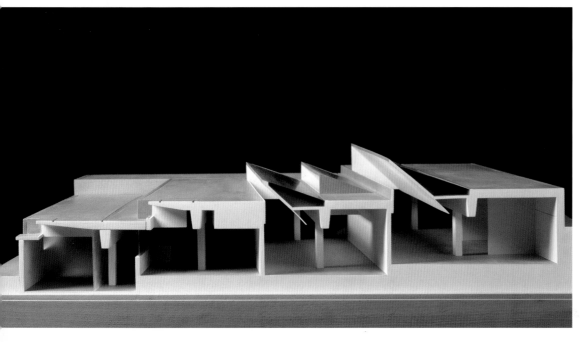

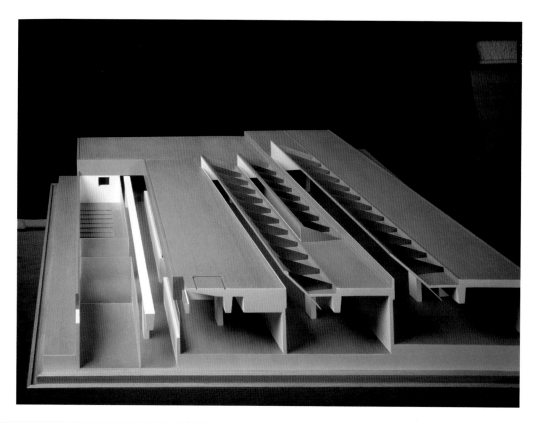

Sectional model

Site model

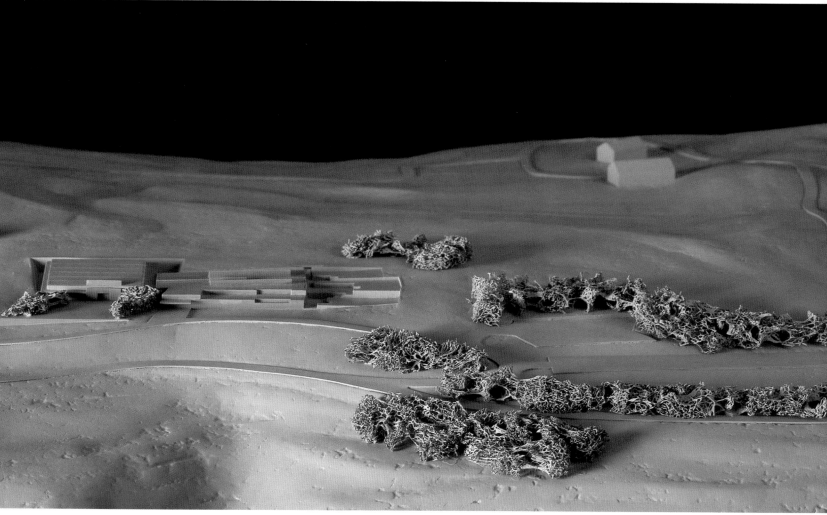

Tadao Ando
Modern Art Museum

Fort Worth, Texas, since 1997

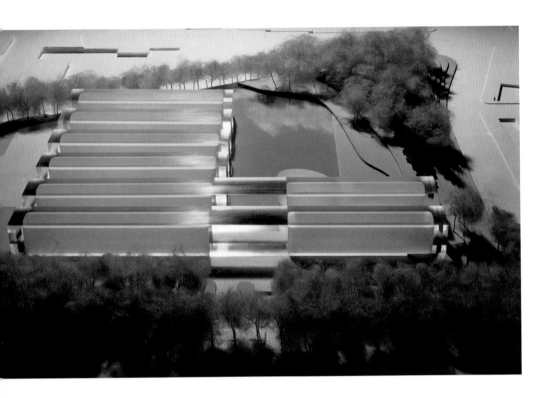

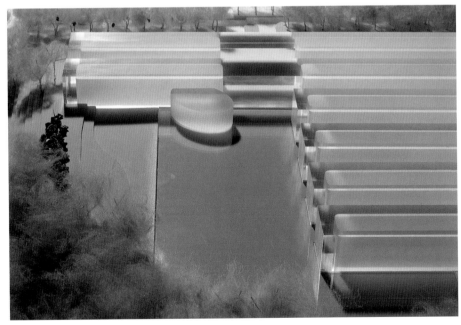

Site models

From the Wall of Negation to the Wall of Naming

The most spellbinding power of the Modern Art Museum of Fort Worth lies in its abrupt encounter between the glass and Ando's beloved concrete box. Tadao Ando's architecture has long been composed of bare concrete walls. From Row House in Sumiyoshi to the Rokko Housing series, his works, more than two hundred in number, have all consisted of concrete walls (with the exception of a few wooden buildings). The features have changed—sometimes showing the precisionism of a craftsperson, sometimes the cognition of a scientist, sometimes the dynamism of a sculptor—but under Ando's hand, the concrete wall has reached a mastery that might be called Ando-style. Then, all of a sudden, this architecture of the Modern Art Museum of Fort Worth intervenes, full of tension and determination to break from the vectors of the past.

All in all, Ando's concrete walls assume an architectonization of intense negation; and he has achieved a power to attract people by the architectonic of negation. Furthermore, his architecture of the past might also be called an architecture of the negative. If so, then the Modern Art Museum of Fort Worth might be the negation of negation by way of wrapping the negative walls with glass. This method seems to epitomize Ando's new line of experimentation. And the primary effect of the glass box, among its various significations, lies in its function of naming. By shifting from the concrete box to the glass box, and with the twofold wrapping of the concrete box by the glass box, Ando makes a profound material statement.

The Wall of Negativity

Ando's concrete boxes can be categorized into three types: walls of silence, walls of interdiction, and walls of negation. Furthermore, they can be said to correspond to the Lacanian concepts of the imaginary, the symbolic, and the real. From this stance, we can uncover the unconscious of Ando's wall.

The first is the wall of silence, as seen in the façade of Row House in Sumiyoshi. This wall says nothing. Yet its silence itself assumes our theme. When this wall of silence appeared all of a sudden in downtown Osaka, we greeted it with surprise and awe, for the primary feature of this wall appeared to be the expression of rage. The blank face—with extreme intensity—is certainly uncanny, and serves to defamiliarize the pedestrian downtown landscape. At the same time, however, if we approach it calmly, the atmosphere of the wall appears to contain splendor, or the decency of Japanese virtue, or even sorrow. The concrete surface—as smooth as if it were polished—accepts our empathy like a Noh mask, and then begins to function as a mirror of our soul. As it reflects our mental state, the wall gradually assimilates into our consciousness.

Although the wall is dumb, we know well how it feels. For the wall reflects the mental picture of those who gaze at it. By reflecting our mind, the wall builds a specular relationship with us. It does not state anything, but persists in listening to what we have to say. In this manner, the imaginary relationship between humans and objects is born.

But is the wall really dumb? It has no other choice but to be silent. Isn't that because it hides what cannot be spoken of—like, for instance, a secret? As Wittgenstein said, "Whereof one cannot speak, thereof one must be silent." The specular relationship implies that although the wall is dumb, we know how it feels. But in this case, if the wall is silent, it must be for the sake of nondisclosure.

Sketch

Site plan

The authentic function of a wall is to define the spatial order of an architectural interior. That is to say that the rapport between humans and walls does not remain at the mirror stage but develops into the symbolic order. While the concrete wall has a beauty of flatness, it also contains severity, dread, and even cruelty. In this sense, it is the wall that orders, the wall that defines human relationships. In other words, the wall interdicts the tie between mother and child, and forms the symbolic order as the agency of the father's name. By introducing the severity of geometry into the imaginary relationship, the wall constructs the law that orders under the name of father, namely, that rules the family relationship. And, of course, toward the outside it functions as a barrier to control the exchange between family and community.

In this sense, the function of the wall is to interdict anarchic desire and order the human relationship by molding it into shape. As a result, an unfulfilled desire, or desire distorted by order, comes into existence. This appears as an emptiness, or lack, around which the symbolic order is constructed. The real of the wall is not the substance of the wall, but the absence.

As an example that the attraction of that emptiness or lack captures people, we

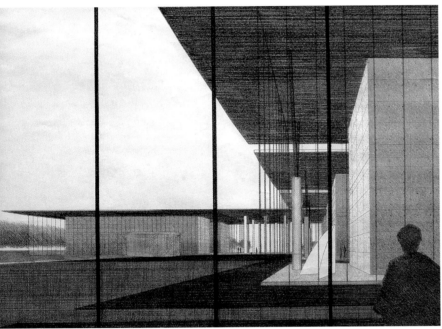

have *Waiting for Godot* by Samuel Beckett. In this play, the awaited Godot never arrives. Yet the absence of the character himself attracts people, their relationship is formed around it, and the power of the play's development is dependent upon it. On the other hand, Row House in Sumiyoshi, a monumental masterpiece of postwar residential architecture, conceives of a mythified lack—that residents have to go to the bathroom carrying an umbrella when it rains. It embraces an ever unfilled emptiness, the lack of a roof in the courtyard. This is nothing but a lack, or perhaps even a trauma, of architecture that nevertheless organizes the order of life around

Elevational and plan studies

Perspective

the wound. Furthermore, this lack as an unconscious of architecture comes into consciousness at the sudden resurgence of natural phenomena such as rain and wind. While this is very much a Japanese traditional method, the courtyard as a receptacle waiting to receive natural phenomena operates in the spatial order just as Godot operates in the performative order. By dividing human relationships, the wall rules man/woman as well as parent/child. In this precise sense, the wall is a system of order, namely, articulated language itself.

As such, Ando's wall embodies the imaginary, the symbolic, and the real. Then, in Fort Worth, the concrete walls are enclosed in a glass box. What does the glass signify?

The Wall of Naming

The glass walls of the Modern Art Museum have at least three significations. The first derives from the implications of the glass box—the freezer effect: the literal transparency of the glass box assumes the effect of freezing the interior. Enclosed within a gigantic glass box, the architecture of concrete is instantaneously frozen as if it were an ice cube. The concrete box enclosed within the cuttingly sharp contours of glass looks like an excavated archeological artifact in a huge vitrine; a sample of contemporary architecture is exhibited within the glass showcase. This also contains a message: that an epoch—the one of the freshly excavated architecture on display—is over.

The glass box freezes not only space but also time, which is to say that it transforms an instant into an eternity by stopping time. In this frozen space is also embodied the classicist value of someone like Johann Joachim Winckelmann—"noble simplicity and still grandeur."

The representation of frozen time by use of a glass case certainly calls to mind an analogy to the museum. And finally, the message of this architecture might be, "Will you please be quiet?"—as a critique

of the superficial plasticism that has blossomed with postmodernism.

The second effect of the glass lies in its power to shift from outside to inside and back again. Wrapped in a glass box, there is an inversion of inside and outside. A previously external wall becomes an internal wall when it is wrapped by the glass, and the courtyard contained in the concrete wall now turns into an interior space—thus the abyssal nesting box structure in which inside and outside are inverted. In this manner, when a transparent membrane is added, the external wall becomes an object to be gazed at. The concrete wall that hitherto has had a power to repel a viewer's gaze now becomes something to be gazed at. As soon as the active and even offensive external wall is put in the glass box, it turns into an internal wall, an object of the fixed gaze like a framed painting. At the same time as it inverts internal and external spaces, the glass box also functions to invert the reciprocity of the gaze—from the gazer to the gazed at.

The glass box also plays a strong indicative function. The act of placing something in a glass box calls to mind Nietzsche's cry: *Ecce homo*. The transparent glass has the same function as the indicative pronoun "this," which functions deictically; that is, it indicates *no other than this*. As a result, the glory and solitude of the chosen—Ando's signature—is sealed inside the glass. The deictic function of the glass box lies in naming the enclosed object as a singularity. It is this function that gives architecture—the one-time event full of contingency—historicity and necessity.

Every architecture exists in a different place; nothing is the same as anything else. So many views of architecture are derived from this obvious fact. For instance, the nominalist stance claims that architecture is a concept empirically abstracted from individual architectures, while the realist stance insists that individual architectures are merely contingent appearances of the idea of Architecture. Unconcerned with

architecture *in general*, Ando's architecture is consistently singular.

The intense indicative function of the glass box manifests the fact that *no other than this* has been chosen. It is a ritual of naming, that is, a baptism. In the sense that it gives architecture a proper name, it assumes the function of naming. According to Saul Kripke, proper names are "rigid designators" that point to one and the same object in all possible worlds. This indicates the ground of necessity that, no matter how conditions are changed, this

architecture has had no other way to be but this. Architecture is a consistently one-time event full of contingency. Nevertheless, once a proper name has been assigned, it achieves the necessity of its existence.

The Modern Art Museum of Fort Worth makes a solitary specimen out of a modernity of concrete wrapped in a glass box. The gigantic glass wall's function of naming means that only a solitary, singular man can achieve the necessity of the irreplaceable *no other than this*. This is Ando's new signature, and his letter to the future in which the twentieth century is sealed.

Masao Furuyama

Elevations

Computer simulation
of exterior view

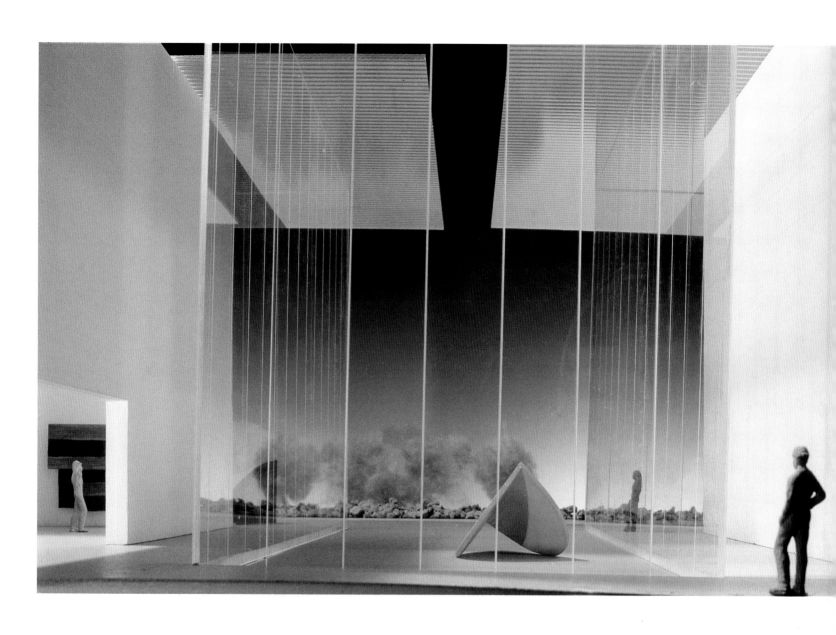

Computer simulation
of interior view

Steven Holl
Bellevue Art Museum
Bellevue, Washington, since 1997

Conceptual studies for various stories

Volumetric study of entire building

Not until the turn of the twentieth century did American art museums begin to take on the aspect of classical temples or treasure houses of quasi-sacred objects. In the nineteenth century, they came into being as teaching institutions, often adjunct to art schools, or else as more permanent venues for the artwork shown in commercial exhibitions. With the widespread adoption of the European model, however, the museum was frequently compared to a mausoleum, a place where art objects severed from their vital connection to the everyday world were interred and embalmed for posterity. In this vein, the American pragmatist philosopher John Dewey begins his book *Art as Experience* (1934) with a condemnation of the deadening "museum conception of art," calling for an organic reintegration of painting, sculpture, and architecture with "the significant life of an organized community."

The Bellevue Art Museum, designed by Steven Holl Architects for a contemporary boomtown in the Pacific Northwest and slated to open on New Year's Day in 2000, recalls the American art museum's alternative genealogy. Born out of the Pacific Northwest Arts Fair, an annual outdoor crafts event held since the fifties on the local streets of Bellevue, the museum has no permanent collection. Its mission is to provide community outreach and education, collaborating with local arts groups and schools. Until about a decade ago, Bellevue, located eight miles east of Seattle across Lake Washington, was a nondescript suburb. In the nineties, however, with the founding of the Microsoft Corporation there as well as another computer-industry

Wunderkind, the book distributor Amazon.com, it acquired a high-tech profile and urban density. Having operated for fifteen years on the second floor of a shopping mall, the museum will now occupy a central site at the heart of the burgeoning downtown area, flanked on one side by a new pedestrian corridor. Intended to provide Bellevue with an active cultural hub, it is dedicated to innovative programming and changing exhibitions that explore the intersection of art with science and technology.

Steven Holl has frequently relied in his projects on a metaphoric or figurative device to trigger his spatial imagination. At the Museum of Contemporary Art in Helsinki, the concept of "chiasma"— meaning crossing or exchange—inspired his parti, while in his addition to the Cranbrook Institute of Science in Bloomfield Hills, Michigan, the notion of "strange attractors" helped him to situate the new building in relation to the existing complex. At Bellevue, Holl takes the idea of "tripleness" as an organizing concept. The concept comes from the triad of art, science, and technology to which the museum is dedicated, as well as its philosophy of bringing together the experiences of "seeing, exploring, and making" art.

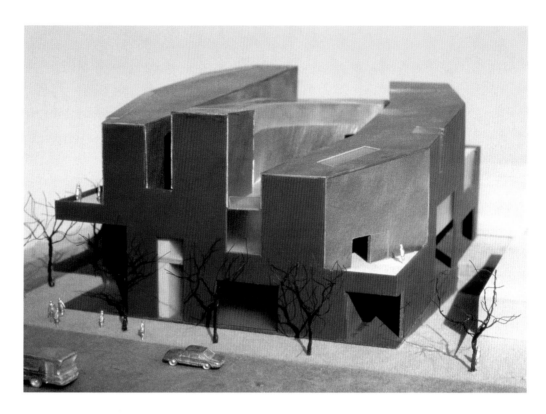

Model: views of entrance front

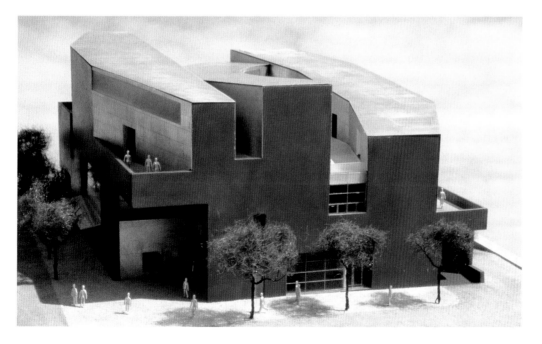

Holl has interlaced the concept of tripleness through multiple facets of the project. There are three main circulation levels in section, three loft-like gallery spaces in plan, three qualities of light that filter into the exhibition spaces. He has articulated these triplets by carving into the solid mass of the building, sculpting the residual voids to create a kind of gestural organism defined by its entry points, courts, and outdoor terraces.

At street level, Holl opens up the northwest corner of the volume to create a diagonal entry to the museum underneath a third-story terrace overhang. Once inside, the visitor encounters the belying space of the Forum, a 30-foot-high atrium for opening receptions and special events. The Forum is circumscribed by a stepped ramp that ascends to the museum's second floor by way of a landing at its apse end, which also doubles as a stage. To the left at street level are a shop and café opening out to an awninged sidewalk terrace, relieving the pressure of the convex central void. On the other side of the Forum are a trapezoidal, 100-seat auditorium and an Art Garage, an unloading area for trucks

making deliveries that is also used as a staging zone for informal shows and performances.

The major feature of the second level is the Explore Gallery, an expandable double-height exhibition space reached from the stepped central ramp. Illuminated by punched skylights, it is meant to evoke a sense of time Holl describes as "fragmented" or "gnostic." Adjoining it are an artist-in-residence studio and, carved out of the southeast corner of the floor plate, one of the building's several triangular outdoor spaces. Called the Terrace of Planetary Motion, this one is programmed for the display of digital images of astronomical phenomena, which are projected onto its angled two-story exterior wall.

Continuing up the stepped ramp, one arrives at the museum's two other principal galleries. As its name suggests, the South Light Gallery is illuminated by southern light that filters in from an arcing slot in the ceiling, corresponding roughly to the sun's path at the building's latitude of 48 degrees north. Intended to evoke a "cyclic" sense of time, the gallery's trajectory follows the curve of the adjacent Court of Light. The latter is located directly above the Forum and, as the largest of the museum's outdoor spaces,

Conceptual studies

Longitudinal section

Cross-section

Longitudinal section
at southern end

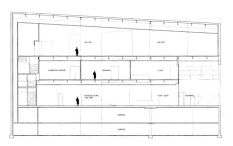

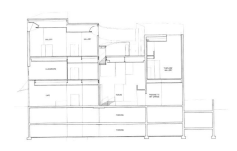

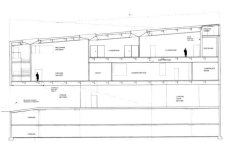

accommodates al fresco classes as well as exhibitions and events on summer evenings. On the opposite side of the South Light Gallery is the North Light Gallery. This space is evenly lit by northern light emanating from flush pockets carved into the ceiling, representing the idea of "linear" or "ongoing" time. Each of the three principal galleries is inflected about the building's north–south axis and anchored by its east–west end walls. These inflections or deformations pull the building volume apart, articulating its tripartite organization and opening up peripheral and interstitial spaces like those between the outstretched fingers of a hand or the webbed foot of an animal. The deeper ones become outdoor terraces, each celebrating a different natural element or scientific phenomenon, or, in the case of a large triangular indent on the eastern elevation, a water court where, on rainy days, the droplets produce reflective patterns that dapple the surrounding walls.

Holl's preoccupation with organic phenomena and the natural effects of weather and light is most powerfully conveyed by his use of materials. The building's sheer walls are made of shotcrete, a form of structural concrete in which the material is sprayed from a hose at a one-sided exterior formwork. Holl has utilized this technology—typically employed to date in civil engineering structures like dams and reservoirs—to produce a rough-

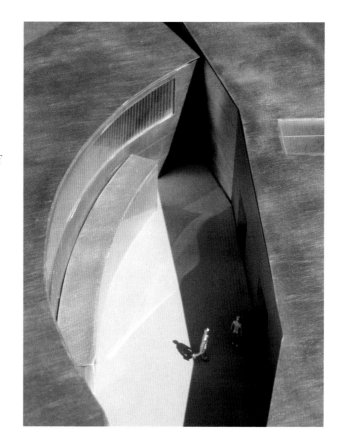

Model: view into
Court of Light

Third-floor plan

Ground-floor plan

Second-floor plan

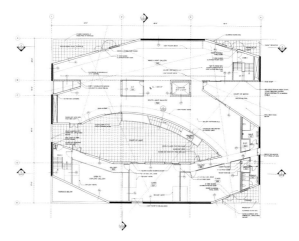

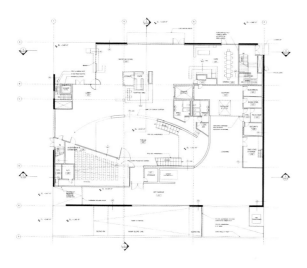

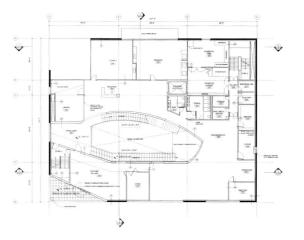

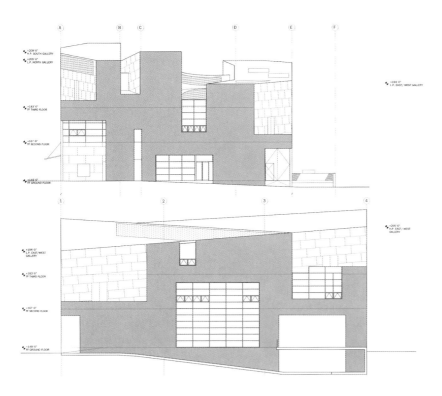

West elevation

①

WEST ELEVATION

②

SOUTH ELEVATION

textured carapace, stained rust-red in con-
trast to the building's nonbearing surfaces
and interstitial elements. The latter are
sheathed with aluminum plates that are
cool bluish in coloration and have been
hand-sanded, then acid-etched and
anodized to an elegant matte finish. The
process was developed in consultation
with a local metal finisher for Boeing,
the aerospace giant that, together with
Microsoft today, dominates this region
of the United States.

Originally a native of Washington
State, Holl seems to be particularly at
home in this project, drawing on the
Pacific Northwest tradition of "inventive
imagination and irreverence," as he has
described it (rather than the stylistic
clichés of heavy-timber elements and
broad sloping roofs). It is an indigenous
sensibility keyed to assertive experimenta-
tion with technology and active engage-
ment with the natural environment. At
the same time, Holl's longstanding interest
in the experiential phenomena of space,
light, and materials has led him to evolve
a distinctive architectural vocabulary in
which intellectual and intuitive intentions

West elevation
South elevation

fuse unselfconsciously. While recalling the
form-language of a Hugo Häring or Hans
Scharoun, his "organic" approach seems
particularly apposite to the program of a
contemporary American art museum dedi-
cated to a hands-on pursuit of aesthetic
and scientific knowledge. "To open archi-
tecture to questions of perception," Holl
has said, "we must suspend disbelief, dis-
engage the rational half of the mind, and
allow ourselves to play and explore. Rea-
son and skepticism must yield to a horizon
of discovery. Doctrines are untrustworthy
in this laboratory. The creative spirit must
be followed with happy abandon. A time
of research must precede synthesis."

At the Bellevue Art Museum, Holl has
created a phenomenological field for dis-
covery and interaction. Updating the phi-
losophy of art as experience, he has pro-
vided an expanding local arts community
with a museum that functions as a genera-
tor of new energies, a kind of cultural
powerhouse.

Joan Ockman

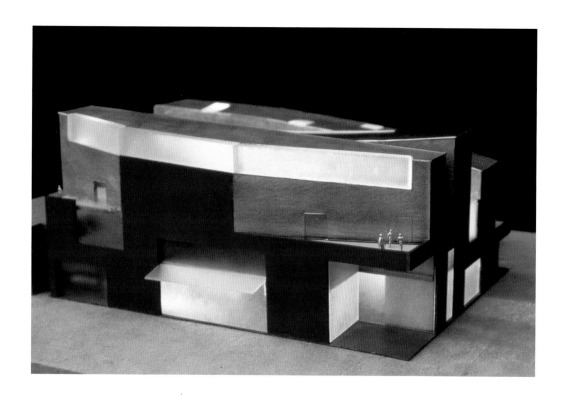

Model: side view

Model: entrance area

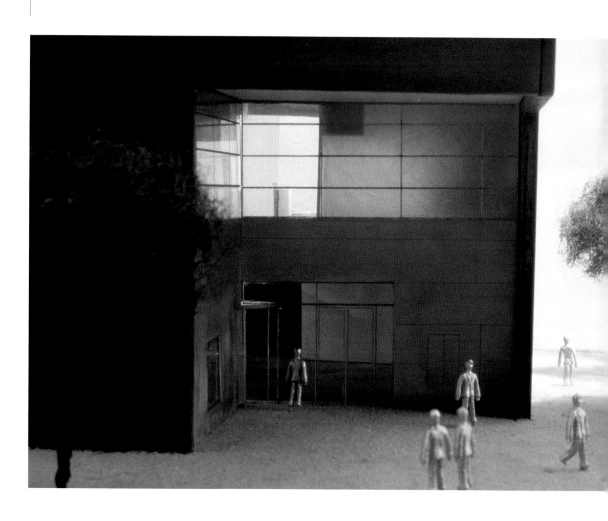

Interior studies of Forum

Model: view into Forum

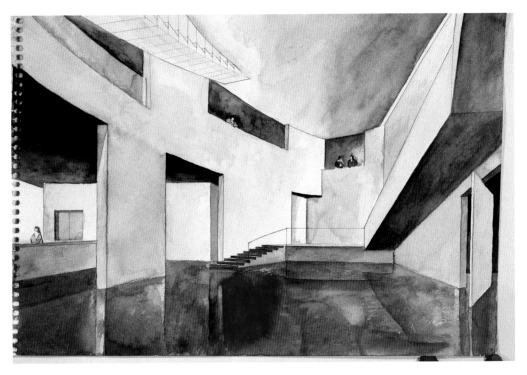

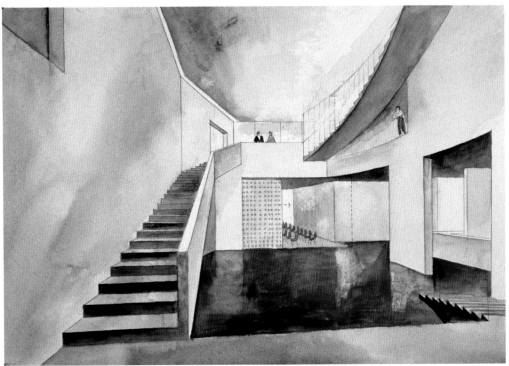

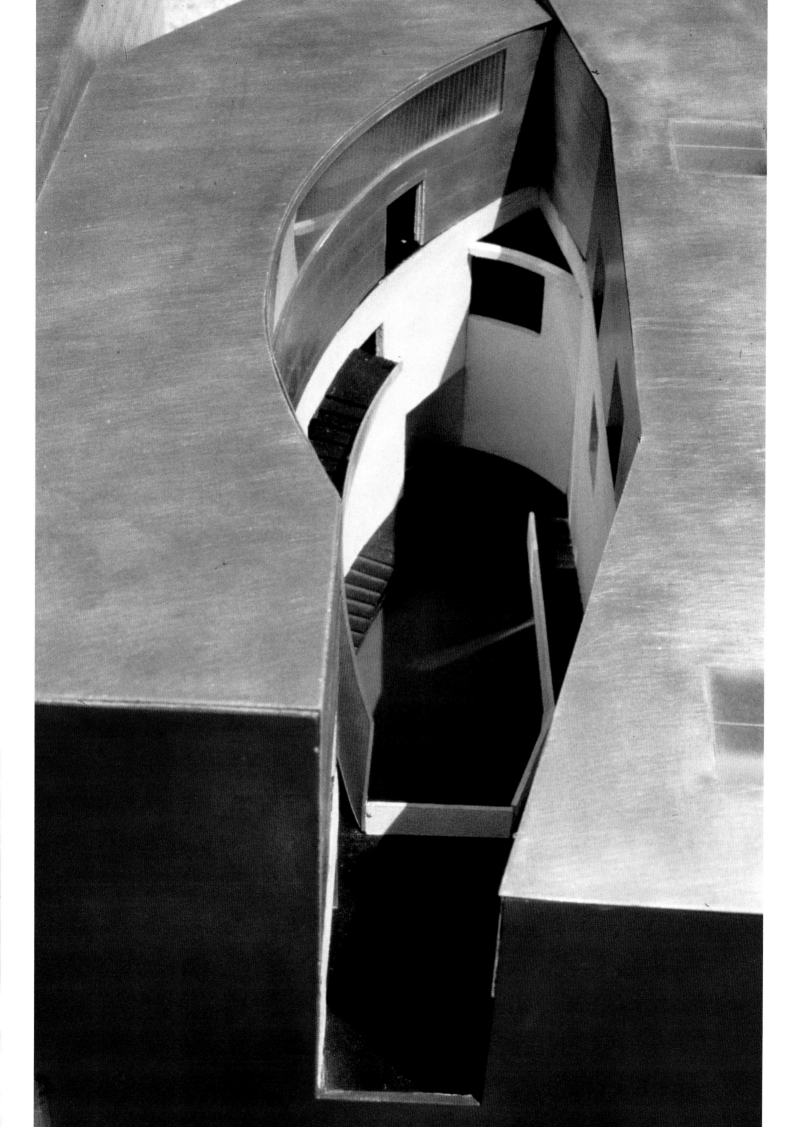

Zaha Hadid
Contemporary Arts Center
Cincinnati, Ohio, since 1998

Relief model: study
for entrance situation

Study drawings

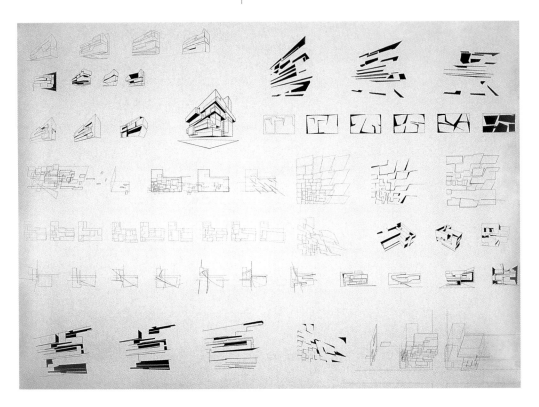

A Successful Synthesis of Art and Space

The crisis in art and competition between its disciplines have for some time recast architecture in the leading role in the arts as a whole. Now that traditional, object-related art has been relativized by the non-representational idiom of minimal, conceptual, video, and performance art, architects feel challenged by a new freedom in design to transform their own work into exhibition pieces. They strive to create psychological and emotional environments that are inspired by the utopian ideal of the early modern movement: the *Gesamtkunstwerk* as a synthesis of all disciplines.

Although the range of expression is limited in an applied art form such as architecture, designs that want to apply the generic claim of the objects to themselves share an approach to utilizing a common plastic characteristic: dissolving spatial and access systems, and adapting floor plan and elevation in the sense of a continuous flow of space from the horizontal into the vertical.

The archetypal image of this three-dimensional figure—Tatlin's constructivist spiral monument for the Third International in 1920—has found widespread acceptance in stage and theater design, from Frederick Kiesler to Walter Gropius. But its first large-scale use was Frank Lloyd Wright's Guggenheim museum in New York—an eight-story building with one continuous spiraling level. Yet this first realization simultaneously destroyed the intended synthesis between fine and applied art just when it had reached its peak. For curators across the world have found the sloping levels and the omni-

present contact to the open spaces to be a visual and acoustic distraction to the contemplative experience of art. And thus the new addition to the Guggenheim in New York and the planned expansion for the Museum of Modern Art are both expressions of a return to classic choices: separation into different floors and neutrality in exhibition rooms.

With her award-winning competition design for the Contemporary Arts Center in Cincinnati, Ohio, Zaha Hadid tries to find a balance between the radical, modern spatial integration and the classic division. The eight-story building—six main floors and two mezzanine levels—in downtown Cincinnati strives for harmony between architecture and urban development by integrating the structure of the urban plan as an "urban carpet" into the ground-floor lobby like a modern version of the loggia and by a relief-like extension of the vertical to the rear. Floors, walls, and ceilings are treated in a variety of ways, intermingling and merging in undulating levels and ramps. Yet this synthesis of horizontal space and vertical access is far from complete. For Hadid has located elevator shafts and stairs behind the urban carpet wall to the rear, set far enough back from the gallery *per se*, despite the wall openings, to avoid unwanted interference between the different sections.

In a newer version of a similar design, Rem Koolhaas's unrealized designs for the Bibliothèque Nationale de Paris and for the Jussieu university library work with the total integration of ground plan and elevation by means of meandering promenades which run through the entire building. By contrast, Hadid is more forward in her articulation of the interplay between mass and space and between open and closed elements, more implosive than explosive in approach by comparison to the aesthetic of her earlier buildings.

The Cincinnati art museum, founded in 1939, like the Museum of Modern Art in New York, is an exponent of the first

Study of the museum
in its urban context

View from above

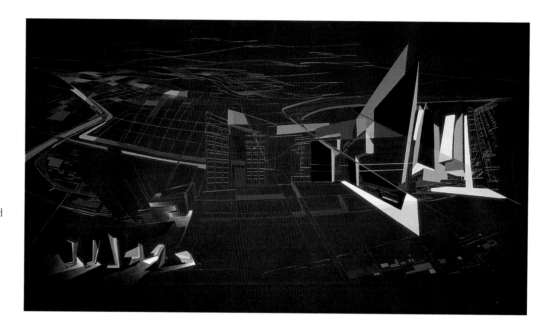

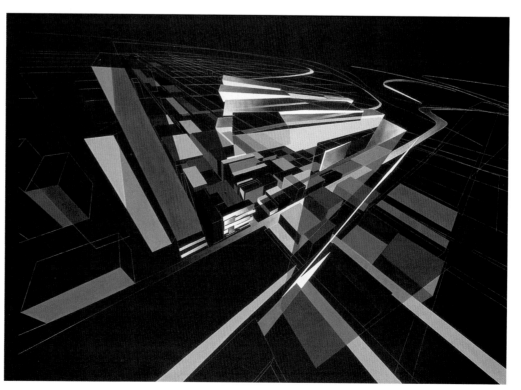

generation of exhibition buildings in the United States. In the absence of a permanent collection, the contemporary art division organizes changing exhibitions. Until recently it was housed in a rented space in an apartment building. The new building, whose costs are estimated at $18 million, will offer three times the space with a total of 8,000 square feet. To prepare for the unpredictability and the flux of future exhibitions, performances, and other uses, Zaha Hadid has decided to forgo neutrality; instead she has created strongly articulated rooms that are anything but neutral.

As far as one can see from existing plans, the building reverses the traditional structure from heavy to light components, with individual floor sections rising above the recessed entrance atrium in a cubical manner. In contrast to the massive, cantilevered floors in Marcel Breuer's Whitney museum in New York, Hadid's façades are transparent and open. The architect explains that she wanted to chisel the individual rooms as roughly and unpolished as possible out of the large volume and at the same time achieve an impression of weightlessness.

What is unusual is not only the placement of offices and workshops, which are generally to the rear of such buildings but are here visible behind transparent façades along the front, but also the multiplicity in individual building sections. Thus the reception desk and the cash counter can be transformed into a bar at night; a (still somewhat undefined) rotating, suspended ceiling between the lobby in the raised ground floor and the performance space in the first basement level will allow for flexibility in both areas.

The galleries, whose ceiling height ranges from 4.5 meters to 9 meters, are not linked in the manner of an enfilade; instead they are connected by intermittent ramps that open up varying lines of sight. This differs from the standard tour by allowing visitors to view exhibitions and

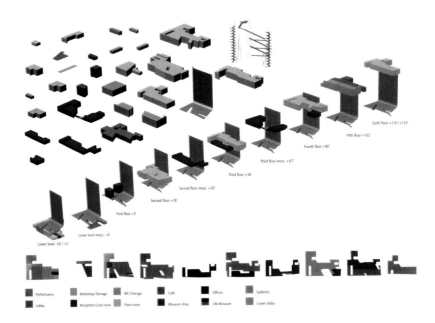

Diagram of building elements

Overall concept

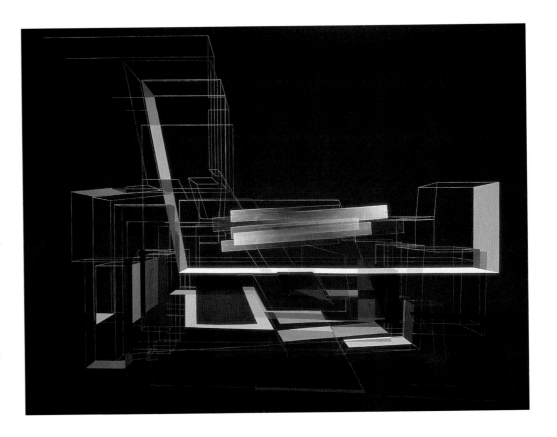

individual spaces from above, from below, or from the side. The galleries float like pipes or stacks above one another, leaving great gaping voids that act as negative connective elements. Zaha Hadid speaks of "multiple perception," of "distant views," and also of a more physical experience of the space; the rooms, increasing in size and transparency from floor to floor, are all designed to profit from a maximum incidence of daylight and are crowned by an open roof garden.

Ambitiously, the State of Ohio has been a patron of architecture for the past decade. It has supported projects by Frank Gehry, Peter Eisenman, and other artist/architects. Should the city of Cincinnati actually build the Contemporary Arts Center designed by Hadid, it would be a breakthrough on several levels. For the first time the masterful architecture of the Iraqi architect, inspired by constructivism and suprematism, would be put to the test in a real setting and on a large scale. Moreover, "deconstructivist" architecture—often criticized as hostile to context because of its plasticity—could finally

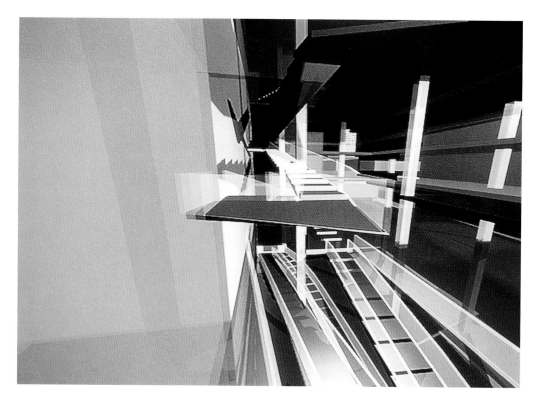

Interior view

Corner view

prove that it is capable of urban integration in a dense city location.

Finally, the leading role of architecture in the arts as a mega exhibition object beyond discipline would be relativized at least to the extent that Zaha Hadid's powerful three-dimensional flights of fancy would result in a sufficiently structured and layered exhibition landscape, where art and space could compete equally for the visitor's attention. In Cincinnati, Kandinsky's *Concerning the Spiritual in Art*, as well as the corporeal, psychological, and emotional dynamics expressed in the concepts of the new "event" architecture from Koolhaas to Hadid, could merge to create a successful synthesis.

Michael Mönninger

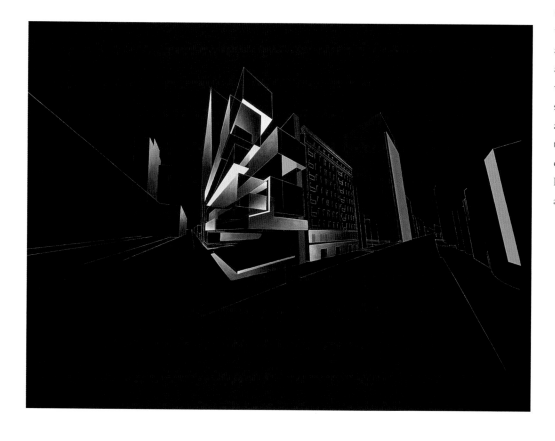

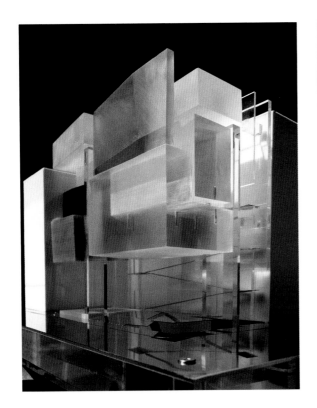

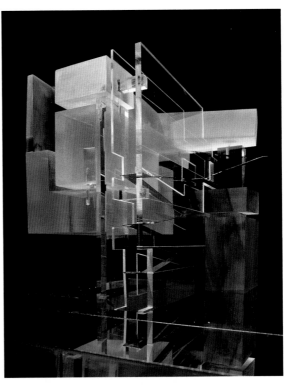

Presentation model,
July 1998: corner view

Presentation model,
July 1998: rear view

Presentation model,
July 1998: front view

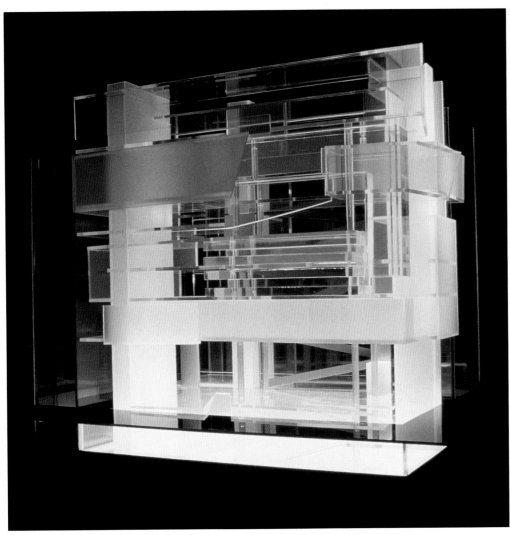

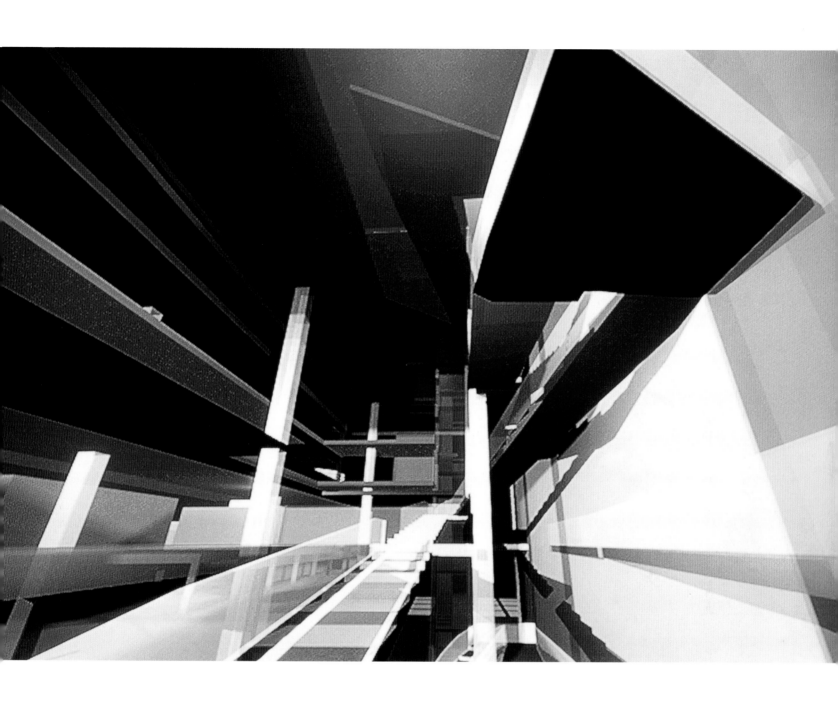

Computer simulation
of interior view

Biographies and Selected Bibliographies

Tadao Ando

Tadao Ando was born in Osaka in 1941. His understanding of architecture was formed by Japanese traditions as well as by various journeys in the years 1962–69 in the Unites States, on the African continent, and in Europe. In 1969 he founded Tadao Ando & Associates. After visiting professorships at Yale University (1987), Columbia University (1988), and Harvard University (1990), Ando has been a professor at the University of Tokyo since 1997. Ando has received numerous awards, including the Pritzker Prize in 1995 and the Royal Gold Medal of the Royal Institute of British Architects in 1997.

Among his most important works are the prizewinning Azuma house in Osaka (1975–76), the Koshino house in Ashiya by Kobe (1979–81), the Church of Light in Ibaraki by Osaka (1987–89), the Chikatsu-Asuka Historical Museum in Osaka (1985–94), the Naoshima Contemporary Art Museum in Okayama (1992 and 1995), as well as the wood pavilion for the World's Fair in Seville in 1992.

Selected Bibliography
Ando, Tadao. "Progetto per il Modern Art Museum di Fort Worth." *Casabella*, no. 653, 1998, 14–21.
dal Co, Francesco, ed. *Tadao Ando. Complete Works.* London: 1995.
Frampton, Kenneth, ed. *Tadao Ando, Buildings Projects Writings.* New York: 1984.
Furuyama, Masao. *Tadao Ando.* Zurich: 1993.
Jodidio, Philip. *Tadao Ando.* Cologne: 1997.
Tadao Ando 1988–1993. GA Architect, no. 12, Tokyo: 1993.

John M. Armleder

John Armleder was born in Geneva in 1948. He has lectured and held workshops at numerous universities and academies in the United States and Europe, and holds professorships at the Institutes of the Arts in Lausanne and Braunschweig. He has received numerous awards, such as the Prize of the City of Geneva in 1994. The artist lives and works in Geneva and New York.

Since 1973 John Armleder has presented his work through numerous one-man exhibtions: at the Kunstmuseum in Basel (1980), at the Living Arts Museum in Reykjavik (1982), at the Künstlerhaus in Stuttgart (1984), at the Musée d'Art Moderne, ARC in Paris (1987), and at Le Consortium in Dijon (1989). Further, he exhibited at the Centraal Museum in Utrecht (1992), at the Vienna Secession (1993), at the Centre d'Art Contemporain, Le Capitou in Fréjus (1994), at the Cabinet des Estampes in Geneva (1995), at the Staatliche Kunsthalle in Baden-Baden (1998), and at the Holderbank in Aargau (1999).

Parallel to this activity, he was involved in numerous international exhibitions, such as in 1975 at the Paris Biennale, in 1986 at the Swiss Pavilion for the Venice Biennale, as well as at *Prospect 86* at the Kunstverein of Frankfurt, the Schirn Kunsthalle in Frankfurt am Main, both in 1986. In 1987 he exhibited at the *Documenta* in Kassel, in 1989 at the *Metropolis* in Berlin, and in 1993 at the World's Fair in Seville.

Selected Bibliography
John M. Armleder. Exhibition catalog. Milan and Fréjus: 1994.
John M. Armleder. Exhibition catalog. Kunstmuseum Winterthur: 1987.
John M. Armleder—at any & speed. Exhibition catalog Staatliche Kunsthalle Baden-Baden, Holderbank Aargau, Ostfildern-Ruit: 1999.
John M. Armleder—Funiture Sculpture, 1980–1990. Exhibition catalog Musée Rath, Geneva: 1990.
John M. Armleder: Pour Paintings 1982–1992. Exhibition catalog Centraal Museum. Utrecht: 1992.
Parkett, no. 50/51, Zurich: 1997.

Mario Botta

Mario Botta was born in Mendrisio, Ticino, in 1943. After a technical drafting apprenticeship from 1958 until 1961, he studied at the Instituto Universitario di Architettura in Venice from 1964 until 1969. Besides working in Le Corbusier's office, he was influenced by encounters with Louis I. Kahn and Carlo Scarpa. He opened his own office in Lugano in 1969. Mario Botta was visiting professor at the Federal Polytechnic Institute in Lausanne and at the Yale School of Architecture in New Haven, Connecticut. Botta has received numerous prizes and honors, and since 1996 has taught at the Accademia di Architettura in Mendrisio, which he founded.

A selection of his most important works includes the house in Riva San Vitale, Ticino (1972–73), the Banca del Gottardo in Lugano (1982–88), the Maison de la Culture André Malraux in Chambéry (1984–87), the Cathedral of Evry by Paris (1988–95), the chapel on the summit of Mount Tamaro in Ticino (1990–95), as well as the Tinguely Museum in Basel (1993–96).

Selected Bibliography
Abrams, Janet. "Mario Botta. Il museo di arte moderna di San Francisco." *Lotus International*, no. 86, 1995, 6–26.
Botta, Mario. *Ethik des Bauens. The Ethics of Building.* Basel, Boston, Berlin: 1997.
dal Co, Francesco, ed. *Mario Botta. Architetture 1960–1985.* Milan: 1985.
Botta, Mario. *Mario Botta. Architectures 1980–1990.* Barcelona: 1991.
Pizzi, Emilio, ed. *Mario Botta. Das Gesamtwerk.* 4 volumes, Zurich: 1993–99.

Santiago Calatrava

Santiago Calatrava was born in Benimamet by Valencia, Spain, in 1951. After having attended the School of Art in Valencia from 1968 until 1969, he studied architecture from 1969 until 1974 at the Escuela Técnica Superior de Arquitectura in Valencia. From 1975 until 1979 he studied civil engineering at the Federal Institute of Technology in Zurich, graduating in 1981. That same year Calatrava opened his own office in Zurich, followed in 1989 by a studio in Paris. He has been awarded numerous honorary doctoral degrees from international universities. Among various awards, he was given the European Award for Steel Structures in 1997.

Calatrava's main works include transportation facilities such as the Zurich-Stadelhofen Train Station (1983–90, for which he was given the Brunel Award in 1992, among others) and the Lyon-Satolas TGV Train Station (1989–94), passages such as the BCE Place Gallery in Toronto (1987–92), as well as technical structures such as the broadcast tower on the Montjuic in Barcelona (1989–92) and bridges such as the Alameda Bridge in Valencia (1991–95).

Selected Bibliography
Blaser, Werner, ed. *Santiago Calatrava. Ingenieur-Architektur*. Basel, Boston, Berlin: 1989.
Harbison, Robert. *Creatures from the Mind of the Engineer. The Architecture of Santiago Calatrava*. Zurich: 1992.
Molinari, Luca. *Santiago Calatrava*. Milan, Geneva: 1998.
Polano, Sergio. *Santiago Calatrava. Gesamtwerk*. Stuttgart: 1997.
Tzonis, Alexander and Liane Lefaivre. *Movement, Structure and the Work of Santiago Calatrava*. Basel, Boston, Berlin: 1995.

David Chipperfield

David Chipperfield was born in London in 1953. He completed his studies in 1977 at the Architectural Association. Afterwards he worked for Douglas Stephen, Richard Rogers, and Norman Foster. In 1980 Chipperfield was a founding member of the 9H Gallery in London. In 1984 he opened his own office in London; presently, he maintains offices in Berlin and New York as well. Chipperfield has been a visiting teacher at international universities in Boston, London, Graz, Naples, and Lausanne. In 1995 he assumed a professorship at the Federal Academy of Fine Arts in Stuttgart.

Chipperfield's most important works include atelier buildings in Camden, London (1987–89), the Knight House in Richmond, Surrey (1987–89), the Gotoh Private Museum in the prefecture of Chiba (1987–90), the Design Center in Kyoto (1989–91), the main headquarters of the Matsumoto Company in Okyama (1990–92), and the River and Rowing Museum in Henley-on-Thames in Oxfordshire (1996), which received the distinction of 1999 Building of the Year by the Royal Fine Art Commission.

Selected Bibliography
Chipperfield, David. *David Chipperfield*. Barcelona: 1992.
Chipperfield, David. *Theoretical Practice*. London, Zurich: 1994.
David Chipperfield 1991–1997. el croquis. no. 87, 1997.
Feireiss, Kristin, ed. *David Chipperfield Architects. Houses, Offices & Museums*. Exhibition catalog Aedes Gallery, Berlin: 1995.
Kieren, Martin, "Il concorso per la ricostruzione del Neues Museum a Berlino." *Casabella*, no. 657, June 1998, 34–61.

Norman Foster

Norman Foster was born in Manchester in 1935. After graduating in 1961 from the Manchester University School of Architecture and City Planning, he received a scholarship to attend Yale University in the United States. In 1963 he opened an architecture office in London together with Wendy Cheeseman (later to be his wife) as well as Su and Richard Rogers. In 1967 he founded Foster Associates—with his wife—now expanded to Foster and Partners. Besides its London headquarters, the office maintains "project offices" throughout the world. Norman Foster has taught in England and in the United States, and has received numerous international awards. In 1990 he was knighted, and honored by the Queen in 1997 with the Order of Merit. In 1999 he became Lord Foster.

A selection of Foster's most important works includes the Willis Faber & Dumas Head Office in Ipswich (1971–75), the Sainsbury Centre for the Visual Arts in Norwich (1974–78), the Hong Kong and Shanghai Banking Corporation Building in Hong Kong (1979–86), the Sackler Galleries of the Royal Academy of Arts in London (1985–91), the Commerzbank skyscraper in Frankfurt am Main (1991–97), and the renovation of the Reichstag building in Berlin (1992–99).

Selected Bibliography
Benedetto, Aldo. *Norman Foster*. Zurich, Munich: 1990.
Blaser, Werner, ed. *Norman Foster. Sketches*. Basel, Boston, Berlin: 1992.
Foster, Norman. *Buildings and Projects of Foster Associates*. 4 volumes, Berlin: 1989–90.
Powell, Kenneth. *Carré d'Art Nîmes. Architects Sir Norman Foster and Partners. Blueprint Extra*, no. 11, 1993.
Safran, Yehuda. "Norman Foster. Le Carré d'Art Nîmes." *Domus*, no. 751, 34 / XXII, July / August 1993, 26–32.

Katharina Fritsch

Katharina Fritsch was born in Essen in 1956. She studied from 1977 until 1984 at the Academy of Art in Düsseldorf as a master student of Fritz Schwegler. The artist lives and works in Düsseldorf.

Fritsch's works are part of numerous international public collections including the Museum of Modern Art in Frankfurt, the Staatsgalerie in Stuttgart, the Emanuel Hoffmann Foundation in Basel, the Museum of Contemporary Art in Basel, and the Museum of Modern Art in New York. Among various awards, she received the Coutts & Co. International Award in 1994 and the Art Prize of the City of Aachen in 1995.

Of particular note among Fritsch's one-woman exhibitions are those, for example, at the Institute of Contemporary Art in London (1988), the German Pavilion at the Venice Biennale (1995, with Martin Honert and Thomas Ruff), the San Francisco Museum of Modern Art (1996, also appearing in 1997 in the Museum of Contemporary Art in Basel), and the exhibition *Damenwahl* (1991, with Alexej Koscharow) in the Kunsthalle of Düsseldorf. In addition, Fritsch participates regularly in numerous international group exhibitions. These have included *Doubletake: Collective Memory & Current Art* (1992) in the Hayward Gallery in London, *Looking at Ourselves: Works by Women Artists from the Logan Collection* (1999) in the San Francisco Museum of Modern Art, and the exhibition *dAPERTutto* (1999) at the Venice Biennale.

Selected Bibliography
Fritsch, Katharina. *Katharina Fritsch*. Museum. Exhibition catalog German Pavilion, Venice Biennale, Ostfildern: 1995.
Fritsch, Katharina and Theodora Vischer. *Katharina Fritsch*. Exhibition catalog San Francisco Museum of Modern Art and the Museum of Contemporary Art Basel, Basel: 1996.
Heynen, Julian. "Katharina Fritsch." *Weitersehen (1980–1990)*. Exhibition catalog Haus Lang Museum and Haus Esters Museum, Krefeld: 1991, 67–74.
Katharina Fritsch 1979–1989. Exhibition catalog Westfälischer Kunstverein Münster and Portikus Frankfurt am Main, Cologne: 1989.
Meister, Helga. "Damenwahl. Katharina Fritsch. Alexej Koschkarow." *Kunstforum International*, vol. 144, March/April 1999, 346.
Winzen, Matthias. "Katharina Fritsch." *Journal of Contemporary Art*, vol. 7, no. 1, 1994, 59–73.

Frank O. Gehry

Frank O. Gehry was born in Toronto in 1929. He did his architecture studies at the University of Southern California in Los Angeles and at Harvard University in Cambridge, Massachusetts. Beginning in 1953, Gehry gained practical experience with Victor Gruen, Hideo Sasaki, and William Pereira, until he opened his own office in Los Angeles in 1962. Frank O. Gehry was a visiting professor at Yale University in 1982, 1985, 1987–89, and at Harvard University in 1984. Besides other international honors, he received the Pritzker Prize in 1989.

Among Gehry's most important works are his own house in Santa Monica, California (1977–79, 1988), Santa Monica Place, a retail and garage complex in Santa Monica, California (1973–80), the Main Street Project in Venice, California (1986–91), the Vitra Design Museum in Weil am Rhein (1987–89), the Frederick R. Weisman Art Museum at the University of Minneapolis (1990–93), and the Nationale Nederlanden Office Building in Prague (1992–97).

Selected Bibliography
Bechtler, Cristina, ed. *Frank O. Gehry – Kurt W. Forster*. Ostfildern-Ruit: 1999.
dal Co, Francesco, Kurt W. Forster and Hadley Soutter Arnold. *Frank O. Gehry. The Complete Works*. New York: 1998.
Frank Gehry. Projets en Europe. Exhibition catalog Centre Georges Pompidou, Paris: 1991.
Jencks, Charles, ed. *Frank O. Gehry. Individual Imagination and Cultural Conservatism*. London: 1995.
Romoli, Giorgio. *Frank O. Gehry. Museo Guggenheim, Bilbao*. Turin: 1999.
van Bruggen, Coosje. *Frank O. Gehry – Guggenheim Museum Bilbao*, Ostfildern-Ruit: 1997.

Giorgio Grassi

Giorgio Grassi was born in Milan in 1935. He later concluded his studies there at the Polytechnic. From 1961 until 1964 he worked for the architecture magazine *Casabella-continuità*. Since 1965 Grassi has taught at the Polytechnic in Milan, while also teaching at the University in Pescara from 1965 until 1978.

A selection of his most important works includes the design for the San Rocco housing quarter in Monza (1966, together with Aldo Rossi), the partially built project for the reconstruction of Teora by Avillino (1981–82, with Agostino Renna), the reconstruction of the Roman theater of Sagunt by Valencia (1985 and 1990–93, with Manuel Portaceli), the City Library in Groningen (1989–92, with Cor Kalfsbeek), the competition design for the ABB tract at Potsdamer Platz in Berlin (1993), as well as competition designs for the Felix-Nussbaum-Museum in Osnabrück (1995) and for the Wallraf-Richartz-Museum in Cologne (1996).

Selected Bibliography
Bundesbaudirektion Berlin, ed. *Museumsinsel Berlin. Wettbewerb zum Neuen Museum*. Stuttgart, Berlin, Paris: 1994.
Crespi, Giovanna and Simona Pierini, eds. *Giorgio Grassi. I progetti, le opere e gli scritti*. Milan: 1996.
Grassi, Giorgio. *La costruzione logica dell'architettura*. Venice: 1967.
Grassi, Giorgio. *L'architettura come mestiere e altri scritti*. Milan: 1980.
Kieren, Martin. "Il concorso per la ricostruzione del Neues Museum a Berlino." *Casabella*, no. 657, June 1998, 34–61.

Vittorio Gregotti and Manuel Salgado

Vittorio Gregotti was born in Novara in 1927. In 1952 he concluded his studies at the Polytechnic in Milan. From 1953 until 1968 he worked in an office alliance with Lodovico Meneghetti and Giotto Stoppino in Milan, with the addition in 1974 of Pierluigi Cerri, Hiromichi Matsui and, later, Augusto Cagnardi. From 1964 until 1978, Gregotti was already active at the Polytechnic in Milan. Since 1978, Gregotti has held a professorship at the Instituto Universitario di Architettura in Venice. In addition, he was active as Chief Editor of the architecture magazines *Edilizia Moderna* (1963–65), *Rassegna* (since 1979), and *Casabella* (1982–95).

A selection of his most important works includes housing for the Bossi company in Cameri by Novara (1956–57), the urban design plan for Novara (1962–67), the Zen quarter in Palermo (1969–73, with Franco Amoroso, Salvatore Bisogni, Hiromichi Matsui, and Franco Purini), the University of Palermo (1969–78, together with Gino Pollini), the University of Calabria by Cosenza (1973–84, with Emilio Battisti, Hiromichi Matsui, Pierluigi Nicolin, Franco Purini, Carlo Rusconi Clerici, and Bruni Vigano), sports stadiums in Barcelona (1984), Nîmes (1986), and Genoa (1986) as well as the development plan for Turin (1987–95).

Manuel Salgado was born in 1941 and concluded his studies in 1966 at the Academy of Art in Lisbon (ESBAL). Salgado's works include a housing project in Moita (1975–81) and an office building in Lisbon (1979). In 1993 Salgado won the competition for the urban space planning of the EXPO 1998 in Lisbon. Together with Marino Fei, he built the Jules Vernes Theater (1993–98) and the International Exhibition Hall-South for the EXPO 1998 in Lisbon (together with Studio Risco).

Selected Bibliography
Gregotti Associati. "Centro culturale di Belem. Belem Cultural Centre." *Lotus International*, no. 1, 1989, 28–35.
Gregotti Associati 1973–1988. Milan: 1990.
Rykwert, Joseph. *Gregotti Associati*. Milan: 1995.
Gregotti, Vittorio. "Gregotti Associati e Manuel Salgado. Centro culturale di Belém, Lisbona." *Domus*, no. 738, May 1992, 27–37.
Gregotti, Vittorio. *Il territorio dell'architettura*. Milan: 1966.
Nicolin, Pier Luigi. "Tessuto e monumento. Fabric and monument." *Lotus International*, no. 1, 1989, 24–27.

Zaha M. Hadid

Zaha M. Hadid was born in Baghdad in 1950. After having studied mathematics at the American University of Beirut from 1968 until 1971, she studied architecture from 1972 until 1977 at the Architectural Association School of Architecture in London, where she also taught from 1977 until 1986. In 1978 she was employed in the Office for Metropolitan Architecture (OMA) founded by Rem Koolhaas, Elia and Zoé Zenghelis, as well as Madelon Vriesendorp. Hadid has run her own office in London since 1982. She received international recognition in 1983 with the design for the international open competition for "The Peak" in Hong Kong. Hadid has repeatedly been a visiting professor at Columbia University and Harvard University as well as at numerous other international universities. In addition, Hadid occupies herself with product design as well as furniture and interior design.

Hadid's most important works include the fire station for the Vitra company in Weil am Rhein (1989–93), the installation for *The Great Utopia* exhibition in the Guggenheim Museum in New York (1992), the prizewinning competition design for the Cardiff Opera House (1994), and the exhibition hall for the Landesgartenschau in Weil am Rhein (1997–99).

Selected Bibliography
Hadid, Zaha. *Planetary Architecture*. New York: 1981.
Hadid, Zaha. *Planetary Architecture Two*. London: 1983.
Hadid, Zaha. *Zaha Hadid. Das Gesamtwerk*. Stuttgart: 1998.
Mönninger, Michael. *Zaha Hadid. Projekte 1990–1997*. Stuttgart: 1998.
Zaha Hadid 1983–1991. el croquis, no. 52, 1991.

Jacques Herzog and Pierre de Meuron

Jacques Herzog and Pierre de Meuron were both born in Basel in 1950. They studied together at the Federal Polytechnic Institute in Zurich, from which they graduated in 1975. In 1979 they opened an office together, joined by partners Harry Gugger in 1990 and Christine Binswanger in 1991. Following Jacques Herzog's teaching appointment in 1983 at Cornell University in Ithaca, New York, both he and Pierre de Meuron were guest professors in 1989, 1994 and from 1996 until 1998 at Harvard University in Cambridge, Massachusetts. The office collaborates regularly with artists, such as Rémy Zaugg. In 1996 they received the European Prize for Industrial Architecture.

The most important works of Herzog and de Meuron include the Frei Photographic Studio in Weil am Rhein (1981–82), the Ricola warehouse in Laufen (1986–87), the renovation and expansion of the SUVA housing and office building in Basel (1988–93), the switch building on the Wolf in Basel for the Swiss Federal Railways (1988, 1992–95), the building for the Goetz Collection by Munich (1989–92), the Pfaffenholz sports facility in St. Louis (1989–93), the student dormitory for the University of Burgundy in Dijon (1990–92), the library for the Technical University of Eberswalde (1994–97), as well as the Dominus Vinery in Napa Valley, California (1995–97).

Selected Bibliography
Herzog & de Meuron. Architektur Denkform. Exhibition catalog Architekturmuseum, Basel: 1988.
Herzog & de Meuron 1993–1997. el croquis, no. 84, [II], 1997.
Mack, Gerhard. *Herzog & de Meuron 1989–1991. Das Gesamtwerk*. Volume 2, Basel: 1996.
Sudijc, Deyan. "Tate Gallery of Modern Art. Selecting an Architect." *Blueprint*, no. 115, supplement, March 1995, 1–21.
Wang, Wilfried. *Herzog & de Meuron*. Zurich: 1992.

Steven Holl

Steven Holl was born in Bremerton, Washington, in 1947. After architectural studies at the University of Washington and the Architectural Association in London, he opened his own office in New York in 1976. In 1981 he was invited to teach at Columbia University, where he is still active today. Steven Holl has received numerous international awards, such as the Alvar Aalto Medal (in 1998) as well as the National AIA Design Award for the St. Ignatius Chapel at Seattle University in Washington (1994–97).

A selection of Holl's most important works includes the Pace Collection Showroom in Manhattan (1985), the Berkowitz house on Martha's Vineyard, Massachusetts (1988), the experimental house in Fukuoka, Japan (1989–91), the Stretto house in Dallas, Texas (1989–91), offices for D. E. Shaw in Manhattan (1992), the Museum of Contemporary Art in Helsinki (1993–98), and the Science Center at Cranbrook, British Columbia, Canada (1998).

Selected Bibliography
Holl, Steven. *Anchoring. Selected Projects 1975–1988*. New York: 1989.
Holl, Steven. *Edge of a City*. New York: 1991.
Holl, Steven. *Intertwining. Selected Projects 1989–1995*. New York: 1996.
Holl, Steven. *Steven Holl*. Zurich: 1993.
Steven Holl 1996–1999. el croquis, no. 93, 1998.

Josef Paul Kleihues

Josef Paul Kleihues was born in the German town of Rheine, Westphalia, in 1933. He studied at the Technical Universities in Stuttgart and Berlin as well as at the École des Beaux-Arts in Paris. From 1960 until 1962 he worked in the architectural office of Peter Poelzig in Berlin. In 1962 he set off on his own, opening an office there in partnership with Hans Heinrich Moldenschardt until 1967. After having taught design and architectural theory at the University of Dortmund from 1973 until 1985, he accepted an invitation in 1986 to teach at Cooper Union in New York, where he was active until 1990. In addition, from 1979 until 1987, Kleihues was Planning Director for the new construction area of the International Building Exhibition Berlin (IBA), where he coined the phrase "critical reconstruction." Since 1994, Kleihues has been teaching at the Academy of Art in Düsseldorf.

The most important works of Josef Kleihues include the main workshop of the Berlin Sanitation Authority in Berlin-Tempelhof (1969–78), the Berlin-Neukölln Hospital (1973–86), the housing block at Vinetaplatz in Berlin-Wedding (1971–77), the Museum for Prehistory and Early History in Frankfurt am Main (1980–89), the Kant Triangle in Berlin-Charlottenburg (1984–94), the transformation of the Deichtor Halls in Hamburg to exhibition buildings (1988–89), as well as the Museum for Contemporary Art in Berlin's Hamburg Train Station (1989–96).

Selected Bibliography
Josef Paul Kleihues im Gespräch. Tübingen, Berlin: 1996.
Kleihues, Josef Paul and Kim Shkapich, eds. *Josef P. Kleihues. The Museum Projects*. New York: 1989.
Mesecke, Andrea and Thorsten Scheer, eds. *Josef Paul Kleihues. Themen und Projekte. Themes and Projects*. Basel, Boston, Berlin: 1996.
Mesecke, Andrea and Thorsten Scheer, eds. *Museum of Contemporary Art Chicago. Josef Paul Kleihues*. Berlin: 1996.
O'Regan, John, ed. *Josef Paul Kleihues*. Dublin: 1983.

Rem Koolhaas

Rem Koolhaas was born in Rotterdam in 1944. After an initial career in Amsterdam as a journalist and filmmaker, he studied at the Architectural Association in London from 1968 until 1972. A long stay in the United States followed, where, among other activities, he collaborated from 1972 until 1973 with Oswald Mathias Ungers at Cornell University. The ensuing years until 1979 were spent at the Institute for Architecture and Urban Studies in New York. Koolhaas worked there on his manuscript for *Delirious New York* (published in 1978), in which he investigated the effect of metropolitan culture upon architecture. Together with Elia and Zoé Zenghelis and Madelon Vriesendorp, he had already founded the Office for Metropolitan Architecture (OMA) in 1975 in New York and London. In 1984 Koolhaas left London and settled in Rotterdam.

Among the most important works of Rem Koolhaas are the project for the Parc de La Villette in Paris (1982–83), the Netherlands Dance Theater in Den Haag (1981–87), the Villa Dall'Ava in Saint-Cloud by Paris (1984–90), the Kunsthalle in Rotterdam (1987–92), the Congress Building in Lille (1991–94), as well as competition designs for the Grande Bibliothèque in Paris and for a harbor terminal in Zeebrugge (both in 1989).

Selected Bibliography
Koolhaas, Rem. *Delirious New York. A Retroactive Manifesto for Manhattan*. New York: 1978.
Koolhaas, Rem and Bruce Mau. *S, M, L, XL*. New York: 1995.
Lucan, Jacques. *OMA. Rem Koolhaas*. Zurich: 1991.
OMA. Rem Koolhaas 1992–1996. el croquis, no. 79, 1996.
Puglisi, Luigi Prestinenza. *Rem Koolhaas. Trasparenze metropolitane*. Turin: 1997.
Zentrum für Kunst und Medientechnologie Karlsruhe. Architektur-Wettbewerb. Stuttgart, Munich: 1990.

Ricardo Legorreta

Ricardo Legorreta was born in Mexico City in 1931. From 1948 until 1952 he studied architecture at the Universidad Autonoma de México. During his studies he was already working as a draftsman for José Villagrán García, advancing to project manager and then to García's partner from 1955 until 1960. After a period thereafter as a freelance architect, he founded Legorreta Arquitectos in 1963, opening an additional office in Los Angeles in 1985. Legorreta lectured in the United States, including at Harvard University and the University of Texas, and taught at numerous universities in Mexico, Argentina, Chile, Costa Rica, Japan, and Spain.

Legorreta's most important works include the Hotel Camino Real in Mexico (1967–68), the Renault office building in Durango (1982–84), the San Antonio Library in Texas (1993–95), and the City of the Arts in Mexico City, completed in 1994.

Selected Bibliography
Attoe, Wayne. *The Architecture of Ricardo Legorreta.* Austin, Texas: 1990.
Mutlow, John V. *The Architecture of Ricardo Legorreta.* London: 1997.
Noelle, Louise. *Ricardo Legorreta. Tradición y Modernidad.* Mexico: 1989.

Daniel Libeskind

Daniel Libeskind was born in Lódz, Poland, in 1946 and became an American citizen in 1965. He first studied music in Israel and the United States, followed by architecture at the Cooper Union School in New York until 1970 and at the University of Essex in England until 1972. From 1975 until 1977 he taught at the Architectural Association in London. Libeskind was dean of the Department of Architecture at the Cranbrook Academy of Art in Bloomfield Hills, Michigan, from 1978 until 1985. From 1986 until 1989 he was founder and director of the Architecture Intermundium in Milan. Libeskind has taught at many universities in North America, Europe, Japan, Australia, and South America, and has been professor at UCLA in Los Angeles since 1994. Daniel Libeskind is one of the most important advocates, theorists, and teachers of Deconstructivism. In 1997 he received the American Academy of Arts and Letters Award for Architecture. Since 1989 he has lived and worked in Berlin.

Libeskind has participated in numerous competitions; his most important built works include "Marking the City Boundaries" in Groningen (1989–90), the "Polderland Garden of Love and Fire" in Almere (1997), the Uozu Mountain Observatory in Japan (opened the same year), and the Felix-Nussbaum building in Osnabrück, opened in 1998. Presently in the design phase are projects for the Jewish Museum in San Francisco and the expansion of the Victoria & Albert Museum in London.

Selected Bibliography
Daniel Libeskind. 1987–1996. el croquis, no. 80, 1996.
Dorner, Elke. *Daniel Libeskind. Jüdisches Museum Berlin.* Berlin: 1999.
Feireiss, Kristin, ed. *Daniel Libeskind. Erweiterung des Berlin Museums mit Abteilung Jüdisches Museum.* Berlin: 1992.
Müller, Alois Martin, ed. *Daniel Libeskind. radix – matrix. Architecture and Writings of Daniel Libeskind.* Munich, New York: 1997.
Rodiek, Thorsten. *Daniel Libeskind – Museum ohne Ausgang. Das Felix-Nussbaum-Haus des Kulturgeschichtlichen Museums Osnabrück.* Tübingen, Berlin: 1998.
Schneider, Bernhard. *Daniel Libeskind. Jewish Museum Berlin.* Munich, London, New York: 1999.

Richard Meier

Richard Meier was born in Newark, New Jersey, in 1934. After having studied architecture from 1953 until 1957 at Cornell University in Ithaca, New York, he worked in several architectural offices including Skidmore, Owings & Merrill as well as the office of Marcel Breuer. In 1963 he opened his own office in New York. Together with Peter Eisenman, Michael Graves, Charles Gwathmey, and John Hejduk, Richard Meier was a member of the New York Five, which became known in 1969 through their exhibition as well as their book 5 Architects, published in 1972. Among many teaching appointments, Richard Meier was guest professor at Yale University in 1975. He has received numerous awards including the Pritzker Prize in 1984 and the Royal Gold Medal of the Royal Institute of British Architects in 1988.

A selection of his most important works includes the Douglas House in Harbor Springs, Michigan (1971–73), the Twin Park Northeast housing project in the Bronx, New York (1969–74), the Atheneum in New Harmony, Indiana (1975–79), the Museum of Applied Art in Frankfurt am Main (1979–85), the High Museum of Art in Atlanta, Georgia (1980–83), the City Hall in Ulm (1986–93), the City Hall and Main Library in Den Haag (1986–95), as well as the Museum of Contemporary Art in Barcelona (1987–91).

Selected Bibliography
Blaser, Werner, ed. *Richard Meier. Building for Art. Bauen für die Kunst.* Basel: 1990.
Brawne, Michael. *The Getty Center. Richard Meier & Partners.* London: 1998.
Cassarà, Silvio. *Richard Meier.* Basel: 1996.
Meier, Richard. *Building the Getty.* New York: 1997.
Richard Meier. Architect. 1986–1991. New York: 1991.
Vaudou, Valerie. *Richard Meier. Pour la modernité.* Paris: 1986.

Gerhard Merz

Gerhard Merz was born in Mammendorf by Munich in 1947. From 1969 until 1973 he studied under Rudi Tröger at the Academy of Fine Arts in Munich. Presently, he lives and works in Pescia, Italy.

Gerhard Merz has had numerous important one-man exhibitions since 1975. Pre-eminent examples are *Dove Sta Memoria* in the Kunstverein Munich (1986), an extensive room installation in the Kunsthalle Baden-Baden (1987), the exhibition series *Costruire* an important stopover in 1989 in the Kunsthalle in Zurich, and *Den Menschen der Zukunft* in the Kunstverein Hannover (1990). Noteworthy in addition are the exhibition series Archipittura which experienced a high-point in 1992 in the Kunsthalle Hamburg and in the Deichtorhallen Hamburg, and the exhibition *Licht* in the Kunsthalle Basel (1996). Together with Katharina Sieverding, Gerhard Merz represented the Federal Republic of Germany at the Venice Biennale in 1997. That same year he exhibited in the Kunstverein Bozen and the following year in the Zurich Helmhaus and the Museum of Fine Arts in Bregenz.

Since 1977 Gerhard Merz has participated regularly in the *documenta* in Kassel. Further important exhibitions were Chambres d'Amis in Gent (1986), *Mythos Italien – Wintermärchen Deutschland* in the Art Museum as well as in the State Gallery of Modern Art, both in 1998 in Munich, *Prospect 89* in the Kunstverein of Frankfurt and the Schirn Kunsthalle in Frankfurt am Main (1989), *Metropolis* in the Martin Gropius Building in Berlin (1991), *Weltmoral* in the Kunsthalle Basel (1994), and *A House is not a Home* in Rooseum, Malmö (1997).

Selected Bibliography
Den Menschen der Zukunft – Gerhard Merz. Exhibition catalog Kunstverein Hannover, Hanover: 1990.
Gerhard Merz – 1998. Exhibition catalog, Helmhaus Zurich, Zurich: 1998.
Gerhard Merz. Archipittura. Exhibition catalog Kunsthalle Hamburg and Deichtorhallen Hamburg: 1992.
Gerhard Merz. Biennale Venedig 1997. Exhibition catalog, Zurich and Munich: 1997.
Gerhard Merz. Exhibition catalog Staatliche Kunsthalle Baden-Baden, Baden-Baden: 1987.
Riese, Ute. *Gerhard Merz*. Zurich: 1996.

José Rafael Moneo Vallés

José Rafael Moneo Vallés was born in Navarra, Spain, in 1937. He studied at the Escuela de Arquitectura di Madrid, graduating in 1961. He taught there from 1966 until 1979 and was a full professor from 1980 until 1985. From 1963 until 1964 he was a member of the Accademia di Spagna in Rome. From 1970 until 1980 he taught architectural theory at the Escuela de Arquitectura di Barcelona, followed by international visiting professorships in New York, Princeton, Harvard, and Lausanne, among other places. From 1985 until 1990 he was chairman of the Department of Architecture at the Harvard University Graduate School of Design, being honored there with the Joseph Lluís Sert Professorship. Among numerous awards, he received the Delta de Plata Prize for design in 1986 and the Pritzker Prize for architecture in 1996.

Among his most important works are the Bankinter Building in Madrid (1973–76, together with Ramón Bescós), the National Museum of Roman Art in Mérida (1980–86), the expansion of the Atocha Train Station in Madrid (1984–92), the San Pablo Airport in Seville (1987–91), the museum renovation of the Palazzo Villahermosa in Madrid (1989–92), and the Davis Art Museum at Wellesley College in Massachusetts.

Selected Bibliography
Frampton, Kenneth. "La luz es el tema. Museo de Arte Moderno, Estocolmo. Light is the Theme. Museum of Modern Art, Stockholm." *AV Monografias Monographs*, no. 71, 1998, 12–27.
Moneo, Rafael and John Martelius. *Moderna Museet och Arkitekturmuseet i Stockholm. Modern Museum and Swedish Museum of Architecture in Stockholm*. Stockholm: 1998.
Rafael Moneo. Bauen für die Stadt. Exhibition catalog, Akademie der Bildenden Künste Vienna, Stuttgart: 1993.
"Rafael Moneo. Museums of Modern Art and Architecture, Stockholm." *A+U*, no. 337, October 1998, 12–35.
Rafael Moneo 1990–1994. el croquis, no. 64, 1994.

Juan Navarro Baldeweg

Juan Navarro Baldeweg was born in Santander, Spain, in 1939. After having begun studies in art, he completed his architecture studies in 1965 at the Escuela Técnica Superior de Arquitectura in Madrid, graduating in 1969. Navarro Baldeweg spent the years 1971–75 doing research at the Massachusetts Institute of Technology in Boston and was guest professor in the following years at various universities in the United States, including Harvard University in Cambridge, Massachusetts, in 1997.

Among his most important works are the transformation of the mills on the Segura River in Murcia (1984–88), the San Francisco el Grande Social Center in Madrid (1985–88), and the Congress Center in Salamanca (1985–92).

Selected Bibliography
García, Angel González and Juan José Lahuerta. *Juan Navarro Baldeweg. Opere e progetti*. Milan: 1996.
Juan Navarro Baldeweg 1992–1995. el croquis, no. 73 [II], 1995.
Lupano, Mario, ed. *Juan Navarro Baldeweg. Die Rückkehr des Lichtes*. Basel: 1996.

Jean Nouvel

Jean Nouvel was born in Fumel, France, in 1945. From 1966 until 1971 he studied at the École des Beaux-Arts in Paris. Before completing his studies, he had already opened his first office in 1970 (until 1974 with François Seigneur). Nouvel was among the founders of the "Architectes Français Mars 1976" movement and the "Syndicat de l'Architecture" in 1979. In addition, Nouvel was engaged as the consultant for the design of the Les Halles quarter in Paris. In 1980 he founded the "Biennale de Paris" and worked as its artistic director. In 1988 the office of Jean Nouvel, Emmanuel Cattani et Associés was opened (until 1994).

His most important works include the Institut du Monde Arabe in Paris (1981–87, together with Lézénès, Pierre Soria, Architecture Studio), various experimental housing projects (from 1985 until 1987), such as the Nemausus I housing complex in Nîmes (with Jean-Marc Ibos), the renovation of the Lyons Opera House (1986–93, with Emmanuel Blamont), the Congress Center in Tours (1989–93), the Galeries Lafayette in Berlin (1991–96), and the Congress Center in Lucerne (1990–99).

Selected Bibliography
Blazwick, Iwona, Michel Jacques and Jane Withers, eds. *Jean Nouvel, Emmanuel Cattani et Associés*. Zurich, Munich, London: 1992.
Boissière, Olivier. *Jean Nouvel*. Basel, Boston, Berlin: 1996.
Cavero, Sergio. "L'exacte représentation d'une volonté." Interview with Jean Nouvel. *Jean Nouvel – Luzern. Concert hall, konzertsaal, salle de concert*. Basel: 1998, 41–56.
Goulet, Patrice. *Jean Nouvel*. Paris: 1994.

Renzo Piano

Renzo Piano was born in Genoa in 1937. He studied at the University of Florence and at the Polytechnic in Milan, and worked for Louis I. Kahn in Philadelphia as well as for Z. S. Makowsky in London. From 1971 until 1977 he worked in partnership with Richard Rogers in Paris and from 1977 until 1993 with Peter Rice in Genoa. Since then, the collaboration with various architects has taken place in the offices of the Renzo Piano Building Workshop in Genoa, Paris, and Berlin. In 1988 Renzo Piano received the Pritzker Prize.

A selection of his most important works includes the Centre National d'Art et de Culture Georges Pompidou (1971–77, together with Richard Rogers), the museum for the de Menil Art Collection in Houston, Texas (1981–86), the passenger terminal at the Kansai International Airport in Osaka (1988–94), the master plan for Potsdamer Platz in Berlin (1992–98), the Museum of Contemporary Art in the "Cité Internationale" in Lyons (1996) and the Jean-Marie Tjibaou Cultural Center in Nouméa, New Caledonia (1998).

Selected Bibliography
Buchanan, Peter. *Renzo Piano Building Workshop. Sämtliche Werke*. 3 volumes, Stuttgart: 1994–97.
Fondation Beyeler, ed. *Renzo Piano – Fondation Beyeler. Ein Haus für die Kunst*. Basel, Boston, Berlin: 1998.
Loderer, Benedikt. "Calme, luxe et volupté. Museumsarchitekt Renzo Piano". *du*, special edition for the Beyeler Foundation for no. 678, 82/XXIII, December 1997, 18–19.
Piano, Renzo. *Mein Architektur-Logbuch*. Ostfildern-Ruit: 1997.
Renzo Piano. Bauten und Projekte 1987–94. Stuttgart: 1995.

Aldo Rossi

Aldo Rossi was born in Milan in 1931. From 1949 until 1959 he studied architecture at the Polytechnic in Milan. From 1955 until 1964 he wrote regularly for the architecture magazine *Casabella-continuità*. Beginning in 1965, he taught at the Polytechnic in Milan until his Italian teaching permit was revoked in 1971 because of political activity. In 1966 Rossi delivered the foundation for the Rational Architecture movement emanating from him with his main theoretical work *L'architettura della città*. From 1972 until 1974 he was a visiting professor at the Federal Polytechnic Institute in Zurich. His teaching permit was reinstated in 1975, allowing him to accept a post at the University of Venice. In 1990 he was honored with the Pritzker Prize. Rossi died in Milan in 1997.

A selection of his most important works includes the housing block in the Gallaratese II housing complex in Milan (1969–73), the swimming "Teatro del Mondo" in Venice (1979–80), and the housing complex on the Wilhelmstrasse within the framework of the International Building Exhibition in Berlin (1981–88, with Braghieri and others). There followed a series of large-scale projects such as the expansion of the Linate Airport in Milan (1991–93), an office complex for the Walt Disney Corporation in Orlando (1991–96), as well as the block on the Schützenstrasse in Berlin (1992–98).

Selected Bibliography
Ferlenga, Alberto, ed. *Aldo Rossi. Opera completa*. 3 volumes, Milan: 1987–96.
Rossi, Aldo. *L'architettura della città*. Padua: 1996.
Rossi, Aldo. *A Scientific Autobiography*. Cambridge, Massachusetts, London: 1981.
Rossi, Aldo. *Scritti scelti sull'architettura e la città*. Milan: 1975.
Savi, Vittorio. *L'architettura di Aldo Rossi*. Milan: 1975.

Álvaro Siza Vieira

Álvaro Siza was born in Matosinhos, Portugal, in 1933. From 1945 until 1955 he pursued his studies of architecture and aesthetics at the Escola Superior de Belas Artes (ESBAP) in Porto. After graduation, he worked together with Fernando Távora—the founder of the Porto school—until 1958, and afterwards on his own as an architect. He taught at the ESBAP from 1966 until 1969, receiving a chair for building construction there in 1976. In 1992 he was awarded the Pritzker Prize. Besides his practical work as an architect, Siza has occupied himself in various essays with the development of a critical theory of architecture.

Among his most important works are the beach restaurant by Matosinhos (1963), the Leça da Palmeira swimming pool (1961–66), the bank building in the center of Oliveira de Azeméis (1971–74), and the Beires house in Póvoa de Varzim (1973–76). Besides the reconstruction of the Chiado quarter in Lisbon (1988–97), of particular note in recent years are the Pedagogical University in Setúbal (1988–94), the University Library in Aveiro (1988–95), as well as the Portuguese Pavilion for the 1998 World's Fair in Lisbon.

Selected Bibliography
Álvaro Siza – Professione Poetica. Álvaro Siza – Poetic Profession. Quaderni di Lotus / Lotus Documents, no. 6, Milan, London: 1986.
Nakamura, Toshio, ed. *Álvaro Siza 1954–1988. A+U extra edition.* Tokyo: 1989.
Testa, Peter. *Álvaro Siza.* Basel, Boston, Berlin: 1996.
Trigueiros, Liuz, ed. *Álvaro Siza 1986–1995.* Lisbon: 1995.

Oswald Mathias Ungers

Oswald Mathias Ungers was born in Kaisersesch, in the Eifel region of Germany, in 1926. From 1947 until 1950 he studied architecture at the Technical Polytechnic Institute of Karlsruhe, graduating under Egon Eiermann. In 1950 Ungers opened his architectural practices in Cologne and Berlin. He was invited as full professor to the Technical University of Berlin in 1963, teaching there until 1968. From 1969 until 1986 he taught at Cornell University in Ithaca, New York, opening an additional office there in 1970. A professorship from 1986 until 1990 at the Academy of Art in Düsseldorf brought him back to Germany. In addition to his built work, Ungers has composed a series of important programmatic texts reflecting his understanding of rational architecture.

A selection of Ungers's most important works includes his own residence in Cologne-Müngersdorf (1958–59) and competition designs for the German Embassy at the Vatican (1965) and the Tiergarten quarter in Berlin (1973). Further buildings of importance are the German Architecture Museum in Frankfurt am Main (1979–84), the Alfred Wegener Institute for Polar Research in Bremerhaven (1980–84), the Badisch State Library in Karlsruhe (1980–92), the Gate Building at the Gleisdreieck in Frankfurt am Main (1983–84), the residence of the German ambassador in Washington (1988–94), and Block 205 of the Friedrichstadt Passages in Berlin (1992–96).

Selected Bibliography
Herstatt, Claudia. *Hamburger Kunsthalle. Galerie der Gegenwart.* Ostfildern-Ruit: 1997.
Kieren, Martin. *Oswald Mathias Ungers.* Zurich: 1994.
Oswald Mathias Ungers. Bauten und Projekte 1991–1998. Stuttgart: 1998.
Ungers, Oswald Mathias. *Morphologie. City Metaphors.* Düsseldorf: 1982.
Ungers, Oswald Mathias. *Quadratische Häuser.* Stuttgart: 1986.
Ungers, Oswald Mathias. *Die Thematisierung der Architektur.* Stuttgart: 1983.
Ungers, Oswald Mathias and Stefan Vieths. *La città dialettica.* Milan: 1997.

Robert Venturi and Denise Scott Brown

Robert Venturi was born in Philadelphia in 1925. He studied architecture at Princeton University in Princeton, New Jersey. Among various positions, Venturi worked for Eero Saarinen and Louis I. Kahn until he opened his own office together with several partners in Philadelphia in 1958. Joining the office were John Rauch (in 1964), Denise Scott Brown (in 1967; Venturi's wife as of that same year), and later Steven Izenour and David Vaughan as well. From 1957 until 1965 Venturi taught at the University of Pennsylvania in Philadelphia and from 1966 until 1970 at Yale University in New Haven, Connecticut.

Denise Scott Brown, born in Zambia in 1931, studied at the Architectural Association in London and at the University of Pennsylvania. Among various positions, Denise Scott Brown was the Aaro Saarinen Visiting Professor for architectural design in 1987 at Yale University.

The theoretical texts on architecture *Complexity and Contradiction in Architecture* (1966) and *Learning from Las Vegas* (1972) received international acclaim.

A selection of their most important works includes the Vanna Venturi house in Chestnut Hill, Philadelphia (1959–64), the Guild House in Philadelphia (1960–66), the Dixwell Fire Station in New Haven, Connecticut (1967–74), the Humanities Building for faculty at the State University of New York at Purchase, New York (1968–73), Franklin Court in Philadelphia (1972–76), the expansion of the Allen Memorial Art Museum in Oberlin, Ohio (1973–77), the Best Showroom in Oxford Valley, Philadelphia (1977), the Research Clinic at the University of Pennsylvania in Philadelphia (1985–89), the expansion of the National Gallery in London (1985–91), and the Seattle Art Museum (1986–91).

Selected Bibliography
Davies, Hugh M. and Anne Farrell. *Learning from La Jolla. Robert Venturi Remakes a Museum in the Precinct of Irving Gill.* San Diego: 1996.
Vaccaro, Carolina and Frederic Schwartz. *Venturi, Scott Brown und Partner.* Zurich, Munich, London: 1992.
Venturi, Robert. *Complexity and Contradiction in Architecture.* New York: 1966.
Venturi, Robert, Denise Scott Brown and Steven Izenour. *Learning from Las Vegas.* Cambridge, Massachusetts: 1972.

Venturi Scott Brown & Associates. On Houses and Housing. Architectural Monographs, no. 21, London: 1992.

von Moos, Stanislaus. *Venturi, Scott Brown & Associates. Buildings and Projects 1976–1997.* New York: 1999.

Peter Zumthor

Peter Zumthor was born in Basel in 1943. After having begun an apprenticeship as a cabinetmaker in 1958, he studied interior design beginning in 1963 at the School of Design in Basel and architecture and interior design at Pratt Institute in New York as of 1966. Thereafter Zumthor worked for the historic settlement survey of the Cantonal Historical Monuments Commission of the Grisons. After having received an invitation to the University of Zurich in 1978, he started his own office in Haldenstein, the Grisons, in 1979. There followed visiting professorships at the Southern California Institute of Architecture in Santa Monica in 1988 and at the Technical University of Munich in 1989. Since 1996, Zumthor has been a professor at the Accademia di Architettura founded by Mario Botta within the University of Italian Switzerland in Mendrisio, Ticino. He has received several prizes including the International Prize for Stone Architecture in 1995 and the Erich Schelling Prize for Architecture in 1996.

Zumthor's most important works include the District School in Churwalden, the Grisons (1979–83), the Räth duplex house (1981–83), his own atelier building in Haldenstein (1985–86), the Saint Benedict Chapel in Sumvigt (1985–88), the Art Museum of the Grisons in Chur (1987–90), the Home for the Elderly in Chur (1989–93), the Spittelhof housing project in Biel-Benken, Baselland (1989–96), the Thermal Baths of Vals (1990–96), as well as the design (1997) for the Swiss Pavilion for the EXPO 2000 in Hanover and the international visitor's center and documentation center "Topography of Terror," presently under construction in Berlin.

Selected Bibliography
"Peter Zumthor." *A+U,* no. 316, January 1997, 3–91.
Achleitner, Friedrich. "Heimkehr der Moderne? The Return of Modernism." *Architektur Aktuell,* no. 202, 1997, 66–79.
Peter Zumthor. Drei Konzepte. Exhibition catalog Architekturgalerie, Lucerne: 1997.
Zumthor, Peter. *Eine Anschauung der Dinge. Über die Sprache der Architektur.* Haldenstein: 1992.
Zumthor, Peter. *Architektur denken.* Baden: 1998.
Zumthor, Peter. *Kunsthaus Bregenz.* Stuttgart: 1997.
Zumthor, Peter. *Peter Zumthor. Häuser 1979–1997.* Baden: 1998.

Photo credits

All illustrations and photographs have been provided courtesy of the architects or taken from the archives of the authors, except in the following cases:

Tadao Ando Architect and Associates, Osaka, Japan: pp. 194, 198 bottom, 199
© Bitter Bredt, Fotografie, Berlin: pp. 100, 101 top, 103 top, 104, 105
© Richard Bryant/Arcaid: pp. 37 top, 39 bottom, 40, 41
© Burg/Schuh BFF, Palladium Fotodesign, Cologne, Berlin: pp. 108, 111, 113, 114, 115
Robert Canfield, San Francisco: pp. 76, 77 bottom, 78 bottom, 79 top, 81, 83
© Michel Denancé, Paris: pp. 155 top, 159 top
© Thomas Dix / architekturphoto, Düsseldorf: pp. 154, 157 top, 160, 161
Foster and Partners, London: (photo: Timothy Soar, Norfolk) p. 34 bottom; (photo: James H. Morris, London) p. 35 bottom
© Scott Frances/Esto: p. 43
Centro Galego de Arte Contemporánea, Santiago de Compostela: (photos: Tono Arias, Santiago de Compostela) pp. 69, 71 top; (photos: Juan Rodriguez, A Coruña) pp. 70, 71 bottom, 74; (photo: Massimo Piersanti, Barcelona) p. 75
© J. Paul Getty Trust: (photos: Scott Frances/Esto) pp. 42, 44, 45, 48, 49
Office of Giorgio Grassi: p. 172
© Gregotti Associati, Milan: (photos: Mimmo Jodice, Naples) pp. 62, 66, 67; (photo: Sergio Pascolo) p. 64
© The Solomon R. Guggenheim Foundation, New York: (photos: David Heald) pp. 125, 127, 130, 131
© Hectic Pictures: (photos: Hans Werlemann) pp. 84, 85, 87, 89
Stephen Holl Architects: pp. 201, 203 top, 205, 207
Timothy Hursley, Little Rock, AR: pp. 56, 57 bottom, 58, 59, 61
Kleihues + Kleihues, Berlin: (photos: Hélène Binet) pp. 132, 134, 135 bottom, 137, 138
Lourdes Legorreta: pp. 92, 94, 95, 98, 99
Duccio Malagamba, Barcelona: pp. 140 bottom, 141 center, bottom, 142, 145
© Milwaukee Art Museum: pp. 163, 164, 165, 166, 167
Stefan Müller, Berlin: pp. 50, 51 top, 54
Museum of Contemporary Art, Chicago, © Hedrich Blessing: (photo: Steve Hall) p. 139
Museum of Fine Arts, Bregenz: (photos: Edward Hueber, New York) pp. 117, 121, 122, 123
Jean Nouvel, Paris: (photos: Philippe Ruault, Nantes) pp. 147, 149, 150, 153
OMA, Rotterdam: (photos: Christoph Corunbert) pp. 90, 91
Heinz Pelz, Karlsruhe: p. 28
Philippe Ruault, Nantes: pp. 10, 146
Margherita Spiluttini: p. 16 top left
Hisao Suzuki: pp. 188, 190 bottom, 192, 193
© Tate Gallery, London: (photo: Chorley Hanford Ltd.) pp. 21, 181 top; (photos: Hayes Davidson, London) pp. 180, 185, 186, 187; (photo: Marcus Leith) p. 181 bottom
Nic Tenwiggenhorn, Düsseldorf: p. 30
Elke Walford, Hamburg: p. 55
© Reimer Wulf, 1998: p. 51 bottom